Best Business Practices for Photographers

John Harrington

THOMSON

COURSE TECHNOLOGY Professional
Technical
Reference

A DIVISION OF COURSE TECHNOLOGY

© 2007 John Harrington. All rights reserved. No part of this book may be reproduced or transmitted in any form or by any means, electronic or mechanical, including photocopying, recording, or by any information storage or retrieval system without written permission from Thomson Course Technology PTR, except for the inclusion of brief quotations in a review.

The Thomson Course Technology PTR logo and related trade dress are trademarks of Thomson Course Technology, a division of Thomson Learning Inc., and may not be used without written permission.

Publisher and General Manager, Thomson Course Technology PTR: Stacy L. Hiquet Associate Director of Marketing: Sarah O'Donnell
Manager of Editorial Services: Heather Talbot
Marketing Manager: Heather Hurley
Acquisitions Editor: Megan Belanger
Marketing Coordinator: Adena Flitt
Project Editor/Copy Editor: Cathleen D. Snyder
Technical Reviewer: Mark Loundy
PTR Editorial Services Coordinator: Erin Johnson
Interior Layout Tech: Jill Flores
Cover Designers: Mike Tanamachi and Cindy Li Design
Cover Image: John Harrington
Indexer: Katherine Stimson
Proofreader: Steve Honeywell

All trademarks are the property of their respective owners.

Important: Thomson Course Technology PTR cannot provide software support. Please contact the appropriate software manufacturer's technical support line or Web site for assistance.

Thomson Course Technology PTR and the author have attempted throughout this book to distinguish proprietary trademarks from descriptive terms by following the capitalization style used by the manufacturer.

Information contained in this book has been obtained by Thomson Course Technology PTR from sources believed to be reliable. However, because of the possibility of human or mechanical error by our sources, Thomson Course Technology PTR, or others, the Publisher does not guarantee the accuracy, adequacy, or completeness of any information and is not responsible for any errors or omissions or the results obtained from use of such information. Readers should be particularly aware of the fact that the Internet is an ever-changing entity. Some facts may have changed since this book went to press.

Educational facilities, companies, and organizations interested in multiple copies or licensing of this book should contact the Publisher for quantity discount information. Training manuals, CD-ROMs, and portions of this book are also available individually or can be tailored for specific needs.

ISBN-10: 1-59863-315-5

ISBN-13: 978-1-59863-315-3

Library of Congress Catalog Card Number: 2006927130 Printed in the United States of America

07 08 09 10 11 TW 10 9 8 7 6 5 4 3 2 1

Thomson Course Technology PTR, a division of Thomson Learning Inc. 25 Thomson Place Boston, MA 02210 http://www.courseptr.com "This is the most comprehensive business guide for professional photographers I have seen. It is a perfect fit for photographers starting out or those in need of a business refresher course. The use of real-world personal examples greatly enhances the book, bringing your solid business concepts to life."

-Susan Carr, immediate past president, American Society of Media Photographers

"Regardless of the level of your photographic skills, if you want a successful photography career, your business skills are what's really going to matter. Every day, the margin for error gets tighter and tighter. This book gives you an excellent insight into how the business works today, as well as providing strategies for surviving and thriving in the marketplaces of tomorrow. The real-world examples and battle-tested methods provide you with the essential business tools that every working photographer needs to make a good living in this demanding profession. Read this book before you shoot another image for a client!"

-Clem Spaulding, president, American Society of Media Photographers

"Photography is an exciting and rewarding career, but only if you can make a living at it. John Harrington is one of a select few photographers who have worked diligently to share their business knowledge so that the rest of us can make better choices and the industry as a whole can be uplifted. This book deserves a place beside all of the great photo books in your library of inspiration."

-Alicia Wagner Calzada, president, National Press Photographers Association

"There's a new kind of workflow—it's about prospering from good business practices—and John Harrington has just defined it. In this book he does more than just show you how to do the right thing; he shows you how to grow your business by doing the right thing. A thorough and consummate professional, Harrington delivers real-world counsel on how to succeed from good business practices from top to bottom. This book belongs in every photographer's back pocket."

-George Fulton, president, Advertising Photographers of America

"Well, it's about time that someone put together a map of how to operate in the photography business world of the new century, and I'm glad John Harrington is the one to do it. So much has changed in our business in the last dozen years. We have gone from a world of the handshake deal to one of multi-page contracts and predatory practices on the part of too many clients. John is very knowledgeable about both photography and business, and shares his savvy with those of us who might not be as alert to the pitfalls and possibilities of our new realm. He knows what he's talking about, and this book should save a lot of bad deals from happening, and turn many of them into good deals."

-David Burnett, co-founder, Contact Press Images

"If there ever was a 'how to' book on how to better succeed in the business of photography, this is it. For the past 16 years I've been a photography student, intern, freelancer, staffer, contractor, corporate and commercial photographer—and I made it through that journey through trial and error, hard work, my fair share of luck, and a determination to steadily educate myself on all aspects of photography. I've also greatly benefited from the shared knowledge from many good friends in the business—something not everyone is fortunate enough to have access to, especially when they're at the start of their careers. Ultimately, there is no true substitute to following in the same path that I did—but this is the best shortcut money can buy. John Harrington's book has so much to offer in so many areas that I'm not sure there is a single photographer out there who doesn't stand to benefit from this book."

> ---Vincent Laforet, Pulitzer-prize winning photographer and New York Times contract photographer

"Creativity is a given but business is a learned art. Your art is your business. The art of business is equally, if not more, important than creativity itself. While John can't necessarily enhance your creativity, he can certainly increase your knowledge of business and help provide you with the necessary tools for a successful business. As a photographer, improving your bottom line is not just dependent on taking good pictures. Getting the right deal and having the right paperwork can mean the difference between success and failure."

-Seth Resnick, D65.com, and past president, Editorial Photographers

To my dad, who inspired my interest in photography. To my mom, who taught me right from wrong. To my wife, who is my best friend.

And

To my children, who sustain my belief in the promise of the future and the inherent good in everyone.

Acknowledgments

It is with heartfelt thanks that I express my appreciation and gratitude to the professionals, friends, and family who have had an influence on my life and development over the years. To my siblings—Laura Rettinger, Robert Harrington, and Suzanne Seymour, and my extended Harrington/ Seymour/Taylor siblings—thank you for allowing me to grow up with and through you.

To my editors: Project editor Cathleen Snyder, technical editor Mark Loundy, and acquisitions editor Megan Belanger, thank you for shaping and helping to make sense of the 1,001 ideas, concepts, and thoughts I had as I worked to put them on paper and in some sense of order.

To photographers Cameron Davidson and Bill Auth, who read every word as friends with different perspectives, and whose suggestions helped me to clarify what I had to say and how I said it. And to David Love, Kenneth Watter, Peter Hoffberger, and Jamie Silverberg, who also reviewed chapters of the book specific to their professions and made thoughtful suggestions in the insurance, accounting, and copyright chapters.

To my office staff, past and present: Talley Lach, Katie Burgess, Audrey Lew, Nikki Wagner, Rosina "Teri" Memolo, and the dozens of interns, all of whom have been a part of the growing business I sought to continue, and who have seen the inner workings of the office. I'd like to especially thank those on hand during the writing of this book, who, when I announced I would be writing a 26-chapter book with nearly 100,000 words, looked at me as if I had grown a third eye as they wondered where I would find the time to write. Thank you for helping me make the time, Talley, Katie, Audrey, and Nikki.

To Dick Weisgrau, Elyse Weissberg, and Emily Vickers, who started the original ASMP Strictly Business seminar in the early part of my career, from which I learned so much. Especially to Elyse, may she rest in peace, whose keen eye, gentle but firm sense of humor, and compassion for photographers and the work we do helped shape me and my early portfolios. Although we spent hours and hours together, I always left meetings with her looking forward to the next one.

To Lois Wadler, Anh Stack, Ben Chapnick, and Dennis Brack, of Black Star. To Lois, who took a chance and saw me without an appointment and ultimately signed me to the agency. To Anh Stack, who works tirelessly on behalf of all her photographers. To Ben Chapnick, who leads the agency and makes available to the world iconic images from some of the world's most prolific photographers. And, to Dennis Brack, who has made more than a few of those images, and with whom I work in Washington, D.C. as a part of the Black Star team, hoping one day to make just one or two of those caliber of images.

To Ken Weber, who published my first photo essay, which led to me working for my first editor, David Hill, at *The World & I* magazine. Thank you both.

To photographer Nick Crettier, who is a mentor and friend, both professionally and personally. To photographers Michael Spilotro and Ken Cedeno, both of whom have challenged everything I know about photography and this business, sometimes just trying to prove me wrong, but always trying to be helpful. And, to Mark Finkenstaedt, Cliff Owen, Jeff Snyder, and Ron Lizik, for your friendship and professional guidance. To photographers and editors David Burnett, Vincent Laforet, Rick Rickman, Cathleen Curtis, Judy Hermann, Clem Spaulding, George Fulton, and Susan Carr, who shared their thoughts and perspectives on this book and the importance of this subject to all photographers, staff and freelance. Thank you.

And to Anne and Sam Seymour and Keith Taylor, who have for 20-plus years been an integral part of my life, helping to grow, mold, and shape me.

About the Author

John Harrington has built and runs a successful photography business, with income having risen tenfold since he started. He has spoken in the past at numerous courses, seminars, and meetings on the subjects of business practices for photographers and his creative vision. Among the organizations he's made presentations before are the American Society of Media Photographers, Advertising Photographers of America, National Press Photographers Association, the White House News Photographers Association, PhotoPlus Expo, the Smithsonian Institution, Corcoran School of Art and Design, and the University of Maryland. He has worked for more than 17 years as an active photographer in Washington, D.C. and around the world, with both editorial and commercial clients. Editorially, his credits have included the Associated Press, the New York Times, the Washington Post, Time, Newsweek, US News and World Report, the National Geographic Society, USA Today, People, MTV, and Life, among hundreds of others. Commercially, John has worked with more than half of the top Fortune 50 companies, and even more of the top Fortune 500. Ad campaigns for Siemens, Coca-Cola, General Motors, Bank of America, and XM Satellite Radio, to name a few, have been seen worldwide. In addition to John operating his own business and licensing his own stock, John's work is also represented by the Black Star Picture Agency in New York City.

John's photography has illustrated four books, three specially commissioned by the Smithsonian Institution's National Museum of the American Indian: *Meet Naiche* (2002), *Meet Mindy* (2003), *Meet Lydia* (2004), and *Patriotism, Perseverance, Posterity: The Story of the National Japanese American Memorial* (2001).

John resides in Washington, D.C. with his wife, Kathryn, and his daughters, Charlotte and Diana.

Contents

	Introductio	on		
Part I	Nuts and Bolts of Your Business1			
	Chapter 1	You Are a Business–Now Let's Get to Work! .3 Whether or Not You Think You're a Business, You Are		
	Chapter 2	Professional Equipment for Professional Photographers .11 We Are Professional-Grade: Why We Must Use That Equipment .11 Pro-Line versus Prosumer-Line Lighting: Why Spend the Money? .12 Cameras and Optics: Why You Want the Best .14 Computers: Desktops, Laptops, and What's Wrong with That Three-Year-Old Computer .15 Specialized Equipment: From Gyros to Blimps to Generators .17 Renting to Yourself and Others .18		

	Chapter 3	Planning and Logistics: Why a Thirty-Minute Shoot Can Take Three Days to Plan21
		Be Ready for the Unexpected
		It All Comes Down to Now! You'd Better Be Ready
		Conveying Your Plan to a Prospective Client Can Win
		You the Assignment23
		When a Seven-Minute Shoot Becomes Three,
		What Do You Do?
		When to Call in a Specialist: From Lighting to Location
		Management, Catering, and Security
Davet II	Einancial a	nd Personnel Considerations
Part II	Filialiciai a	
	Chapter 4	Working with Assistants, Employees, and Contractors: The Pitfalls and Benefits31
		The Hurdle of Growing from Just You to Having People
		Working for You
		Who Must Be an Employee?
		The Benefits of Someone Regular versus Various People38
		Paying Those Who Make Your Life Easier
		One Solution for Concerned Employers40
	Chapter 5	Pricing Your Work to Stay in Business41
	enapter e	School of Thought #1: All Creative/Usage Fees Are Listed as a
		Single Line Item
		School of Thought #2: There Should Be Separate Line Items for
		Creative and Usage Fees
		Raising Your Rates: Achieving the Seemingly Impossible47
		Surveying Your Competition: How to Gather Information
		without Risking a Price-Fixing Charge
		Never Be the Cheapest
		If You're the Cheapest, Find out What Is Wrong

х

	What Do You Charge for Whenever You're Working for a
	Client?
	Photographic Pricing
	Words to Avoid52
	Pro Bono: When to and When Not To
	Licensing: A Primer
	Why Work-Made-for-Hire Is Bad for Almost All Non-Employee
	Photographers
	Recommended Reading
	Books on Negotiating Developed by and for
	Photographers
Chapter 6	Overhead: Why What You Charge a Client Must Be More Than You Paid for It63
	What Is Your Overhead?63
	Back in the Day: The Forty-Dollar Roll of Kodachrome64
	Markup: What's Yours? How Do You Establish It Fairly?66
Chapter 7	Who's Paying Your Salary and 401K?67
·	If Everyone Hiring You Has a Retirement Plan, Shouldn't You
	Have One Too?
	If Everyone Hiring You Is Paid a Salary, Shouldn't You Be Too? $$ 68
	Establishing a Fair Salary68
	Targeting That Salary in the Short Term and Long Term70
	Transitioning from a Salaried Staff Position to Freelance71
Chapter 8	Insurance: Why It's Not Just Health-Related,
	and How You Should Protect Yourself73
	Health Insurance: Your Client Has It, So You Should Too73
	Life Insurance: Get It While You're Young, and Protect
	Your Family Too

.

	Disability Insurance: Think Again if You Believe You'll Never Get Hurt
Chapter 9	Accounting: How We Do It Ourselves and What We Turn Over to an Accountant81
	Software Solutions: The Key to Your Accounting Sanity
	Separation
	When to Call an Accountant (Sooner Rather Than Later)91 What Is a CPA? How Is a CPA Different from a Bookkeeper?92
Part III Legal Issue	es
Chapter 10	Contracts for Editorial Clients
	Be the First to Send the Contract
	Software or Your Own Database
	Editorial Clients

xii

Chapter 11	Contracts for Corporate and Commercial Clients
	What's the Difference between Corporate and
	Commercial?
	What a Corporate or Commercial Contract Must Have141
	How to Work through a Contract Negotiation for
	Corporate/Commercial Clients
	Multi-Party Licensing Agreements
	Case Study: Law Firm Portraits
	Case Study: Regional Corporate Client
	Updated Contracts
Chapter 1	Contracts for Woddings and Pitos of
Chapter 12	2 Contracts for Weddings and Rites of
	Passage
	From Time to Time, Even the Non-Wedding Photographer Will
	Cover a Wedding or Rite of Passage
	What a Wedding or Rite-of-Passage Contract Should
	Look Like
	Parents
	Protecting Yourself from Liability
	Multi-Photographer Events: Calling the Shots and Taking
	Control
	Recommended Reading
Chapter 1	3 Negotiations: Signing Up or Saying No181
Chapter is	Negotiating from a Position of Strength
	Creative Solutions in the Negotiation Process
	Defining Your Policies
	Deal Breakers: What Are Yours?
	Why "No" Is One of Your Most Powerful Tools
	Studying the Aftermath of a Lost Assignment
	Case Study: Science Competition
	case study. Science competition

Chapter 14	Protecting Your Work: How and Why203
	It's the Principle of the Thing for Me203
	Don't Steal My Work, Period205
	Copyright: What Is It, When Is It in Effect, and Whose Is It?205
	Pre-Registration: How to Protect Your Work
	Registration: How to Register Your Work Systematically206
	Title of the Work
	Nature of This Work
	Year in Which Creation of This Work Was Completed .216
	Date and Nation of First Publication of This
	Particular Work
	Sign and Date
	Archival 218
	Definitions: Published versus Unpublished-the Debate $\dots .218$
	Recommended Reading
Chapter 15	The Realities of an Infringement:
·	Copyrights and Federal Court
	What to Do When You're Infringed
	Timeline of an Infringement Suit
	Types of Infringers
	The Preexisting Client
	The Third Party Who Legitimately Obtained Your Image but
	Is Using It Outside of the Scope of the License223
	A Licensor Who Stated One (or a Limited, Smaller) Use
	and Who Is Using the Image in a Much More
	Expansive Way
	A Potential Client Who Reviewed/Considered Your Work
	and Stated They Were Not Using It, but Then Did223
	The Outright Thief224
	When to Engage an Attorney224
	Settlement Agreements

Chapter 16	Handling a Breach of Contract: Small Claims and Civil Court
Chapter 17	Resolving Slow- and Non-Paying Clients233 How to Engage the Client and the Accounting Department233 You Delivered on Time, and Now They're Paying Late236 Statistics of Aging Receivables, and the Likelihood of Collecting at All
Chapter 18	Letters, Letters, Letters: Writing Like a Professional Can Solve Many Problems
Chapter 19	Attorneys: When You Need Them, They're Your Best Friend (or at Least Your Advocate) Advocate)

Advising You on Legal Matters
Taking a Case258
What You Can Expect to Be Billed258
Retainer Fee258
Phone Calls260
Copy/Fax and Other Miscellaneous Charges
Ask Your Attorney Whether It's Economically Sound to
File Suit
Why Attorneys Are Reluctant to Take Cases on Contingency
(and When They Will)261
When You Pay for Advice, Heed It

Part IV	Storage and	Archiving		
---------	-------------	-----------	--	--

Chapter 20 Office and On-Location Systems: Redundancy and Security Beget Peace of Mind265

Redundancy: What Is It?
Communications Networks
Firewalls and System Security
Port Forwarding: Port What?
Back Up, Back Up, Back Up!
Backing Up Your Desktop
Backing Up Your Laptop
Backing Up Your Work in Progress
Dual Backups of Image Archives, On Site and Off271
Dual Cameras on Assignment
Excess Lighting Equipment: Don't Take Three Heads on a
Shoot That Requires Three Heads
It Only Takes One Flight: Carry On Your Cameras
Software Validators and Backup Solutions
The Aftermath: How Do You (Attempt to) Recover from a
Disaster?

Chapter 21	Digital and Analog Asset Management:
-	Leveraging Your Images to Their
	Maximum Potential
	Recommended Reading: The DAM Book
	Solutions beyond The DAM Book: Adapting the Principles
	to a Variety of Workflows
	Evaluating the Cost of Analog Archive Conversions to Digital:
	Is It Worth It?
	Immediate Access to Images Means Sure Sales in a Pinch $\dots 281$
Chapter 22	Stock Solutions: Charting Your Own
	Course without the Need for a

"Big Fish" Agency	283
What's the Deal with Photo Agents These Days? $\ldots \ldots$	283
Personal Archives Online	285
Digital Railroad	285
PhotoShelter	286
IPNStock	287
Others	288

Part V	The Human Aspect		.289
--------	------------------	--	------

91
92
93
96
97
98
9 9 9

	Return E-Mails and Send Estimates ASAP
Chapter 24	Education, an Ongoing and Critical Practice: Don't Rest on Your Laurels
	Continue the Learning Process: You <i>Can</i> Teach an Old Dog
	New Tricks!
	Know What You Don't Know (Revisited)
	Seminars, Seminars: Go, Learn, and Be Smarter304
	Subscriptions and Research: How to Grow from the Couch .304
	The Dumbest Person in Any Given Room Thinks He or She Is
	the Smartest
Chapter 25	Striking a Balance between Photography and Family: How What You Love to Do Can Coexist with Your Spouse, Children, Parents, and Siblings if You Just Think a Little about It
Chapter 25	and Family: How What You Love to Do Can Coexist with Your Spouse, Children, Parents, and Siblings if You Just Think a Little about It
Chapter 25	and Family: How What You Love to Do Can Coexist with Your Spouse, Children, Parents, and Siblings if You Just Think a Little about It
Chapter 25	and Family: How What You Love to Do Can Coexist with Your Spouse, Children, Parents, and Siblings if You Just Think a Little about It
Chapter 25	and Family: How What You Love to Do Can Coexist with Your Spouse, Children, Parents, and Siblings if You Just Think a Little about It
Chapter 25	and Family: How What You Love to Do Can Coexist with Your Spouse, Children, Parents, and Siblings if You Just Think a Little about It
Chapter 25	and Family: How What You Love to Do Can Coexist with Your Spouse, Children, Parents, and Siblings if You Just Think a Little about It

Engaging the Photo Community: Participating in Professional
Associations and Community Dialogue on Matters of
Importance to Photographers
Your Colleagues: They May Be Your Competition, but They're
Not the Enemy
Reaching Out: Speaking, Interns and Apprentices, and
Giving Back
Pay It Forward

Index)

Introduction

Our chosen profession is in the midst of a profound transformation, a sea of change. When I became a photographer, 35mm film was the standard for photojournalism. Twenty years earlier, medium format was king, and that had evolved from a 4×5 mindset. Medium format was the format of choice for many magazine photographers, and although many advertising photographers were also using medium format, numerous were large-format only. Ansel Adams, in the introduction to his 1981 book, *The Negative*, foretold the coming digital era when he wrote, "I eagerly await new concepts and processes. I believe that the electronic image will be the next major advance. Such systems will have their own inherent and inescapable structural characteristics, and the artist and functional practitioner will again strive to comprehend and control them." In each successive shift, there was disdain for the new technology, and that held true for digital too, despite Adams' anticipation. Now there are few compelling reasons to use film.

Although there is much discussion and posturing about file formats, workflows, and such, the concepts of running a business have remained remarkably unchanged. From Dale Carnegie's advice in *How to Win Friends and Influence People*, to the requirement that the income we generate *must exceed what we spend* on expenses, solid business principles have stood the test of time. The founding fathers' inspiring notion in the Constitution that you are the creator of your works and, as such, you are entitled to a limited monopoly on them has changed little. When Arnold Newman led a boycott of *Life* magazine in the 1950s, it was over egregious business practices by the publisher, and the photographers won.

The points made in *Best Business Practices for Photographers* about customer service, giving back, the value of asset management, negotiation, and so on are timeless. The opportunity to revise and update this book will no doubt take place during successive printings and editions, but it is my hope that this book and its core messages and lessons will always be a well-worn resource on your bookshelf. Or, perhaps it will be passed along to a colleague or an aspiring photographer who you feel could benefit from these insights and what's written herein.

Some photographers may disregard commercial photography, espousing the documentary photographer's status as the most honorable, and hold some irrational disdain for commercial photographers or business practices. So I return to Adams, who is cited by William Turnage of the Ansel Adams Trust, in the PBS *American Experience* series *Ansel Adams*. Turnage is credited with securing Adams' financial future shortly after they met, when Adams was 70. Turnage notes, "He and Edward Weston were criticized because they weren't photographing the social crises of the 1930s, and [Henri Cartier] Bresson said, '[T]he world is going to pieces, and Adams and Weston are photographing rocks and trees.' And Ansel was very stung by this criticism. He felt that documentary photography, unless it was practiced at an extremely high level, was propaganda, and he wasn't interested in that. He wasn't trying to send a message."

Turnage then went on to say, "I never met anyone who worked as hard as he did—never took a day off, never took a vacation, ever. He simply worked seven days a week, every day of the year, every year. Even when he was eighty he was still doing that.... [H]is own career was really precarious, economically.... [O]ne of the reasons he worked so hard was to make a living, and it was difficult to make a living as a photographer in those days.... [H]e really struggled to pay the

rent and to make ends meet, literally. He couldn't go on a trip somewhere to make photographs because he didn't have a hundred dollars to pay the costs all his life."

Turnage was not alone in regarding Adams' recognition of the importance of commercial work and the business of photography. Michael Adams, Ansel's son, notes during an interview in the documentary that his mother "was sort of the unsung hero. My mom had the business in Yosemite—she inherited from her father, after he passed away in the '30s—and that enabled them to live, and for Ansel to do the creative work. Commercial jobs were very important, but her support financially allowed him to do a lot of things that he might not have otherwise been doing." And Andrea Gray Stillman, editor and assistant to Ansel Adams, noted that "when [Ansel's wife, Virginia] gave birth to their second child, Ann, in 1935, Ansel was not there. Virginia was in San Francisco; Ansel was in Yosemite on a commercial job."

Frames from the Edge is a documentary about Helmut Newton. When asked, "Are your works for sale? And if yes, how much?" Newton responded, "Not through museums. Museums are not the kind of institutions that sell photographs. Of course they are for sale. For me, everything is for sale. It's just a question of the price! But I do this for a living. I work because I love it and because I love to make money."

To many photographers, appearing in print and achieving a photo credit in a prestigious publication are the ultimate goals, but as poet Dorothy Parker said, "Beauty is only skin deep; ugly goes clean to the bone." When you encounter an offer to work primarily (or only) for a photo credit, and the costs of doing so are greater than your revenue, the beauty of that photo credit is skin deep, but the ugliness of what you are required to sacrifice in order to achieve that goes to the bone.

What's in a photo credit? Validation of your worth as a photographer? Bragging rights? Can you deposit that photo credit in the bank? Pay your rent or mortgage with it? Go to dinner on it?

As I was writing the final chapters of this book in the summer of 2006, I had several of my images appear in a number of prestigious newspapers, all of which are viewed with some level of contempt by many in the photographic community for their low pay and insidious contracts. Yet countless photographers line up to sign their contracts, and photo credits read like the names are going through a revolving door, with photographers staying around for a year or two until they can't afford the "privilege" of working for these publications. My images were not my first, nor will they be my last, appearances within those papers. The images, however, were not produced as a result of an assignment for these papers; instead, they were produced on behalf of other clients—ones who paid a fair assignment fee, paid me for each electronic transmission (*read: e-mail*), enabled me to keep my rights (of which being made available to editorial outlets was a part). I stipulated what rights I would license and what fee I would require to perform the work, and I was paid that.

For a long time, friends and colleagues would express joy at appearing in every publication under the sun, literally from A to Z, whatever the name—especially the marquee national and major metropolitan publications. My biography lists a few of the many publications in which my work has appeared, in large part because people not *in the know* judge me and my work based upon this. For those who do, this is such a disservice to both me and my work. A prosaic image suddenly becomes validated because of where it appeared? I think not. My work—and yours—should stand on its own and be valued regardless of where it appears. Yet many of today's problems with contracts, rights grabs, and low pay are because people were willing to accept low pay (outdated in many cases by at least two decades) and suffered under oppressive rights grabs because they erroneously thought that having their work published by so-called "important" publications would validate them and their work. I submit that this is wrong, but worse than that, the more onerous contracts force those same photographers to lose the right to say they are even the authors of the works.

I long ago gave up trying to value my photography based on where it appeared. Instead, I value my images by what's in them; what they convey; and how people respond, react, pause while viewing them, or, perhaps, are enlightened by them.

I wrote *Best Business Practices for Photographers* not only to help photographers see the significant intrinsic value in the work they produce and to minimize their need for validation by photo credit, but also to help them to see how they can evolve their business model. At best, I hope this book helps photographers so that the work they do becomes a more profitable and personally satisfying experience. At the least, I hope this book helps photographers remain in business so that, in the long run, they hopefully can achieve the former objective.

In the documentary *American Masters* series on the legendary photographer Richard Avedon, details about his 1966 contract with *Vogue* were reported. "As the presence of the real world rose into his fashion work…and needing to support his personal work, Avedon accepted *Vogue*'s unprecedented million dollar offer…. [H]e learned to separate his personal and professional work." Avedon, in his own words, went on to say, "There is no downside to my commercial photography. I am so grateful that I have the capacity and the ability to make a living and support my family—which is the definition of being a man for my generation—and to support my studio, support my special projects by doing advertising."

As you hold in high regard Adams, Newman, Avedon, and others, remember that they held on to their rights, and regarded what they do as something worthy of continuing—by having it sustain them spiritually *and financially*. So let this book guide and encourage you to be as successful as possible in your professional work, if for no other reason than to support your own special projects.

Part I Nuts and Bolts of Your Business

Chapter 1 You Are a Business–Now Let's Get to Work!

This book was written for the professional photographer. It will serve as a helpful guide where you're looking to improve your business, as well as a refresher and an affirmation of what you are doing right. It was not written for the aspiring photographer looking to get into the photo business, although at some point, earlier in your career rather than later, the topics covered in this book will be crucial to your longevity and staying power.

Something that's not taught to most photographers graduating from college with a degree are the skills necessary to be in business as a photographer. The notion that a photography school would fail to teach its students all the necessary skills to pay back their student loans and remain in their chosen profession seems to me incredibly shortsighted. Recently, some forward-thinking schools have begun to see the writing on the wall and are instituting a required class or two. Art schools with photography concentrations, on the other hand, seem oblivious to the dollars and cents aspect of serving their students. I will applaud the day when every photographer graduates from a photography program understanding all that is necessary to hang his or her shingle out and grow a business responsibly.

Whether or Not You Think You're a Business, You Are

You are a type of business. Not you the photographer, but you the individual. Your ability to generate revenue is seen by the IRS as a form of a business, and you must pay taxes for the right to generate that revenue and reside in the United States. The government has deemed that your taxes are the necessary totals to provide you with the services you're better off not paying for yourself—roads, the police, mayors, and so on. A percentage of your revenue goes to these items. How you choose to function as a business is your choice; you may be an employee of a company who pays your taxes out of your earned check, you may opt to be self-employed, or you might choose to run a formalized corporation, LLC, partnership, or the like, but taxes are inevitable and not a matter to take lightly.

What you do for your earned revenue is your choice as well. However, over a period of time, what you earn must exceed what it costs to earn it—not just now, but projected into the future as well. This reality is lost on most graduating photographers and those entering the profession

4

from other arenas. This message is important—not because you're reading this and hoping to go into business, but so you can understand that regardless of whether you see yourself as a business, everyone else does—especially the IRS, as well as your family and your current and prospective clients. How you run your business will be the primary determining factor in your success. And remember, vendors, some as simple as MasterCard and Visa, not to mention supply houses and camera stores, see you as a business, and not only expect to be paid promptly, but will cut you off and damage your credit rating if you do not do so.

Save for the independently wealthy, anyone can operate a photography business for free for a short period of time, after which point the money runs out and the debts pile up, and you must then do something else to pay the bills. Understanding this extreme means you can understand that if you have not taken into consideration all of the factors—short term and long term—that go into being in business, at some point the expenses will catch up to you and you will be required to do something else to earn a living. To a lesser degree, you might eke out a living, renting apartments rather than buying a home, always buying an old used car instead of the occasional new one, and scrimping to afford new clothing and the expense of children (from diapers to graduation, and everything in between). While this may be an easy out for the new graduate, it provides no plan to upgrade equipment in a few years or replace the dropped \$8,000 camera that is now a paperweight. The eked-out living is worse than living paycheck to paycheck; it's a disaster waiting to happen.

Many photographers approach their photography purely as a calling, and their goal is to change the world by making pictures that reveal poverty, despair, suffering, and the human condition. These photographers believe that making money for these types of assignments is contrary to that effort, but nothing could be further from the truth. If this is truly your philosophy and you believe that your pictures can and are making a difference, then making business decisions that make it impossible for you to remain in business to make this difference in the long term does the world-changing movement a disservice. It's akin to a physician, who has been trained for years to save lives, not taking the necessary safety precautions (for patients and for themselves) of gloves and a mask when working in a Third World clinic. Although such physicians may make a significant difference, their contribution to society may be cut short by contracting the diseases they fought so hard to cure, and they would fail to protect their patients by moving from one to another without wearing gloves. You too must take the necessary business-safety precautions to ensure you remain in business long enough that you make the difference you seek to achieve. Unfortunately, for so many, this message that good business practices really matter is either lost or perceived to be too hard to follow. This book aims to change that idea.

Further, if you operate all other aspects of your business profitably and you want to be a modern-day Robin Hood, you can take your profits and self-fund an assignment to document plights and underreported issues of our day. You can then take those stories and present them to media outlets and offer up a written and photographed package that they find very attractive. Absent a printed outlet, there are innumerable outlets with wide audiences on the Internet where you can get your story picked up and start making that difference. Charging enough that you can save for these projects means that you can take assignments from those who can afford to pay you top dollar, and then transition those dollars into footing the bill for altruistic projects.

In the chapters that follow, I will provide the resources to answer questions on a wide variety of topics and will direct you through the confusion and give you guidance and insight based upon my own experiences and the lessons I've learned. In some instances, rather than reinvent the wheel, I will direct you to resources on which I rely, from pricing to digital asset management and the like.

This book is not written for someone who's just starting out. However, that does not mean that a photographer just starting out wouldn't benefit from reading it. In fact, doing so truly can allow you to start out on the right foot. However, some of the content may, at first, be confusing to the beginning photographer, because you won't find much Business 101 content. The contents are designed to be applied to an existing photography business, so that those in business can take their enterprise to the next level, find poor and underperforming facets of the business, polish and fine-tune them (or make major overhauls), and make an overall improvement in the success of their business or save it from failing. Students or first-year photographers will take away from their reading of this book a roadmap of their future once in business and a practical set of solutions that will help them understand how an established photographer is (or should be) operating his or her business.

Making Decisions: Strategic versus Tactical

You've likely heard the statement about losing the battle but winning the war. This is when you may have made a tactical error in the battle, but your overall strategy was effective enough that you came out on top. Tactics are changeable, whereas strategies are more difficult to switch. The problem is that many photographers are so certain they are going to succeed despite their poor strategies and repeated bad tactical decisions that they continue to follow a path that is not in their best interests. In many cases, there may be a short-term gain, but with a significant long-term negative impact. Further, studies in the investing community have shown that of people in the age group of 16 to 24, 20% consider "long term" to be three years or less. In the 35 to 44 age group, just over 40% consider long term to be more than 10 years, and three out of five believe that five years or fewer constitutes long term.¹ Although this study was investor-focused, the mentality still applies. Someone just graduating from college might well see taking work that does not account for their true expenses as beneficial and may see their long-term success as only in the next few years. This is a strategy that is sure to backfire.

All tactics you employ must serve the greater strategy, namely remaining in business as a photographer for the long term (and I see that as much more than 10 years!). If you've looked at your annual expenses and divided them by the number of assignments you completed last year (or hope to complete next year) and that number is \$178.80, then taking an assignment for a day that pays you \$150 is a bad tactic and will lead to the failure of your strategic goal if repeated for long enough. A better tactic would be to spend that day researching higher-paying clientele in your market and developing an outreach plan to obtain work from them.

It is imperative that you look at all the decisions you make as being tactically wise. The purchase of a new computer or software upgrade must make you more productive or efficient. When every photographer had pagers and had to find pay phones or wait until they got home to

¹ KUSI News - San Diego. http://www.kusi.com/business/2557181.html.

return a page, or when they had to return home to find a message from a prospective client on their answering machines, it was tactically a good move for me to pay a large amount of money (at the time) for a cell phone, and then use my local phone company's call-forwarding feature to forward all my calls to my cell phone when I left home. While prospective clients were waiting for the paged photographers to return their calls, I was already on the phone booking the assignment. Often colleagues would lose assignments to me for no reason other than I was the first photographer the client was able to talk to, and that closed the deal. Each month, more than enough assignments came through to justify the decision to pay for the cell phone. Tactically, it was a good move and served to advance my strategy in a major way.

Today, it's the immediate response to e-mails from clients, followed by immediate estimates, that helps me secure assignments. Tactically, it was a good move to pay the premium to enable my current cell phone to send and receive e-mails. Forty dollars per month for unlimited e-mail over my cell phone is a small price to pay—just one assignment a year, and the costs for the call-forwarding phone feature have more than paid for it. This feature has paid for itself over and over—so much so that it now seems irresponsible for me not to do it.

Decisions must be thoroughly considered. Expenditures must be examined, but more importantly, revenue inflow must be at an appropriate level to cover expenditures. If you're not considering the appropriateness of decisions in the good-tactic/bad-tactic approach, then you are doing a disservice to the strategy.

Reviewing Your Current Business Model and Revamping What You're Doing

Your current business model must be reviewed. Whether you're a freelance news photographer, an advertising photographer, a wedding photographer, or a high school portrait photographer, all good businesspeople sit down and examine what they are doing and how they could do it better. Large corporations have whole divisions dedicated to productivity and efficiency, and you're a micro-version of that corporation—You, Inc.

One example of this is the You, Inc. shipping department. For freelancers, there are two main types of physical shipping—overnight delivery and hand delivery. Consider that You, Inc. actually has a shipping department. If every time you deliver the finished photography to a client by hand, you don't charge a delivery charge, you're taking a loss in two categories—labor and expenses. The labor is your time delivering the materials, and the expenses are the gas and parking (whether garage, meter, or other charge) associated with that the delivery, not to mention mileage. A 10-minute delivery also means five minutes parking and going in, and 10 minutes back, for a total of just under 30 minutes of your time, plus a few dollars in gas/parking.

Charging a fee of \$12 to \$18, commensurate with what outsourcing to a courier/delivery company would charge, means you are ensuring that your shipping department is not reliant on the other "divisions" (photography, post-production, reprints, and so on) to sustain it. Furthermore, when you get so busy shooting that you can't take the time to make deliveries, you will have in place a mechanism to charge for delivery, since you are now making more money using that time to shoot. Furthermore, your clients now expect to pay for that service. If you can

no longer make deliveries when you get so busy and you start charging all your clients a delivery charge at that time, they'll object and you'll have to deal with angry customers who feel over-billed. Or, you'll have to eat the charge into your overhead. For the last decade, my shipping department has generated enough revenue to cover the expense of the vehicle I use to make those deliveries, including new car payments, insurance, gas, and the like. At the very least, the You, Inc. shipping department should offset those same expenses for you.

And, if you're a staff photographer doing work on the side (weddings, portraits, and so on), you really must examine your freelance business because when you're no longer staff, you'll want to make sure that the work you're doing can sustain you. If you only establish clientele for a few hundred dollars a day that you can earn on your mid-week days off, then when you go freelance (or are forced into freelance by being laid off) and that amount of revenue from an assignment can't sustain you, you won't be able to remain in business. Even if you're a staffer, you should treat all assignments as if they were freelance—not only will this create a collection of clients for you that pay a self-sustaining rate, but it also will ensure that you're not cutting your freelance colleagues' throats with low-ball assignment fees that the client will no doubt use to beat down the freelancers in your market. But we'll discuss more on rates and such in Chapter 5, "Pricing Your Work to Stay in Business."

A review of what's profitable and what's not will ensure that you maximize your potential. Some photographers get into the wedding or event business and hope to someday become bigdollar advertising photographers, or they work in the mid-level family portrait business and hope to become a major magazine portrait photographer of the movers and shakers of the world. However, these photographers often become complacent in that model and never work to seek out the types of photography they wanted to do. They remain in a type of photography business that they had not intended to, and then they look back 10 or 15 years later and wonder why they didn't act sooner.

Perhaps having a studio is where you are now, yet you review the expense and find that because a majority of your portrait subjects want to be photographed on location, carrying the overhead of the studio for the small percentage of in-studio portraits you do just isn't wise. Although you don't need to sell the space, taking in two (or more) other photographers to share the studio expense could be a solution that makes more sense for you; alternatively, offering to rent it out and promoting it as available might be a better solution.

Suppose you are taking assignments for editorial work through a typical photo agency that takes 40% of the assignment fee and you keep the remaining 60%. Perhaps that is not the best solution, and securing clients directly so that you keep 100% of the assignment fee is a more sustainable choice. If you are working for a photo agency and the editorial fee is \$450, it means you only get to keep \$270. If your per-shoot-day operating expenses are \$150, then you only earned \$120 for the day, which is not a sustainable figure long term.

A cursory review every two to three years, followed by a serious sit-down every five, will ensure that in 20 years you will not only be in business, but you will be earning a fair wage and you will be satisfied that you made smart decisions along the way.

CHAPTER 1

Know What You Don't Know

8

One of the lessons I pass along to every group I speak to on this subject is this mantra: *Know what you don't know*. I know it sounds silly at first blush, but when you stop and think about it, you realize that it's really a wise idea. If you don't know about marketing, don't pretend that you do. Admit that you don't (at least to yourself), and then work to fix that. When you've figured out what you don't know, then and only then can you work to know what you now know you don't know. (*Reread that last part—it's critical that you understand it.*)

Make a list. If you don't know how to find new clients, write that down. If you don't know how to raise your rates, write that down. If you don't know how to charge for post-production of your digital images, write that down too. Now you are beginning to grasp what you don't know, and you can begin to learn what you don't know.

One problem this brings up is being honest with yourself. Many photographers pride themselves on knowing it all; however, that thought process will backfire. It used to be that technology improved slowly, and all we had to worry about was about the newest film emulsion or the improved auto focus or flash TTL technology, but today we must learn and then relearn new software and new and improved versions every 18 months. We begin again teaching ourselves (or taking seminars to teach us) just how to use the new software or latest camera body. There is no shame in sitting down and reading a camera manual from front to back, and then doing it again in two weeks to learn what you've forgotten already. There is nothing wrong with calling a colleague, admitting you've never used the latest version of Photoshop, and asking what the difference is between the latest and previous versions.

There are many facets of business that are unfamiliar to photographers. From sales tax, to quarterly payments, to terms such as "2 10 net 30," to profit, to expense ratios—understanding that these are important to the long-term success of your business and that seeking out the answers will serve your long-term interest means that you will be in business in 20 years. These and innumerable other business facets mean that there's a lot you don't know, and you need to know what you don't know before you're ready to move forward and grow your business wisely.

Creating a Business Plan for an Existing Business

Creating a business plan midstream is like trying to turn an ocean liner 90 degrees starboard in two football fields. Without precise tools and know-how, it's next to impossible. Yet, there are a variety of reasons why it's important to create a business plan. For one, the Small Business Administration won't give you a loan without one. Banks will be reluctant to loan you money as well. But often, you're so focused on the next two weeks, you just can't seem to find the time to sit down and write a plan. If you don't know how or where to begin, the Small Business Administration (www.sba.gov) is a great resource with in-person and online classes, as well as samples on just how to do this.

Harry Beckwith, author of *What Clients Love: A Field Guide to Growing Your Business*, makes this point about business plans that cannot be missed:

Most people assume that business plans will tell them what to do. Few businesses, however, follow their plans. Things change, assumptions change—and plans change with them, as they should. Yet businesses still plan.... The value of planning is not in the plan but in the planning.... Like writing a book, writing a plan educates you in a way that nothing else can.

Fortunately, you're in business, transitioning from one business to another or from staff to freelance, and you are not trying to start your plan as a pie-in-the-sky idea; rather, you're looking to document what you are currently doing, and this can be an interesting exercise. By analyzing your clientele, marketing efforts (to date), and profits from the various assignment types you complete, you can begin to see patterns emerge. From the type of clients who seem to always pay late (and thus may be enticed to pay on time with discounted rates or surcharges for late payments added); to marketing efforts that used to work, such as the major photo annuals, but which are dying on the vines; to profits, where you can find that clients who used to be profitable are now demanding more for the same price and, therefore, the profits per assignment are below continuing in that line of photography and should be jettisoned from consuming your time and resources—a review of a business plan drafted from existing work is more often than not an enlightening experience.

There are numerous books and courses (many free or very inexpensive) in communities across the country that you can utilize to help you draft this plan. Bring your tax returns, marketing materials (postcards, Web sites, and so on), and in a day or two you'll find that you have a banker's perspective on your business. Bankers are math people who look to make sure that if they loan you the money, you'll be able to pay them back; they have a vested interest in making sure you can do so and that you remain in business.

Whatever course you choose, you'll want to make sure you establish a business plan. If you're not the planning type, think again. You've planned to have the right equipment and the right computers, and you've planned to learn the software necessary to do your assignment. For assignments for which you're not familiar with the subject or subject matter, you did your research so you know that XM Satellite Radio is not a local radio station, but rather the nation's premiere satellite radio company, so that when you walk in for your assignment to photograph the CEO, you don't ask where they are on the dial. For your assignment to cover a sports team, you've done research that tells you who the key players are in the game and what to expect from them. For a stakeout, you studied the entry and exit points so that the indicted politician has to pass by you when he leaves his lawyer's office building. If you're planning all of these things, planning for your future success should be just as important (if not more so). Those planning exercises were tactical—they helped you complete the assignment successfully and hopefully earn another assignment from the client. Developing a business plan in which success is defined as you remaining a photographer is a strategic decision, one that is critical to your future.

Understand, though, that your plans must incorporate the idea that the business of photography is constantly changing. You not only must plan for what you expect, but you must establish responses to unexpected events and responses to those responses, and so on, and so on. By doing so, you will ensure that you are prepared for whatever clients and trends get thrown at you. This is not a plan-it-and-forget-it, check-that-box-I'm-done situation; it's one that will require you to be just as on top of your business as you are on the trends in news, weddings, portraiture, and the like.

Chapter 2 Professional Equipment for Professional Photographers

Top-of-the-line and specialized equipment is expensive for a reason. In many lines of cameras, there are the consumer models, the prosumer models, the professional models, and, in some, the top-of-the-line models.

We Are Professional-Grade: Why We Must Use That Equipment

Can you use a consumer or prosumer piece of equipment and often produce exceptional images? Of course. In fact, there are premium newspapers and magazines that are using some of the prosumer bodies because of the size difference. If, in an analysis of your circumstances, you've evaluated the available equipment, and you are not making the choice on what's cheapest, then the use of consumer/prosumer equipment may be what's best. Otherwise, should you? Not in my book. Typically, the prosumer lines have fewer features than the professional line and more features than the consumer line. Further, in many lines, especially in the areas of camera chips and lenses, the purist chips that render within higher tolerances are given to the professional cameras, and the chips that fall out of that tolerance end up in the prosumer or consumer bodies, with the software then dumbed down to limit the functionality of the chip. There are several times when this has occurred. One time in particular was several years back, with Canon EOS Rebel bodies carrying the same chip as prosumer models. There was a great deal of discussion surrounding just how to effect a change in the software to "upgrade" the EOS Rebel to have the functions of its more expensive sibling.

When you're on assignment is not the time to find that you have a need that exceeds your equipment's capabilities, from chip size, to f-stops, to flash duration, to incremental flash settings to a tenth of an f-stop, and so on. If this occurs, you will find yourself making compromises on the quality of your imagery and what you produce creatively for the client.

Pro-Line versus Prosumer-Line Lighting: Why Spend the Money?

I'll be the first to admit that I started with Dyna-Lites 15 years ago. Soon, I got tired of trying to put lights in disparate locations, even with extension cords for the heads. I never had enough extension cords, packs, or f-stop adjustment abilities. As a result, I upgraded to Paul C. Buff's White Lightning line of monobloc heads. I relied on the White Lightnings for a number of years and held the Dyna-Lites in reserve as my backup lighting kit or for use when I had a larger shoot that called for additional lighting. One day, I found myself doing a number of portraits on location, and one room in particular just couldn't be lit the way I wanted it—the White Lightnings just were not powerful enough, so I began to explore my options. I looked at a number of professional-grade lines and settled on Hensels. I liked a number of their features. I'm not saying they are the brand to go with, but they are the kind of high-quality gear I strongly recommend. There are numerous reasons to go with pro-level lighting, not the least of which is durability.

Professional-grade lighting has two significant features that are often lost among the less detailoriented—color temperature shift and flash duration.

Color temperature shift is what it sounds like—the change from 5500°K to, say, 4800°K over the range from full power to 1/4 power. Although technology has advanced to the extent that color shift over lighting power ranges has diminished over the years, there are still a limited number of definitive situations in which this will have an effect. Here are a few:

- ▶ Food photography (especially chocolate)
- Product photography (consider client logos and Pantone colors)
- Scientific photography

In addition, a change of even 100°K is a perceptible change in color temperature when two images are placed next to each other with varying temperatures of that small a shift. Further, a shift of 700°K is between a 1/4 and 1/8 CTO and can make your subjects warmer than you expected. Although this shift might have presented a much more significant concern in the days of film, it is still important to know that you are shifting color temperatures when adjusting power on prosumer lines of equipment. This will also explain why your whites are not a pure white, but a warm white when a subject is photographed on a white seamless.

NOTE

CTO is the orange gel that converts daylight to tungsten. A full CTO gel converts 5500°K light to 3200°K, and 1/2 and 1/4 gels are relative reductions in that shift.

The major issue that affects prosumer lighting is flash duration, and it's still a problem with digital cameras. If you've ever seen the Edgerton photograph of a bullet going through an apple or popping a balloon, where everything's frozen and crisp, or one of performers is frozen in midair, where you can see every minute detail, then you've seen flash duration at its extreme.

While the bullet and apple/balloon photographs are frequently done with customized flash equipment, the performers frozen in midair are done with professional-grade lighting with extremely short flash durations.

Back in the days of film, I'd use a Hasselblad, and I'd be at 125th of a second at f/22, photographing a subject in the midday sun on ISO 100 film. I'd want the sky to be deeper than the 1-stop under that it currently was, so I'd stop down to 250th and I'd lose a little of the pop directed at the subject. At 500th I'd lose 1-1/2 stops of light and I'd be stuck. I had to return to, at best, 250th, all because the flash duration was longer than the time the shutter was open, and with all the settings the same, just a shutter speed stop-down, I was losing light.

More recently, I was involved in photographing an ad campaign in which we were shooting day for night. Typically this is done when you need a scenic vista with some degree of illumination—at night—and you don't have any way to light it. You allow the sun to be your background light to give tone to the shadows, but you want it three to four stops under your strobe, and that means ISO 50 at 250th at f/22 with some clouds cutting the sun down. Having a strobe system with a short flash duration will ensure that you can make a photo of this scene and meet the client's needs. When the ad in this case was delivered, everyone except the art director and subject who were on set was convinced that the shoot had taken place after sunset, yet it had taken place under midday sun.

To understand flash duration, picture a line graph in which the light output looks like a bell curve. At the moment when the shutter is tripped, the stored energy in the flash pack begins to be discharged and the element in the bulb begins to brighten to its stipulated power. The first few milliseconds are when the light output is increasing, from zero to a few watt-seconds, and during the next few milliseconds the bulb filament achieves its maximum brightness and light output, and then begins to power down. As it discharges and the power output diminishes back to zero in the last few milliseconds, the illumination is complete. Less like a bell curve and more like a spike means a shorter duration in power up/peak/power down. As a result, a shortduration flash will not have its "tails clipped" as the shutter closes while the flash is still producing output. If all your photography takes place at 125th of a second or slower and you rarely find yourself using full power on the strobes, then flash duration might not be important to you, nor will it have a significant impact. However, if you get the call for a big assignment that calls for intricate lighting or you don't want your creativity clipped by long flash duration lighting kits limiting shutter speeds and maxing out at f-stops to "stop down the sun," then you will want a professional-grade flash system. There are, in all fairness, only two systems that can deliver on this level when it comes to battery-powered packs. They are the Hensel lights and the Profoto 7Bs. The other systems work well; however, when tasked with the aforementioned big assignment, having—and being familiar with—the right equipment means you will be able to deliver repeatedly.

One last point about lighting equipment might seem tangential to lighting, but is integral. When you arrive at an assignment, don't have multicolored cases, bags, and such. Your cases, from the outside, should look like they are pieces of a cohesive unit. Typically, this means sticking with one brand, or, the safe bet, all black. And when your cases are opened, they should look like the person who packed them knows what he or she is doing. I am amazed every time I peer inside the toolbox of an auto mechanic by how every tool is clean and neatly organized. Every tool has its place, and your equipment should too.

Cameras and Optics: Why You Want the Best

There's a reason why top-of-the-line cameras are so expensive—it's because the cost of R&D going into improving the capture capabilities is extremely high, and the number of cameras they can expect to sell using that cutting-edge technology is relatively small. So, they need to spread the cost of bringing that technology to you over the number of new cameras. Of course, you're also underwriting that R&D, which will eventually find its way into prosumer- and consumer-grade equipment.

Consider that today's professional-grade cameras can capture amazing detail and low noise at 800, 1600, and even 3200 ISO. This capability wasn't available even 18 months ago. Back in the days of film, I could use a camera from the 1970s, load in current-generation film, and compete for image quality against a camera produced in the 1990s. Now, a camera that is 18 months to two years old produces significantly poorer-quality images than today's cameras, and that will change again two years from now.

If you're using a camera with a chip that is not capturing the maximum amount of data and you're covering a news event where the photographer next to you is capturing the maximum amount of data, he is producing images that have more potential than yours. If he's a bit too wide, he can crop in and still have a sizeable image. If you are too wide, you can't. If the photographer is using a camera with a greater latitude than yours and she's over/under, a usable image can be obtained after the fact. If your camera only shoots in JPEG (and this is the case with some of the prosumer bodies) or the latitude of your camera's chip is one or two generations back, then you're again at a disadvantage. Of course, when everything goes right, you have no worries. It's when you're too wide/bright/dark that you'll need that extra range to make the difference, and with prosumer and consumer cameras, you're limiting yourself beyond what you'd find acceptable if you were shooting film.

One of the bigger mistakes I see a lot of photographers make is not seeing the value in the pro-line lenses. The best lenses typically have a maximum aperture of f/2.8 or better and are fairly expensive. This isn't a marketing ploy; the more expensive lenses have better optics. So what does this mean? It means the lens was designed for digital, set up so that all the colors focus at the same point in space (previously, this was referred to as *apo-chromatic*, or *APO* for short). This was only really seen in Leica and Hasselblad (also known as *Zeiss glass*), which accounted for the significant quality shift in images produced through that glass and the high price point for those lenses. They met the highest and most stringent standards for optics, and it sure made a visual difference. The top-of-the-line lenses deliver the purest of optics. You might read a review in a photography magazine on the latest lenses, and for the pro-line lenses they'll list "expensive" in the cons section. As a professional, I don't subscribe to this as a con.

Further, stopping into your glass to f/2.8 is going to give you a sharper image than shooting wide open at f/2.8. What I mean is, if you have an 85mm f/2.8 lens and an 85mm f/1.4 lens, when you are at f/2.8 on the former lens, you are wide open, using the edges of the optics to produce the image at f/2.8. When you stop down to f/2.8 from f/1.4, 2+ stops, you are "deep" into the glass, and the resulting images will generally be sharper because you are using more of the center and less of the edges of your optics.

15

Computers: Desktops, Laptops, and What's Wrong with That Three-Year-Old Computer

What's wrong with that three-year-old desktop computer? For starters, it's slow. Second, its hard drive will most likely crash sooner rather than later. Computers, like cameras, have a fairly short lifecycle. Friends of mine make sport of my desire to have the best and most useful gear and computers. But in the end, I have the tools to do the job, and that's what the client pays for.

MACS VERSUS PCS

Windows fans cite the statistic that in the U.S., only 8% of today's computers are Macs. What that statistic fails to reveal is that approximately 70% of the entire group of computer users from which that same 8% is drawn are enterprise-level major corporations whose IT departments dictate the PC mantra-in part because it keeps them employed fixing all the PC crashes and the like. When you extract enterprise-level networks from the equation, the Mac percentage skyrockets, and rightly so. Here's why:

Viruses. 99% of all viruses (and some would suggest 99.9%) are written to take advantage of weaknesses in the Windows operating system. From Internet Explorer to Windows XP, there's a reason why Microsoft must put out security patches once a month or more. Thankfully, Macs don't incite the ire of hackers wishing to take on (and take down) the behemoth that is Windows. Further, the UNIX operating system, on which Mac's OS X is based, is a better programmed and safer operating system. That said, if you buy a Mac and boot into Windows on it (or use Apple's Boot Camp application to run Windows operating systems on your Mac), you'll be just as susceptible to those viruses.

Stability. Microsoft's operating systems constantly face delays on their launch dates and often end up being pared down to meet those pushed-back deadlines because they have not started from scratch since early versions of Windows. As a result, the feared "blue screen of death"—the indication that your PC has fatally crashed—appears far too often in my opinion, and it inevitably occurs when you're on deadline or you have not saved all the Photoshop retouching, for example, and you lose your work and possibly the data on that drive. At some point, Microsoft will begin an operating system from scratch and not build on the faulty and error-strewn code from previous builds.

Macs have always been the choice of "creatives," from art directors to photographers, illustrators, graphics designers, and the like. Software has been written specifically to take advantage of Mac functionality and often is then transferred over to PCs. The software that best serves this community is often Mac-optimized, Mac-centric, or sometimes Mac-only.

If you are an employee of a large company that dictates you must use a PC, then by all means use a PC and take full advantage of the IT department. Make them your friends by gifting them with coupons for Starbucks, donuts, or danish, because you want to be on their good sides. You want them to help you and look out for you, and java and pastry are an appreciated way to ensure that your IT department looks forward to your calls and panicked visits.

I spent close to eight years running cross-platform with an equal number of PCs and Macs, and every time I had a problem with a PC, it took two to three days to find and fix the problem. Problems with the Mac were fewer and further between, and they took 30 minutes to an hour to resolve. I finally donated all my PCs to the Salvation Army, took a tax deduction for my donation, and said good riddance. I do, however, keep one PC in the office to ship software that is PC-only, to test CDs with client deliverables on them, and to remind me of just how much I never want a PC office network again. That said, there is a studied reason why the latest and greatest machines are worthwhile acquisitions. The first and foremost reason is productivity. If you want to know just how much time and money you can save by buying a new computer on a regular schedule, do a little homework. First, take a hundred raw camera files and run them through your workflow from ingestion to final deliverable form, timing the entire process. Then, visit a friend who has a faster machine than you and do the same workflow, timing that as well.

Now, work the math, in this instance using the Mac pricing as an example. The latest top-of-theline Mac is around \$3,300. Currently, that's a Quad 2.5-GHz G5. If you have an older machine, look on an auction Web site such as eBay and review the completed sales to see what the cost differential is. (In other words, if you sold your current machine, what would be the difference between the sold price and the new computer's price?) For example, a Dual 2-GHz G5 is selling for around \$1,800, and a G4 Dual 1.25-GHz machine is selling for around \$1,000. Taking the G4 as an example, there is a net outlay to you of \$2,300 for the latest top-of-the-line machine. So, what does this do for you?

If it takes 38 seconds to process an image in your raw processor on the G4 and another 13 seconds to complete other workflow tasks (metadata application, saving, downsizing, and so on), then you are at 51 seconds per image. However, that Quad G5 will take (from my own experience) about six seconds to process that same file, and then another eight seconds to complete the rest of the tasks, for a total of 14 seconds—a time savings of 37 seconds per image.

My hourly rate charged to clients for sitting in front of a computer works out to be about \$125. This works out to be about 3.4 cents per second. This means that if I am saving 37 seconds of processing time with the new computer, I am *saving* \$1.28 per image in processing time. If 100 images used to take 85 minutes to process, with the new machine they take 23 minutes. With a net outlay of \$2,300 for the new machine, the machine pays for itself after about 1,800 images processed, and every image after that provides both cost and efficiency savings.

If you offer video as a service, which is very processor intensive, the difference is even more dramatic.

If you've ever sat at a computer and complained that you had to baby-sit it, you couldn't process the images fast enough to get to other work, or you were overwhelmed with images, then a faster machine will free you up sooner than the older technology.

The next question is whether it's worthwhile to sell that old computer for \$1,000, or whether you should keep it as a second machine that you can use to do invoicing, Web surfing, e-mailing, and other non-processor-intensive work while your new faster computer is crunching away on images. In my studio, machines migrate from the processor-intensive work to other workstations as new machines become available with significant speed increases. While a jump from a 2-GHz processor to a 2.5-GHz processor might not be a justifiable expense from a cost-benefit standpoint, taking the time to evaluate the speed jumps that are justifiable will mean less time for you watching a progress bar or batch process, and more time for doing other things.

For laptops, the same speed issues come into play, and as you migrate from a slower machine to a faster one, the immediate past laptop becomes your backup laptop. This way, in the event of an equipment failure or if your primary laptop is in the shop, you have a laptop that allows you to continue to service clients' needs on the road and do other work while away from the studio, whether for a day-long assignment or one lasting a few weeks. Monitors are another issue altogether. They age, and they all render colors slightly differently. As they age, their rendering capability reduces and then reduces again. The average lifespan of a CRT monitor is between 15,000 and 20,000 hours. Although this may equate to three to five years before the monitor actually ceases to function if used during a typical cubicle-employee's workday, after a period of 18 months to two years of "always on" use, your monitor will fail. To render colors accurately and consistently, you'll want to replace it within 18 months to two years for the average workday and yearly if your computer screen is always being used (by you or a screensaver). On a CRT monitor, the phosphors diminish in capacity; on an LCD, the backlight will dim, change color, or just deliver erratic shifts in both, requiring a replacement. In many cases, the monitor won't be color-calibratable after this time, or the longevity of a calibration will be quite short. If you're buying a used monitor, use as a basis the "manufactured on" date to determine whether it's a good deal or whether you're buying someone else's "aged out" monitor.

Specialized Equipment: From Gyros to Blimps to Generators

Not every assignment can be completed with a 50mm lens. Almost all require a range of lenses, from wide to zoom. Although this might seem like a given, at what point do you begin to have specialized needs? Some photographers will need a range of 24mm to 200mm, and they're A-OK for 98% of their assignments. For the other 2%, fisheye or 300mm to 600mm+ lenses become necessary. At some point, you'll be called on to utilize specialized equipment, and you can opt to purchase it (recognizing that your ownership of this equipment makes you more valuable to a client) or rent it when necessary, passing along that cost to the client.

Whatever your specialized need, make sure the client understands that you are capable (whether by ownership or by your previous extensive experience with rented ones) of delivering to meet his or her needs.

Recently, I was called by a major financial cable news program to do photography on set in Washington during an interview. Setting aside the egregious rights demands for the purposes of this example, the client wanted to ensure that I had experience shooting on set and that I had a "blimp." A blimp is a customized box that encloses the camera and lenses and dampens the shutter and other camera noises to nearly imperceptible levels from even two feet away. In the past, I've used towels, suit jackets, blankets, and even padded rain shields in an effort to reduce audio on set, and they all pale in comparison to the real thing. Once you've used a blimp, you realize that doing work on a movie set, TV studio, or any other place where your camera's noises will be a distraction is a must. There are other manufacturers out there, but the Jacobsen Sound Blimp is the gold standard, and some movie sets require that particular brand be used to allow shooting on set. You can find out more information at www.SoundBlimp.com. Further, using the words "camera sound blimp" on search engines will yield additional information on these products and their necessity.

I also find myself being called to deliver photography from either extremely low light locations or from unstable shooting platforms (from the back of a motorcycle to an off-road vehicle, or from watercraft to helicopters). If you've ever tried your hand at this, you know that your ratio of sharp/in-focus to blurry images leans significantly to the unusable side. Having a tool such as a Kenyon Gyro (www.Ken-Lab.com) will tip the scales significantly toward the sharp/in-focus side. Once you've used a gyro, you will understand and begin to consider other applications for its use so you can deliver higher-quality finished results to your clients.

On occasion, I end up working on location where my battery-powered strobes won't meet all of my needs. Whether it's more watt-seconds that I need, or computer power or other power needs that the car's cigarette lighter won't handle (or can't handle because it's not close by), a generator has found its way into my resources collection, and more than once it has been a significant benefit. I've outfitted the generator with multiple power-calming protectors-in-line plugs that ensure no surges will be sent down the power line to fry my laptop/light packs and so on. These plugs will trip before damaging my equipment. To date, I've never had one piece of equipment damaged by the "geni" (my affectionate term for it, pronounced "Jenny"). In fact, following a hurricane, the neighborhood where my studio is located experienced a power outage for six days. I was able to power my entire home office, critical other items (TV, cable box, refrigerator, and strategically placed lights), as well as two neighbors' refrigerators for all six days, nonstop. I just kept refilling the fuel tank until the city's power returned. An \$800 investment that paid for itself years earlier on assignments became a critical "must have" during this time, and I will never find myself without one for all of these reasons.

Renting to Yourself and Others

If you own specialized equipment, you can recoup the expense of owning and maintaining it through rental. For years in the video industry, there has been a line item for the camera operator, the sound technician, and camera rental. It didn't matter that the camera operator owned the camera; it was not a part of what came with the camera operator, and in some instances the contracting company provided the camera operator with equipment. So in the instances when the assigning client wanted the equipment, they paid for the rental. For years, we photographers included our film cameras in our fees. However, during the shift to digital, many photographers did not own digital cameras, so they began to pass along a digital camera rental fee to the client.

Those who made the significant investment began to apply the video model, and a line item on invoices began to appear to amortize the cost of ownership over client requests, in the form of a rental to clients. This model is especially prevalent among those using \$20,000 to \$40,000 medium-format digital backs and the even more expensive 4×5 digital backs.

This model can extend to other specialized equipment, from ultra-wide angle lenses, to 300mm+ lenses, to blimps, gyros, generators, location vehicles, and even lighting. Many photographers do not own lighting equipment and will rent on an as-needed basis. Some shoots require multiple simultaneous lighting setups or complicated and extensive lighting, so additional kits are necessary. Ensuring that you will be able to rent additional lighting or including a line item for the use of your own lighting or other specialized items is as simple as outlining it on your estimate/contract, and, if necessary, being prepared to justify the line item when asked. If you feel that the line item listing of "Lighting kit rental \$275" is dishonest because of the use of the word "rental" and the fact that you own the lighting kit, then simply use one of the following:

- ▶ Lighting kit \$275
- Lighting kit charge \$275
- ▶ Lighting kit, as necessary \$275

or some variation thereof. When a contract is returned signed with that as a line item, it's approved as a client-payable charge. This same methodology applies equally to all other equipment.

For gyros, Kenyon Labs will rent theirs to you for around \$200 a week (plus \$25 shipping each way). At a purchase price of around \$2,500, if you're going to need a gyro more than occasionally, it makes sense to own one and rent it to yourself for \$250. After 10 uses, it's now yours. The daily rental charge of the same gyro from rental houses that have them available is \$60/day, plus shipping/courier. This, however, presumes that you are local to them. If you are an overnight shipping day away, you're looking at either a two- or three-day rental from them, again approximately \$175 to \$230. So, establish your own rental charge to yourself (and your colleagues) of \$200 for up to a week; it will pay for itself over time, and then become a profit center for you.

Jacobsen blimps rent for around \$50 a day plus shipping if you're not nearby, with an assortment of lens tubes to accommodate your various zooms and fixed focal length lenses. So, it'd be fair to charge, say, \$90 a day. Jacobsen will sell you a blimp and the three most common lens tubes for around \$1,400, so with about 15 days of use, it has again paid for itself and is now a profit center. However, don't try to buy a blimp within a week. Orders can take up to three months from the time you order until you receive it. They are handmade and exceptional pieces of equipment, so don't expect a fast turnaround; however, they are worth the wait.

For generators, a national company such as Sunbelt Rentals will rent to you a powerful generator that delivers 5,600 watts, a peak capability of 44 amps, and a continuous load of 22 amps for \$50 a day on average, with a \$20 delivery and a \$20 pickup charge within 10 miles of their location. You can offer the same generator capabilities from one bought from a national home-products warehouse, plus the power calming cords for \$800, for the same price that you were paying to rent it from the rental company. After a few rentals and uses yourself, again it can turn a profit (as with everything else), not to mention get you back up and operating during a lengthy power outage. Few things are worse than being on deadline without power, especially when your client is four states (or a world) away and is not experiencing a power failure, can't see your local problems on their news, and thus can't understand why you can't deliver as promised. Further, when you can offer to a client the capability of being up and running during the aftermath of a disaster, you can become a valuable resource to them, either as their on-site photographer or as a logistical command post for the crews they send in. If your local community won't be hiring you anytime soon because of their own loss of business situation, you will need to be able to make your services available in other ways to those coming in from the outside.

Chapter 3 Planning and Logistics: Why a Thirty-Minute Shoot Can Take Three Days to Plan

An oft-heard refrain from the unknowing client is, "Why is it so much? It's only a...

- …30-minute press conference."
- …portrait that will take 10 minutes."
- …hour-long reception."
- ...shoot where we need one good photograph."

...and the list goes on.

There is an old story about a customer with an ill-performing car who comes into a mechanic's shop for a repair. The mechanic, after less than five minutes of looking at the car, reports to the owner that the fee will be \$250. The customer is relieved that it's not higher and approves the estimate. The mechanic returns five minutes later to report that the car is now repaired and ready to go. The once-happy customer now feels swindled and begins to object. "You took less than 10 minutes total to look at and fix my car, and you want \$250? That's outrageous!" To which the mechanic responds, "You're not paying me for my time; you're paying me to know which screw to turn and how much to turn it."

Planning and preparation are cornerstones of success. The Roman philosopher Seneca once said, "Luck is what happens when preparation meets opportunity." I have often found myself in circumstances in which we were told it would be an indoor portrait, and perhaps it was raining lightly that morning as my assistant and I left for the assignment. We arrive, and sure—we could make a nice image of the subject in a boardroom or his office. As we're carting the equipment into the building, I notice the rain has stopped. When we get upstairs, I propose to the subject we take the portrait outside. He is amenable, plus it gets him out of the office for awhile. We head back outside, where we load the power packs back into the car and pull out a softbox, a scrim, and the battery packs that I packed as well, but which remained in the car.

We set up the softbox and the scrim, make a few tests to ensure we're a stop or so above ambient, out comes the subject, and 10 minutes later we're done and the subject is happy. The client will be too, because they commented that they wanted something outdoors if possible, but they understood it might not be possible. As we're breaking down, the assistant has, on more than one occasion, remarked, "You were lucky that you were able to make an outdoor portrait." My stock answer is "yup," but had I not been prepared with the battery packs, we would have missed the opportunity and not been as "lucky."

Be Ready for the Unexpected

When you're doing a portrait of a CEO for the company, do you have additional wardrobe in the event that his shirt is the wrong color, is wrinkled, or has a moments-ago coffee stain? What about a tie alternative? What about the executive who cancels the portrait session because of pink eye? The construction vehicles in the background of a shoot you scouted two days ago, when it was clear? The addition of four people to the portrait you thought was of just one person?

TIP

Always travel with a nine-foot seamless, instead of a five-foot one. You're far more likely to be able to make it happen that way. As a last resort, run the seamless you have horizontally along the wall, taping it at the top and sides with gaffer's tape, instead of hanging it from stands and a cross-pole. Because you billed the client for the seamless, there's no reason not to use it up unless you're at the last eight feet of the seamless and didn't bill the client for it. You did bill for it, didn't you?

All of these are circumstances you could find yourself in, and myriad other things could go wrong, go sideways, or just plain throw you off. If you do not have multiple backup plans and the resources to carry them out (preferably seamlessly), then you are not ready for the unexpected, and this lack of preparation will ruin your shoot(s) at the least desirable times.

Another circumstance occurs when you have a plan for a particular look, lighting setup, backdrop, or otherwise creative concept. You set up for it, set up your equipment for it, move furniture to the best location, and then the subject walks in and objects. Maybe he or she objects to the fact that the furniture was moved or doesn't like the overall backdrop.

On one particular assignment quite early in my career, I traveled to the Los Angeles area for an article on a museum. One setting I wanted was a grand room with chandeliers and an amazing decoupage piano. The problem was, the piano was in the background, and I wanted it as a foreground element. I looked around for the curator and, not finding her, decided to move the piano myself. The photo was great, and I was about to move on to the next scene when the curator appeared and almost had a coronary. It seems that I had moved an antique, extremely expensive, and extremely fragile piano. Not only had I moved it, which she would have expressly forbade, but I had moved it across an extremely rare Persian rug. She informed me that she'd have to bring in expert movers to move it back. Lesson learned, but that photo ended up being the section opener for the magazine, and the art director loved the shot! My bad.

It All Comes Down to Now! You'd Better Be Ready

I have found myself in numerous very relaxed situations in which, in an instant, we are moving at 100 miles per hour without warning. This situations range from a stakeout of a scandalized politician who makes an unexpected appearance to get the morning paper outside his home; to a CEO whose schedule changed and we had to wait around with lighting already set for what his executive secretary said would be 90 more minutes, but then announced the CEO would be there in two minutes; to war photographers who can be mid-cigarette when an all-to-close mortar round not only signifies an immediate risk to life, but also, for those with nerves of steel, the beginning of possible news photos.

This is somewhat different than being ready for the unexpected. These are the circumstances that you were expecting at some point, but they arrived sooner or later than you expected, or in a manner that generally threw you off. This means that you need to set your lighting and be ready earlier than scheduled, have cards (or film) in the camera, and have nonessential equipment stowed. And neither you nor your assistants are making a bathroom call until the shoot is over.

When you get a message that there is a delay in a subject's availability by 60 minutes, you want to really think about allowing assistants/makeup people to go get a sandwich or otherwise take a break. On more than one occasion, I sent the assistant out just to feed the meter, and when he or she returned not 10 minutes later, the shoot was over. In these situations we were all ready to go, and I successfully completed the shoot, but had something gone awry—head failure, setup change, and so on—I would have had a challenge on my hands.

Conveying Your Plan to a Prospective Client Can Win You the Assignment

Many times during the initial client dialogue—especially when you're an unknown quantity to the client—one of the client's concerns is, "Can this photographer do what I need, when I need it, how I need it?" Of course, the client will try to whittle down prospects by reviewing portfolios, Web sites, and the like. When the client gets a referral from a colleague, you're even further along the way to winning the assignment.

A few years back, I was called in after a portfolio review to discuss the details of the shoot and do a little brainstorming about it. I wanted to be careful because I didn't want to give them my creative suggestions, only to see them presented as if they were ideas from the client to another photographer, who then would bring the ideas to life. The task at hand was to produce portraits of the CEO and president of a company in three distinct portrait settings, two on location and one in a studio. The challenge was to accomplish all three in less than 60 minutes, including travel time.

During the meeting, I outlined how I would make this work—two assistants in each location, additional rented lighting, a generator, catering at all three locations, a location manager for the two on-location portraits, permits, and so on. I pitched a few nebulous creative ideas for each of the locations, and the client liked them. More important, the client was taken with my grasp of their needs and my solutions to making all three photographs happen within the client's time constraints.

During the course of the conversation, I learned that not only was I bidding against two good friends of mine, but also that I was the highest-priced photographer. At the conclusion of the meeting, I knew I had made my best proposal, but I was slightly concerned that the client would go with a lower-priced photographer. In the end, they called the next day to say I was their choice for their five-figure assignment, and they faxed back my contract. We completed all three shoots in 48 minutes, with results better than the client expected.

I find that outlining a scope of work and approach can allay the client's concerns about your capabilities, and if the conversation goes well enough for a mini-relationship to begin to build, and the client has told you enough, and you've had a good conversation, they have invested enough in you (in terms of explanation, objectives, and so on) that they say, "I'm just going to give you the assignment." This means that no one they called and left message with, or whom they spoke to and requested a bid from, is going to win the assignment.

I find this to be the case quite frequently; one situation was an assignment in which the client was looking for a photographer using the search term "ESPN Magazine cover photographer" on Google. Fortunately, I rank fairly high for these search terms. I note this not for a point about marketing, but because I did not come to be known by this client by any trusted means (referrals, the client having seen my work elsewhere, and so on), but rather from a Web search. We began to discuss the shoot, and within a short period of time, an e-mail came though saying, "You can have this assignment. Let's talk today." Bingo! Shoot's mine! Now, this wasn't a small editorial shoot. It was a cover assignment, and the group photograph of players on a basketball court earned roughly \$3,000. This was not only a nice "get" that validated the critical nature of my Web site; more importantly, it illustrates the value of conveying your plan to a prospective client.

When a Seven-Minute Shoot Becomes Three, What Do You Do?

Short answer: Make pictures first, ask questions later. Now, smart answer aside, it's critical that you be prepared and honor the latest instructions about time limits. On more than one occasion—once at the Pentagon, once in the Oval Office, and once at a symposium on cancer research—a painful reduction in my shooting time was passed along with just minutes to make accommodations.

This is the ultimate illustration of why what you charge for your services should not be based upon time. Rather, it should be based on skill, creativity, and usage. Imagine having a sevenminute shoot cut to three—that's a 43% reduction! Would you be willing to perform for a comparable 43% reduction in your photo fees? I certainly would not. More on this in Chapter 5.

First things first, you should have a contingency plan for this, and now is the time to put it into play. Jettison the extra angles/shots you were thinking you could do, knock out one of the accent lights (if you also have to set up within this timeframe) if you can, and make sure your light tests are done with your assistant (or your minder) making sure you stay in line and on schedule, so that every minute is used making images, not tests. One of the first situations I experienced this in was during the days of film, when we needed to shoot a Polaroid. Ninety seconds was an eternity while it developed. So, even with light tests shot, we first shot a Polaroid, then, without waiting for it, we began shooting film. I refer to this technique as "shooting through the Polaroid." After 90 seconds, halfway through the shoot, the assistant pulled the Polaroid, and if there was a problem, we'd correct it during the remaining 90 seconds. With just three minutes and a fast recycle time (one more reason for high-powered lighting kits, as noted in Chapter 2), we were about to shoot five rolls of 120mm film on a Hasselblad, or 60 frames.

I also made certain that my assistant was tracking three minutes. The assistant's job was to convey to me, "One minute, two minutes, two-and-a-half minutes, time." I didn't want a minder calling the shoot 30 or 45 seconds early. In one case, I said to two world-renowned cancer researchers, "I understand we have you for three minutes"; much to my surprise, they responded, "Yes, and only three minutes," to which I responded, "Yes, and I will have you done within that time limit." Twice during the three minutes, I made frames that ended up capturing one of them as he checked his watch. My assistant gave me the 30-seconds-remaining mark, and after four more frames, I stopped and said, "Gentlemen, thank you for your time." They were pleasantly surprised that I actually was done.

The key is to have planned what to do, what not to do, and what you can do to accommodate a change in the schedule that is beyond your control. Some of the best times to go over these details are prior to arriving at the shoot, during a pre-briefing, or during the car ride to the assignment.

When to Call in a Specialist: From Lighting to Location Management, Catering, and Security

There are times—frequently for the "big time" photographer, and less so for the "middle of the pack" photographer—when specialists have a definite role to play. Interestingly enough, many a well-known and highly regarded photographer in New York City couldn't light a candle, let alone an assignment that calls for a basic 3-to-1 lighting ratio, or even light from head to toe and a shadowless white seamless. These photographers rely on talented assistants who can quickly and perfectly light a scene as the photographer (or the art director) describes it.

If you're a photographer who's used to shooting available light, but you get an assignment that calls for lighting expertise, renting the lighting from a local rental house and culling through assistants looking for those who have experience with that brand of light and are familiar with lighting will be your solution. Although some may suggest that every photographer should know how to light without relying on the talent (and creative contribution) of an assistant, it's one thing to know what look and feel you want and to have an assistant achieve the technical objective and refine it to your direction, and it's another thing for you to tell the assistant to "just light it nice." Unless you've taken the necessary precautions, doing so could result in that assistant taking partial credit for the creative input and coming back for a larger piece of the pie than you'd originally agreed upon.

Many photographers who regularly use assistants rarely use makeup or stylist services, but they should. Consider that every time there is a guest who appears on a television show, they go into makeup—sometimes only to remove the glow, but often for much more. Although today's digital photography-enabled shoots can often have some degree of retouching of bags/shadows under the eyes, problem hairstyles, and the like, even today an often overlooked crew member is the makeup person or stylist. In fact, I've had clients say to me that I was the only photographer who included a makeup person in my estimate, and they knew that I was aware of what went into making the type of photograph they needed, so I got the assignment. When a stylist or makeup artist is a line item, it's easy for the client to suggest it be struck, which will cover you in the event the subject looks less than he or she could be. It could also justify retouching fees to fix the blemishes on the subject's skin. You can also advise the client that you feel strongly about the subject having makeup on hand. On the occasions when I get push back saying that the subject doesn't want makeup, I remind the subject being photographed that if he went on television, he'd have to have it. Besides, we're not doing a makeover, just a light powdering. This usually makes an impact.

A more technical, but no less important specialist is the location manager. It's the location manager's responsibility to secure the location that meets your needs (often by scouting locations themselves or by hiring a location scout on your behalf) to find just the right basketball court for a sports shoot or the perfect scenic overlook for a particular city you are traveling to. It is even sometimes the location manager's job to meander through the permitting process on your behalf in your own city, either because you are too busy or you just don't know what's involved. In addition to the pre-production days the location manager will be charging you for (\$500 to \$800 per day is not an uncommon range), he or she will also be on hand the day of the shoot to facilitate load-in and load-out of equipment—making sure you have a permit for rush hour parking, you have backup locations (and accompanying backup permits for it) in the event that your view has been usurped by construction vehicles or some other distraction, and you have or are aware of necessary power resources (whether hardwired or requiring a generator), as well as numerous other items.

For large-scale shoots (and even complicated mid- and small-scale shoots), a producer can make your life much easier. The producer's job is to handle everything from your arrival to your departure, making sure you're picked up at the airport; ensuring that you have local assistants, a competent location manager, talent agencies, and models; facilitating scouting and tech scouting; making sure the client arrives and is taken care of; ensuring there are catering and pre-/post-shoot dining recommendations; making sure there are production vehicles and resources for backup equipment; obtaining security if required by city permitting ordinances or if you've taken over a large location and need assistance keeping the general public out of your pictures and your set so that equipment doesn't walk away. Imagine arriving, and the only thing you have to worry about is showing up on set, discussing final details of the shoot, making the photographs, reviewing them with the client, and then having everything else taken care of by your crew. If this sounds fantastic (in other words, fantasy, not reality) then you'll be surprised to know that these types of shoots take place numerous times a day, every day, across the country. If you think you'd like to get into this level of work, take the time to call a producer nearby and discuss what he or she can do for you and what the charge would be.

In the end, you can farm out the more noncreative aspects of a shoot to people who not only do nothing but those things, but really enjoy and thrive on doing them, the more you can concentrate on making great pictures and ensuring the client is happy and your work meets and exceeds their expectations. This will ensure the client comes back to you. In the end, these specialists appear as line items on your estimates and invoices, so you're not covering the cost of their services out of your pocket.

One more thing. If you're hiring a helicopter or other mission-critical transportation (seaplane, boat, desert land rover, and so on), take the advice that leading aerial photographer Cameron Davidson gives: Safety trumps all other concerns. Also, the more people and equipment you are hauling, the less likely you will be to have a good safety margin—then see advice item #1. Just because there might be room in the helicopter for the client, unless he or she absolutely, positively must be in the aircraft with you, the client stays on terra firma. Come back, review the images on a laptop with the client, and then go back up if you have to or can. Second, do everything you can to have a helicopter with twin engines. If one fails, you can make it back to the ground safely, without having to eat your knees. In addition, make sure your pilot is not some low-hours hotdog or a pilot used to flying a pattern to show tourists the sights of the local area. Choosing a pilot who's experienced in working with aerial film and still photographers and who has *at least* 1,500 hours in the aircraft in which you will be flying will mean better results for the client and a safer return for you.

This holds true for small, fixed-wing aircraft as well. On assignment for the Smithsonian Institution in Alaska for a book I was doing for them, we had to have a pilot who could take off from a grass field and land on a sandbar along the ocean. Further, he had to know when that sandbar was going to disappear because of the tides and how much time it would take to get both plane loads of crew and gear out before then. En route, he also pointed out where the black bears congregated along the inlet so we could avoid that area. He was well-versed in these and numerous other details, and I was glad I didn't have to worry about. But that's the point—he's the specialist, and we hired him to get us safely there and back home.

If you're in need of someone who does one thing (or just a few) and does them well, reach out and establish relationships, collect names, and understand areas of expertise and associated rates. You never know when you'll need a specialist and the figures and details necessary to complete that estimate you're working on at midnight.

27

Part II

Financial and Personnel Considerations

Chapter 4 Working with Assistants, Employees, and Contractors: The Pitfalls and Benefits

During the early years of my business, it was just me. Not only was I a sole proprietor in the IRS's eves, I was the sole worker. I was my own IT department, accounting department, new business department, shipping department, and—oh, right, creative department. It got to the point where I could not be in two places at once-creating photographs and sending invoices, planning a shoot and sending estimates. It really became too much. When I began considering bringing on some help, I kept thinking, "Ten dollars times eight hours, times five days a week, times fifty-two weeks a year equals how much?!" I didn't see that I had that amount of "extra" revenue to be able to pay for the extra set of hands. For so long I struggled with this, and I ended up hiring a niece during her summer months between her college studies. I saw this as a way to get my feet wet in having someone help me out. The problems arose come September, when I found myself being far less productive as she returned to school. I looked forward to Christmas break, when she would return for a few weeks-that was my personal Christmas present, and one that gave me the insight that I really needed some help around the office. (When I say "office," what I'm really saying is the second bedroom of my three-bedroom home. The master bedroom was for my wife and me, the larger bedroom in our row house on Capitol Hill was my office, and the smaller one was for our dogs.)

NOTE

In case you're curious, the answer to the math equation about the cost of hiring a new employee is \$20,800 per year. By comparison, minimum wage of, say, \$6.50 an hour yields \$13,520 per year, and minimum wage was not set by the government with the intent that it paid enough to live on alone. It was intended as a minimum wage for youth still living at home or as an entry-level job wage.

The Hurdle of Growing from Just You to Having People Working for You

I evolved from having just summer help to having part-time help twice a week. Every month, I looked at how much I was spending for this assistant, and in a short period of time, I found that I was signing at least two additional assignments each month simply because I had someone in the office to not only handle the phone calls, but to send estimates out and lock in assignments that I couldn't, for no other reason than my lack of availability to lock them in myself. I saw these transactions initially as a form of a "trade" between my accounting/new business departments and my creative department. The creative department would do two assignments, usually a total of two or four hours in length, and in exchange, the accounting/new business departments got 16 hours a week for four weeks a month in help. This was a really good trade in my mind—four hours of creative for 64 hours of help per month.

NOTE

Sometimes thinking about the various types of work you do by serving different "departments" within your business can help you to understand how you spend your time, and demanding that as many departments as possible remain either profitable or cost-efficient can ensure that you stay focused.

Within a year or so, I realized that incurring the additional expense to have someone in every day of the week was really going to have an impact. This impact would be felt in sending and getting back signed contracts as well as serving client needs, but also because in the downtime between doing these things, the person I hired could work on projects that I needed to get done but just couldn't find the time to begin, let alone complete. This created a new concern that I did not address: Must this person be an employee or a contractor? As a small business, I could not take on the additional work of issuing paychecks that took out taxes, social security, and so on. I needed to ensure that I could handle this extra help as a contractor, not as an employee. I took the time to review the Internal Revenue Service points that they use to determine whether someone you have working for you must be defined as an employee or may be deemed a contractor.

Who Must Be an Employee?

The Internal Revenue Service has listed 20 factors in Revenue Ruling 87-41 that it considers in determining whether individuals are employees or common-law independent contractors for federal tax purposes. The degree of importance of each factor depends on the occupation and is case-specific. When evaluating each factor in light of your business practices, remember that a "yes" weighs in favor of assessing a worker as an employee.

To determine whether an individual is a contractor or an employee, all factors must be applied. A fair evaluation would be that if a majority of the 20 factors carry a "yes" response, then an individual might be considered an employee. If you believe a person working for you should be considered an employee, you must either handle that person as such or make appropriate changes to resolve the situation to achieve an independent contractor status for all individuals providing services to you.

Following are the IRS factors from their Web site, as outlined in their Revenue Ruling 87-41, and my responses to each:

▶ Factor 1: Instructions. Is the worker required to comply with the employer's instructions? A worker who is required to comply with other persons' instructions about when, where, and how he is to work is ordinarily an employee. This control factor is present if the person for whom the services are performed has the right to require compliance with instructions.

Response. Contractors working for me are given projects and tasks to complete as a part of their responsibilities. Contractors are given significant leeway as to how they wish to complete tasks and when those tasks are to be completed. In instances when tasks are time-sensitive (sending out an estimate or reprint order, or calling a courier), contractors understand that delays could cause a loss of a photo assignment. However, no requirements such as "within 10 minutes" or "within 20 minutes" are placed on contractors.

▶ Factor 2: Training. Is the worker required to receive training from the employer? Training a worker by requiring an experienced individual to work with him or by requiring the worker to attend meetings, or by using other methods, indicates that the services are to be performed in a particular method or manner.

Response. Contractors are required to have a basic understanding of photography and computers. Contractors are expected to apply their knowledge of photography when assisting me on location at photo shoots. The roll of contractor-assistant is not expected to grow into a position in which the contractor becomes an experienced photographer working for me shooting. Where contractors are not knowledgeable in specific applications (Photoshop, QuickBooks, and so on), the contractor is not trained by attending classes paid for or directed by me; rather, these skills are to be learned on the contractor's own time.

▶ Factor 3: Integration. Does the worker provide services that are integrated into the business? Integration of the worker's services into the business operations generally shows that the worker is subject to direction and control. When the success or continuation of a business depends on the performance of certain services, the workers who perform those services are generally subject to a certain amount of control by the owner of the business.

Response. The services provided by contractors are not integrated into the business, but rather, they are of a supportive position to the business.

Factor 4: Services Rendered Personally. Must the worker personally perform the services? If the services must be rendered personally, an employer/employee relationship is assumed.

Response. Contractors for me may contact other authorized contractors to perform the services if the contractor scheduled for coverage has other obligations for other clients. This happens often when a contractor has another job they can take, and they then make the substitution with another contractor. In some cases, the contractor simply does not come in without sending a replacement, at their option. Contractors have a responsibility to know whether

they have time-sensitive tasks to complete, and they will always confirm their intent to take another assignment before doing so.

▶ Factor 5: Hiring, Supervising and Paying Assistants. Does the worker hire, supervise, and pay assistants for the employer? If the person for whom the services are performed hires, supervises, and pays assistants, it generally demonstrates control. However, if one worker hires, supervises, and pays the other assistants pursuant to a contract under which the worker agrees to provide materials and labor and under which the worker is responsible only for the attainment of a result, this factor indicates an independent contractor status.

Response. No current contractor hires or supervises other contractors. One contractor may be a resource for information about work processes, but all contractors are hired and supervised by me directly.

▶ Factor 6: Continuing Relationship. Does the worker have a continuing relationship with the employer? A continuing relationship between the worker and the person for whom the services are performed indicates an employer/employee relationship. A continuing relationship may exist where work is performed at irregular intervals if they are recurring.

Response. Contractors are retained initially on a three-month contractual basis, which is automatically renewed for successive one-month terms, provided the quality of services remains as high as when initially contracted. Further, contractors are allowed and encouraged to work for the competition—and not because we expect (or do) get information. In fact, we are very clear not only that our assistants maintain our confidentiality, but also that we do not ask them about their dealings with the competition. We don't ask for whom they provide their services (although we know they do provide services for other clients), nor do we ask who the other photographer's clients or subjects are. Not only is this bad form and unethical, but it is against an unwritten rule that exists amongst assistants.

► Factor 7: Set Hours of Work. Must the worker follow set hours of work? The establishment of set hours of work by the person for whom the services are performed is a factor indicating control.

Response. Contractors understand that the office *should* be staffed from at least 10:00 a.m. through 6:00 p.m. Monday through Friday. Each contractor determines when it is best for him or her to arrive and when it is best to leave, given the day's flow and activities. No monetary penalties occur (docking of pay and so on) when a contractor arrives after 10:00 a.m., and some contractors opt to come in prior to 10:00 a.m. when it benefits them. Certain events (shoots on location) require specific timing, setup, and so on, and in these instances time is of the essence, so contractors should be at a certain place at a certain time.

▶ Factor 8: Full Time Required. Does the worker work full time for the employer? If the worker must devote substantially full time to the job, control over the amount of time the worker spends working is assumed and restricts the worker from other gainful employment. Therefore, an employer/employee relationship is assumed. An independent contractor, on the other hand, is free to work when and for whom he or she chooses.

34

Response. No contractors work full time. Contractors not only perform services outside of their work for me, but in fact are allowed to (and do) work for businesses that are direct competitors of mine.

Factor 9: Doing Work on Employer's Premises. Does the work take place on the employer's premises? If the work is performed on the premises of the person for whom the services are performed, that factor suggests control, especially if the work could be done elsewhere. Work done off premises, such as at the office of the worker, indicates some freedom from control. However, this fact by itself does not mean that the worker is not an employee. Control over the place of work is indicated when the person for whom the services are performed has the right to compel the worker to travel a designated route or to canvass a designated territory.

Response. Because my contractors have their own offices (whether a desk in their home or a complete room), the possibility exists for these contractors to perform many of their work functions (office work, organizing of receipts, and so on) outside of my office—and in a number of cases, they do. In addition, my contractors perform services at shoots on location—work that could not be performed on premises. Further, contractors often query me for details concerning variables (shoot fees for estimates or category information for receipt organization) and often find it easier to complete these tasks on premises.

Factor 10: Order or Sequence Set. Does the worker have to follow a work sequence set by the employer? If a worker must perform services in the order or sequence set by the person for whom the services are performed, that factor shows that the worker must follow established routines and schedules. Often, because of the nature of an occupation, the person for whom the services are performed does not set the order of the services. It is sufficient to show control, however, if the person has the right to do so.

Response. When contractors are completing work, tasks such as filing, reprints, estimates, and cleaning do not have a set sequence. In fact, significant leeway is given as to how and when to complete these (and other) tasks. Where efficiency or client demands are a consideration, the contractor may be asked to complete tasks in a certain order.

• Factor 11: Oral or Written Reports. Does the worker have to submit regular reports? A requirement that the worker submit regular or written reports to the person for whom the services are performed indicates a degree of control.

Response. No reports are requested or required from contractors.

• Factor 12: Payment by Hour, Week, Month. Does the worker receive a regular amount of compensation at fixed intervals? Payment by the hour, week, or month generally points to an employer/employee relationship, provided that this method of payment is not just a convenient way of paying a lump sum agreed upon as the cost of a job. Payment made per job or on a straight commission basis generally indicates that the worker is an independent contractor.

Response. Contractors are paid biweekly, on an hourly basis. Due to the highly variable nature of each shoot or project, it is difficult to determine with a

reasonable degree of certainty how long each one will take. In addition, the contractor has the right to suspend services to me to meet the needs of other employers or for personal reasons. As a result, the contractors and I have agreed that an hourly fee is a reasonable way to determine work actually performed for me versus time not working for me, but working for others.

► Factor 13: Payment of Business and/or Traveling Expenses. Does the worker receive payment for business and traveling expenses? If the person for whom the services are performed pays the worker's business and/or traveling expenses, the worker is ordinarily an employee.

Response. I do not pay business or travel expenses for contractors. My contractors are obligated to pay any travel expenses between their office and my offices or on location. In the event that I ask them to travel with me to a distant location to assist me in completing an assignment, the expenses associated with that request are covered by me.

• Factor 14: Furnishing of Tools and Materials. Does the employer furnish tools and materials? The fact that the person for whom the services are performed furnishes significant tools, materials, and other equipment to do the job tends to show the existence of an employer/employee relationship.

Response. Contractors' primary obligation is the use of their hands and minds to complete tasks. The roll of assistant to photographer does not require any equipment beyond, perhaps, an assistant's grab bag, which I do not furnish. Contractors are required to have cellular phones, which I do not furnish nor reimburse.

Factor 15: Significant Investment. Has the worker invested in facilities used to perform the service? If the worker invests in facilities that he uses in performing services that are not generally maintained by employees (such as the maintenance of an office rented at fair market value from an unrelated party), that factor tends to indicate that the worker is an independent contractor. The lack of investment in facilities indicates dependence on the person for whom the services are performed and the existence of an employer/employee relationship.

Response. Contractors make investments in equipment to further their own businesses (office computers, cell phones, light meters, and so on), and from time to time they use these to provide services to me. Contractors are not dependent on me for the existence of their own businesses; rather, they complete a varying portion of their tasks at my office for the sake of convenience.

Factor 16. Realization of Profit or Loss. Can the worker make a profit or suffer a loss? A worker who can realize a profit or suffer a loss is generally an independent contractor. For example, if the worker is subject to a real risk of economic loss due to significant investments or liability for expenses, such as salary payments to unrelated employees, that factor indicates that the worker is an independent contractor. The risk that a worker will not receive payment for his or her services, however, is common to both independent contractors and employees and thus does not constitute a sufficient economic risk to support treatment as an independent contractor.

Response. No profit or loss from a contractor's performance or lack thereof could be a possibility at this time related to their own contractors or employees, given that no current contractor has employees or contractors themselves. However, it is possible for a contractor to make investments in his or her own business or engage in liability for expenses, for which we are not responsible. This possibility could have an adverse impact on the contractor's profit (or loss) during the course of his or her tax year.

Factor 17: Working for More Than One Firm at a Time. Can the worker work for more than one employer at a time? If a worker performs services for a number of unrelated persons or firms at the same time, the worker is generally considered an independent contractor.

Response. Current contractors not only work for more than one employer, but in fact they can work for direct competitors of mine.

▶ Factor 18: Making Service Available to General Public. Does the worker offer services to the public? The fact that a worker makes his or her services available to the general public on a regular and consistent basis indicates an independent contractor relationship.

Response. My contractors not only provide their services to me, but they provide photographic services (as both a photographer *and* an assistant) to the general public as well.

▶ Factor 19: Right to Discharge. Can the worker be fired? The right to discharge a worker is a factor indicating that the worker is an employee and the person possessing the right is the employer. An employer exercises control through the threat of dismissal, which causes the worker to obey the employer's instructions. An independent contractor, on the other hand, cannot be fired so long as the independent contractor produces the result that meets the contract specifications.

Response. No contractor can be fired provided that he or she meets the contract specifications. In the event that a contractor fails to produce the results outlined in his or her contract, the contract may not be renewed.

▶ Factor 20: Right to Terminate. Can the worker quit without incurring liability? If the worker has the right to end his or her relationship with the person for whom the services are performed at any time without incurring liability, an employer/employee relationship exists.

Response. A contractor has the right to terminate his or her contract with proper notice, but cannot quit without incurring liability.

So ask yourself the 20 questions/factors to ensure you don't end up on the wrong end of an IRS or Department of Labor inquiry, or worse. Further, employment law is very complex and varies greatly between jurisdictions. It is critical that decisions about how and when to use contractors be done with the advice of an attorney who is versed in employment and tax law in your area.

The Benefits of Someone Regular versus Various People

So you've decided you want someone to help you out. Now the question becomes, who? The first thing *not* to do is take out a classified ad. You are asking for someone to come into your home/office and not only do work for you, but also be there when you're not. That's a big risk and requires a lot of trust. So, how do you find the right person or persons? First, I'd suggest you choose one person over two, and no more than two to do the job together.

Bringing someone in requires a significant learning curve. You want that person to learn how you do everything, where everything is, and the like. In my experience, it takes a bare minimum of three months for someone to be up to speed when he or she is there full time, so that becomes a much longer period for part-time assistance. After three months, I feel totally comfortable with someone sending estimates and doing invoices and post-production. I remain in an oversight position, spot-checking the paperwork that goes out and giving guidance on the post-production that runs in batches. (I still do the customized retouching for major assignments.) Bringing someone different in each time means that person will have to learn everything from scratch and, further, may not have the impetus to do that extra step that ensures the clients get the best service possible.

In addition, I've found that having people who are interested in the field of photography means they see the work they are doing for you as learning to do something they hope to do themselves someday. Thus, they are more eager to learn to do it right than someone who's just coming in for the paycheck.

I first found folks to assist in the office and on shoots at local trade association meetings. From ASMP, to APA, to ASPP, to ADCMW, I found association meetings to be an exceptional resource for talented and enthusiastic assistants, both for on-location photography and in-office help.

When making hires, be absolutely certain that you hire people who have a good disposition. They should be happy people as well. When you find yourself in a position where you've made a mistake, correct it. Replace them as soon as possible. It's the people you don't fire who will ultimately give you far more headaches and problems than those you do fire.

NOTE

ASMP is the American Society of Media Photographers; APA is the Advertising Photographers of America; ASPP is the American Society of Picture Professionals; and ADCMW is the Art Directors Club of Metropolitan Washington. Those and/or numerous others meet in your area and are an excellent resource.

Today, I draw upon interns who come during or immediately following their studies in college. I'll talk more about the importance of interns and apprentices in Chapter 26, "Charity, Community, and Your Colleagues: Giving Back is Good Karma," but for now I'll simply make note of the fact that interns can be your best source for aid on a more ongoing basis.

Paying Those Who Make Your Life Easier

This is one of the more difficult issues to review and resolve. On one hand, you may instinctively want to pay the lowest amount you can; on the other hand, you don't want to be cheap, nor do you want to overpay. I've tried to research the landscape amongst photographers and assistants to come to some conclusions that might be helpful as you determine what to pay.

At a minimum, you must pay anyone who works for you minimum wage. Unless you're hiring waiters and waitresses, or others who have a tip-based income source, you'll want to make sure you don't run afoul of this rule.

For full-time interns who travel from outside of our region to work with us, we pay \$8.00 an hour. This is based upon what I found other companies who are my clients are paying their interns. Although an intern won't get rich from this hourly pay rate, the intent is to cover their expenses while here and give them a bit of savings at the end of the summer.

If you are interning part time and come from the local area, we typically take on interns for either two or three days a week. These internships are not paid, consistent with Department of Labor standards for students coming from a bona fide educational institution. We make sure we stay within their rules. Although interns are handled as contractors when paid, it should be understood that issues such as legal minimum wage, withholding, and so on relate to traditional employees, not to contractors. Because interns have far more responsibilities put upon them, we want to make certain we do not cause them to be considered employees, and thus eligible for benefits and such.

From this point, the sky is the limit—or, more definitively, what you pay yourself is the limit! There are a number of ways you can opt to pay—a base hourly plus a percentage of all assignments (say, 5 to 10% or so), just a base hourly, or a flat rate.

Assistants who work for photographers on an as-needed basis for assignments typically are paid a flat rate ranging from as low as \$125 per day to upwards of \$250. These figures are paid whether the assignment is for two hours or ten, but after ten, typically the assistant will charge an overtime charge that should have been agreed to beforehand if going over ten hours was a possibility. Further, although you may technically be getting an assistant for ten hours at that flat rate, if your shoot goes for only three and you then tell the assistant you want him or her to come back to the studio and sweep the floors, organize receipts, or perform other office tasks, you'll not likely get the assistant back again. This practice is considered poor form among assistants, unless you've outlined these terms before the assistant agrees to take the work. Some who assist won't mind, others will. Ask first.

So, with a floor of minimum wage and a ceiling of \$125 to \$250, you want to find a happy medium for what you're paying. If we use the 10-hour-day rule as a guideline, that works out to between \$12.50 and \$25 an hour.

There is a common concept across the spectrum of business: Bulk purchases and guaranteed purchases over time should mean discounts over one-at-a-time purchases. Thus, if the pay of \$12.50 to \$25 is applicable for a one-off, then figures of less than that should apply if you're committing to two or three days a week, every week of the year. For me, interns returning to the office as contractors and other office assistants range between \$10 and the mid-teens. As prices and the cost of living rises, I could see this figure approaching \$20 in the not-too-distant future.

CHAPTER 4

(You realize that by my saying this, I am going to be hit up for raises by my contractors when they read this book.)

There are, however, many states—California among them—that have very strict labor laws, and you could run the risk of back pay of taxes, Social Security, workman's comp, and overtime, as well as civil penalties in the event that a former contractor/assistant decides that he or she wants to make trouble for you. There is, however, at least one photo-specific solution to this.

One Solution for Concerned Employers

Although there are temp agencies, such as Accountemps or Randstad, there is only one that delivers and manages assistants and other staffing specifically for photographers—Stillwell & Stillwell, based in Atlanta, Georgia, but providing services nationwide.

Technically, when your assignment has been completed, whether in a single day or multiple days, an assistant may file for unemployment in most states if he or she is determined to be an employee. There are exceptions if the assistant is fired "for cause," or if he or she quits, and, as such, any person in any profession could not file for unemployment. However, even when a contract specifies a series of days (say, a week or three months), when the work is done in your mind, the IRS and/or Department of Labor (or state labor agency) could very well find that you laid off the assistant for a lack of work.

A service established through APA is called APA Payroll; it resolves the liability issues of workman's comp insurance and the incorrect classification of an assistant as a contractor when he or she is an employee—a scenario that could create a huge expense for you if you are audited by the IRS. With enough years under your belt, such a situation might well run into the tens of thousands of dollars, if not more.

They provide (or, if you're using another firm, they should provide):

- ▶ Withholdings for staff, taking into consideration work done on location in a state other than your own, as well as federal taxes and social security
- Workman's comp and unemployment insurance
- Direct payment to assistants from the firm—not you—when you've approved the payment
- In cities that require it, the payment of union fees, dues, or union scale rates, if applicable

Utilizing a service such as this will mean you can have people help you with peace of mind, rather than worrying about the headaches of keeping someone in your office or studio with paperwork and confusing local, state, and federal regulations.

One final note: There is also a risk that if your assistant made a significant contribution to a shoot (light placement, subject direction, camera angle, and so on) and he or she is classified as an independent contractor, the assistant might have a viable claim of joint authorship in the resulting copyrighted image. Classifying the assistant as an employee or using a payroll service that deems the assistant an employee of that service will reduce this risk significantly. In addition, some photographers will ask that assistants sign an agreement waiving any such rights.

Chapter 5 Pricing Your Work to Stay in Business

How do you establish your prices? This is seemingly an age-old question, and certainly one that perplexes many of the more experienced photographers, who, when asked, simply shrug their shoulders and respond with something like, "I sort of just guesstimate."

If this is you, don't be alarmed—you're not alone. That doesn't mean you're free and clear; it means you need to reverse-engineer your rates to see whether what you've been doing meets your long-term goals. You also need to know which types of assignments are revenue positive and which may be, without your even knowing, revenue negative. (Yes, that means taking a loss on a job.)

Although 10 years ago resources were few and far between to help you come to reasonable and logical conclusions about rates, they are abundantly available now in books, online, and in software specially designed for photographers.

First things first, though. Repeat the following phrase out loud three times. If you're reading this in midair while flying over country, say it anyway. If you're reading by bedside light and your significant other is asleep, say it anyway. But if you're in a church, then...wait. Why are you reading this book in church? Anyway, say this:

"I am a profitable business and must remain so. If I am not, I'll be waiting tables soon."

 $``{\rm I}\xspace$ and must remain so. If I am not, I'll be waiting tables soon."

"I am a profitable business and must remain so. If I am not, I'll be waiting tables soon."

Now, no disrespect to wait staffs all across the country, but I doubt very many of them aspire to be wait staff for the rest of their lives. For most, it's a waypoint during college, while they wait to be discovered and become a famous actor, or perhaps someday own the restaurant. Regardless of their goals, *yours* is to remain a photographer.

Second, in keeping with the mentality of the mechanic who repaired your car in five minutes (as related in a previous chapter), the amount of time involved in the shoot is a relatively small factor in determining your rate. In fact, your fees could well be increased conversely to your

ability to execute the shoot expeditiously, and thus you should earn a premium. Nowhere else that I know of does someone more skilled get paid less because they completed their tasks faster than another less-experienced person.

Taking the approach that being the lowest-priced photographer will earn you all the work you need is a failing goal. The commoditized photographer promotes himself first on price, then on service or style of photography, and then finally on himself.

The best photographer is one who promotes and markets first himself, second his services and style, and finally, his price. Recently, I was CCd on the following dialogue between one of my existing clients and someone who had sought a recommendation for a photographer from him:

Subject: Re: Photographer Recs Needed

Dear

John Harrington is a great photographer that would more than satisfy your client's needs. **Example 1** uses him almost exclusively...and you may have met him at the recent **Example 1** event. Go see his Web site at www.johnharrington.com. His e-mail is John@JohnHarrington.com.

Here's the response from the recipient of that e-mail:

Hil	
1111	

Thank you so much. I do remember John-great guy, and he's my first recommendation.

Thanks again so much,

Here is a clear and concise indication of this point. How does the party receiving the recommendation gauge me? "Great guy." This, in my opinion, is a successful referral (and my ongoing goal to receive). I am not going to be compared on price—in fact, I am the top choice before a quote is provided.

Of course, before you charge a profitable rate, you'll need to have a clear understanding of what is required to be in business. Even if you've been in business for years, you may have been allowing your personal expenses to subsidize your business, and as such, you might have been in the dark about what it truly costs to be in business. Now, you'll need to change that to get a handle on your business and move it forward.

There are a few "cost of doing business" calculators online. One that I contributed to (no bias here!) is the National Press Photographer's Association CODB calculator, which can be found under the Professional Development > Business Practices section of http://nppa.org. Look for the NPPA's Cost of Doing Business Calculator link. An interactive calculator, it pre-populates the

CHAPTER 5

form with reasonable numbers for all the categories. In addition, when clicked, a circled "i" next to each category will give extensive information about that category (see Figure 5.1).

Fi	gı	ır	е	5.	1
	0		-		

000	NP	PA: Cost of Doing Business Calculator		0
	http://nppa.org/p	rofessional_development/business_practices/cdl	o/c ▼ ◎ (G)-	
NPPA: Cost of Doing Business Cal.				0
Business Pract Cost of Doing Busin		lator		
	Annu	al Expenses		
Office or Studio @	\$3,600.00	Advertising & Promotion @	\$1,000.00	
Phone (Cell, Office & Fax) @	\$2,400.00	Subscriptions & dues @	\$600.00	
Photo Equipment @	\$7,000.00	Business Insurance @	\$1,200.00	
Repairs @	\$900.00	Health Insurance @	\$5,000.00	
Computers (Hardware & Software)	© \$2,500.00	Legal & Accounting Services @	\$600.00	
Internet (Broadband, Web site & email) ©	\$750.00	Taxes & Licenses (Business, Property & Self-employment) Φ	\$6,000.00	
Vehicle Expenses (Lease, Insurani & Maintenance) Ф	\$7,000.00	Office Assistance (Payroll) @	\$5,000.00	
Office Supplies @	\$800.00	Utilities @	\$600.00	
Photography Supplies @	\$500.00	Retirement Fund @	\$2,100.00	
Postage & Shipping @	\$300.00	Travel @	\$1,200.00	
Professional Development Φ	\$200.00	Entertainment (meals with clients) @	\$600.00	
Desired annual salary @	\$40,000.00	Total days per year you expect to bill for shooting $\boldsymbol{\Phi}$	100.0	
Non-Assignment In	come			
Stock, print, and reprint sales $\ensuremath{\mathbb{O}}$	\$0.00	Submit Use Defaults	Clear	
	F	Results		
Total annual expenses (including desired salary)			\$89.850.00	
Weekly Cost of Doing Business			\$1,727.88	
and the second terms of the second terms of the	Shooting (1)		\$898.50	

After you've determined your CODB, it's time to compare that to what you're charging for what are typically referred to as "photo fees" on many generic invoices. These are a separate line item from all the expense lines.

Suppose you have an editorial assignment for which you are charging \$1,200 plus expenses, and, using the NPPA's default figures for their CODB calculator, your business costs \$898.50 per day of shooting. This means that the difference between what you are charging and your CODB —\$301.50—is either a profit for the business, a usage fee for the use of the images, or some combination thereof. Typically, in this line item of \$1,200, you've rolled in your CODB costs as well as usage. There is, however, a school of thought that suggests those two items should be separate, and both sides of the debate are passionate about the issue amongst photographers.

I'll present the two schools of thought as fairly as I can regarding photo fees. Before moving to that, though, it is important to consider whether what you are paying yourself is going to be a fixed cost within the CODB calculation or a percentage of profits. I would submit that you should determine a fair wage and include that figure as a fixed cost, and one that increases annually—not only by approximately 5% for standard cost-of-living-adjustments (COLAs), but

also commensurate with your growth and increased experience as a photographer. A 5% annual COLA and a 10% increase every two years would be more than reasonable.

The following sections discuss two schools of thought regarding photo fees.

School of Thought #1: All Creative/Usage Fees Are Listed as a Single Line Item

Many photographers simply put both CODB costs and usage fees together. Typically, they do so because they don't want to separate the two or they don't have a solid grasp of how to best separate the two. (Or perhaps they don't know their CODB.) Thus, many photographers list both items as a single line item because they don't want to get into unknown territory. They do what they've done before, which has seemed to work so far.

One argument for keeping them together is that this is the way software companies handle it, and that's a fair comparison. When I purchase my license to use Photoshop, I am obtaining, at nominal expense, the materials (CD, manual, and so on), and at a larger expense, the license to use the software on one desktop (and one laptop, according to the last EULA I read). If, after buying the software, I learn it's not Universal Binary, but rather must run under emulation, I opt not to even peel the wrapper off the box. (This is a Mac issue, so you PC users need not worry about this (yet), but it's an understandable analogy, so go with it.) I continue to run the previous version under emulation, because all the online reviews say it's better. I then call the creator (Adobe) and say I've opted not to exercise my licensed rights, and, therefore, would like to not be charged (or get a refund) for the license.

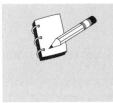

NOTE

Please make sure you're not using pirated software. Photoshop is one of the more common software packages and is highly pirated. If you don't respect others' licenses, you have little room to object when someone steals your photographs.

NOTE

A EULA (*End User Licensing Agreement*) is a standard agreement for which you usually just click Agree when you are installing the software or before you open the CD jewel case. Sometimes it's a sealed envelope with the text printed on it, and sometimes it's a sticker which, by breaking, you acknowledge as having read a printed document that accompanied the CD in the packaging.

The argument is that the license is included in the fee because, whether or not you've exercised your right to use the photo, you contracted for that fee and are obligated to pay it. Were there to be line items of, say, \$1,800 for creative fees and \$12,000 for usage fees, if the client specified that they killed the project or the usage is being scaled back to a figure for which you would

45

have quoted a \$2,000 usage fee, there is a valid argument as to why they should be paying the lower fee if it's broken down.

Another argument is that clients often come back to photographers for additional uses or to extend the existing rights package to include another six months (or longer), and if you're figuring this based upon the larger creative+usage fee, then the end result is a higher additional fee for the added or extended uses.

School of Thought #2: There Should Be Separate Line Items for Creative and Usage Fees

Some photographers break these fees out, often at the request of clients trying, as they've said to me on more than one occasion, "to compare apples to apples." This means that other photographers are regularly separating the two. In addition, the client can understand that you're not earning \$13,800 for the day, but \$1,800 for the day, and then the \$12,000 is for X period of time, during which the client can exploit the work to serve their company's interests. This often makes for a better understanding of the fees outlined on an estimate—something that must be justified to the end client. Even when the bottom-line total is the same, details such as a separation can make a difference.

NOTE

"Exploit" is not a bad word, so get used to seeing it. It basically means "use to the fullest extent allowable," but it's been perverted into its more commonly used meaning—"to take advantage of." Almost all contracts drawn by lawyers who know what they're doing use the word (albeit sparingly). Dictionary.com's first definition of the word is, "to employ to the greatest possible advantage: exploit one's talents."

A downside that becomes obvious when you apply the math from #1 is that if you're basing your quoted fees for additional or extended uses on the original figure, subtracting \$1,800 will reduce your additional fees when you are coming up with a percentage-based rights extension. The upside, though, is that clients understand the percentage better when they see how you arrived at the original, and now expanded, fees.

After you've figured out whether usage is a part of creative, then figure out your fees. As a baseline, take your CODB, add 7 to 15 percent as a profit for the business, and consider that as what you charge for an assignment for which you remain in "first gear" (if you're a five-speed manual) and for which little of your extensive skills or creativity are called for. With a CODB of \$900, that's a \$990 creative fee (which includes a 10% profit for the business).

For assignments that require a bit more effort and creativity, consider a percentage-based increase in your creative fee—say 30 percent to hit "second gear," for \$1,200. For assignments that require you to get moving (and creatively interesting), you bump to "third gear"—say a 50-percent increase, or \$1,350. For assignments that are creatively exciting, you hit "fourth gear" at a 75-percent increase over your CODB, or \$1,575. For assignments that are creatively challenging and taxing (and exciting), you could end up at 100 percent of your CODB, or \$1,800.

On top of all this is usage. With all the resources available to you via software and online sites, you can determine usage guidelines (and modifying factors) fairly easily after you review the available historical surveys, more recent surveys, and, in some instances, factors of a media buy. Following the review, you'll have a good idea what to add for usage.

A model that has been discussed and debated, and one that I feel is not only fair, but also comprehensible by clients—especially those who are art buyers—is a percentage-based model. I first came across this concept during a panel discussion at a conference where primarily advertising photographers were speaking, and the concept struck a chord with me. Usage, it was suggested, should be based upon a percentage of the media buy, and there are photographers who are having success with this usage pricing model. In many instances, however, usage is limited by the photographer to a specific state, region, ad type (bus backs, billboards, movie theater pre-show screens, and so on), and time frame, so without knowing the media buy, you are setting a price that will delineate the usage to such an extent that your usage fee set forth is akin to knowing the actual media buy. However, there might be uses within your description that you'd not thought of, and the client may be exploiting the right to employ images for those uses.

In addition, media buys can be a moving target. The initially stated buy could be midsized, so you estimate for that, and then when/if it's reduced (sometimes significantly), your percentage total must go down. Perhaps you'll have a minimum buy, or perhaps you have a sliding scale.

Almost all advertising agencies are paid a commission based upon the media buy, and the commission ranges from 10 to 15 percent. However, for extensive multimillion-dollar buys, agencies have been known to accept commissions as low as three percent. This approach of a sliding scale makes a great deal of sense. Although some art buyers may state that they don't know what the media buy is (and that may be the case), more than likely many just do not want to disclose to you the media buy.

Here are a few ranges and percentages that would be fair and appropriate to apply, and would take into consideration the value of the usage:

- ▶ \$2MM or greater: 3%
- ▶ \$1.5MM to \$2MM: 4%
- ▶ \$1MM to \$1.5MM: 4.5%
- ▶ \$600k to \$1MM: 5%
- ▶ \$450k to \$599k: 5.5%
- Less than \$450k: 6%

There are, however, a few caveats to this list. If it's a full-page ad with a heroic photo that's not yours, and yours is a quarter-page inset photo, then your percentage should then be adjusted downward. If it's all your photos in the ad, even multiple photos taken at different shoots, you would have been paid for each of the shoots, but the usage fees would be a single sum combining them all. If nothing else, in the end, you can do the research and find that a full-page ad in a trade magazine with a circulation of 30,000 costs \$8,000, and if they want unlimited rights to advertise in all trade magazines for two years, that's 24 months times \$8,000, times four or so magazines, or \$768,000 in possible media buys. In this case, a five-percent usage fee is \$38,400. Of course, this would be the likely maximum media buy they could make under those rights, but this certainly gives you a starting point to quote from for usage; moreover, you can

negotiate downward for the total and the expanse of usage. A percentage such as this is often something that clients can not only get their heads around, but also can accurately and in simple terms convey to their own clients.

At the conclusion of your determination of how much you'll have to put into delivering the best images to meet client needs and usage, you can combine them or not, consistent with your decision about the aforementioned factors involved in delivering a clear and understandable estimate for the client's consideration.

Raising Your Rates: Achieving the Seemingly Impossible

No matter what rate structure and fees you've decided are right for you, ultimately you'll need (and want) to raise your rates. The federal government gives its employees a cost-of-living adjustment (COLA) each year, as do most corporations across the country—or at least they used to! This is done for purely economic reasons. If a loaf of bread cost \$1.29 last year, this year it costs \$1.35, and the government wants to take this into consideration. Otherwise, over time, you wouldn't be able to afford the same grocery needs that you had, say, five years ago. If for no other reason than "everyone else is doing it," your rates should increase over time. If they don't, everyone but you will have more buying power, and you'll be at a disadvantage. The car that cost \$20k ten years ago now costs \$27k, and you can no longer afford it—among other things.

Understand, though, that the COLA does not take into consideration promotions and raises that everyone else is striving for in their jobs. You too should strive to earn more as an employee of your business than you did last year. How much is up to you. Ten percent? Fifteen percent? Did you do a bang-up job for the business, working extra hours and weekends, outperforming last year? If so, a promotion of 20 or 25 percent is what others are achieving. Yet how do you do this when you are both the raise seeker and the raise approver, as well as the justifier to the customer of the new rates? It's a huge challenge.

Consider the scenario in which you have based your rates and fees on time-typically covering luncheons, dinners, galas, or even rites of passage. I adjusted my rates somewhat quietly. Early in my career, I had a four-hour minimum and was charging \$100 an hour—in other words, a \$400 minimum—but for that, the client could book me for up to four hours. After a few years, I raised my rates to \$125 an hour, reduced my minimum to three hours, and added an administrative fee that was 10 percent of the estimate total—usually around \$48 or so. This meant that the combined photo fees and administrative fee was \$375 + \$48, or about \$423. In addition, for the clients who did need me for four hours (or booked me for three, then ran over), I was able to bill an additional \$125, so my four-hour assignments were bringing in \$500, and no one was complaining. In addition, this eliminated situations in which clients figured out that it was the same to have me arrive at 8:00 am for a 10:00 am event concluding at noon as it was for me to arrive at 9:30. Not only did this save me the headache of fighting rush hour traffic and getting up early (one of my least favorite things to do), but I was able to take assignments that ended, say, at 5:00 pm and move on to assignments that were from 6:00 pm until 9:00 pm. Previous clients were having me arrive at 5:00—something that I couldn't do, and thus had to lose one job or another.

NOTE

A study of my client bookings revealed that most clients hiring me for this type of work only needed me for two or three hours, and my risk involved the few clients who did need me for four hours.

A few years ago, I decided I was busier than I expected, and I thought I might be able to weed out a few clients if I raised my rates again, so I did. I increased them to \$150 an hour, with the same three-hour minimum, and the administrative fee jumped to around \$68, meaning that a three-hour event earned \$450 + \$68, or \$518, and that four-hour event was earning \$600 + \$75 (approximately) in administrative fees, or \$675. This was a decent increase over the original \$400 of a decade earlier. Is almost a 60-percent increase over, say, 10 years good? Perhaps. Does it take into consideration a COLA? Yes. Did it award me raises and promotions because I am more competent than I was 10 years ago? Maybe.

Other downward pressures are more demands for "all rights," "buyouts," work-for-hire (more on these later in this chapter), hobbyist photographers who claim to be working photographers capable of filling client needs, and market forces in my community. In the coming year, I am looking to increase my rates again because that previous bump from \$125 to \$150 didn't cause the reduction in assignment load I had expected.

In the scenario with rates based mostly on creative and not so much on time—often editorial assignments or corporate/commercial/advertising work—how I adjusted my rates did not occur with any more fanfare than necessary. Many of my clients, although repeat clients, are accustomed to receiving estimates before each assignment, so increases were less perceptible, and I certainly maximized my ability to increase my rates during the transition to digital. This not only covered the costs of the transition, but an increase in overall profitability per assignment. Magazine assignments that used to be \$750 including expenses are now in the \$1,300 to \$1,500 range.

Of course, it's imperative that you (internally) have an hourly rate that you use and apply to your calculations to arrive at your rates as a baseline for services rendered, from photographic to post-production and such. This is not an external figure that you share with clients; rather, it's a figure that helps ensure that you are paid that fixed salary from the CODB calculator.

Surveying Your Competition: How to Gather Information without Risking a Price-Fixing Charge

One of the ongoing issues among professional trade associations is that they cannot endorse, encourage discussion about, or advise a particular set of rates.

Law.com provides the following definition of price fixing:

n. a criminal violation of federal antitrust statutes in which several competing businesses reach a secret agreement (conspiracy) to set prices for their products to prevent real competition and keep the public from benefiting from price competition. Price fixing also includes secret setting of favorable prices between suppliers and favored manufacturers or distributors to beat the competition.

Discussing with your colleagues and competitors what prices they charge (or would charge) for a particular assignment or type of assignment is not price fixing. If you agree to charge a set price and are among "several" (as noted above) companies that "prevent real competition," then you have a problem. However, many trade associations have worked diligently to avoid even the appearance of a price-fixing charge—an understandable measure of self-preservation, because no one wants to be the subject of a Federal Trade Commission probe. Back in the 1980s, ASMP produced a well thought-out survey of its membership as to the prices they charged (and presumably would charge in the future) for their services. Despite this well-intentioned work product, the federal government took a dim view of this and expressed as much to the ASMP in no uncertain terms. This has caused a chilling effect regarding pricing information and how (and by what means) it is shared. However, this should not discourage you from appropriately reaching out to others about pricing you may be less than familiar with.

NOTE

I would submit that it would be very difficult to "prevent real competition" in the photographic marketplace with so many providers.

Perhaps your reason for inquiry is that although you can produce the final product you're being asked to, you might not be familiar with all that goes into it. Suppose it's aerial photography, and you don't know the risks to life, delays in weather, and pre-production and post-production demands that go into the final product. A call to an aerial photographer—quite possibly one far outside your market—could yield insights that would give you the knowledge necessary to prepare a proper estimate and equipment rental needs, so that you're not selling yourself short and you don't end up taking a loss on an assignment because of all the non-behind-the-camera work involved.

Perhaps your reason for inquiry is you are new to a market, and your "big city" pricing is turning off many of your clients. You are capable of doing the work in this new-to-you midsized town because you were booked often in your old location, so perhaps a review of your competition's pricing will cause you to reevaluate your pricing. It's not much different than a gas station owner coming to his corner of an intersection and seeing that his competitors on the other three corners have dropped their prices by 33 cents a gallon. He's going to be making some adjustments to his pricing signage post haste, or risk going out of business.

If, when you reach out to others, they are reticent about sharing their prices with you, don't instead have a friend call up and try to book several assignment types from each photographer. That's unethical and dishonest to be sure. Instead, share with the photographers in question that you are hoping to get a fair gauge of the marketplace, and you may not recognize all that is necessary to deliver to clients in that town. Discuss the fact that you may be setting yourself up to over-deliver, and thus over-price, say, raw files, and not charge any post-production fees, which would make you under-priced and under-delivering to the marketplace's expectations.

I have found that my Web site, which contains hundreds of pages of pricing information and an assignment calculator to aid clients in pricing an assignment before they call, is often used by my potential competition both locally and across the country to price their own assignments.

This doesn't bother me—in fact, I am happy to know that it's happening. If someone independent of me opts to calculate what I'd charge for an assignment and values their work as I do, then if we both are competing for the same job (and I have no way of knowing whether this is occurring), we will be competing on the level of service, creativity, and quality, not on price.

Never Be the Cheapest

It's true. You never want to be the cheapest. I don't want to be the "always low prices, always" Wal-Mart version of photography. Nor do I want to be the Target version. I want to be the Nordstrom, Saks, Tiffany, or other high-end-exclusive-boutique version of photography. Further, I believe that's the level of service, quality, and commitment I bring to each assignment.

NOTE

I have nothing against Wal-Mart. In fact, I've completed assignments for them. I brought to the assignment a level of service they wanted, and I wasn't the cheapest photographer. The results validated that, as well as their decision that I was the right person for the assignment.

When I am discussing an assignment with prospective clients, they give off cues that they are going to be getting estimates from other photographers, and usually there is a hint of "we're looking at a few photographers' estimates right now" that gives me a clue that they're shopping price, among other things. At this point in the conversation, I attempt to diffuse the priceshopping by stating, "If you're shopping price, I can pretty much assure you that I am not going to be the cheapest, but I will deliver the quality that you (or your client) demand, at a fair price." Sometimes they are taken aback, but if you see that cost comparison down the road, you'll likely lose the assignment anyway, unless the client sees the value you bring. It's beneficial for you to point this out to the client sooner rather than later, and perhaps the other person on the phone who often isn't the decision maker—will go to bat for you, and you'll get the assignment.

If You're the Cheapest, Find out What Is Wrong

If you're the cheapest—and finding this out isn't too difficult—you want to know why. Perhaps it was in the expenses area of your estimate because you didn't include catering on a shoot that called for it, or a second assistant when the shoot only called for one. Or perhaps it was because you used ambiguous licensing terms that gave away more than you intended without your being paid the correct fees for the assignment.

NOTE

I know who the cheapest photographers in my community are because whenever I lose an assignment, I always ask to whom, and I always follow that up with, "And was it a matter of price?" Then, I ask what the price difference was. About 80 percent of the time, clients tell me who they did hire. Seventy percent of the time they also tell me it was about price, and then they tell me what the differential was. It's amazing what you can learn just by asking! When on assignment with clients, I often will discreetly survey them about how I came to be their photographer of choice. To date, I've not had a client state that it was due to price; I am aware that I am not the least expensive photographer in my community. Typically, I am a sole-source contractor who came to them by a recommendation, or a review of my Web site gave them the confidence to book me. If, however, it was because I was the cheapest, I'd ask a few more questions. Perhaps there was a misunderstanding about rights, rush turnarounds, or what was included in the assignment expectations. Either way, asking appropriate questions can give you insight into what you might not have (but should have) factored into the assignment.

What Do You Charge for Whenever You're Working for a Client?

One of the most surprising things I see my fellow photographers do is forget when they are free to do as they wish, and when they are doing things on behalf of a client. I see my colleagues making lab runs; participating in site visits and conference calls; and doing scouting, preproduction, and post-production—and they worry about billing for these things. Whenever you are working on a part of a project that is for a client, you should charge for that. Period.

We bill for a delivery service to and from the lab, whether we outsource that to a courier company, I send my assistant, or I opt to do it myself. If we have to produce a second CD of images for a client, we bill for that. If we have to pull an archive drive and send out e-mails, that's billable. Retouching blemishes on a face? Billable.

The key is to explain to the client that these things do apply so there are no surprises. Just as with other professions—lawyers, doctors' initial consultations, general contractors, accountants, and the like—the first meeting or phone call is free and, more often than not, meetings and calls beyond that are billable.

Tools and Resources for Understanding the Body Politic of Photographic Pricing

First, it's important to understand that media giants are *not* producing magazines for altruistic reasons; they are producing magazines to generate revenue. If even a modicum of altruism existed, *Life* magazine—a publication that changed lives and arguably governments—would still be published. In the end, *Life*'s circulation declined, and advertisers were not getting the bang for the buck they wanted from the demographic they wanted, so they cut back on the advertising, and "poof," away it went. Oh, and this applies to newspapers as well. The articles, stories, and accompanying photographs are designed to cause you to turn from page to page, seeing the ads that pay the reporters, keep the presses running, and, most importantly, earn money for the owners or shareholders. In the end, editorial publications serve commercial interests. If you have any doubts about this, visit the Web sites of the parent corporations that own groups of publications, and look under the For Investors tab or the promotional material they make available to potential advertisers to entice them to spend their money in the

magazine's pages. You will have a different and less generous purse when considering whether it's smart to take the assignment because the magazine's goals are to change the world.

Advertisers are looking to get the most for the least. Can you blame them? Almost everyone wants this in some form or another. However, in this case, they are paying you the least, and you're usually giving the most. This means that you're getting the short end of the stick more often than not. It's important to realize that how valuable your images are is, as they say, in the eye of the beholder. If they are willing to pay for your talent at your stipulated fees, then you have done a good job of illustrating your value to the project or assignment; otherwise, they'll have gone with someone else for some other reason (cheaper price or higher price when they've done a better job at illustrating their value). This is a universal truth for photographers, and it applies to commercial and editorial work alike. It's fair, not some shell game or other deceitful tactic. This is about being paid fairly for your contribution to the assignment. In some cases, you might believe a \$30,000 licensing fee is astronomical, but when compared to the fact that it will be the signature image of an advertising campaign in which several million dollars in media buys will be made, and from that, many more millions will be earned in product sales, it begins to be equitable.

Words to Avoid

Often clients will use words they don't know, frequently ones that have no real definition. The most common one is "buyout." It has an ambiguous definition, at best, in the photographic world, and is open to a wide array of interpretations. A buyout of what? All rights? Exclusively? Forever? Copyright?

"Collateral" is another word that is ambiguous at best when describing rights that are granted to a client for photographic images. "Advertorial" is another made-up word. Its definition comes closest to "a page in a magazine that is paid at an advertising rate, but is designed to look like an editorial page, with a similar typeface and style." Most publications have policies specifying that so-called "advertorial" content not use the same fonts as the editorial portions of the publication. The content is usually not solely controlled by the advertisers, but is usually written by staffers of contractors in a manner to make the advertisers look good. The content is submitted for review and approval by the advertiser, which means that they want you to charge an editorial rate for an advertising use. Don't succumb to this—consult your advertising pricing guidelines and quote the advertising price. When they come back to you with a quote that's a third of this price, respond that those are your advertising rates, and it's your policy to charge advertising rates for advertising uses, which is what an advertorial is. The same holds true for "custom publishing," in which an entire magazine is printed and looks like an editorial magazine, but, in reality, is a brochure disguised as a magazine. That's an advertising rate for me too.

Pro Bono: When to and When Not To

There seems to be an altruistic and socially conscious bone in every photographer's body, and, as such, there is a predisposition to have a soft spot in one's heart for the phone calls that you'll inevitably get espousing every good cause under the sun, asking for free or cheap photography services. Be careful.

First, it should be you who decides which causes you want to support. That means deciding what's near and dear to you, and reaching out to those causes. When others call looking for your services, it's easier for you to say, "I've decided which charitable organizations to donate my services to this year, but I would be happy to discuss your needs and see whether I can give you the services you need at a fair price."

When I get a call that starts with, "We're a non-profit...," I typically (and respectfully) inquire whether the person is a volunteer for the organization or an employee. Ninety-five percent of the time, the person is an employee, and I become far less likely to consider a pro-bono assignment or a discounted rate. If the entire organization is made up of volunteers, that might be an indicator to you that a review of your free time may be in order.

Often there are events that appear to be so worthy, so pure of heart that they call out for someone to help. When you arrive, though, you find out that the event was able to secure a location at a nice hotel and bring folks in from distant locales because the event, for a debilitating disease or condition, is being underwritten by a pharmaceutical company who has a drug that will cure or lessen the effects of the disease, and if their drug ends up on the list of drugs approved for reimbursement by the state or federal healthcare system, they stand to make millions. It's at this time that you feel taken advantage of. This holds true for ad campaigns as well. In addition, non-profits don't get discounts on their power and telephone service, nor on printers, copier paper, and such. Don't offer special pricing to a non-profit unless they are special to you, and you decide that's something you want to do.

Licensing: A Primer

If your estimates refer to "sales," or if you say, "I will sell you this photograph for X amount of money," or if they say anything other than "license" or "licensing," you are setting yourself up for a huge headache. When I hear someone pose the question, "How much would you sell the photo for?" I cringe, and then I object. Dictionary.com defines the words "sell" and "license" as follows:

Sell: To exchange ownership for money or its equivalent; engage in selling.

License: Official or legal permission to do or own a specified thing.

So, while you may "sell" a print such as an 8×10 , there is no license included to reproduce that print. When you buy a poster (or artwork) for your wall, you are not also obtaining a license to reproduce it for other walls in your home or to sell to others.

Although this might come across as a given for most people, if you refer to the selling of a photograph, there is an inherent expectation that you no longer own it. Never, never refer to what you do as "selling" an image. The correct term that should be used at all times is "licensing."

You should not see revenue from your stock photography as sales from stock, but rather as licensing income. There are a number of books that deal only with negotiating and how to become good at it; the book doesn't have to be one specifically geared toward photographers. I've outlined several such books at the end of this chapter.

One of the most ambiguous areas in photographic licensing is the language. Simply put, what is a brochure, versus a sales-slick, versus a custom-published magazine, and what the hell is an advertorial anyway? Throughout the years, there has been no single source where you could come to understand, mutually with your clients, what usages types, extents, and scopes apply to your negotiation over licensing of your work. This has changed with the advent of the PLUS Coalition.

PLUS stands for *Picture Licensing Universal System*, and the message on their Web site (www.useplus.com) is:

The Picture Licensing Universal System (PLUS) is here to make image licensing easy. A worldwide coalition of leading companies, respected associations, and industry experts have joined this unprecedented nonprofit mandate to clearly define and standardize the core aspects of image licensing and its management. Now we can all agree.

And our common language will make every license simpler, more transparent, more secure, and of greater value for everyone on every side of the process. Here is where you'll find that information and much more.

Further, the PLUS licensing information will become a part of the photo's metadata, so the uses are denoted by a number, termed by PLUS as a PGID#. For the term "collateral" it returns the PGID# 10610000 0100. To get there, search for the ambiguous term "collateral" on the PLUS Web site (see Figure 5.2).

4. m. f	2 🕄 👫 \varTheta http://www.useplus.com/glossary.asp	▼ © (G·	(mark)
0 :	: PLUS ::		
PLUS'		This is an evolution. Now that FUUS is here, we need you to help ensure that this universal system continually odapt to the forest technologies, trends, and luminess disibling. Join FUUS.	
. 200	Home System Glossary Coalition Resources	Contact	
Media Selector Propose a New Terrs	The PLUS Glossary of Picture Licensing	00	
	Find a Definition Collatoral Collatoral Compte: "watemark"; or by PGID number Second	ch Use this field if you know a term and would like to find it in the Glossary.	
	Find a Term	Use this field if you are seeking a term to use in a license to	
	Advanced Search Coming Soon Advanced Search Coming Soon Search for exact match Search	communicate a specific concept,	
	Browse the Glossary		
	1 A B S D E F G H 1 2 K L M N Q P Q B S I U Y W X Y X	Use this field if you are not looking for a specific term but would like to browse the list of terms.	

Figure 5.2

(-) -	7 3 6 9		eprosecut grosse	iry_list.asprox	arermsearch *	© (G-		
0 :	: PLUS ::	Therese						
PLUS	Home System	Glossery	Coolitios	Resources	you to help ens	tion. Now that PLUS is one that this universal next technologies, the LUS.	system continual	
Media Selector	Home System	, owney	Connor	A	Contract		0.0	
Propose o New Term	Find a Definit	tion	Find a Term			Browse the G		
Prior Versions						14850	EEGH	
	Exact match	Search	Advanced Exact m	I Search Com atch	ing Soon 💌 Search	I I K L M R S T U Y		
	Filters Set	Clear						
		L. L	categories only: Al	I				
		searching in these	categories only: Al	1				
	You are currently	searching in these	categories only: Al	1				
	You are currently	searching in these	categories only: Al	1				
	You are currently	searching in these	categories only: Al					
	You are currently	searching in these	categories only: A	1				
	You are currently	searching in these	categories only: A					
	You are currently	searching in these	categories only: A					
	You are currently	searching in these	categories only: A					
	You are currently 1-1 of 1 Results Collateral	searching in these	categories only: A					

Such a search returns the result shown in Figure 5.3.

Figure 5.3

When clicked on the Collateral link, the site returns what is now an unbiased body's definition of what has heretofore been a term that has been misinterpreted (almost always to the client's best advantage), yet now has an agreed-upon definition by both those licensing photography and the largest organizations involved in licensing photography, from Getty to Corbis, the Picture Agency Council of America (PACA), and many smaller organizations. Thus, a broad crosssection of the business has agreed to a set of terms, and this can only lead to good for all photo licensing down the line.

The returned definition is:

Printed marketing and advertising pieces for use in direct request and personal contact, not in publications.

And PLUS provides additional information (see Figure 5.4):

Often reflects a larger broadcast, print or direct mail campaign. May include leaflets, brochures, pamphlets and business cards, among many other possible uses. However, collateral is often misunderstood to comprise an even longer list of uses. Listing individual uses may be more practical for most licensing situations.

(a		:: PLUS ::			
A	🖉 🕜 🚹 🛛 http://	//www.useplus.com/glossary_term.asp	?tmid=106101 🔻 🔘 ([G]•	
	PLUS ::				
PLUS	Home System Gl	Nossary Coolities Resources	you to help ensure that the	e that PLUS is here, we need its universal system continuals volagies, trends, and business	
edia Selector				0.0	
opose a New Term	Find a Definition	Find a Term	Brow	se the Glossary	
ior Versions	Exact match	arch Advanced Search Com	ing Soon - I J	ABSREEGH IKLMNQPQ SIVYWXYZ	
	Filters Set Clear You are currently searching	r] ng in these categories only: All			
			1	Display Term List	
	Term. In the Context of			P	
	Note Definition	 Printed marketing and advertising placement of the publications. 	eces for use in direct req	uest and personal	
	Additional Info	Often reflects a larger broadcast, print or			
		brochures, pamphiets and business cards, collateral is often misunderstood to comp	among many other possible rise an even longer list of u	e uses. However,	
	Term In Use	brochures, pamphlets and business cards,	among many other possible rise an even longer list of u using situations.	e uses. However, ises. Listing individual	
		brochures, pamphlets and business cards, collateral is often misunderstood to comp uses May be more practical for most licer "collateral is delivered directly to the con	among many other possible rise an even longer list of u using situations.	e uses. However, ises. Listing individual	
	Term In Use	brochures, pamphlets and business cards, collateral is often misunderstood to comp uses May be more practical for most licer "collateral is delivered directly to the con	among many other possible rise an even longer list of u using situations.	e uses. However, ises. Listing individual	
	Term In Use	brochures, pamphiés and buliness cards, collatent le orten misundentido to comp uses May be more practical for most licer "colletenal is delivered directly to the con s & related terms coming soon Castion	among many other possible rise an even longer list of u using situations.	e uses. However, ises. Listing individual	
	Term In Use Variations Pluzal Abte: Synonyms, antonyms PLUS Usability Rank Preferred Term	brochures, pamphiés and buliness cards, collatent le orten misundentido to comp uses May be more practical for most licer "colletenal is delivered directly to the con s & related terms coming soon Castion	among many other possible rise an even longer list of u using situations.	e uses. However, ises. Listing individual	
	Term In Use	brothures, pamphiés and bulines cans; collateral is often misunderstood to comp uses May be more practical for most licer "colleteral is delivered directly to the con " ms & related terms coming soon Caution gastion regarding this term.	among many other possible rise an even longer list of u sing altuations. sumer or dealers rather tha	e uses. However, ises. Listing individual	

And then a sample of the defined term in use:

Collateral is delivered directly to the consumer or dealers rather than via mass media.

Special attention should be paid to the last sentence of the "additional info" section, where it is noted:

However, collateral is often misunderstood to comprise an even longer list of uses. Listing individual uses may be more practical for most licensing situations.

PLUS has done an exceptional job of establishing this structure and noting terms that carry risks or are too general and may create confusion. Collateral is one of these. Dictionary.com defines "collateral" as:

Situated or running side by side.... Coinciding...or accompanying.... Serving to support.... Of a secondary nature; subordinate.... Of, relating to....

I'd say that's pretty darn ambiguous, and would therefore follow the recommendation by PLUS to list individual, more specific uses.

Why Work-Made-for-Hire Is Bad for Almost All Non-Employee Photographers

We, as members of this society, have agreed to be governed by the laws of the land. And when the laws of the land, as enacted by Congress and signed into law by the President, become a topic of disagreement, the third check comes into play—the judicial branch. From small claims, to federal courts in districts across the country, to the Supreme Court, the courts, absent prior case law (and often contrary to past case law), look to the debate and dialogue that took place while the laws were being enacted. This is known as the "intent" of the lawmakers. Courts attempt to understand what dialogue and debate made up the final decision so they can test the case before them with Congress' intent. Save for a very narrow scope of work, work-made-forhire is absolutely contrary to copyright law—a tenet of the Constitutional framers—as well as Congress' intentions. The framers granted artists a limited monopoly over their work for a limited period of time as an incentive for them to continue to create their works and for inventors to do the same.

If you're going to "sell" your copyright, then it must be with an understanding of just what you're selling. Almost everyone has heard of the garage-sale treasures that were purchases for \$20 and ended up being extremely valuable works of art. PBS' *Antiques Roadshow* has made a multi-year series out of this reality, in which someone doesn't know the value of what he or she is selling. Understanding the maximum potential for revenue over the life of the image— approximately 100 to 150 years when you factor in your life plus the 70 years that your heirs own and control your copyright—will give you an understanding of just what those images could be worth and how you must be appropriately compensated for that loss (or transfer of revenue potential to a third party).

As an employee of a company, your work is vested with your company the moment it's created. Your employer is the author and owner of the work from its inception. Period. If your employer allows you to use the photographs for your portfolio—or anything, for that matter—consider yourself lucky. To be especially careful, get this in writing. I am aware of more than one photographer who, when his employer went looking for reasons to terminate a staff photographer, used the photographer's use of the photographs on his own Web site as grounds for termination. However, if you own your own photography business, once you create images, you are the author and owner of the work, period. You can't go back and sign a WMFH agreement—in fact, backdating an agreement of that nature will most certainly invalidate it. If you sign a WMFH agreement prior to the creation of the images, make sure that at the same time, you get a license for, at a minimum, your portfolio from the author and owner of the images you are about to create. In situations in which you're delivering photography under a WMFH agreement to a stock agency and, say, you go to shoot the US Capitol (or other landmark in your town) at sunset or on a bright, sunny spring day and deliver them to the stock house, you will find yourself in a legal predicament if, separate from your work for them (either off hours or after you've left), you return to a similar spot and make new photos. Those new photos could infringe on the previous photographs, whose copyright is owned by the stock house.

At one point not too long ago, I was presented with the following terms in an "agency" contract:

Ownership of Assignment Images.

Photographer hereby acknowledges and agrees that, unless subject to a separate written agreement between Photographer and the Company, all Assignment Images:

(i) have been specially ordered and commissioned by the Company as a contribution to a collective work, a supplementary work or other category of work eligible to be treated as a work made for hire under the United States Copyright Act;

This language attempts to portray the work I would have been delivering to them as eligible for WMFH status. This is a problem because there are only nine categories of work that are legally allowed to be categorized as WMFH under part 2 of the definition of Work Made for Hire in the US Copyright Office's Circular 9. They are:

- 1. A work specially ordered or commissioned for use as a contribution to a collective work
- 2. As a part of a motion picture or other audiovisual work
- 3. As a translation
- 4. As a supplementary work
- 5. As a compilation
- 6. As an instructional text
- 7. As a test
- 8. As answer material for a test
- 9. As an atlas

... if the parties expressly agree in a written instrument signed by them that the work shall be considered a work made for hire.

Further on, in Circular 9, it states:

If a work is created by an independent contractor (that is, someone who is not an employee under the general common law of agency), then the work is a specially ordered or commissioned work, and part 2 of the statutory definition applies. Such a work can be a work made for hire only if both of the following conditions are met: (1) it comes within one of the nine categories of works listed in part 2 of the definition and (2) there is a written agreement between the parties specifying that the work is a work made for hire. Work shot on assignment for photo agencies is, in my opinion, on shaky footing and could well be rendered as not fitting within the nine eligible categories of WMFH. As such, the contract stipulates in the clause immediately following it:

(ii) will be deemed a commissioned work and a work made for hire to the greatest extent permitted by law;

Hmmm. Seems I'm not the only one who thinks that there is cause for concern about the classification of the assigned photography as falling within the nine categories—attorneys do too. In fact, it is not enough that you be given an assignment to cover a news event or produce scenic stock of a city; the photograph must be created at the direction and supervision of the commissioning party. Further, if you're assigned to cover a movie premiere, and en route you come across breaking news of a fire and you make images of that, the client could argue that it was a part of the assignment because they were paying you. But, in fact, they didn't request that you make the photographs of the fire, nor was their request the motivating factor for you to make the photos, so the images would fail the tests that are necessary to create a permissible WMFH circumstance. This direction could be taken a step further. If your client stipulates, "I need tight headshots and full-lengths of the star of the movie," anything else—images of the director, unexpected stars not a part of the movie, other VIPs, and so on—could not fall within the "direction and supervision of the client" test and would be ineligible for WMFH status, hence the next few clauses.

(iii) the Company will be the sole author of the Assignment Images and any work embodying such Assignment Images according to the United States Copyright Act;

More intent to claim ownership.

(iv) to the extent that such Assignment Images are not properly characterized as a work made for hire, Photographer hereby assigns, transfers and conveys to the Company all right, title and interest in such Assignment Images, including all copyright rights, in perpetuity and throughout the world. Photographer shall help prepare any papers the Company considers necessary to secure any copyrights, patents, trademarks or intellectual property rights in the Company's name at no charge to Company.

Here, you find that the attorneys and the companies they represent are adding in an insurance policy, whereby you agree to transfer every right (including copyright) to the company at no charge. Would that be no "additional charge?"

Photographer further acknowledges and agrees that the Company will have the right to undertake any of the actions set forth in Section 106 of the Copyright Act (17 U.S.C. §106) with respect to such Assignment Images. This includes, without limitation, the right to sell, license, use, reproduce and have reproduced, create derivative works of, distribute, display, transmit and otherwise commercially exploit such Assignment Images by all means without further compensating the Photographer. Notwithstanding the foregoing, the Agreement is not intended to and shall not prevent Photographer from engaging in assignment photography for Photographer's own account outside of the scope of the Company's representation of Photographer.

There's that word "exploit" again. It's not a bad thing, but it reminds you that they're going to do everything they can to generate revenue from the images. In the end, they remind you that you can work for other companies, and they won't stand in your way.

Suffice it to say, I did not sign this contract. Understand that if you sign and work under a WMFH agreement, you will be required to constantly be generating additional images from additional assignments. At no time will you be able to earn anything from your past work. As you work you're paid, but never again, so you must continue to work and be at the whim of losing those assignments (to someone cheaper?), at which time you would have to seek out more work to pay your bills and feed your family. To quote noted copyright expert Jeff Sedlik, "Copyright is the thin line that separates photographers from day laborers."

In 1955, photographic legend Arnold Newman organized what became a major strike over rights issues at *Life* magazine. This eventually became a fight against copyright transfers, lesser rights, and such. In a 1993 interview by Kay Reese and Mimi Leipzig celebrating the 60th anniversary of the ASMP (the entire transcript is available on the ASMP Web site), Newman talks about his experiences surrounding this strike. Reese/Leipzig cite what Newman wrote in the foreword to the book *10,000 Eyes: The American Society of Magazine Photographers' Celebration of the 150th Anniversary of Photography.* It reads, in part:

A key victory nearly forgotten and often overlooked was a non-ASMP act. In 1955, *Life* published nine essays, *Arts and Skills in America*, and sold them to Dutton as a book. Five of the essays were shot by staffers or were handouts. The problem was, they conveniently forgot that the other four were shot by three freelancers: Gjon Mili, Brad Smith, and myself. We naturally requested the additional payment for this unauthorized use. In settlement, *Life* offered remuneration with the stipulation that we sign a contract, also sent out to all their other freelancers, that required us to give up copyrights, reducing or wiping payments for reissues. Our hardearned rights were threatened, as control over (and indeed the very loss of) our negatives, our work, was at stake. All hell broke loose. Seven other top freelancers refused to sign and, in effect, ten of us went on strike.

In the Reese/Leipzig interview, Newman goes on to talk more about the strike he organized:

We just simply said we wouldn't work for them anymore. Their attitude was, if you didn't work for *Life*, you weren't a photographer. At that time, the only other magazine (which I'd already begun to work for) was *Holiday*. And there [were] *Bazaar*, *Vogue* and one or two others that didn't compete with *Life*.... We absolutely refused to accept any assignments until it was done. As an aside before I continue, I discovered during that year that I earned more money working for other magazines than I did for *Life*, and it made me much more independent. I had already begun to worry that I had too many eggs in one basket. An excerpt from Newman's 10,000 Eyes foreword wraps up the point:

Alternate contracts were offered and refused, again and again.... The turning point came when *Life*, attempting to divide and conquer, claimed that they could do without five of us. [One photographer] became furious and confronted his friend, *Life*'s editor-in-chief Ed Thompson, saying, "I think Kessel [Dmitri Kessel, a staff member] is going to have one hell of a time crossing any picket line I'm on." *Life* at this point gave up and offered us a fair agreement, restoring all our rights. What would have been a disastrous precedent for all ASMP members was avoided.

In some instances, agreements, if not properly scrutinized, appear at first to be fair, but upon closer inspection turn out to be unfair and unreasonable. I call them "stealth" WMFH contracts. They are all-rights/work-made-for-hire/copyright grabs. Here's an example of one publication's attempt:

Copyright License — Freelancer shall retain ownership of copyright in the Content, and grants an unlimited worldwide license, for the full duration of copyright, and any extensions thereof, to [publication] to use and to freely sub-license the Content by any means, without further compensation to Freelancer. For greater clarity, this means that [publication] may, for the full duration of copyright, and any extensions thereof, use, publish, re-publish, store, sell, re-sell, distribute, license or otherwise deal with the Content in its sole and absolute discretion.

While this is egregious, it leaves you to think that at least you can license your assignment images as stock. However, it's clear that they too could do this, so you would be competing with the publication for that stock license. And, because the potential photo buyer would be contacting the publication where you were credited for the image, the publication would be offering to license the image, rather than doing what it should—directing the interested party to you, the photographer, for a stock license. However, all of this becomes null and void because of the next clause:

Exclusivity of License — The above license is exclusive in [country]. [Publication] may make exceptions to this exclusivity to allow Freelancer to publish the Content in another media in [country], but that exception is not valid unless obtained in writing from [publication].

Tricky, isn't it? They have an exclusive license, meaning that all of the rights you grant them are exclusive to them, and you may not exercise any of those same rights without their permission. This is essentially a work-made-for-hire in disguise. What rights do you retain? I see few, if any.

When you are dealing with contracts that prospective clients present to you, be absolutely certain of what you are agreeing to and how, when spread across a multi-page document, terms become less offensive one at a time than if they were all lumped together. Yet, in the end, these terms all apply just as if they were lumped together, and you then are signing away rights you thought you were retaining.

Recommended Reading

The final section of this chapter includes some recommended further reading for you.

General Books on Negotiating

Camp, Jim. Start with NO...The Negotiating Tools that the Pros Don't Want You to Know (Crown Business, 2002)

Cohen, Herb. You Can Negotiate Anything (Bantam, 1982)

Fisher, Roger, William L. Ury, and Bruce Patton. *Getting to Yes: Negotiating Agreement Without Giving In* (Penguin, 1991)

Ury, William. *Getting Past No: Negotiating Your Way from Confrontation to Cooperation* (Bantam, 1993)

Books on Negotiating Developed by and for Photographers

Pickerell, Jim. Negotiating Stock Photo Prices (Stock Connection, 1997)

Weisgrau, Richard. The Photographer's Guide to Negotiating (Allworth Press, 2005)

Chapter 6 Overhead: Why What You Charge a Client Must Be More Than You Paid for It

Overhead consists of those expenses directly associated with the production of your photographic services. A few of the numerous examples of overhead include office supplies, from paper for your printers to staples and pens; utilities, including electricity, gas, high-speed data lines, and so on; advertising and accounting; and some might suggest computers and cameras, although those might be debatable, instead allocated as "cost of goods sold" items or such.

Overhead is one of the categories of expenses that photographers most often fail to include accurately in their cost of doing business, and thus they will incorrectly attribute these expenses to the personal side of their tax ledger. Or, they will be significantly less profitable than they expected because they didn't take into consideration certain expenses that they should have.

What Is Your Overhead?

Someone has to pay your overhead, and in the end it's you, but amortizing your overhead over each assignment you expect to do will mean that you pass on to your clients your cost of being in business—something that every other successful business does. If you've been running your business for awhile and you don't know what your total overhead is, it's time to sit down and take one of those non-shooting days to get a handle on this.

First, have a look around your office space. Think about supplies, software, computers, cameras, lighting, accessories, phone and data services, desks, filing cabinets, hard drives for data storage, off-site data storage, and so on.

Next, sit down with your past 12 months' worth of credit card statements and banking statements, and see what items you bought that could fall into the category of overhead. Do not count film processing, shipping charges (if you bill each client for their shipping), or other items that are associated with your cost of goods sold or items that are reimbursable expenses by the client for each job.

Take this collection of expenses and review it with an eye toward annual totals for each item. Some might be biannual (computers and cameras) and others will be monthly (data services, cell services, rent/mortgage, and so on), but by making the necessary calculations, you will begin to see a larger picture come into play about what your true overhead is.

Back in the Day: The Forty-Dollar Roll of Kodachrome

One of the things that arose when the bean counters at the media conglomerates began to try to cut costs and increase profitability of their companies (and thus justify their jobs) was that they began to look at photographers' invoices. The bean counters' personal familiarity with purchasing consumer-grade film at \$5 or so a roll did not jibe with seemingly exorbitant prices for rolls of film on the invoices.

What these accountants did not consider was that in order to best have film ready for a client, it had to be ordered and either shipped to you or picked up via courier and brought to you. This incurred an expense. Then, professionals don't take the film out of the shipping box and shoot an important assignment—they shoot a test roll (or two) under controlled conditions and have it processed. This incurred an expense. Then the film came back from the lab—another expense. Then there was time involved to determine the best settings for the use of that film. This was an expense. Then there was the cost of storing the film in a refrigerator. Another expense. Then there was the waste when you were required to have your film x-rayed twice during your trip and you had to attribute 20-plus rolls of film to "waste" and trash it. This was an expense. All these expenses contributed to a cost per roll of film that was higher than the accountant's \$5 roll of film he dropped into his happy-snap camera for family photos, yet he decided that this was an area in which they would establish a new policy regarding only reimbursing actual expenses. This made matters difficult because how do you amortize a courier charge over 20 rolls of film delivered among the numerous other items, and then provide the client with receipts? My answer is that I don't.

Our policy—my policy—detailed on my Web site, which stood for years in response to client demands for receipts back when film was the default medium to deliver photography, is as follows:

We do NOT supply clients with receipts for any expenses. We do this for several reasons:

We are independent contractors, not employees. When tax time comes, the IRS requires us to provide receipts to verify expenses on our Schedule C. The IRS does NOT require you to have those receipts on hand.

It is critical to the success of our business to maintain a proprietary suppliers network—an absolute cornerstone of a profitable business, and in an insecure environment we do not wish our competitors to learn who our suppliers are. While this is less applicable on film and processing than on unusual items, and from time to time, applies to assistants as well, it is nonetheless critical throughout our supplier chain. We have a set fee per amount of supplies used, regardless of what was actually paid for it. This is done for several reasons: 1) We keep film on file to meet last-minute and unusual requests, therefore we sometimes discard film that does not meet our technical expectations or that has been through several passes of an x-ray machine; this cost must be split across the cost of actual film shot. 2) Time is taken to investigate new films, to test films before they are used in shoots, to go to the various suppliers we use, and to maintain the stock necessary. The cost for this time, billed by staff, must be spread across the cost per roll.

By way of example, publishing houses do not request receipts from printing plants for the cost of ink and paper, nor receipts for the wholesale prices paid on the repair of a copier, nor gasoline receipts from the delivery service who delivers the copies of the magazine.

Please discuss with us any issues you have with this policy beforehand.

This has resolved a number of client issues over the years, and, well, it's our policy—my policy. Understand that just as it's perfectly acceptable and understandable that companies across the country have policies, so too is it acceptable that you have policies! Just as you have policies such as, "I won't allow clients to curse and yell at me on the phone," or "I expect to be paid for my services because I don't work for free," so too can you establish and put forth other policies for clients to adhere to. This isn't to say that policies can never be bent or broken, but that's for *you* to decide when it happens. You'd be surprised at how many accountants will appropriately accept the fact that my policy prohibits the disclosure of proprietary supplier information to them in the form of receipts from those suppliers, and will pay the bill that they were questioning.

This issue was much more of a problem during the days of film than it is now. However, an updated policy looks like this:

We have a set fee for delivery services regardless of what was actually paid for it. Examples may include delivery—sometimes delivery services must make second attempts, and we cannot know of these additional expenses until 30+ days beyond an assignment, which must have been billed before we receive the actual bill, or other surcharges may apply. We stipulate delivery charges to avoid this paperwork. Post-production: We allocate our post-production vendor's services over set periods of time, based upon image counts, and outline that expense to you. We pay a set figure to them for each day's work, and that workload is not delineated by the job where hours are allocated to each job. Further, we may work with our vendor to investigate new production techniques, from plug-ins that produce superior raw-tojpeg conversions, or other services that benefit you, the end client. The cost for this time, billed by staff, must be spread across our assigned fees per assignment.

By way of example, publishing houses do not request receipts from printing plants for the cost of ink and paper, nor receipts for the wholesale prices paid on the repair of a copier, nor gasoline receipts from the delivery service who delivers the copies of the magazine.

Please discuss with us any issues you have with this policy beforehand.

Markup: What's Yours? How Do You Establish It Fairly?

Very few things are not subject to markup consideration. I don't mark up my hotel or airfare charges, but the figure I quote on the estimate is what the client is charged, and is based upon the quote from the hotel and a nominal charge for our time. Typically, it's very close to the actual charge, but issues such as the time involved in booking the ticket (searching for the right flight, determining excess baggage charges, and so on) are included in this item, rather than as a part of the pre-production charges (although that also could be a fair method).

One way to evaluate what a fair markup rate is for you is to find a day when you are not shooting or doing post-production work for a client, and look at the items you typically use for assignments—seamless backdrops, film (if you're still shooting film), packaging materials for shipping and overnight services, and so on. Understand, too, that you will be carrying these expenses for a period of time that ends up being somewhere around 30 to 45 days, with some clients demanding 90-plus days before payment. There are businesses that earn millions of dollars just on the "float" between when they receive payment as a middleman and when they have to pay that money to the ending third party. If you're carrying a \$1,000 expense for a client for 60 days at 15% APR interest, you're paying \$12.50 in interest on your credit card. If you are paying off your balance, that \$1,000 you paid off with \$1,000 of personal or business resources was not available to earn interest in an interest-bearing checking account or to be invested in higher-yielding accounts.

I know, for example, that when I provide services to a PR or advertising firm, they mark me up somewhere between 12% and 19%. Some have pegged their markups at 17.65% and printing markup at 20%. This covers their cost of hiring me, paying me, dealing with any problems that I may create for them or their client, and dealing with my paperwork. All their client has to do is have me turn up and make photographs. More important, markup percentages are no secret they are typically outlined in contracts between client and firm. Everyone involved is aware of them, and although there might be some haggling (especially when the client is the federal government or a charity), markups are a given in many business transactions. In cases such as a charity, I have been directed to bill the charity directly, so that they could save the markup on me. Although it is standard for PR and ad firms not to charge a markup for media buys where the client who is making the media buy pays their firm a surcharge, they make their profits on their commission from the media buy, usually paid to them from the publication's advertising department. This is typically done one of two ways-one where the ad firm delivers published rates, receives payment, and pays a lower figure to the publication, and the other where the client pays the publication the published rate directly, and a commission check is cut from the publication's ad department to the ad firm. For both of these situations, the commission has a range of somewhere between 10% and 15%. However, on multimillion-dollar media buys, commissions can drop to as low as 3%.

With all of this said and your understanding that markups are a common practice, you should be more empowered to charge markup on everything and not feel any sense of guilt in doing so. I accept a fair markup of around 17% for many services we render and expenses we cover on behalf of a client. It's imperative that I not be their "float" and have to leverage my credit cards to service their debts.

Chapter 7 Who's Paying Your Salary and 401K?

It's never too late to plan for your retirement. In fact, it's never too early to do so either, and the earlier to you start, the better off you'll be when you do retire. Many of us think we'll be making photos until our last breath because we love to, but what if we *had* to because we didn't plan for retirement?

If Everyone Hiring You Has a Retirement Plan, Shouldn't You Have One Too?

Most professional employers—the people who will be picking up the phone and calling to give you assignments and projects—have some form of retirement program for their employees. Some are stock programs, 401Ks, and the like. There is no shortage of retirement benefits for the companies that are hiring photographers, so you'd do well to expect the same from yourself. Factor this into your overhead and cost of doing business. Few photographers I know can tell me what their retirement fund total is, and next to none can say they know what the projected yield is (all things remaining fairly stable) when they reach retirement age.

There are a few tax-deferred plans available to freelancers, but I'd be doing you a disservice if I advised you of the best plan for you and your circumstances. There are skilled investment and retirement specialists at your bank who can send you in the right direction. The important thing to do is to get one started. This tax year, ask your accountant to advise you of the maximum contribution you can make to your account(s). (See Chapter 9 for a discussion of why you should have an accountant!)

One word of caution: There are a wide variety of financial advisors who are paid a commission based on every time you effect a financial transaction, how much you invest in certain types of investments, or investments which their financial institution is handling. Make absolutely certain that you are aware of these fees and the fact that the investment advice you may be receiving could be tainted by this. In addition, your accountant should be an excellent resource for qualified investment specialists, and further, they can advise you about retirement planning to maximize your savings and minimize your tax liability.

If Everyone Hiring You Is Paid a Salary, Shouldn't You Be Too?

This idea dovetails well with Chapter 26, where I discuss pro-bono work. If the person hiring you is being paid a salary to do his or her job, then it stands to reason (and common sense) that you're paid a salary by your business! Too often, however, photographers fail to consider themselves as due a salary. This is short-sighted.

Typically, when a photographer's business starts up, every dime gets reinvested in the business and a scant amount of money gets directed toward non-photo-related endeavors. However, to fairly and accurately determine and pay you, your business must begin to pay you a defined salary sooner rather than later, and it should be a cornerstone of your CODB (cost of doing business).

As times change, you should be getting raises—most of the rest of the working public is, and they're more than likely not working as many hours as you are. To that end, you need to determine just what your salary should be.

Establishing a Fair Salary

Because most photographers tend to undervalue themselves and the contributions they make, let's start with a few figures so you don't sell yourself short out of the gate. The NPPA CODB calculator automatically defaults to a \$40,000 salary. That's not far off the national average. A survey by Salary.com yields the results shown in Figure 7.1.

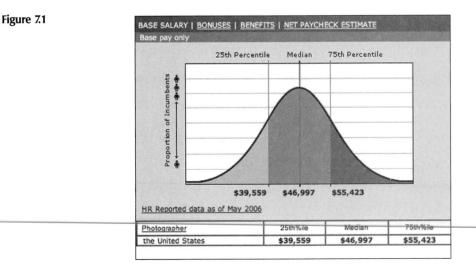

This results in a base salary of \$46,997. This, however, is not the broader picture. Numerous other expenses are associated with an employee whose salary is \$46,997. Drilling down into Salary.com's bonus and benefits details reveals an interesting set of additional figures, shown in Figure 7.2.

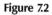

Figure 7.3

BASE SALARY BONUSES Total compensation (base + bonuses + benefi		PAYCHECK	ESTIMATE
Benefit	Median Amount %	o of Total	
Base salary	\$46,997	71%	
Bonuses	\$387	1%	
Social Security	\$3,625	5%	
401k/403b	\$1,715	3%	
Disability	\$1,156	2%	
Healthcare	\$5,390	8%	And the second second second
Healthcare Pension Time off	\$1,535	2%	A STATE OF A
Time off	\$5,176	8%	
Total	\$65,982	100%	

As shown in Figure 7.2, this same employee is actually costing the company close to \$66,000 a year. These aren't made-up numbers; they are real, fair, and most important, *reasonable* figures. Understand that if you were to pay this same amount yourself, you'd have to consider that expenses such as self-employment tax, health and disability, and social security are not expenses that your company (in other words, you) can pay part or all of, but instead, you are responsible for those expenses.

To see what this same photographer's take-home pay is, Salary.com also provides an insightful breakdown in Figure 7.3.

t paycheck estimate rrent assumptions are below. Select y ductions for a more precise estimate.		E
Your Estimated Paycheck	Results	
Bi-weekly Gross Pay	\$ 1,807.58	
Federal Withholding	\$ 298.47	
Social Security	\$ 112.07	
Medicare	\$ 26.21	
Washington DC	\$ 117.16	
Net Paycheck Estimate	\$ 1,253.67	
Calculation Based On	-	
Gross Pay (Annually)	\$ 46,997.00	
Pay Frequency	BI-weekly	
Federal Filing Status	Single	
# of Federal Exemptions	0	
Additional Federal Withholding	\$ 0.00	
State	Washington DC	
Exemptions	0	
Filing Status	Single	
Additional State Withholding	\$ 0.00	

That's a whopping \$1,253 a paycheck, take-home. With these results, you want to consider what value you bring to your own company. One factor I try to consider is if the photo editor who is hiring me is making \$80,000 plus benefits, maybe I should be making \$60,000 plus benefits. Or, if the vice president at the PR firm that is hiring me is making \$100,000, then maybe I should be making just as much if I bring to the table a comparable level of skills, or maybe \$80,000 if my skills are not quite comparable. And, if the senior photo buyer at the ad agency is making \$140,000, then I should be making around that much. Right?

CHAPTER 7

Figure 7.4

It is also critical to understand that if you are billing a total of \$60,000 each year, that is in no way, shape, or form the same as earning a \$60,000 yearly salary. Costs for camera, computers, overhead, and such could cause that figure to approach or go past zero. Your salary is what you'd earn before taxes. Don't confuse the two!

A remarkable survey by David Walker was published in *Photo District News* in June, 2006. It was the first survey conducted by *Photo District News* of salaries within the industry, and the response—it was not a random sampling, but a voluntarily contributed to survey—was huge. More than a thousand photographers were among the 2,114 respondents to their survey. The numbers in Figure 7.4 are average income figures—a fraction of the overall resulting insights, which can be viewed at the PDN Web site (www.pdnonline.com). There, you'll find breakdowns by state/region, median levels, and other survey results (such as what studio managers, art directors, account executives, art buyers, and photo editors) also are earning.

Figure 7.4 shows the average income for freelancers in each category.

For editorial photographers, an average wage of \$60,000 with corporate photographers averaging just under \$120,000 certainly gives you a good place to begin when thinking about what salary you should be earning. There are a number of factors involved in determining your salary, and because you're the boss and the employee, you'll have to set your own wage. The key is to actually set a wage and work toward achieving it.

Targeting That Salary in the Short Term and Long Term

If you're just into the business a few years, perhaps your salary should be closer to the left of that bell curve in Figure 7.1, somewhere in the low to mid \$30s. This is not an unreasonable

salary to expect if you have a baseline skill set that will allow you to meet client needs on a variety of basic assignments. However, you'll want to be realistic about what you pay yourself now versus what you'll be paying yourself in 10 years.

One of the remarkable things that happens to people as they transition from one arena to another is that they have to make an adjustment in their self-perception. During your last year in elementary school, you were on the top of the heap. All the other kids looked up to those in the upper grades, and this was true whether you were the cool kid or the nerd. Even the nerds got respect from those three and four grades below them. However, the tables quickly turn as summer turns to fall, and that top-of-the-heap elementary school kid becomes a freshman in high school, and it's back to the bottom of the ladder. And so it goes again as a high school senior transitioning to a college freshman. And again, the supposed top of the heap, college senior...until you graduate and find yourself in the lifelong climb of the professional world. Even the photo school award-winning valedictorian can easily find himself working for a weekly paper in the middle of nowhere, and this becomes a reality check for that photographer and his salary expectations.

When I graduated, having not studied photography—my degree was in political science, with a minor in economics—I took a job as a staff photographer for a magazine that paid a whopping \$15,000 per year. I was by no means at the top of my graduating class, but even this stung a bit. Yet the opportunity to have my own studio sizable enough to fit a car in, my own darkroom and film processing line, as well as an extensive range of cameras from 35mm through 4×5 and more studio lighting than I'd ever seen was a dream come true for an aspiring photographer who'd had a few stories published. The important thing was that I was a salaried employee with benefits paid by my employer, zero investment in capital, and zero risk of no revenue. As long as I did my job, I got my paycheck. Today's starting photographers can hope to find salaries in the low to mid \$20s, where they will cut their teeth for a few years.

As you look at your current experience level and do your own research as to what others are earning or what you could earn in another field were you not a photographer, you'll want to choose a salary level that also takes into consideration growth potential over 5-, 10-, 15-, and 20-year periods, and target those salary levels in your projections of overhead costs and your cost of doing business (CODB). That way, you can incrementally raise your rates to pay you a higher salary as you become more experienced, and, more than likely, have familial obligations you didn't have when you graduated.

Transitioning from a Salaried Staff Position to Freelance

This is one of the more difficult transitions to make, usually because it happens to you without notice and you've not planned for this occurrence. The trend over the years, starting with *Life* magazine and then moving on to *People*, *Newsweek*, *Time*, is evolving into shrinking photo staffs at newspapers across the country who are now relying on freelancers and either laying off or diminishing full-time, salaried staffs through attrition.

This trend started when papers began hiring freelancers on a regular basis, not because of unexpected breaking news, but as a cost savings over large employee budgets. Soon, the

accounting departments learned that a freelancer could deliver the same "all rights forever" package for a fraction of what it cost to maintain an employee. The trend began to spread like wildfire and shows no signs of a reversal. The staff photographer who believes he will have a job in 10 years is kidding himself. Photo departments that used to have six to twenty photographers on staff will now be one- or two-person departments, or six to nine for the largest papers. The director of photography or photo editor will find himself with a camera in hand occasionally, whereas just a few years ago he thought he'd never pick up a camera again.

The challenge facing today's staffers is that they are devaluing their services while the freelance work they do is "gravy" income, and they are building bad habits for themselves and poor expectations for their clients down the line. If, as a staffer, you were doing assignments for \$200 to \$300, your clients that you've established will come to expect those same prices when you are freelance. Remember that now you must cover the costs of equipment, computers, and everything else that your employer was paying that was subsidizing your freelance life. In addition, your subsidized photo rates had a downward effect on photography prices in your community, meaning that everyone has been suffering.

When establishing your salary and benefits, it is fair to start with what you are earning now. In addition, your personal economic equation from mortgage, to car payments, to other expenses is tied to what you've been able to afford up until now, and whatever you can eke out in personal expense reductions will end up being a cushion as you make the transition as smoothly as possible.

Of critical importance will be the reality that you don't want to try to make any major purchases, car payments, new homes, refinancing, and so on for at least two years, maybe three. Bankers want to see a track record of success before they will loan you their money. Although your pay stub was voucher enough for them while you were an employee, what will vouch for you now is your track record of success as illustrated by your tax returns. Most lending institutions want to see your last *three* years' worth of returns. Further, this isn't a lesson you want to learn after you've sold a car or decided to move and put up a For Sale sign.

So, to prolong your staff life, you should be encouraging your DOP to pay freelancers a premium and to allow their images to rightfully belong to them. And, because they can't fall into a workmade-for-hire (WMFH) category, they should be paid for the assignment as one-time use only, and then paid again when there is a reuse. Not only is this the right thing to do, it will affect the longevity of your staff job for a few more years.

Further, when prospective freelance assignments come into the photo desk, since you don't *need* the work to make ends meet (now), charge a rate that takes into account the numerous expenses you would incur if you were freelance and begin developing a client base that places a significant value on the work you do so you can rely on *them* in the future. Of equal importance, they are not calling the paper looking for someone who "maybe" could do the work. As a staffer, you have the imprimatur of a talented photographer. You wouldn't have that same imprimatur in the prospective client's eyes had you not been hired by the paper, and so the notion that they can get a cheap photographer by calling the paper's photo desk should be dismissed as disrespectful of the talent that the paper does have and brings to the community every day.

Chapter 8 Insurance: Why It's Not Just Health-Related, and How You Should Protect Yourself

Insurance is one of the most important things you can do to ensure the longevity of your business. Although you may understand that insurance is important, understanding all the necessary components beyond just health insurance can save you and your business-literally. Insurers will underwrite just about anything for a price. If you are a staff photographer, you have a wide assortment of coverage that you benefit from individually, and then usually your employer carries the necessary insurance for your actions on their behalf. When you are transitioning from staff to freelance, you will need to not only secure these insurance types for yourself, but account for their cost in your overhead. Many freelancers that I know carry what they consider to be the bare minimum-health insurance-and more than a few wing it and carry none. When I ask them why they're not carrying the various types of insurance, their response is uniform across the board, "It's too expensive." If it's too expensive to carry these types of insurance, then you are not operating your business in a sensible or cost-appropriate manner. I won't go into health insurance in depth, but will touch on it briefly because almost everyone seems to understand that it's critical to their own personal well-being. However, the following insurance types are crucial to being successful in the long run, protecting what you've earned, and ensuring the well-being and safety of family members in the event that you can't work anymore.

Health Insurance: Your Client Has It, So You Should Too

If you don't have health insurance, you are playing with fire and you will get burned. One of the secrets of the health insurance industry is that, although you and your insurer are billed the same amount for visits and prescriptions, your insurer is allowed to pay less. This means if you do not have health insurance and you have to get X-rays done of your wrist after falling while carrying your camera, it will likely cost upwards of \$1,000 for the visit, and the hospital will send a bill to either you or your insurer for the same amount. However, when the insurance company pays their standard amount of, say, \$450 for the medical attention you received, the hospital will consider that bill paid in full. For you, until you pay the full amount of \$1,000,

73

they will hound you for every dollar. Although this might seem a tolerable amount, for more serious injuries you could literally find yourself destitute for no other reason than you don't have health insurance. This concept of health insurance is called "accessing network plans," and you'd do well to seek out insurance carriers that can access the local networks of providers, as well as allow you to go out of network for care. If you can't afford health insurance comparable to the one you or your spouse carries (or carried) or one that your parents had, at least get catastrophic coverage, which will have a much higher deductible but will still cover you for the big problems.

Life Insurance: Get It While You're Young, and Protect Your Family Too

One of the types of insurance that is most often associated with the elderly or people in their forties or fifties is life insurance. Although this sentiment is commonplace, as you evolve from your twenties into your thirties, life insurance becomes much more of a necessity. While this (along with health insurance and disability insurance) might not be a business expense—unless you have employees and are offering it to them as well as yourself as an employee of the company—it is important that you include the expense as a part of your salary/benefits needs. Not only should you plan for the expense early, but the earlier you make the expense a part of your monthly personal financial obligations, the less expensive it will be each month. For example, through a combination of good fortune, healthy parents, and a non-smoking/non-drinking lifestyle, my insurance company considered me a low risk, and for a six-figure life insurance policy, I pay less than \$200 a month. As a husband with children, I have significant peace of mind that if the worst were to happen to me, my family would be able to pay the bills and complete their education. Further, my insurance plan includes a tax-deferred savings feature that can be used as a financial tool to assist the business or my family in the event of an emergency or as a retirement supplement.

There are numerous life insurers and types of life insurance. Because I am not an expert on them, I encourage you to seek out the professional advice of a life insurance agent who will help you make the best decision for you and your family. I would, however, encourage you to do a few things on this. The first is to contact an insurance agent who does not represent just one company, but rather multiple companies. Each company has different policy types, and although it may be convenient to use the same company that you use for your homeowner's insurance, auto insurance, or the like (and to obtain discounts associated with doing so), you should work with a professional who spends all of his or her time evaluating policies specific to individual needs. Perhaps, in the end, the benefit of buying a multiple-policy situation through your homeowner's/auto insurer might be the right choice, but you won't know that until you've evaluated your options with a professional. The second suggestion I would make it to have this expense (with other critical expenses, such as mortgage (or rent), health insurance, auto insurance, and so on) automatically deducted from your bank account. This ensures continuity of service and is one less thing you have to remember to pay each month.

Disability Insurance: Think Again if You Believe You'll Never Get Hurt

When you're young, you're invincible. Maybe you don't wear seatbelts in the car, or you take risks that make many older people cringe. However, the odds of your making it to old age without a disability are not insignificant. The probability of disability between the ages of 30 and 60 is 28%, and the odds-makers on this issue are—you guessed it—the insurers. They've got very experienced people—whose official title is *actuary*—who do nothing but analyze risks and determine the probability that when an individual exhibits certain sets of risks, he or she will call upon the financial reserves that the insurance company has. Although it might be obvious to many that a smoker, skydiver, or other risk-taker has a higher probability of disability, healthrelated issues, or life insurance claims, there are numerous other much less contributory risks (city dweller versus country resident, commuter via car versus commuter via mass transit, and so on) that make up your risk. Further, do not assume that your risk is limited to accident or injury. The risk from a disability that results from illness or infirmary is just as great. Heart attacks, strokes, nervous or mental health issues, as well as crippling diseases are the greatest risks to one's ability to earn an income. As a result, insurance companies offer insurance for disability because there is a probability that you will have a need for this service, and your type of job and other factors will be determining factors in what your monthly payment will be. For me, it's around \$500 a year for disability insurance through my membership in a professional organization.

My disability insurance will cover my mortgage and most other household/living expenses in the event that I am disabled and can no longer work or can't work in my current profession. I can't tell you the number of times I walk down a sidewalk at night—especially during the winter when the leaves are off the trees—and get poked in the head by a tree twig. As a photographer, my fear is always that I'll lose an eye, and I panic that the twig that poked me in the cheek could have been two inches higher and poked me in the eye. I worry about an eye infection should I switch from glasses to contacts (which is why I don't wear contacts, since my vision correction is fairly slight), and I worry about other risks to my hands, knees, and mobility—all cornerstones of being a mobilized and active photographer. While I have these worries, they don't overwhelm me because I know that should something go wrong, I will be protected and my family will too.

NOTE

In most states, the income from disability insurance is tax-free. Check with your accountant.

Although disability insurance will provide you with income to pay your bills, it won't cover hospital bills if your disability is severe or if it exceeds health insurance coverage. In this instance, an adjunct to disability and health insurance is long-term care insurance. When you're talking to your life insurance specialist, ask him about this too. For young, healthy individuals, it's a very minimal expense and could well save you from having to sell your home and all your assets before Medicare/Medicaid takes over. Before Medicare/Medicaid kicks in, you must be essentially destitute. Although you'll ultimately be qualified for some kind of care at this point, the burden your family would fall under so that you could qualify for this government aid would be something that you, today, would be unwilling to subject your loved ones to.

Business Insurance: When Things Go Wrong, You Need to Be Covered

I can't conceive that it would be acceptable to operate a business without some level of business insurance, yet friends and colleagues do it all the time. I just think that's plain crazy. In fact, you won't be able to complete assignments that take place in many locations without insurance for reasons I'll go into later in this chapter, in the "Certificates of Insurance" section. You'll have problems obtaining loans, and the risk of you losing your entire business because of a lawsuit or a catastrophic loss of equipment, other assets, or data is just too great. Many photographer-specific policies are available that will cover your business. The following sections discuss the primary insurance types.

Camera Insurance

The most important tools to your business, equipment valued at tens of thousands of dollars, could disappear in an instant. From your trunk, from your shoulders in a bad neighborhood, from checked luggage—it could happen almost anywhere. Almost everyone knows of someone who's had a lens get stolen, "walk off," or just plain disappear. Many people know colleagues who've had all their gear stolen. All of these incidents would have been covered by the proper insurance, except for the "just plain disappear." That one you'll have a hard time explaining, or getting coverage on!

Several years ago, a close friend of mine called me one Sunday from outside of a wire service's offices in Washington. He'd parked next to a church that was across the street from the office to go in and drop off a roll of film from a quick, routine Sunday morning assignment. When he came out, his car had been broken into, and his bag with both bodies, all his lenses, and the like had been stolen. He'd had them covered and was only inside for 10 minutes on a Sunday morning. He was devastated because he didn't have insurance, which meant his considerable talents as a compassionate photojournalist would be put on hold, frozen, until he could save up enough money to buy more equipment. For him, this meant odd jobs and such. I asked about insurance, and he'd let it lapse three or four months prior. In the end, I ended up being his temporary insurance, loaning him the previous generation's bodies and lenses that I had yet to sell on eBay so he could do what he does best—make great photos and earn back his equipment, returning my equipment as he purchased replacement equipment for his stolen gear.

I know of a number of people who carry a homeowner's policy and think that their cameras are covered on that. Some homeowner's policies can allow for a "rider"—a schedule of specific items—for professionally used equipment...at an extra cost, of course. There's a problem: Without that rider, your coverage rarely covers your equipment (the coverage is for hobby cameras, point-and-shoots, and so on, not your work tools), and moreover, they're covered with depreciation. This means if you paid \$500 for a camera three years ago, they're not going to give you \$500; they will amortize that over the life of the camera (say five years) and just give you the depreciated

value of \$200. Although there are numerous other benefits to a professional-level camera insurance policy, one of the regular items in most is "replacement value." So, if you paid \$4,500 for a camera body a year ago, you'll get replacement cost reimbursement for that, and the same will hold true for lenses (which tend to hold their value longer than bodies these days). Understand, though, that if you paid \$4,500 for a camera body, and the actual cost to replace it after price reductions is now \$3,800, you'll get the \$3,800, since that is the current replacement value.

Your insurer will usually provide a combination of coverage types for both photo equipment and other equipment necessary for your business. You'll list the brand and model, along with serial numbers, and the insured value. You can choose what you want to insure from among your equipment. Most major trade associations have some form of photographer-specific insurance, and all plans make it worth the cost of membership just to join so you can get the discounted rates and options available to members. There are numerous reasons to be a member of trade organizations, but if you're looking for an economic justification, the insurance options alone make it worthwhile. As you sell equipment, contact them to remove the items, and as you buy new or updated equipment, contacting them to add the items will ensure that if a loss occurs, you are covered.

Office Insurance

Although office insurance might seem to only make sense if you have an office in a commercial building (in which case, your lease will require it), operating a business even from your home will benefit from office insurance—not to mention if you maintain a studio space. Most office insurance coverage is a component of the camera insurance policy, or in some cases an optional add-on. It covers your computer equipment, desks, office décor, and in more and more policies, the costs to recover data (a.k.a. business records reconstruction) if you lose data due to a crashed hard drive.

List your equipment (laptops, desks, and so on) by serial number and replacement cost. This allows coverage in the event of equipment loss from lightning, theft, or whatever, since little of your equipment, except a desk or laptop, will be covered by your homeowner's or renter's policy. Some office policies have exclusions (flood, hurricane, tornado, or other acts of God), so make sure you know what you are—and are not—covered for. In many cases, you can add on additional protection for a supplementary—often nominal—fee.

Lastly, make a point of doing a biannual review to ensure that as you buy new equipment or take older equipment offline (disposing of it via sale, donation, and so on), you are not carrying items that are no longer assets of the business. Of course, a better tactic would be to add items (especially major ones) as you acquire them for maximum protection.

Liability Insurance

One of the often overlooked benefits of your camera/business policy is the liability insurance that is included in almost all policies. Typically, it's a \$1 million policy. We've extended that for the work we do to \$2 million, which is not a significant additional cost for the peace of mind it brings. Many organizations are now requiring this type of liability insurance before you can shoot for them or on their property.

77

Liability insurance covers you for most accidents or claims brought against you during a shoot (and usually en route to/from it). So if your light stand crashes into a \$200,000 painting in a CEO's office and damages it, you're covered. These incidents sometimes occur, and liability coverage will limit your loss. I cannot imagine operating a business and going out on location without insurance. For many businesses—and certainly the government—you won't be allowed to shoot within their property or purview without proof that you do have insurance and include them in the coverage. So how do you do this? With a "COI."

Certificates of Insurance

A "COI" is a Certificate of Insurance. It is almost always a single-page document that you carry with you (or usually fax/e-mail ahead of time) to the location where you are going to be shooting. The COI not only proves that you have insurance, but also what your limits are. Often a facility or venue where you are shooting will require you to list them as an "additional insured," which gives them a right to be protected under your policy while you are there. In this instance, you'd ask for how they'd like to be listed on the COI, and they would provide their official corporate name or government entity. Then you'd simply e-mail or fax that information to your insurer, and they would generate the proper form and fax one to you and one directly to the location.

In one situation, I wanted to be doing photography at Niagara Falls during the Millennium celebration, which included fireworks. This required a tripod. A call to my insurance agent the day before—late on a Friday—was all that I needed to add the National Park Service's local division to the COI as an additional insured, and I was all set to make my photographs without any problems.

The federal government, many state governments, and even local governments will require a COI from you before you can shoot. There's a place for the information on the forms you'll fill out, as well as a requirement to attach the COI as a part of your permit application. Frankly, private-property owners should always require a COI, and although many do, the majority of them do not know to ask you for it. On more than one occasion, I've used the fact that I carry liability insurance as a tool to secure an assignment. During the dialogue with a client, when I am able to discern that I am bidding for an assignment, I'll make a point of bringing to the client's attention that a COI will most likely be needed, and not only can we provide that, but we do so on a regular basis. I encourage the client to inquire of the other photographers whether they can also provide a COI, knowing that many can't. Further, I come across as prepared and knowledgeable about the shoot requirements, so I have a leg up on my competition. However, on more than one occasion I have been told that "all the other photographers had no idea what a COI was." Access to venues that would have been difficult or impossible to get into has been secured when I, or the client, discussed the needs with the property manager and volunteered a COI, offering to name the location as an "additional insured." It lets the property manager know that they won't be on the line if something goes wrong.

OD	UCE	R {Your insurance agent's and address are listed he		ONLY AND HOLDER. T	CONFERS NO RI HIS CERTIFICAT	D AS A MATTER OF INFO GHTS UPON THE CERT E DOES NOT AMEND, E FORDED BY THE POLIC	IFICATE XTEND OR
				INSURERS AF	FORDING COVE	RAGE	NAIC #
SUF	RED			INSURER A:		surance Company	
		Tohn Hennington Dh		INSURER B:			
		John Harrington	otograpny	INSURER C:			
		John Harrington Ph John Harrington 2500 Rear 32nd St Washington DC 2002	SE 0	INSURER D:			
-		AGES		INSURER E:			
THI AN MA PO	e pol y reg y per	LICIES OF INSURANCE LISTED BELOW HAV DUIREMENT, TERM OR CONDITION OF ANY RTAIN, THE INSURANCE AFFORDED BY THE S. AGGREGATE LIMITS SHOWN MAY HAVE	CONTRACT OR OTHER DOCUMEN POLICIES DESCRIBED HEREIN IS	T WITH RESPECT TO WHICH	THIS CEDTIEICATE M	AV DE ISSUED OD	
R	NSRC	TYPE OF INSURANCE	POLICY NUMBER	POLICY EFFECTIVE DATE (MM/DD/YY)	POLICY EXPIRATION DATE (MM/DD/YY)	LIMIT	8
		GENERAL LIABILITY				EACH OCCURRENCE	\$1,000,000
	х	X COMMERCIAL GENERAL LIABILITY		01/16/05	01/16/06	DAMAGE TO RENTED PREMISES (Ea occurence)	\$ 300,000
		CLAIMS MADE X OCCUR				MED EXP (Any one person)	\$ 10,000
						PERSONAL & ADV INJURY	\$ excluded
						GENERAL AGGREGATE	\$2,000,000
-		GEN'L AGGREGATE LIMIT APPLIES PER:				PRODUCTS - COMP/OP AGG	\$2,000,000
		AUTOMOBILE LIABILITY ANY AUTO				COMBINED SINGLE LIMIT (Ea accident)	\$
		ALL OWNED AUTOS SCHEDULED AUTOS				BODILY INJURY (Per person)	\$
		HIRED AUTOS NON-OWNED AUTOS				BODILY INJURY (Per accident)	\$
						PROPERTY DAMAGE (Per accident)	\$
		GARAGE LIABILITY					\$
		ANY AUTO				AUTO ONLY	\$
1		EXCESS/UMBRELLA LIABILITY				EACH OCCURRENCE	\$
		OCCUR CLAIMS MADE				AGGREGATE	\$
						NOONEONIE	\$
		DEDUCTIBLE					\$
		RETENTION \$					\$
Τ	WOR	RKERS COMPENSATION AND				WC STATU- TORY LIMITS ER	
	ANY	LOYERS' LIABILITY PROPRIETOR/PARTNER/EXECUTIVE				E.L. EACH ACCIDENT	\$
	OFFI	CERVMEMBER EXCLUDED?				E.L. DISEASE - EA EMPLOYEE	\$
4		s, describe under CIAL, PROVISIONS below				E.L. DISEASE - POLICY LIMIT	\$
	OTH						
Vi	de:	ION OF OPERATIONS / LOCATIONS / VEHIC O Production	LES / EXCLUSIONS ADDED BY ENC	KORSEMENT / SPECIAL PROV	VISIONS		
R	TIFI	CATE HOLDER		CANCELLATI	ON		
	-					BED POLICIES BE CANCELLED	BEFORE THE EXPIRAT
						R WILL ENDEAVOR TO MAIL	
		(uch a saway way los - to	ating bind			R NAMED TO THE LEFT, BUT FA	and a second sec
	1	{wherever you're she				Y OF ANY KIND UPON THE INSU	
		needs to be listed he	ere}	REPRESENTATIN	VES.		
				AUTHORIZED REP	PRESENTADE	L	
				Jay	07-0	- State of the sta	

CHAPTER 8

In the end, a COI is a required tool for on-location photographers everywhere. Lastly, more and more hotels and other "rite of passage" event venues are requiring photographers to provide a COI and complete forms about their conduct while on site. I know from experience that even when photographing a friend's wedding, the hotel planner at the Four Seasons in Washington D.C. required me to complete the forms and provide a COI, asking the bride-to-be whether I had insurance and such. If you are (or hope to be) doing events of this nature at large hotels and palatial estates, having the right insurance will ensure that you don't get disqualified just because you didn't have insurance.

A Few Insurance Endnotes

A word about insurance and taxes: First, consult your accountant (see Chapter 9, "Accounting: How We Do It Ourselves and What We Turn Over to an Accountant"), but there are varying degrees of deductibility for health, life, and disability insurance, and the like. Because businesses that offer their employees insurance can deduct that expense of serving their employees, the laws are changing on both federal and state levels about the percentage of deductibility of these insurance expenses. Make sure you are maximizing your benefit by discussing the variety of insurance types with your accountant. Business insurance is deductible, so I see no reason why you shouldn't have it.

Chapter 9 Accounting: How We Do It Ourselves and What We Turn Over to an Accountant

I can't say I know many photographers who enjoy the accounting side of business. In fact, I know more accountants who've left the field to become photographers. There are so many financial transactions to handle—and I'm not even speaking of those who have a large number of invoices. I am referring to the need to track expenses, expense types, vendors, tax records, cash receipts, reimbursement paperwork, and such, before you've even got many invoices to handle. How about those credit card bills—that's just one check to MasterCard, Visa, or American Express, but you've got meals, equipment expense, and numerous other categories of expenses on that one bill. How do you handle all those things? My solution? Accounting software, coupled with a great accountant.

Software Solutions: The Key to Your Accounting Sanity

There are several accounting solutions, from Microsoft Money, to FotoBiz, InView and StockView by Hindsight, and QuickBooks by Intuit. All have their strong suits, and I encourage you to look carefully at all of them to determine which one works best for you, and check with your accountant of choice to determine which he or she uses so you can easily exchange files. Using software, you can track your expenses, bank account balances (many via online integration directly with your bank), credit cards, and cash outlays. Further, by using accounting software, when a lender asks for a profit and loss statement (referred to as a $P \partial L$), a statement of income, or other forms, these statements and reports are mouse-clicks away, and they are accurate (or at least as accurate as the data you put into them). Almost all software solutions are available as 30-day trials or as demos. For my office, our solution for accounting is QuickBooks, which is available for both the Mac and PC. Although we use separate software for estimating, our invoicing, bank accounts, and check writing all take place in QuickBooks. One challenge is documenting every expense you make on behalf of the business, so that you are deducting all those expenses from your taxes and conveying that information to your tax preparer accurately and in a format he or she can understand.

Retain Those Receipts and Don't Give Them to Clients

In Chapter 6, I outlined why we do not release our receipts to clients. I will restate what our policy is again because it's an important point:

Our policy—my policy—detailed on my Web site, is as follows:

We do NOT supply clients with receipts for any expenses. We do this for several reasons:

We are independent contractors, not employees. When tax time comes, the IRS requires us to provide receipts to verify expenses on our Schedule C. The IRS does NOT require you to have those receipts on hand.

It is critical to the success of our business to maintain a proprietary suppliers network—an absolute cornerstone of a profitable business, and in an insecure environment we do not wish our competitors to learn who our suppliers are. While this is less applicable on film and processing than on unusual items, and from time to time applies to assistants as well, it is nonetheless critical throughout our supplier chain.

We have a set fee per amount of supplies used, regardless of what was actually paid for them. This is done for several reasons: 1) We keep film on file to meet last-minute and unusual requests, therefore we sometimes discard film that does not meet our technical expectations or that has been through several passes of an X-ray machine, and this cost must be split across the cost of actual film shot; 2) time is taken to investigate new films and test films before they are used in shoots, and due to the time taken to go to the various suppliers we use and to maintain the stock necessary, the cost for this time, billed by staff, must be spread across the cost per roll.

By way of example, publishing houses do not request receipts from printing plants for the cost of ink and paper, nor receipts for the wholesale prices paid on the repair of copiers, nor gasoline receipts from the delivery service who delivers the copies of the magazine.

Please discuss with us any issues you have with this policy beforehand.

And our updated version is:

We have a set fee for delivery services regardless of what was actually paid for it. Examples may include delivery—sometimes delivery services must make second attempts, and we cannot know of these additional expenses until 30+ days beyond an assignment, which must have been billed before we receive the actual bill, or other surcharges may apply. We stipulate delivery charges to avoid this paperwork. Post-production: We allocate our post-production vendor's services over set periods of time, based upon image counts, and outline that expense to you. We pay a set figure to them for each day's work, and that workload is not delineated by the job where hours are allocated to each job. Further, we may work with our vendor to investigate new production techniques, from plug-ins that produce superior raw-to-jpeg conversions, to other services that benefit you, the end client. The cost for this time, billed by staff, must be spread across our assigned fees per assignment.

By way of example, publishing houses do not request receipts from printing plants for the cost of ink and paper, nor receipts for the wholesale prices paid on the repair of a copier, nor gasoline receipts from the delivery service who delivers the copies of the magazine.

Please discuss with us any issues you have with this policy beforehand.

One of the issues is that the IRS wants *me* to keep the receipts—the originals. Photocopies make the IRS think that maybe you *and* another business used the same receipt. The following information is from the IRS Web site:

The following are some of the types of records you should keep:

- Gross receipts are the income you receive from your business. You should keep supporting documents that show the amounts and sources of your gross.
 - Cash register tapes
 - Bank deposit slips [bank statements and copies of the deposit slips]
 - Receipt books
 - Invoices
 - Credit card charge slips
 - Forms 1099-MISC
 - Purchases are the items you buy and resell to customers. If you are a manufacturer or producer, this includes the cost of all raw materials or parts purchased for manufacture into finished products. Your supporting documents should show the amount paid and that the amount was for purchases.
 Documents for purchases include the following:
 - Canceled checks [the IRS accepts photocopies of checks from the bank, instead of the actual check, as proof of payment]
 - Cash register tape receipts
 - Credit card sales slips
 - Invoices

• Expenses are the costs you incur (other than purchases) to carry on your business. Your supporting documents should show the amount paid and that the amount was for a business expense. Documents for expenses include the following:

- Canceled checks
- Cash register tapes

continued

- Account statements
- Credit card sales slips
- Invoices
- Petty cash slips for small cash payments
- Travel, transportation, entertainment, and gift expenses.

If you deduct travel, entertainment, gift, or transportation expenses, you must be able to prove (substantiate) certain elements of expenses. For additional information on how to prove certain business expenses, refer to Publication 463, Travel, Entertainment, Gift, and Car Expenses.

- Assets are the property, such as machinery and furniture, that you own and use in your business. You must keep records to verify certain information about your business assets. You need records to compute the annual depreciation and the gain or loss when you sell the assets.
- Employment taxes

There are specific employment tax records you must keep. Keep all records of employment for at least four years. For additional information, refer to Recordkeeping for Employers.

For more information, refer to their Publication 583, which is available on the IRS.gov Web site. One note about receipts—official, original receipts are not required for expenses less than \$75. However, you must have a self-written note detailing the expense, what it was for, who was paid, how much, and the date of the expense. To be safe, include why—something like "batteries from street vendor for flash," if that's what you just purchased. The note should be timely for best proof—that is, a note made at the time the expense was incurred. Notes made after the fact are less persuasive.

If you are doing business with the federal government (and some state governments), they will require original receipts for travel-related expenses. Be sure to spell out your policy and consider whether you're willing to make an exception to your policy for these clients.

As for just how long you must keep your receipts, some guidance states three years and some states seven years. In some rare cases (such as an ongoing audit), the requirements are even longer. Further, your insurance company or a lender might require receipts for longer than the IRS, so be certain you remain in compliance with their policies. However, it's important that you recognize the liability of keeping receipts too long. Statutes of limitations on audits can get confusing, so it is best to consult your own tax expert on this subject. That said, here's the lowdown: The statute of limitations for IRS audits is three years unless greater than 25% of gross income is omitted—then it is six years. In the case of fraud, there is no statute. Understand, though, if you do have receipts that go back 10 years and you are audited for a tax return from three years ago, if you say something during the audit such as, "I've been taking that deduction for the last 10 years" and you have your records, the IRS can require them. In a case

such as this, your own records may increase your tax audit liability if fraud is found. We'll talk more later in this chapter about why your accountant should be representing you in the unfortunate situation that an audit occurs.

Reimbursing Yourself: Say What?

Your business and personal expenses are, and should remain, separate. Any time you make a personal (or any non-business) purchase with a business check or your business credit card (and you'd better do this only once in a blue moon), or you withdraw money from an ATM connected to your business' bank account, it is essentially the same as if you owned a brick-and-mortar storefront business, and you walked up to the cash register and removed that amount of money in bills. At the end of the day (or month or certainly year), the business will require you to either document that expense as a "draw" or provide receipts showing that the removed money was used for business purposes.

Here's how I handle this. Suppose I go to the ATM and withdraw \$200 from the business account on February 5. Initially I classify this as a draw, until such time as I have receipts in hand for those expenses to validate that they are business expenses. Suppose that in June I have some downtime and a collection of receipts from the beginning of the year for cash expenses (parking, taxis, small office supply purchases, and so on). Hopefully I have noted on parking receipts the assignments each one correlated to; however, if I've not done that, it is easy to track an assignment or business-related trip into downtown by date and time, and then validate that as a business expense. Suppose my receipts subtotal \$86 for five garage expenses in January, \$18 for three cabs, and \$46.20 for the office supply store purchase. This totals \$150.20. I would take a blank piece of paper and attach all the receipts in groups by type, note the totals for each group, and handwrite a note on it about when I was "reimbursed" for the expense: "Reimbursed by ATM withdrawal on 2/5." However, this leaves \$49.80 unaccounted for. This I treat as a draw, so I would note on the piece of paper "Draw: \$49.80." I would then go to the line item in my accounting software, "split" the line item, and assign each subtotaled amount to the correct expense category, including the line item for a draw. I would then file the piece of paper with the receipts under "petty cash reimbursements" in my tax records folder for the current year. Now my accounting software has an accurate accounting of what it had previously listed as a draw, I am properly reimbursed for my business expenses, and whatever unaccounted-for amount between the receipt total and the ATM total becomes a draw. Often I am able to get within \$10 of the ATM total.

Another example would be if a spouse made a purchase on the business' behalf or you had to use a personal credit card for a business expense (again, this should be once in a blue moon). In this case, suppose the expense was for \$350—maybe a new flash that either you bought en route to an assignment because yours had broken, or perhaps your spouse was out running errands and you called to ask her to pick up your lab order. In both cases, suppose a personal credit card (or check) was used. There are two ways for you to be reimbursed. The first would be for the business to issue a check to you or your spouse for the exact amount, with the receipt filed with the business expenses. In this instance, I would again attach the receipt to a blank sheet of paper and note the details of the expense. Most importantly, I would record that it had been purchased with a personal check or credit card, and I would then note how it was reimbursed: "Reimbursed via check #12345 on 6/6" or "Reimbursed by ATM charges on 3/6 — \$200, 3/19 — \$100, 4/15 — \$100, balance of \$50 listed as draw." I would then go in and classify check #12345 as the proper account for the expense type (equipment purchase or lab processing). For the ATM, I would classify the first and second ATM withdrawals as the correct account type, and then the third would be listed as \$50 for that expense type and \$50 as a draw.

Although the reimbursement via check is the cleanest and fits the "best business practices" bill, in the end every photographer I know uses the ATM when he or she needs to. If you're not listing these as a "draw," you've got to list them as something, and I find this to be an effective way for me personally, and my business, to handle cash expenses between us.

Separate Bank Accounts: Maintaining Your Sanity and Separation

One of the first things your accountant will tell you is that you and your business must have separate bank accounts. In the event of an audit, the IRS takes a dim view of "co-mingled" funds and expenses, and it's just a bad business practice to keep both accounts together. Further, when bank fees are charged to you—monthly maintenance fees, bounced check charges, and the like—when the account is strictly for business purposes, those bank fees are a deductible expense. If the accounts are co-mingled, then allocating what part of the fees are personal and what are business is next to impossible, and to be safe, you'd do well to attribute those fees as a nondeductible expense. One new solution is to change from writing checks to many companies you do business with, and instead use a debit card, which is handled by the store as a credit card, but debits your account for the exact purchase amount.

Lastly, you'll be getting checks made payable to your business, not you. For me, clients cut checks to my business—John Harrington Photography—and I have a "dba" on my business checking account. My bank classifies this as a personal account (in other words, it's handled not by the bank's business division, but by their consumer division). This was the original account I used when I started business, and I was able to add the "dba" (which stands for "doing business as"), which allows me to deposit into that account checks made payable to me—John Harrington—when a client cuts the check just in my name (although I try to avoid this happening), as well as checks made payable to John Harrington Photography. If you don't have a "dba" on your account, you won't be able to deposit checks made out to your unincorporated business.

When you are trying to balance or reconcile your bank statements every month, knowing for sure that all the checks and deposits to that account are business-related gives you piece of mind. It also means that your spouse won't be writing a check that drops your account total below what you thought you had, so that you inadvertently bounce a check to a vendor, and as a result they put you on a C.O.D. basis for a period of time, plus charge you a large bounced-check penalty (consistent with their policy).

Separate Credit Card: Deducting Interest Expense and Other Benefits

Just as with separate bank accounts, a credit card is a form of a loan, and keeping loans for the business separate from loans for personal uses is critical to maintaining a proper accounting system. One of the big reasons is that, for credit cards, if all your expenses are business-related and for some reason you don't pay off the bill in the same month, or if you incur a large expense, knowing you will have to pay it off over two months, the interest expense for that carried-over balance is deductible because all the expenses on the card are for the business. If you had personal purchases on the card, allocating the interest to the personal and business expenses properly would be a nightmare and not worth the time or hassle. Further, you can deduct the annual credit card fee as a business expense as well.

Further, if your business is incorporated as an LLC or LLP, your accounting will require separate cards. In some cases, you'll be able to get a credit card with your name, the businesses name underneath it, and your business' federal ID number (which is your business' "social security number"), so that should your business go deeper into debt or carry balances, there will be a limited effect on your personal credit. This is not a way to avoid or work around repaying your debts; rather, it is a method to properly allocate liabilities and credit lines to your business.

A note about your federal ID number, also called your EIN or *Employer Identification Number* you should have one. They're free, and you can apply online (via IRS form SS-4) at:

https://sa.www4.irs.gov/sa_vign/newFormSS4.do

More information about EIN's can be found at:

http://www.irs.gov/businesses/small/article/0,,id=102767,00.html

Part of the application process—for sole proprietors (like me)—requires you to submit your social security number, so the IRS has a cross-reference between you (personally) and your business.

Now, when you have a credit card bill for \$3,456.24, you write a check for that amount, but how do you accurately allocate that single expense to the proper categories in your accounting software? You can't just call it "office expense" and be done with it. Expenses such as dining/entertainment are deducted differently than a gift for a client, flowers for a client or business-related person, large equipment purchases that may need to be amortized, office supplies, and the like. Here's how I do it.

Every month I get a statement, and I go through it, classifying every expense by its expense type. I created the Statement Breakdown form in Figure 9.1. Suppose, for example, that there are six charges for gas. A handwritten notation next to each charge on the statement is made with the legend item C, and they are totaled and entered into the third line of the form: Auto-Gas (200-02). This continues for the entire statement. The most common categories are on the form and corresponding legend, but there's room for the occasional odd charge under "Other."

John Harrington Photography—STATEMENT Breakdown	John Harrington	Photography	-STATEMENT	Breakdown
---	------------------------	-------------	------------	-----------

Credit Card Last 4 Digits:	Statement Closing Date:
Total Amount Paid:	Date Paid:

Does amount paid represent complete payment

Category breakdowns for tax purposes	Amount	Statement paid on	Split? (Y/N)
Advertising (100)			
Portfolio (100-01)			
Auto – Gas (200-02)			
Auto – Repair (200-03)			
Auto - Parking/Tolls (200-04)			
Auto – Other (200-05)			
Telephone – Local (300-02)			
Telephone – Long Distance (300-03)			
Telephone – Cellular (300-012) (AT&T Wireless)			
Contractors/Photographers (352)			
Dry Cleaning (400)			
Dues & Subscriptions (500) (WHNPA, ASMP, DIRECTV, Publications, etc.)			
Education (600)			
Photo Equipment—Supplies (700-01)			
Photo Equipment-Repairs (700-02)			
Photo Equipment—Purchases (700-03)			
Leasing (700-04)			
Interest Expense (900) (Finance charges on statement)			
Office Equipment (1000-01)			
Office Supplies (1000-02) (Staples, Office Depot, etc.)			
Couriers (1100-01)			
(Scheduled Express/Speed Service)			
Overnight Delivery (1100-02) (Airborne, FedEx)			
Postage—Other (1100-03)			
Online Services (1200-01)	TOTAL:		
—Palmnet	1		
—CS Online	1		
-AOL	1		
—Pair Networks			
Security (1300)			
(ADT) Travel & Entertainment—Gifts (1600-01)			
Travel & Entertainment—Dining (1600-03)			
(Out of town/in-town restaurants) Travel & Entertainment—Entertain. (1600-04)			
Travel & Entertainment-Lodging (1600-05)			
Travel & Entertainment—Taxi/Tolls/			
Parking/Metro (1600-06) Travel & Entertainment—Train/Air (1600-07)			
	L		

Category breakdo	wns		Amount	Statement	Split
for tax purposes				paid on	(Y/N
Travel & Entertainment-Of		ls			
(100% Deductible) (1600-09					
E-6 Film Purchase (4000)					
C41 Film Purchase (4100)				
B&W Film Purchase (420	0)				
Film Processing (4500)					
(MotoPhoto/Black&White/Ca					
FOR ANY EXP					
USE THE "O			GORIES	BELOW	1
Other:	()			
Other:	()			
Other:	()			
TATEMENT TOTAI DRAW TOTAL:			_		
3000)			-		
BUSINESS TOTAL:			_		
LEGEND					
4	.Adver	tising			
3					
3					
)					
3			g/Tolls		
1					
3					
I				ance	
	. Contra	ctors/F	hotograp	hers	
ζ					
			scriptions		
M					
1	Photo	Equip	.—Suppli	es	
)	Photo	Equip	-Repair	s	
•	Photo	Equip	-Purcha	ases	
)	Leasin	ng			
ξ	Intere	est Exp	ense		
3	Offic	e Emi	pment		
•					
J			1103		
			Daliwar		
V					
V					
ζ			/ices		
٢	Secu	rity			
7	Trav	el & E	nter.—G	ifts	
	Trav	vel & E vel & F	nter.—G	ifts ining	

....T&E-Taxi/Tolls/Pkg/Metro ... Travel & Enter.—Train/Air ... Travel & Enter.—Office Meals E-6 Film Purchase C41 Film Purchase ç .B&W Film Purchase Film Processing

Λ

Travel & Enter.-Lodging

Figure 9.1

88

Lastly, I ensure that the total in the Statement Total field matches the actual statement total from the credit card receipt. On the rare occasions when there is a personal charge on my business card, that total amount is listed in the Draw Total field, and then the final business total is entered in the Business Total field.

The Payment Breakdown form (see Figure 9.2) is identical to the Statement Breakdown form. Each payment is broken down and paid against the statement from the previous month, except when I am paying for a carried-over balance from months prior. Here is a simplified example.

Suppose in March, I charge \$300 on my credit card. Two-hundred dollars of that was for office equipment (a printer), and \$100 of that was for education (a seminar on lighting). The Statement Breakdown would have just those two totals in the Amount column on the form.

When I receive my March statement in April (mine closes around April 6 for all March charges, and comes in the mail around April 9), I want to pay the \$300 in full, which I do. I then complete the Payment Breakdown form, indicating which card I used, the date of the payment, and a reminder to myself about whether this was a payment of the entire balance (more on that in a moment). This payment, made in April, say on April 21, will appear on my April statement, which I will receive on or about May 9, having closed on or about May 6. I will attach the Payment Breakdown for \$300 to the month on which the payment appears—in this case, on the April statement that I received in May. This validates that the payment applies.

I will then enter this into the line item in my accounting software, which only reads Credit Card Payment, and I'll split the payment for \$300 into the correct categories in the software. There is now not only a paper trail from the software to the payment, but another one from the payment to the corresponding statement. Further, I have the actual charge receipts filed as well.

Now imagine another scenario. In September, I purchase a lens for \$1,000, and it appears on my September statement, which arrives at the beginning of October. It says "Minimum payment due — \$150." In October, I charge another \$1,500 for a new computer. On October 20, I make my minimum payment for \$150 and carry a balance of \$850 over into October. My October statement will arrive in the beginning of November and will have the new charge for \$1,500, the carryover balance of \$850, plus an interest charge of around \$45, for a total of \$2,395. I will have completed a Statement Breakdown for the September statement that includes the single item in the Photo Equipment — Purchases category and a Statement Breakdown for the October purchase of \$1,500 in the Office Equipment category, as well as a \$45 total in the Other line, which I will hand notate as Interest Expense.

I will then complete a Payment Breakdown form for the \$150, paid on October 20, and assign that to a portion of the \$1,000 charge. I will enter a Yes in the Split column. This is an indication to me that I have had to split a payment between two months, and I will check the No box on the line "Does amount paid represent complete payment of balance due?" I will attach this Statement Breakdown to the statement on which it appears—the October statement.

When I make my payment for \$2,395 to pay off both months, I will transfer the \$1,500 and \$45 figures appearing on the October statement to that Payment Breakdown form, and I will also include the \$850 balance from the previous month. In the Statement Paid On column, I will enter Sept, and then another Yes in the Split column. This payment will appear on the November statement I get in December, and thus will be attached to that statement.

John Harrington Photography—PAYMENT Breakdown

o on in the the ton I not of the h	
Credit Card Last 4 Digits:	Statement C
Total Amount Paid:	Date Paid:
Deer smart stil some to state the	

ent Closing Date:

Does amount paid represent complete payment of balance due? Yes_____ No___

Category breakdowns for tax purposes	Amount	Statement paid on	Split? (Y/N)
Advertising (100)			
Portfolio (100-01)			
Auto – Gas (200-02)			
Auto – Repair (200-03)			
Auto - Parking/Tolls (200-04)			
Auto - Other (200-05)			
Telephone – Local (300-02)			
Telephone – Long Distance (300-03)			
Telephone – Cellular (300-012) (AT&T Wireless)			
Contractors/Photographers (352)			
Dry Cleaning (400)			
Dues & Subscriptions (500) (WHNPA, ASMP, DIRECTV, Publications, etc.)			
Education (600)	_		
Photo Equipment—Supplies (700-01)			
Photo Equipment-Repairs (700-02)			
Photo Equipment-Purchases (700-03)			
Leasing (700-04)			
Interest Expense (900) (Finance charges on statement)			
Office Equipment (1000-01)			
Office Supplies (1000-02) (Staples, Office Depot, etc.)			
Couriers (1100-01)			
(Scheduled Express/Speed Service)			
Overnight Delivery (1100-02) (Airborne, FedEx)			
Postage—Other (1100-03)			
Online Services (1200-01)	TOTAL:		
Palmnet			
CS Online			
-AOL			
—Pair Networks			
Security (1300)			
(ADT) Travel & Entertainment—Gifts (1600-01)			
Travel & Entertainment—Dining (1600-03)			
(Out of town/in-town restaurants) Travel & Entertainment—Entertain. (1600-04)			
Travel & Entertainment-Lodging (1600-05)			
Travel & Entertainment—Taxi/Tolls/ Parking/Metro (1600-06)			

Category breakdowns for tax purposes		Amount	Statement paid on	Split? (Y/N)		
Travel & Entertain (100% Deductible		Mea	ls			
E-6 Film Purcha	se (4000)					
C41 Film Purcha	ise (4100)					
B&W Film Pure	hase (4200)					
Film Processing (MotoPhoto/Black		colo	r)			
FOR	ANY EXPENS THE "OTHE	ES	NOT			
Other:	THE "UTHE	()	EGURIES	DELUW	
Other:		()			
Other:		()			

STATEMENT TOTAL:

DRAW	TOTAL:
(3000)	

BUSINESS TOTAL:

LEGEND

AAdvertising
BPortfolio
CAuto-Gas
DAuto-Repair
EAuto-Parking/Tolls
FAuto—Other
GTelephone—Local
HTelephone—Long Distance
I Telephone—Cellular
JContractors/Photographers
KDry Cleaning
LDues & Subscriptions
MEducation
N Photo Equip.—Supplies
O Photo Equip.—Repairs
PPhoto EquipPurchases
QLeasing
RInterest Expense
SOffice Equipment
TOffice Supplies
UCouriers
VOvernight Delivery
WOther
XOnline Services
YSecurity
ZTravel & Enter.—Gifts
2 Travel & Enter.—Dining
3 Travel & Enter. Entertainment
4 Travel & Enter.—Lodging
5T&E—Taxi/Tolls/Pkg/Metro
6Travel & Enter.—Train/Air
7 Travel & Enter.—Office Meals
8E-6 Film Purchase
9C41 Film Purchase
*B&W Film Purchase
#Film Processing

Figure 9.2

When I go to enter the splits into the payment in my accounting software, I will make a note in the Memo field of the fact that the Photo Equipment category was paid on the September statement.

Although at first this might seem somewhat confusing, it ensures an accurate categorization of all charges on my credit card to the appropriate expense categories. Once you get into the habit of using the system every month, it becomes easier. Further, I make a point of using my credit card for every possible expense because it ensures that I won't lose a receipt or forget about an expense—doing so would mean a lost deduction, and thus I would end up paying more in taxes unnecessarily. Because I pay off the card every month, the convenience of writing fewer checks for subscriptions, cell phone bills, and the like without any interest expense means less time paying bills and a better accounting of my expenses.

A note about the numbers that appear between the parentheses for each item: These are accounting codes, which you can self-assign to the various expense types. All major businesses use accounting codes, and I wanted to mimic this methodology. So, all office related purchases are "1000-xx," where "xx" is a subcategory, and all photo equipment expenses are "700-xx," for example. Each accounting software package handles these codes slightly differently and has information in the software manual about to how to use them, but using them will make it easier for you to track expenses. Also, when entering the splits categories, the software recognizes both the name of the expense type and the code number, which means a faster and more efficient time doing your splits.

As with all forms in this book, feel free to use and adapt these forms to your business.

When to Call an Accountant (Sooner Rather Than Later)

If you are operating a business, you need an accountant. It's that simple. I could just end this section with that statement alone, but I won't. You are a professional photographer, you know all about lighting and f-stops, and you find yourself frustrated when you lose an assignment because a client says, "Oh, I have a friend who is shooting it as a favor," or "We're just going to send someone from the office with a camera." For rites-of-passage photographers, the killer line is "There's an uncle who has a camera and can take photos, so we're saving money by just having him shoot some photos." Aaaarrrgggghhhh! You *know* the results will almost certainly be unsatisfactory, if not downright terrible. Unfortunately, they won't know that until it's too late.

If you know this, then you'll want to apply the same mentality to your tax preparation. You can spend a whole lot of time teaching yourself about all the forms, allowable deductions, limits on deductions, changes in tax law, and the like. Or, you can hire a professional to do it. I recommend that route. Further, your accountant can tell you how much to put away for retirement each year based upon your taxable income and advise you when you have a question about taxes. An accountant is an indispensable resource.

Every accountant has a different pricing structure, and your mileage may vary; however, for significantly less than \$1,000 a year, my taxes get completed, including my Schedule C, student loan expenses, mortgages, childcare and medical deductions, income from investments, and

several other factors. In other words, my taxes could never be done on a 1040EZ form—what I file approaches 1/3" thick each year. Further, my accountant advises me as to how much of that expense is personal (which I pay with my personal credit card) and how much is related to the preparation of the business aspect of my return (which I then charge to my business card).

Now, a word on "tax preparation services." They're good for some folks, but I'd strongly discourage their use for a business. You are building a relationship. You don't want a different tax preparer each year; you want the same person. I have been with mine for almost 15 years, and he keeps track of amortized expenses from year to year, knows me and my business, and asks intelligent questions about how I can save more and earn more. He also advises me of smart (and honest) ways to minimize my tax liability. I can get a copy of my return from four years ago if necessary, and when I have a question, I can call. Depending upon your relationship, that call may well carry a charge for the accountant's time, but it won't be much, and it's certainly a worthwhile expense. Further, in the event of an audit, your accountant can represent you during the audit and will know whether it is necessary to engage the services of a tax lawyer. If the error turns out to be the accountant's fault, although the tax liability will be yours, the accountant will most likely cover the costs of the audit (in other words, their time and possibly your penalties). Also, having an intermediary between you and the IRS will surely minimize the possibility that your audit over one or two questions about an item will become a full-blown audit. Your accountant is a professional; he or she won't take questions personally from the auditor and will know and look out for your rights during an audit.

To find a tax accountant, ask around. Ask your colleagues or a vendor or client whom you do business with. Although there are many "Smith, Jones, Doe, and Steptoe, LLC" firms, I encourage you to look for a one- or two-person shop. (Besides, Smith, Jones, Doe, and Steptoe, LLC doesn't exist; I made it up.) I feel like I get better service from the guy whose name is on the door, as opposed to an "accounting associate." Ask potential accountants whether they've ever worked with a photographer before—or with someone who may be receiving royalties, and how that income should be handled. Do they do many self-employed sole proprietors, or just the corporations, LLCs, and LLPs?

Lastly, an accountant can and will sit down with you and go over budgets and cost-saving solutions. The role the accountant is fulfilling in this capacity is financial advisor or financial planner, and he or she should be certified as such. The notation "CFP" in an accountant's business name (or his or her name) usually is a good indicator that the accountant has the added expertise that can help you with long-range planning—both for you personally and for the business.

What is a CPA? How is a CPA Different from a Bookkeeper?

A CPA is a Certified Public Account. CPAs are licensed to practice public accounting and must meet specific educational and experience requirements and pass Board examinations, similar to an attorney or physician. Typically, a baccalaureate degree concentrating on accounting, combined with approximately two years or 4,000 hours of experience in the public accounting field will qualify you to take the examination to become a CPA.

NOTE

Each state is different, and the state is the body that issues CPA licenses. The key is that the accountant is licensed/certified.

As a CPA, your accountant is licensed to be in business as an accountant, has more experience, and participates in continuing education (which varies by state, but is typically 40 hours per year) to ensure that he or she is serving you best. Further, certain auditing, accounting, and reviews can only be undertaken by a CPA. A CPA will have broader experience working with attorneys and agents, as well as personal and business financial planning. If you can't get a referral, begin by looking for a CPA at the CPAdirectory Web site (www.CPAdirectory.com). Locate several candidates near you and meet with them. Ask questions and ask for references. In addition, there is a wealth of resources at the CPAdirectory Web site about software and other accounting-related questions.

In contrast, in many small businesses, a bookkeeper is not an accountant, nor a CPA. In my business, I have an office manager who, among her other duties, fills the role as bookkeeper. Her job it is to generate estimates and send invoices to clients, pay bills for the business, follow up on unpaid invoices, enter in the splits for credit card payments, and generally use our accounting software from day to day. As my business grew, I trained her to do each of the things I was doing myself, one at a time, and sent her off to learn more about the software. I work closely with her about all things related to the financial aspects of the business. She does not have signatory authority on my checks—that's my check on the work she does. But she does most other things, and I trust her implicitly—otherwise, she wouldn't be doing what she's doing. As your business grows, you might ask someone you've brought in to first do estimates when a client calls and you're out. Then, that may grow to sending invoices, and then to paying your bills. Before you know it, you'll have a bookkeeper too.

Part III

Legal Issues

Chapter 10 Contracts for Editorial Clients

Editorial contracts run a very wide gamut in terms of rights needed, rights demanded, prices paid, and numerous other seemingly egregious demands by publishers. In the end, there are far more disagreements—many of them public—over rights grabs and low-paying publications. Yet, a contract is defined as a "meeting of the minds." It is an agreement between two (or more) parties who have a transaction they wish to make to either do (or not do) something. Examples of the "not to do" things would include farmers paid by the government not to farm a particular crop on their land, or an agreement not to disclose where (or how) a photograph was made, or that it was ever made at all (often called a *non-disclosure agreement*).

When you are entering into a contract, it is important that you not only understand what the contract says you and the other party or parties *will* do (for example, "I will take photos for you" and "When I receive the photos you made for me, I will pay you"), but also that you understand what each of you will *not* do. If the contract specifies that you agree to embargo photos for 90 days from the date of publication, then you must not allow them to be published during that term. If the contract specifies that the client pay you on receipt of the images (as opposed to paying upon publication), and that they cannot use the photos again without additional compensation to you, then they must pay upon receipt and not use the photos again without compensating you.

The contract often spells out what happens in these cases. When you are contacted by a publication, they might attempt to send you their contract. That's like you presenting your own contract to the mechanic who's going to work on your car or a lab who's going to process your film. In both cases, the mechanic and lab will most likely refuse the contract. They have their own paperwork, and they feel protected when you sign it so they can do the work you need. You, too, should be the one sending out the contract.

Further, as you begin to negotiate contracts, you must understand what you're negotiating. If you don't understand what a package of rights is or the extent to which you are granting rights, then you need to know these things—and their ramifications—before you agree to them.

"We'll Send Along Some Paperwork": Why You Should Be the First to Send the Contract

You should be sending the contract simply because it's easier for you to agree to negotiated changes in your contract than it is to amend, delete, and otherwise revise the client's contract, which is no doubt geared to the client and written under the laws of the state in which the

company is based. Because the work is being performed by you, and you were solicited in your state, and often the work is in your state, not only is your contract language the most likely to hold up in your state, but you also won't be subject to the laws of a state you're not familiar with, nor would you have to travel there to litigate a dispute if one should arise.

As a conversation is concluding about my availability, fees/expenses, and the creative aspects of the assignment, the first thing I do is state, "Okay, let me put together some numbers, and we'll send along some paperwork for you to review. Let me know if you have any questions, and I look forward to working with you on this assignment!" It's an upbeat and positive way to wind the conversation down. On occasion, they might say they have an assignment sheet they need to send, or some other paperwork of theirs. Often it's just their standard assignment sheet, not a contract, and it might be a W-9 form for me to complete. In some instances, it's their "standard" contract. I'll review it to see what they're thinking, but rarely do I sign it. They've sent me their contract as a set of "proposed" terms under which I might consider working. I instead send along my standard contract, with terms under which I am going to be most comfortable working.

There are cases where what they've sent includes objectionable terms, such as:

- Photographer agrees that this assignment is "work made for hire."
- Photographer consents to the reuse of assignment images in future issues without additional compensation.
- Photographer shall save and hold harmless publication in the event of a claim arising out of the assignment or use/misuse of images by publication or a third party.
- Photographer acknowledges that publication may grant reprint rights to the story to interested third parties, and agrees that in such an instance, where the story is reprinted, no additional payments are made for such reprints to photographer.
- Photographer agrees that this assignment is speculative in nature, and publication shall not be obligated to pay anything should publication opt not to use any images.
- Photographer shall deliver all original receipts, for which actual expenses shall be reimbursed without any markup, and photocopied receipts or expense items for which no receipt is provided shall be rejected.

When they include such terms in their contract, I know and anticipate that my contract might be met with some objections, and I prepare for the conversation and the potential that I might not be chosen to do the assignment. In many cases, our contract comes back signed, without changes, and we complete the assignment even when their proposal included those objectionable terms (and many others I've seen).

In some instances, there are negotiated points in the contract. Some of their responses/ objections are:

- We can't pay an interest charge if there is a late payment.
- We can't pay within 21 days; we pay within 30 (or 45) days.
- We pay on publication.

- We credit photos in the back of the magazine, not adjacent to the photo.
- ▶ We can't pay \$x for post-production; our maximum is \$y.
- We can't have a second assistant on any shoots.
- We have an arrangement with a preferred shipper; I need the CD shipped with our account number and shipper.

These are all negotiable portions of the contract. Some are stylistic (photo credit location), some are accounting policies (pays in 45 days, not 21), and some begin to interfere with the creative options on an assignment where the shoot is outdoors with large softboxes and equipment (no second assistant). However, in the end, I am amenable to a number of solutions that would resolve their concerns while still offering terms with which I am comfortable.

If your contract has 21 terms and theirs comes to you with 10, and there are only two or three of their ten that are substantially similar to yours, you'll end up striking seven or eight of their terms, and then adding in 18 of your own. In such cases, negotiation back and forth can become more of a challenge than it should be. It'll be an uphill battle from the beginning. However, if there are only a few changes that need to be made to yours to make it amenable to the client, then it will be easier to work past those issues.

There are some organizations who have decided that it's their right to issue iron-clad, nonnegotiable contracts, purportedly that every single photographer who's ever worked for them (or ever will) must sign, or there will be no work from them. Sometimes, the contract comes after a last-minute assignment has been completed. To address the non-negotiable aspect: In a worstcase scenario, a photographer has a single publication as their only client, and a new contract foisted upon him or her without any warning, consideration, or consultation places the photographer in a precarious position that will always have the photographer get the short end of the deal. A contract that has no negotiable terms is termed a *contract of adhesion*. Although this type of contract might be suitable for insurance companies—in the end, courts often rule against the insurance company when there is ambiguity in the terms or language—it is neither suitable nor fair for any offering of a photographic nature.

Law.com defines "adhesion contract" as follows:

n.(contract of adhesion): A contract (often a signed form) so imbalanced in favor of one party over the other that there is a strong implication it was not freely bargained. Example: a rich landlord dealing with a poor tenant who has no choice and must accept all terms of a lease, no matter how restrictive or burdensome, since the tenant cannot afford to move. An adhesion contract can give the little guy the opportunity to claim in court that the contract with the big shot is invalid. This doctrine should be used and applied more often, but the same big guy-little guy inequity may apply in the ability to afford a trial or find and pay a resourceful lawyer.

This sounds remarkably like many a proposed editorial contract from a major publishing conglomerate. Little known, however, is what some photographers have changed in their contracts with these publishing houses. In some instances, when contracts are changed to be more balanced (in other words, fairer or better paying), a clause can be included, as noted in the beginning of this chapter, *not* to do something—namely disclose that the photographers have a contract that is not the same as the rest of the contracts that photographers are publicly objecting to.

What an Editorial Contract Must Have

As noted earlier, a contract is "often" signed. For me, all contracts must have my signature and the client's signature. Although a verbal contract is just as enforceable and binding as a written one, the problem with a verbal contract is that people have different recollections of what they agreed to, from rights granted, to allowable expenses, to numerous other issues. The devil is in the details. It is my policy that an assignment is not undertaken without receipt of a signed contract from the client. This alone alleviates almost all disagreements about what was agreed to, with the exception of the client who, when presented with an invoice for \$2,300 for an assignment that was originally estimated at \$1,500, states, "I didn't know that when you called to say that the shoot had to be cancelled and rescheduled for two days later because of a torrential downpour, I would incur an \$800 weather day charge. I didn't read the contract." Now, who do you suppose was at fault here? The assigning client's signature appears at the bottom of page two of our contract, and above her signature are all of the terms and conditions, including a weather day term. My ringing her up at 9:00 am for the 11:00 am call time was to advise her of the weather issue, and my assumption was that she would either: A) ask that we move indoors, or B) allow for the weather day additional charge. However, this assumption is based upon the expectation that the client read the document she was signing—a reasonable supposition from my perspective. Having all this in writing and agreed to by the client also diminishes the belief that we are trying to pull one over on a client and covers the fact that we were unable to complete other assignments on that day and will also be unable to take on other assignments for the new day needed to complete the assignment. In most cases, however, in addition to the assumption, I will say, "We're going to run into a weather charge, as well as another booking of assistant(s) for the next day," and this will either prompt the client to move the shoot indoors on the same day or accept the additional charges.

An editorial contract must also spell out usage—typically one-time usage in one edition of the publication, plus an allowance for the reuse of the cover that includes your image for advertising (if you're doing a cover shoot) for a set fee. I indicate whether the assignment is an "inside" use and the maximum size or number of images, or a cover use, and that affects our rates, of course. In some instances, we'll outline the fee plus expenses, and then state that any use beyond a single image plus a table of contents use will incur additional usage fees. This is what is referred to as a "guarantee against space." If the client tells me that the use is going to be a half-page horizontal opener of the subject, I'll quote slightly less than if the client states that it'll be a full-page vertical. What I want to avoid is a six-page article, which ends up being a full

page vertical, with a triptych on one (or two) of the other pages, for a total of seven images being used. To avoid this, I'll stipulate that usage beyond what is outlined will incur additional space rate use, which I spell out as quarter, half, full, and double-page.

NOTE

Although Dictionary.com defines "triptych" as "a work consisting of three painted or carved panels that are hinged together," the editorial world has used this word—and an alternate spelling, "triptik"—to refer to a set of three (or more) images of a subject, typically during an interview, where they are gesturing differently, running along the bottom of page (or scattered across a two-page spread).

Back in the 1970s, the concept of a "day rate" came into being. Avoid this two-word nightmare. It might have been suitable back when feathered hair and bell-bottom jeans roamed the land, but "day rate" should be just as banished from your lexicon as your bell bottoms and bleached jeans are exiled to your attic or jettisoned to a landfill. When day rate originated, it was what a publication such as Time, Newsweek, or US News & World Report paid, as a minimum, for an eight-hour day for a photographer to go out and cover something, regardless of whether the publication ever published a single photograph from the assignment. While this figure was the down side of the assignment, directly tied to the day rate was a "guarantee against space" concept. This meant that if you made an image that ran a quarter of a page, that space rate was somewhere near \$250, but you were compensated at \$400 to \$450 for your day rate plus expenses of film, parking, shipping/couriers, and often meals if it really was an eight-hour-plus assignment. If the photo ran half a page, because the space rate might have been \$700, you'd earn that plus expenses, instead of the day rate minimum. Where things got especially beneficial was when a full page (\$1,500), double-page (\$2,500), and cover (\$3,000) came into play. For the fortunate photographer, a week's minimum of \$2,000 for five days' work could result in two full pages and a half-page, paying \$3,700, and this might result from just a single assignment day rate.

If this model works for you and the publication agrees to it today, then by all means continue, but understand that day rates are still hovering around \$500 for the aforementioned publications, and that does not even keep up with inflation from when they instituted and set their day rate and space rates, yet their advertising rates have risen tenfold since the 1970s. So why haven't their day rates risen? I'd submit that a higher assignment fee should be your approach, and you should allow for a set maximum number of images published and define the images as "inside" or "cover plus inside" use. If you've got days before and days after working on the pre-production and post-production, call them "pre-production days." Further, would it be acceptable during this "day" that you complete an assignment of a portrait, and then a second assignment during the eight hours without additional compensation? Whatever you finally decide, make sure that your assignment rate you proffer or accept is higher than your CODB for the day, or you'll be paying for the privilege of working and subsidizing multi-million dollar corporations.

Oh, and one more thing about day rates: If you are tiptoeing around banishing "day rate" from your lexicon, wringing your hands and all, under no circumstances should you be billing a "half-day rate!" This is a cheapskate's way of slicing in two your day rate. What about the talented photographer who can slip in and out of a portrait of a subject in an hour? Should that photographer be paid a "quarter-day rate," whereas the beginning photographer will take six hours to light the same assignment, fighting the light, and get a day rate out of it? Although there are photography models based upon time (a corporate assignment covering an all-day conference or VIP reception, and so on), editorial is definitely not one of them. This would mean you'd earn less as you became more talented and could problem-solve a shoot faster!

A final note about what contracts must have—all amendments must be in writing. These amendments are typically referred to as "change orders," and are more prevalent in corporate and commercial assignments than editorial ones. One very tricky (and in my opinion deceitful) contract amendment is the "by endorsing" back of paycheck "amendment." Here you have a client who changes the terms of an agreement by having the back of the check they pay you with, which a bank requires you to sign (or endorse), also include language about rights transferred, work-made-for-hire, and so on.

In the case of Playboy Enters., Inc. v. Dumas¹, Playboy and Dumas were arguing over ownership of works the artist Patrick Nagel had produced for or were commissioned by Playboy, and that were published by them. No contract or other formalized document existed that would outline the terms of ownership, save for what Playboy placed on the back of every check that was required to be endorsed by the recipient prior to deposit. The Court, in reviewing this case, first held:

> We therefore find that the 1976 Act requires that the parties agree before the creation of the work that it will be a work made for hire. We are not convinced, however, that the actual writing memorializing the agreement must be executed before the creation of the work.

Further, the Court reviewed the differing language on the backs of the checks. Between 1974 and 1979, the back of the check read:

Any alteration of this legend agreement voids this check. By endorsement of this check, payee acknowledges payment in full for the assignment to Playboy Enterprises, Inc. of all right, title and interest in and to the following items: (a description of a painting followed)

Because this language does not specifically state "work made-for-hire" or "work-for-hire," it does not fulfill §101(2) of the Copyright statute, holding that "the parties expressly agree in a written instrument signed by them that the work shall be considered a work made for hire." As a result, the courts found that all works between January 1, 1978 (the date upon which the 1976 Copyright Act, as amended, went into effect) and July of 1979 were not subject to the "worksmade-for-hire" term.

¹ 53 F.3rd 549 (2d. Circuit, 1995)

However, the Court then examined the changed check language, which did meet the \$101(2) requirement. The second check back was used between September of 1979 and March of 1981, and read:

Any alteration of this legend agreement voids this check. By endorsement, Payee acknowledges payment in full for services rendered on a work-made-for-hire basis in connection with the Work named on the face of this check, and confirms ownership by Playboy Enterprises, Inc. of all right, title and interest (except physical possession), including all rights of copyright, in and to the Work.

A third revision, which went into place in March of 1981, following on the previous language, and was used until May of 1984, read:

Any alteration of this legend agreement voids this check. It contains the entire understanding of the parties and may not be changed except by a writing signed by both parties. By endorsement, Payee: acknowledges payment in full for the services rendered on a work-made-for-hire basis in connection with the Work named on the face of the this check and confirms ownership by Playboy Enterprises, Inc. of all right, title, and interest (except physical possession), including all right of copyright, in and to the Work.

With the previous two bodies of text being almost identical, the important part of the text is that it contains the words "work-made-for-hire," thus it meets the §101(2) requirement. The check was signed (on the front) by Playboy and by Nagel on the reverse, and although the agreement in each case was not memorialized by these signatures until after the work was performed, which would seem to make the agreement to do so invalid, the Court held that Nagel's repetitive acceptance of these "back of the check" agreements constituted an ongoing understanding of a WMFH agreement that would create an expectation that each subsequent check would carry the same language. There is extensive additional information online about this case. For those interested, a search for "Playboy v. Dumas" or "Playboy Enters., Inc. v. Dumas" will yield a broad amount of information about the case.

NOTE

Had Nagel instead granted "all rights" to Playboy or a copyright transfer for all works created 35 years following publication, or 40 years following the agreement (for work created after 1977), Nagel (or his estate) could have had all those rights revert back to him—a significant distinction between a WMFH and an all rights grant or copyright transfer. From the Copyright Office Web site:

> Section 203 of the Copyright Act permits authors (or, if the authors are not alive, their surviving spouses, children or grandchildren, or executors, administrators, personal representatives or trustees) to terminate grants of copyright assignments and

> > continued

licenses that were made on or after January 1, 1978 when certain conditions have been met. Notices of termination may be served no earlier than 25 years after the execution of the grant or, if the grant covers the right of publication, no earlier than 30 years after the execution of the grant or 25 years after publication under the grant (whichever comes first). However, termination of a grant cannot be effective until 35 years after the execution of the grant or, if the grant covers the right of publication, no earlier than 40 years after the execution of the grant or 35 years after publication under the grant (whichever comes first).

This might seem like an extensive example of an amendment, but that small body of text on the back of a check constituted a contract, and could also, as with the later check language, nullify your contract, especially if you do ongoing work for this publication.

This practice still occurs among some publications and media outlets, so be cautious about amendments of which you may be unaware.

Using a Word Processor for Contracts versus Dedicated Software or Your Own Database

When I began my business, I had my contracts in WordPerfect, and I would go in and change each one from my standard language to meet the specific needs of the client resulting from a negotiation we'd had. It was easy to do, but a few mistakes occurred. In some instances, I'd do the math wrong and either have to eat the mistake or have an understanding client see my mistake and accept the higher estimate figures once they appeared on the invoice. After a few of these mistakes, I began using some simple tables in the word processor that would do the math for me and would be an integral part of the document. This worked for a long time.

I considered switching to any one of the several options of software written for photographers to do contracts and such. One exceptionally well-designed one was integrated with a supply reseller, which would allow you to track your inventory of film, and when you'd shot and billed a certain number of rolls of film, the software would realize you were low on film and offer to reorder it for you. Unfortunately, this software doesn't exist anymore, but a few others have remained. However, I was always worried that others would go the way of the aforementioned one, so I decided to learn how to make a basic database in FileMaker, and I transitioned to tracking my contracts there and still being able to modify them when necessary.

If you're evolving into a more business-oriented operation (which I'd expect because you're reading this book), I'd recommend you start with word processor files, but learn about tables and their ability to calculate for you. Start with my language if you'd like, and modify it to suit

your state's requirements or your specific needs. Or, turn to one of several trade organizations who, as a part of their membership, offer contracts that are an excellent starting point for you to establish your own.

How to Work through a Contract Negotiation for Editorial Clients

One of the biggest challenges, which I'll tackle in Chapter 13, "Negotiations: Signing Up or Saying No," is negotiations. This section of this chapter will deal specifically with editorial clients, although many of the issues will be similar for corporate/commercial work, with just a few differences.

First, you have to understand who you are negotiating with. There's a hierarchy at publications. It usually goes:

- Art Director/Creative Director. This person is responsible for the entire look and feel of the magazine, from font choice to page numbers and other layout details—everything visual for the publication.
- **Director of Photography.** While the AD is responsible for photography, illustrations, and graphics, the Director of Photography usually reports to the AD (if there is one) for all photo-related issues. They carry out the stylistic vision of the AD as it pertains to photos.
- ▶ Photo Editor(s). These folks are usually the ones who do the heavy lifting booking photographers, handling problems that photographers run into, coordinating with subjects, and generally doing whatever is needed to accomplish the assignments.
- ▶ Assistant Photo Editor(s). These folks will research and locate several photographers in a market where they don't have a relationship with a photographer, will handle image intake (whether film or digital), and generally support the PE. The APE will convey photographer options to the PE for the unknown market, and the photo editor will generally make the decision about whom to contact. For covers or major stories, the DOP or AD will get involved.

In many cases there are no APEs, and the PE/DOP role is one person. In very small publications (trade or niche publications), there is no AD. For a publishing conglomerate, one AD handles multiple titles. The key is to know who you are dealing with and who has the ability to sign off on your negotiated points.

Because of the frequency with which editorial clients assign photography, they are the ones most likely to have a set budget for each issue, and often for each assignment. I have found myself in situations in which I have been told that the budget to hire me was higher than normal because they got handouts from companies for other stories in that issue, so they could hire me at my rates.

One of the first questions I ask is, "What's your budget for this assignment?" This is typically met with something along these lines:

"We pay \$250, flat rate, for each assignment, including expenses."

"We pay \$600, plus expenses for an inside story, which is typically just one image used."

"We need to keep the assignment for the cover, which includes one image used inside, to a total of \$1,500 including expenses."

"As long as we can stay under \$3,000 for everything, that should work."

Regardless of the actual numbers, these are the types of comments I get. Regardless of whether I'll take the assignment, I want to know where they are so I can gauge the likelihood that I will get the assignment. Even for the first response—seemingly too low to consider—I'll send them my paperwork. I do this for several reasons.

- Some prospective clients are trying to get their work on the cheap, and they figure they'll start low and see what bites.
- Some prospective clients will actually weed out the ones who accept the cheap fees, especially when it's an important assignment.
- ▶ Many clients who call have experience with a lower rate in their town and will experience sticker shock when trying to book in a larger community. On the other end, in cities such as New York and Los Angeles, some photographers will accept these lowball (below CODB for almost anybody) rates because if they don't, they (wrongly) surmise someone will.
- ▶ Once a client gets over their sticker shock, I want to be in the running for the assignment. If I dismiss requests for my services and don't bother to send the estimate, I am completely out of the running when others send in comparable estimates and the client becomes educated about the market just by the estimates they receive.

I will then work through the numbers. Do I need just one assistant or two? Is it just one portrait of the subject or two? How many subjects? What other complicating factors are there? Will there be staging/propping or a set-building requirement? Do I need permits? A studio? Catering? What about post-production? Is this to become a photo illustration, requiring lots of post-production work?

I will then look into their circulation figures. Sometimes I know the figures because I'm familiar with the publication; other times I have to look the numbers up in the "advertise with us" section of their Web site. While there, I usually bring myself into reality by finding out what they charge for full and half-page ads in the publication. Knowing this can make my rates of even several thousand dollars seem cheap in comparison!

From there, I'll check with software such as fotoQuote to see what a stock image would cost them to license for the magazine. This often might be a choice that the client is considering behind the scenes, and which you may be unaware of. If the only portrait of a subject or photograph of a product is available, but that photographer has quoted a fee of \$3,000 for onetime use, the client might be considering you as a possibly cheaper option to produce an image. If fotoQuote reports a stock fee of \$1,750 for a cover use for this circulation trade magazine, and you know your expenses are going to be around \$700, then a fee including expenses certainly would be fair at \$2,400. The question the client will have to ask is, "Should I commission the work for \$2,400 and hope for a great photo, or license a photo that I know will be great for \$3,000? What is that \$600 variance worth?"

Usually, this research takes less than five minutes and, after sending the quote as a PDF via e-mail, I will follow up with a phone call, ostensibly to see whether they've received the quote, but actually to get a read from them as to whether I am way out of their expectations or to see whether I can get them to commit right then to me, over whoever has not returned their voicemail and might be sending an estimate in an hour when they get home and call. Hopefully, by that time the client will say to other photographers, "We're all set; we've found another photographer." Having been on the receiving end of that before, I do everything in my power to respond immediately to all client calls and inquiries.

During the call, I'll also talk about some creative ideas I've had about the shoot, and I make sure to express that I am excited about the project. This cannot be stated enough—you must be enthusiastic about each assignment for which you are being considered. Nothing sours a prospective client more than a lackadaisical attitude about the assignment they are considering giving you. There is truth to the theory that you should smile when you're on the phone, because people on the other end can tell that you're happy when you do. This applies to enthusiasm too.

Even if I can't get a commitment from the client (and I've followed up with a request that they sign and return the contract at their earliest convenience, because we're not committed until we have a signed contract back), I'll ask when they hope to have a decision, and then I'll let them know that I'll follow up with them...and then I do. I might even follow up the phone call with a short e-mail as a courtesy, if I feel it's appropriate and not going to come across as pushy or overbearing.

If I don't get a signed contact back, but the client seems amenable (or is not objecting) to the contract, I'll ask about the subject and take the approach that the assignment is mine. If the client offers the subject's contact information, I'll gladly take it and reach out to the subject about dates, times, and setting a tentative date. Once I've done this, I convey this to the client in an e-mail. If at a later date (which still must be before we do the shoot) the client has a problem with a term in the contract, I am negotiating from a position of strength because I am already familiar with the assignment and have a tentative date set to photograph the subject. If it's a term I am comfortable with modifying (such as pays in 45 days, not 21), then we're fine. If it's a deal breaker (such as WMFH, reuse in other sister publications with no additional compensation, and so on), then I gently convey this in some manner akin to "It's our policy that we do not do WMFH" or "We are happy to license to your sister publication usage, but it's not included in the fee I've presented for your publication; it's our policy to charge an additional license fee for these secondary uses."

One term that has been demanded—but which the client has relented on—has been the attempt to insist that there be no additional fee for magazine reprints that the subject might want. Because magazine reprints are not editorial, they are of commercial benefit to the subject photographed, with the added endorsement of the publication. Editorial rates do not apply to these uses. Magazine reprints are a substantial source of income for many publications, and the photographs often play a major role in the reprint—frequently becoming the cover of the reprint when the subject was not on the cover in the first place. I'm just not willing to forgo my piece of the pie from this use of my work. Recently, I was contacted to produce more than 20 portraits for a publication, and the publisher was insisting upon the inclusion of reprint rights. When I discussed this further, it was stated by the publisher's representative that, in fact, they expected to generate several thousand dollars' worth of revenue from the reprints, and they were unwilling to pay me more for those reprints. The revenue from the reprints alone would have paid for my photography fees and have turned a profit off of me to boot. Understand that if you do an assignment, the assignment can generate more revenue for the publication through reprints than from the actual editorial usage.

My contracts all have a place for the client to sign at the bottom of the second page. Back in the day, documents such as Delivery Memos, which accompanied film, had a place for a signature on the front and an entire page of Terms and Conditions on the reverse. This led some clients to attempt to get out of any term they wanted (usually the \$1,500 valuation per image for 60 images sent and now lost) by saying they never saw the T&C, and in some states—California among them—some T&Cs must appear on the front of a document for them to be binding. Now, all my documents have the signature space on the bottom of page two, so the signature appears on the page with the T&C. If your contract has the client signing on page one, make sure there is a place on the subsequent page(s) for their initials, and that each page is labeled "Page X of Y." This will minimize the client's ability to suggest they never saw the T&C.

Following are several case studies from actual client negotiations. The names have been removed because it's not necessary to know who the client is or what publication they might be from; the important part is to see how the transaction took shape.

Before moving on to the case studies, there's one tangential aspect of many editorial assignments that needs to be addressed. Often subjects have never had a photograph that they like, or if they did, it's no doubt outdated. They frequently will ask "So are these photos yours or the magazine's?" To which we respond, "They're ours." The client's next question is, "So how do we get in touch with you about the photos if we like them?"

I typically have with me a printed single piece of paper, often in an envelope, and I give it to the client's assistant. If I don't have the information with me, I point the client to a page on my Web site with the same information. It reads:

INFORMATION REGARDING PERSONAL (AND COMMERCIAL) USE OF THE PHOTOGRAPHS WE HAVE CREATED

Thank you for your interest in the photography we just created. When photography is done for a magazine or other publication, there is usually a 1–3 month delay in the images being returned to our offices from the date of the shoot, or available to other parties.

We are more than happy to facilitate requests for a review of the photographs we have created, but in order to properly facilitate your request we need to know what the use of the images would be if copies were to be provided. If the print is for personal use (for a family member or

continued

to frame on a wall), then only the costs to reproduce the image(s) are incurred. (Print costs, couriers/shipping, etc.)

If the images are to be distributed in press kits, on a Web site, or for other uses beneficial to the company or your own commercial interests (speaking engagements, etc.), then there are fees involved for those uses, and those prices are dependent upon how broad (or narrow) the use is.

When images are delivered to you that are indicated for personal use only, a permanent ink stamp is placed on the back of the print, indicating that that image cannot be used in publication or on the Internet. When images are delivered to you that have a specific license for use(s) you have requested, paperwork accompanies the deliverables that outlines the uses for the photography, the length of time for the use of the images, and the fees involved.

Use of images outside of the scope of the license provided, or any use of a "personal use" image other than hanging on a wall or framed on a desk, is a breach of our copyright. You may ask, "Why do I have to pay to use a photograph I let you take of me?"

Simply, you were contacted by a publication that believed their readers would benefit from seeing your image in the publication, and you determined that you would benefit from appearing in the publication. We were compensated by the publication for using our creative processes to give them a desirable image. We specifically granted one-time-only permission to the publication, and they do not have permission to re-run any of the images, nor produce reprints of the article, without additional compensation. Our fees were based upon this "one time only" use.

For you to receive additional benefit (beyond the scope of the magazine in which the image(s) appeared), we, as the creator of the image, need to receive an additional benefit. The more additional benefit you receive (usages), the more we need to receive. This concept, in principle, took hold during the Constitutional Convention of 1787. James Madison suggested that the Constitution include language "to secure to literary authors copyrights for a limited time." The provision passed unanimously. It is found in Article I, Section 8 of the U.S. Constitution. It states "The Congress shall have Power[el. To promote the Progress of Science and useful Arts by securing for limited Times to Authors and Inventors the exclusive Right to respective Writings and Discoveries."

We welcome the opportunity to discuss with you, or your marketing department, the costs of using the images we have created to benefit your organization. While the fees associated with the varying uses may seem high to you, your advertising agency, marketing department, or public relations firm will be familiar with the cost structure that is standard in the creative community for these varying types of uses.

I refer to a one- to three-month delay on images being returned from the publication, and it is important to note that because I cannot remember the last time I actually shot a film assignment, and this was typically a film delay, the concept of "returned from publication," although not applicable in today's digital environment, usually still applies in the form of embargoes from the publication on our doing anything else with them during that time. Feel free to copy and use that text for yourself when you find the same request being made of you.

Case Study: Portrait for University Magazine

Client type: Publication for a state-run university's school magazine.

Assignment: Portrait of a single subject, on location outdoors in Washington, DC.

Deliverables: Single image via e-mail, suitable for a full-page inside use.

Technical notes: No permits necessary, single head on battery pack strobe pack. Total time shooting: 10 minutes; total setup and breakdown: 1 hour.

This was the initial inquiry:

From: Subject: Request for estimate Date: 2:20:38 PM EDT To: 2:20:38 PM EDT
John,
My name is provident and I am the editor for the provident states of the second states of the second states of the . I found your name through the Adobe Photographers Directory, and was very impressed with your portraiture.
Would it be possible for you to give me an estimate for a photo shoot in D.C.?
I am looking for a portrait shot of an alumna we are writing a feature story on; Second States and States and
I appreciate your help and look forward to your response.
Many thanks,

We responded, one hour and 37 minutes later:

From: The second
Dear and the second s
Attached is a PDF of the estimate you requested for your upcoming photography needs for a portrait and other shots of second second se

We followed up with a phone call, and were told that he'd look over it in the next few days. More than a week later, we received this response:

From:

Subject: Re: Photo Estimate for Alumna Portrait

Date: 11:55:19 AM EDT

To:

John,

I went over the contract with our procurement office and must request a few changes.

By **Several Provide Section 8** in the terms and conditions. Please strike that section.

By **an experimental and an experimental and an experimental and an experimental and an experimental and any invoice, within 10 days of the mailing date of the invoice, will incur a late payment charge not to exceed what is allowable under {state} law."**

I have also attached an addendum to the contract clarifying the usage rights, approval of publicity releases, [school]'s indemnification, and cost section certification.

If you have any questions, please email me or call me at

I appreciate your attention to this.

Many thanks,

CHAPTER 10

The addendum contained the following *proposed* addendums, and we treated them as proposed. They were:

Addendum to Contract

GENERAL: The photographer (or "contractor") will provide the [*school*] exclusive non-commercial usage rights.

APPROVAL OF PUBLICITY RELEASES: The contractor shall not have the right to include the [school]'s name in its published list of customers, without the prior approval of the [school]. With regard to news releases, only the name of the [school] and the type and duration of contract may be used, and then only with prior approval of the [school]. The contractor agrees not to publish or cite in any form any comments or quotes from [school] staff. The contractor further agrees not to refer to the award of this contract in commercial advertising in such a manner as to state or imply that the products or services provided are endorsed or preferred by the [school].

INDEMNIFICATION: The [*school*], its officers, agents, and employees shall be held harmless from liability from any claims, damages, and actions of any nature arising from the use of any materials furnished by the contractor, provided that such liability is not attributable to negligence on the part of the [*school*] or failure of the [*school*] to use the materials in the manner outlined by the contractor in descriptive literature or specifications submitted with the contractor's proposal.

COST SECTION CERTIFICATION: I hereby certify that the price included in this proposal is accurate and binding, and that all costs are shown and accurately reflect my total proposal cost.

That's a pretty big difference between "one time use" and "exclusive non-commercial usage rights." A response was in order, and we replied later that same afternoon.

From: Subject: Re: Photo Estimate for Alumna Portrait Date: 2:17:31 PM EDT To: 2:17:31 PM EDT

and the second

We have reviewed both the contract changes outlined in your e-mail and the addendum you attached.

As far as usage and rights, our contract (and your budget) calls for one-time use in your magazine and not the exclusive, unlimited, non-commercial usage for an unlimited period of time proposed in your addendum.

In reference to your request that we strike Section 8, Limitation of Liability and Indemnification, from our contract, while we can agree to an Indemnification clause for the [school], we need parity with regard to our indemnity, which we would forfeit by striking Section 8. We propose a merging of indemnification clauses.

I am attaching a new version of your addendum with revised language under the "General" and "Indemnification" sections. We will be able to revise Section 12 of our contract with your new language, and will not need to change any language in your addendum beyond what is outlined above.

Once approved, we will include the clauses in your addendum as new or revised language in our contract and send you the revised contract for signature. Please let us know if you have any questions.

Best,

John

Addendum to Contract

GENERAL: The photographer (or "contractor") will provide the [*school*] with first world usage rights of image(s), and upon publication of a single image from the assignment, all images from the assignment are released from this embargo. In the event no images are published, after one year, the embargo lapses. The use by [*school*] of image(s) from this assignment remains a one-time use, consistent with the terms of the contract that this addendum applies to.

APPROVAL OF PUBLICITY RELEASES: The contractor shall not have the right to include the [school]'s name in its published list of customers, without the prior approval of the [school]. With regard to news releases, only the name of the [school] and the type and duration of contract may be used, and then only with prior approval of the [school]. The contractor agrees not to publish or cite in any form any comments or quotes from [school] staff. The contractor further agrees not to refer to the award of this contract in commercial advertising in such a manner as to state or imply that the products or services provided are endorsed or preferred by the [school].

INDEMNIFICATION: The [*school*], its officers, agents, and employees shall be held harmless from liability from any claims, damages, and actions of any nature arising from the use of any materials furnished by the contractor, provided that such liability is not attributable to negligence on the part of the [*school*] or failure of the [*school*] to use the materials in the

continued

manner outlined by the contractor in descriptive literature or specifications submitted with the contractor's proposal. The [*school*] shall indemnify, defend, and hold Contractor and Contractor's representatives harmless from any and all claims, liabilities, damages, and expenses of any nature whatsoever, including actual attorneys' fees, costs of investigation, and court costs arising from or relating to the [*school*]'s direct or indirect use of the Image(s) or in connection with Contractor's reliance on any representations, instructions, information, or materials provided or approved by the [*school*].

COST SECTION CERTIFICATION: I hereby certify that the price included in this proposal is accurate and binding, and that all costs are shown and accurately reflect my total proposal cost.

Note the changes to the usage and indemnification clauses.² The resulting e-mail from the client then struck the indemnification for both parties, and I responded:

Dear	,
Dear	l

Attached is a PDF file of the estimate you requested for your upcoming photography needs. I've struck Clause 8 and replaced it with your Approval of Publicity release text, and I've added the Cost text to the end of my Term 2, so we should be all set.

We look forward to working with you.

Best,

John

The shoot terms were agreed to, and we completed the photography as requested, having negotiated from our contract terms as a basis. The client indicated initially that they'd want to accomplish the shoot for less than \$1,000. Because we were delivering only a single image, I was able to reduce my post-production charges below what we'd normally charge. The final redacted contract follows.

² In the "publicity release" section, there is a note about not publishing or citing any comments or quotes from the staff. The individual is not identified, nor is the publication, nor the school or state, and these quotes are not comments nor quotes, per se, but rather an ongoing dialogue over negotiated contract points between myself and the school. Further the disclosure of this does not breach the spirit of the proposal—to preclude the appearance of an endorsement of my services by a state-run and taxpayer-funded institution. Because the intent of this case study is to educate, it is the author's position that this body of text falls outside of the restriction that finally was embodied in Clause 8 of the author's contract with the school.

🔹 🗼 JOHN HARRINGTON			
Photography E	timate and Contract		
2500 32nd Street, SE Washington, DC 20020		Contract	
(202) 544-4578 Fx: (202) 544-4579 Da			
To: Jot	.D.		
Art Bu			
Fax# Clie			
EMail: Client	#: CL2006-1527		
Description of Services and Rights Licensed: Produce portrait of		nna in front of	
the Supreme Court for feature story plus smaller supporting images inside story in Rights include first world usage of image(s), and upon publication of a single imag from the assignment are released from this embargo. In the event no images are performed embargo lapses. The use by the contract.	e from the assignmer published, after one y	ear, the	
Fees Main Illustration	\$750.00		
Weather Days @ \$422/day		\$750.00	
Production Charges			
Crew - 1 - Assistant;	\$95.00		
		\$95.00	
Photographic Imaging Charges Photographic Imaging Charges - Computer	System Time		
and CD delivery-\$100;		\$100.00	
Third Part Fees Billed Direct to Client:	<u>~</u>	\$945.00	
Talent: (Talent fees and the scope of releases are the sole responsibility of Clie			
Other:	Sales Tax	\$945.00	
Terms: All fees and charges on this invoice are for service(s) &	Advance		
licensing described above. I certify that the price included in this proposal is accurate and binding, and that all costs are shown and			
accurately reflect my total proposal cost.	Balance Due:	\$945.00	
Rights are licensed only upon full payment of this invoice, subject to terms			
(Page 1 of 2)			

115

CHAPTER 10

ALL SERVICES AND LICENSES OF LICENSOR ARE SUBJECT TO THE FOLLOWING TERMS AND CONDITIONS

1. DEFINITIONS: This Agreement is by and between John Harrington Photography ("Licensor") and ("Client") which includes Client's representatives . Licensor's relationship with Client is that of an independent contractor, "image(s)" means the visual and/or other forms of materials or digital information supplied by Licensor to Client. Licensor is the sole creator of the Image(s). The Image(s) are Licensor's interpretation, rather than a literat copy of any concepts or layouts provided to Licensor by Client. Service(s)" means the byhotography and/or related digital or other services described on the front of this Agreement that Client is specifically commissioning Licensor to perform pursuant to this Agreement. "Transmits or "Transmission" means distribution by any device or process whereby a copy of an Image is fixed beyond the place from which it was sent. "Copyright Management Information" means the name and other identifying information of Licensor, terms and conditions for uses of the Images, and such other information that Licensor may prescribe.

2. FEES, CHARGES AND ADVANCES: Client and Client's representatives are jointly and severally responsible for full payment of all fees, charges and advances. The rights licensed, fees, charges and advances set forth in this Agreement apply only to the original specification of the Services. Additional fees and charges shall be paid by Client for any subsequent changes, additions or variations requested by Client. All advance payments are due prior to production. I hereby certify that the price included in this proposal is accurate and binding, and t hat all costs are shown and accurately reflect my total proposal cost.

3. POSTPONEMENTS AND CANCELLATIONS: If Client postpones or cancels any photography "shoot date" or other Service, in whole or in part, without first obtaining Licensor's written consent, Client shall pay Licensor 50% of Licensor's quoted fees. If Client postpones or cancels with less than two business days 'prior written notice to Licensor, Client shall pay 100% of Licensor's quoted fees. Client shall in any event pay all expenses and charges incurred in connection with any postponed or canceled shoot date or other Service.

4. FORCE MAJEURE: Licensor shall not be in default of this Agreement by reason of its delay in the performance of or failure to perform, in whole or in part, any of its obligations hereunder, if such delay or failure results from occurrences beyond its reasonable control and without its fault or negligence. Client will pay 100% of Licensor's daily weather delay fee (as set forth on the front of this Agreement) for any delays due to weather conditions or any acts or occurrences beyond Licensor's reasonable control, plus all charges incurred.

5. CLIENT APPROVAL: Client is responsible for having its authorized representative present during all "shooting" and other appropriate phases of the Service(s) to approve Licensor's interpretation of the Service(s). If no representative is present, Licensor's interpretation shall be accepted. Client shall be bound by all approvals and job changes made by Client's representatives.

6. OVERTIME: In the event any Services extend beyond eight consecutive hours in one day, Client shall pay overtime for crew members and assistants at the rate of 1 1/2 times their hourly rates or fees, and if the Services extend beyond 12 hours in one day, Client shall pay overtime for crew members and assistants at the rate of double their regularly hourly rates or fees.

7. RESHOOTS: Client shall pay 100% of Licensor's fees and charges for any reshooting or redoing of Services requested by Client. If the Image(s) become lost or unusable by reason of defects, damage, equipment malfunction, processing, or any other tachnical error, prior to delivery of the Image(s) to Client, Licensor will perform appropriate Service(s) again without additional fees, provided Client advances and pays all charges and charges in connection with the initial Services.

8.APPROVAL OF PUBLICITY RELEASES: The contractor shall not have the right to include the **sectors** name in its published list of customers, without the prior approval of the **sectors**. With regard to news releases, only the name of the **sectors** and the type and duration of contract may be used, and then only with prior approval of the **sectors**. The contractor agrees not to publish or cite in any form any comments or quotes from **set is 15**. The contractor further agrees not to refer to the award of this contract in commercial advertising in such a manner as to state or imply that the products or services provided are endorsed or preferred by the **sector**, roved by Client.

9. RIGHTS LICENSED: The licensed rights are transferred only upon: (a) Client's acceptance of all terms contained in this Agreement, (b) Licensor's receipt of full payment, and (c) the use of proper copyright notice and other Copyright Management Information requested or used by Licensor in connection with the Image(s). Licensor is willing to license the Image(s) to Client only upon the condition that Client accepts all of the terms of this Agreement, all others experiment, all clients are non-exclusive and the duration is one year from the date of Licensor's invoice and for English language use in the United States of America only. Licensor reserves all rights in the Image(s) of every kind and nature, including, without limitation, electronic publishing and use rights, in any and all modia, throughout the world, now existing and yet unknown, that are not specifically licensed or transferred by this Agreement. No license is valid unless signed by Licensor. Client shall not assignable or transferred by this or obligations under this Agreement. This Agreement assignable or transferred by this Agreement, the solidations, and obligations of this rights or obligations of date of advart rights or obligations of advart rights or obligations of a default under this Agreement allowing Licensor to excise all remedies including, without limitation, the remedies including, without limitation, terminating this Agreement, oth any rights or obligations of any assignment or assignment or assignment or assignment or assignment or assignment of any rights or obligations of any rights or obligations of Client shall be deemed a default under this Agreement allowing Licensor to excise all remedies including, without limitation, terminating this Agreement, obligations and complete and subschall assurances of all turb performance.

10. RETURN OF IMAGE(5): Client assumes all risk for all Image(s) supplied by Licensor to Client, from the time of Client's receipt, to the time of the safe return receipt of the Image(s) to the possession and control of Licensor. If no return date appears on the front of this Agreement or on any related delivery memo, Client shall return all Image(s) in undamaged, unaltered and unretouched controlition within 30 days after the first publication or use of the Image(s), whichever occurs first Client agrees to destroy all digital files within one week of reproduction. If the files were sent on digital media, all such material must be returned in undamaged condition within 30 days of reciept.

11. LOSS OR DAMAGE: IN CASE OF LOSS OR DAMAGE OF ANY ORIGINAL IMAGE(S), CLIENT AND LICENSOR AGREE THAT THE REASONABLE VALUE OF EACH ORIGINAL IMAGE IS \$2,500. Once original Image(s) are lost or damaged it is extremely difficult and Impracticable to fit their exact individual value. Accordingly, Licensor and Client agree that the reasonable liquidated value of each original Image (S) are lost or damaged it is extremely difficult and Impracticable to fit their exact individual value. Accordingly, Licensor and Client agree that the reasonable liquidated value of each original Image (S) are lost or damaged it is extremely difficult and Impracticable to fit their exact individual value. Accordingly, Licensor's claim to that amount without regard to the actual value of such Image. An Image shall be considered an original if no high reproduction quality duplicate of that Image exists.

12. PAYMENT AND COLLECTION TERMS: Invoices from Licensor are payable upon re The unpaid amount of any invoice, within 10 days of the mailing date of the invoice, will incur a late payment charge not to exceed what is allowable under South Carolina law. In any action to enforce the terms of this Agreement, the prevailing party shall be entitled to recover their actual attorneys' fees, court costs and all other nonrelimbursable litigation expenses such as expert witness fees and investigation expenses. No lawsuits pertaining to any matter arising under or growing out of this Agreement shall be instituted in any place other than Washington D.C.

13. TAX: Client shall pay and hold Licensor harmless on account of any sales, use, or other taxes or governmental charges of any kind, however denominated, imposed by any government, including any subsequent assessments, in connection with this Agreement, the image(s), the Service(s) or any income earned or payments received by Licensor hereunder. To the extent that Licensor may be required to withhold or pay such taxes Client shall promptly threather fur this Licensor with funds in the full amount of all the sums withheld or paid.

14. RELEASES: NO MODEL, PROPERTY, TRADEMARK, OR OTHER SUCH RELEASE EXISTS FOR ANY IMAGE(S) UNLESS LICENSOR SUBMITS TO CLIENT A SEPARATE RELEASE SIGNED BY A THIRD-PARTY MODEL OR PROPERTY OWNER.

15. ELECTRONIC RIGHTS: No electronic publishing or use of any kind is licensed unless specifically stated on the front of this Agreement. The use rights reserved by Licensor include, without limitation, all rights of publication, distribution, display, Transmission, or other use in electronic, digital and other media of any kind, now existing and yet unknown. Any rights licensed by Licensor for any use in a collective work nectuled all use rights for any kind of revision of that collective work including any later collective work in the same series.

16. MODIFICATIONS, GOVERNING LAW AND MISCELLANEOUS: This Agreement sets forth the entire understanding and agreement between Licensor and Client regarding the Service(s) and/or the Image(s). This Agreement supersedes any and all prior representations and agreements regarding the Service(s) and/or the Image(s), whether written or verbal. Neither Licensor nor Client shall be bound by any purchase order, term, condition, representations, and agreements regarding the Service(s) and/or the Image(s), whether written or verbal. Neither Licensor nor Client shall be bound by any purchase order, term, condition, representation, warranty or provision of ther stapes/fieldly stated in this Agreement shall not be deemed to be a waiver of any other provision of this Agreement. Any objections to the terms of this Agreement must be made in writing and delivered to Licensor within ten days of the receipt of this Agreement by Client or Client's representative, or this Agreement shall be binding, notwithstanding anything to the contrary, no Image(s) may be used and nany manner without Licensor's point written constant, and Client's binding of any Image(s) constitutes Client's complete acceptance of this Agreement. The formation, interpretation, and performance of this Agreement by the fave of by the fave. Quecking the conflict of laws rules of Washington D.C. All paragraph captions in this Agreement are for reference only, and shall not be construing in accordance with its terms and shall not be construed more favorably for or more strongly against Licensor's prices or Client is appresent. This Agreement shall be construed more favorably for or more strongly against Licensor's prices or Client is appresent. This Agreement shall be construed more favorably for or more strongly against Licensor's prices or Client is appresent. This Agreement shall be construed more favorably for or more strongly against Licensor's prices or Client is appresent.

Client Si	onature
-----------	---------

Date

(Page 2 of 2)

Case Study: In-Flight Airline Magazine

Client type: Publication for an in-flight airline magazine.

Assignment: Portrait of a single subject, on location indoors and possibly outdoors in Washington, DC.

Deliverables: Several via e-mail or FTP, suitable for a full-page inside use, and cover.

Technical notes: One or two heads. Total time shooting: 30 minutes; total setup, breakdown, and waiting time: 4 hours.

The initial inquiry came via phone call and was followed up same day with an estimate. Following is our e-mail to the client accompanying our estimate:

Dear

Attached is a PDF file of the estimate you requested for your upcoming photography needs.

Please look the attached estimate over, call with any questions, and sign and fax it back to confirm, and we can firm up specific dates/times. While we are currently indicating we are available, we don't guarantee or commit our photographers' time until we've received the signed estimate back and have agreed to the date(s). Please fax it to **second**.

Once you've confirmed the assignment, please forward, at your earliest convenience, any comps, layouts (draft or final), and/or any other details you have that may help us in the planning and creative development of the assignment. Please e-mail it to this address:

We look forward to working with you!

Best,

John

	Photogiu 2500 32nd Street, SE Wa (202) 544-4578 Fx: (202)	a p h y Ishington, DC 20020 2) 544-4579	Esti _{Date:}	mate and (Contract
o:		Tel# Fax#	Job #: A.D. Art Buyer: Client:	A2006-134	
		EMail: Rights Licensed: Portrait of include two portrait settings, and of gestures from subject to choose		CL2006-1530 for one time use images of subject	
ees	Main Illustration & seco	ndary images		\$1480.00	
	Weather Days	@ \$827/day			\$1,480.00
	tion Charges rew - 1 - Assistant:			\$175.00	
	-				
Cr	rew - 1 - Assistant; iscellaneous - Expendable			\$30.00	\$205.00
Cr Mi hotogi	rew - 1 - Assistant; iscellaneous - Expendable	es-\$30; es_Photographic_Imaging_Charge	es - Computer/Sys	\$30.00	\$205.00 \$260.00
Cr Mi hotogi	rew - 1 - Assistant; iscellaneous - Expendable raphic Imaging_Charg		es - Computer/Sys	\$30.00	
Cr Mi hotogi	rew - 1 - Assistant; iscellaneous - Expendable raphic Imaging_Charg		es - Computer/Sys	\$30.00	
Ci Mi hotogi Ci	rew - 1 - Assistant; iscellaneous - Expendable raphic Imaging Charg D-\$260; art Fees Billed Direct to 0	es_Photographic Imaging Charge		\$30.00 tem Time&	
Cr Mi hotogr CC CC	rew - 1 - Assistant; iscellaneous - Expendable raphic Imaging Charg D-\$260; art Fees Billed Direct to 0 (Talent fees a	es_Photographic Imaging Charge	bonsibility of Client.)	\$30.00 tem Time&	\$260.00

CHAPTER

ALL SERVICES AND LICENSES OF LICENSOR ARE SUBJECT TO THE FOLLOWING TERMS AND CONDITIONS

1. DEFINITIONS: This Agreement is by and between John Harrington Photography ("Licensor") and ("Client") which includes Client's representatives . Licensor's relationship with Client is that of an independent contractor, "image(s)" means the visual and/or other forms of materials or digital information supplied by Licensor to Client. Licensor is the sole creator of the Image(s). The Image(s) are Licensor's interpretation, rather than a literal copy of any concepts or layouts provided to Licensor to process whereby a copy of an Image is fixed beyond the place from which it was sent. "Copyright Management Information" means and other identifying information of Licensor, terms and contentions" means and other information of Licensor, terms and contentions of the information of the information

 FEES, CHARGES AND ADVANCES: Client and Client's representatives are jointly and severally responsible for full payment of all fees, charges and advances. The rights licensed, fees, charges and advances set forth in this Agreement apply only to the original specification of the Services. Additional fees and charges shall be paid by Client for any subsequent changes, additions or variations requested by Client. All advance payments are due prior to production.

3. POSTPONEMENTS AND CANCELLATIONS: If Client postpones or cancels any photography "shoot date" or other Service, in whole or in part, without first obtaining Licensor's written consent, Client shall pay Licensor's Of% of Licensor's quoted fees. If Client postpones or cancels with less than two business days' prior written notice to Licensor, Client shall pay 100% of Licensor's quoted fees. Client shall in any event pay all expenses and charges incurred in connection with any postponed or canceled shoot date or other Service.

4. FORCE MAJEURE: Licensor shall not be in default of this Agreement by reason of its delay in the performance of or failure to perform, in whole or in part, any of its obligations hereunder, if such delay or failure results from occurrences beyond its reasonable control and without its fault or negligence. Client will pay 100% of Licensor's daily weather delay fee (as set forth on the front of this Agreement) for any delays due to weather conditions or any acts or occurrences beyond Licensor's reasonable control, plus all charges incurred.

5. CLIENT APPROVAL: Client is responsible for having its authorized representative present during all "shooting" and other appropriate phases of the Service(s) to approve Licensor's interpretation of the Service(s). If no representative is present, Licensor's interpretation shall be accepted. Client shall be bound by all approvals and job changes made by Client's representatives.

6. OVERTIME: In the event any Services extend beyond eight consecutive hours in one day, Client shall pay overtime for crew members and assistants at the rate of 1 1/2 times their hourly rates or fees, and if the Services extend beyond 12 hours in one day, Client shall pay overtime for crew members and assistants at the rate of double their regularly hourly rates or fees.

7. RESHOOTS: Client shall pay 100% of Licensor's fees and charges for any reshooting or redoing of Services requested by Client. If the Image(s) become lost or unusable by reason of defects, damage, equipment malfunction, processing, or any other technical error, prior to delivery of the Image(s) to Client, Licensor will perform appropriate Service(s) again without additional fees, provided Client advances and pays all charges, and pays all fees and charges in connection with the initial Services.

8. LIMITATION OF LIABILITY AND INDEMNITY: Even if Client's exclusive remedy fails of its essential purpose, Licenso's entire liability shall in no event exceed the license fee paid to Licensor. UNDER NO CIRCUMSTANCES SHALL LICENSOR BE LIABLE FOR GENERAL, CONSEQUENTIAL, INCIDENTAL OR SPECIAL DAMAGES ARISING FROM THIS AGREEMENT, THE SERVICE(S), THE IMAGE(S) OR ANY ACTS OR OMUSIONSOF ULCENSOR. Client shall indemnify, defend and hold Licensor and Licensor's representatives tarmless from any and all claimages, and expenses of any nature whatsoever, including actual attorneys' fees, costs of investigation, and court costs arising from or relating to Client's direct or indirect use of the Image(s) or in connection with Licensor's representations. instructions, information, or materials provided or opproved by Client.

9. RIGHTS LICENSED: The licensed rights are transferred only upon: (a) Client's acceptance of all terms contained in this Agreement, (b) Licensor's receipt of full payment, and (c) the use of proper copyright notice and other Copyright Management Information requested or used by Licensor in connection with the Image(s). Licensor is willing to licens the Image(s) to Client only upon the condition that Client accepts all of the terms of this Agreement. Unless otherwise specifically stated on the front of this Agreement, and (c) the use of proper copyright Management Information requested or used by Licensor in connection with the Image(s). Licensor is willing to licenso the Image(s) to Client only upon the date of Licentor's invoice and for English language use in the United States of America only. Licensor reserves all rights in the Image(s) of every kind and nature, including, without limitation, electronic publishing and use rights, in any and all media, throughout the work(now existing and yet unknown, that are not specifically licensed or transferrabe by this Agreement. No license is valid unless signade by Licensor. Client shall be deemed a default under this Agreement. This Agreement shall not be assignable or transferrabe by this agreement assignment or assignment to apperation of any or any rights or obligations of Client shall be deemed a default under this Agreement tallowing Licensor to exercic

10. RETURN OF IMAGE(5): Client assumes all risk for all Image(s) supplied by Licensor to Client, from the time of Client's receipt, to the time of the safe return receipt of the Image(s) to the possession and control of Licensor. If no return date appears on the front of this Agreement or on any related delivery memo, Client shall return all Image(s) in undamaged, unaltered and unretouched condition within 30 days after the first publication or use of the Image(s), whichever occurs first Client agrees to destroy all digital files within one week of reproduction. If the files were sent on digital media, all such material must be returned in undamaged condition within 30 days of reciept.

11. LOSS OR DAMAGE: IN CASE OF LOSS OR DAMAGE OF ANY ORIGINAL IMAGE(S), CLIENT AND LICENSOR AGREE THAT THE REASONABLE VALUE OF EACH ORIGINAL IMAGE IS \$2,500. Once original image(s) are lost or damaged it is extremely difficult and imparaticable to fix their exact individual value. Accordingly, Licensor and Client agree that the reasonable liquidated value of each original image is \$2,500. Client agrees to pay Licensor \$2,500 for each lost or damaged original image and Licensor agrees to limit Licensor's claim to that amount without regard to the actual value of such image. An image shall be considered an original if no high reproduction quality duplicate of that image exists.

12. PAYMENT AND COLLECTION TERMS: Invoices from Licensor are payable upon receipt by Client. The unpaid amount of any invoice, within 10 days of the mailing date of the invoice, will incur a late payment charge of 1-12% per month but not in excess of the lawful maximum. In any action to enforce the terms of this Agreement, the prevailing party shall be entitled to recover their actual attorneys' fees, court costs and all other nonrelmbursable litigation expenses such as expert witness fees and investigation expenses. No lawsuits pertaining to any matter arising under or growing out of this Agreement shall be instituted in any place other than Washington D.C.

13. TAX: Client shall pay and hold Licensor harmless on account of any sales, use, or other taxes or governmental charges of any kind, however denominated, imposed by any government, including any subsequent assessments, in connection with this Agreement, the Image(s), the Service(s) or any income earned or payments received by Licensor networks the text of the strengt the text of the second secon

14. RELEASES: NO MODEL, PROPERTY, TRADEMARK, OR OTHER SUCH RELEASE EXISTS FOR ANY IMAGE(S) UNLESS LICENSOR SUBMITS TO CLIENT A SEPARATE RELEASE SIGNED BY A THIRD-PARTY MODEL OR PROPERTY OWNER.

15. ELECTRONIC RIGHTS: No electronic publishing or use of any kind is licensed unless specifically stated on the front of this Agreement. The use rights reserved by Licensor include, without limitation, all rights of publication, distribution, display, Transmission, or other use in electronic, digital and other media of any kind, now existing and yet unknown. Any rights licensed by Licensor for any use in a collective work exclude all use rights for any kind of revision of that collective work including any later collective work in the same series.

16. MODIFICATIONS, GOVERNING LAW AND MISCELLANEOUS: This Agreement sets forth the entire understanding and agreement between Licensor and Client regarding the Service(s) and/or the Image(s). This Agreement supersedes any and all prior representations and agreements regarding the Service(s) and/or the Image(s) whether written or verbal. Neither Licensor nor Client shall be bound by any purchase order, term, condition, representations, warranty or provision of the mass specifically stated in this Agreement. No waiver or modification may be made to any term or condition contained in this Agreement unless in writing and signed by Licensor. Waiver of any objections to the terms of this Agreement and the term or distributed in writing and signed by Licensor. Waiver of any objections to the receipt of this Agreement between 1 between a to the terms of this Agreement must be made in writing and delivered to Licensor writin the days of the receipt of this Agreement by Other provision of this Agreement. No objections to the terms of this Agreement, the contrary, no image(s) may be used to a waiver of any other provision of this agreement. No objections to the terms of this Agreement, and greenent, and under the constructive, or this Agreement. No objections to the terms of this Agreement, and the contrary, no image(s) may be used in any manner writing Licensor by provision of the same and the second agreement. The formation, interpretation, and performance of this Agreement the construction to the construction to the construction to the construct of this Agreement. The formation tare for reference only, and shall to be constructing this Agreement. This Agreement the formation and the construction the construing this Agreement. The formation there for orable to construct and construing this Agreement. The formation the formation control to the second the construction than construing the set of the second

OI!	0				
Client	5	lar	a	เน	re

Date

P

Case Study: Major Financial Newspaper

Client type: Major financial newspaper.

How they found us: A search on the Internet resulted in us being listed #3 for their search term.

Assignment: Portrait of a Washington, DC sports team for a special section of the paper, indoors in Washington, DC.

Deliverables: Several via e-mail or FTP, suitable for a full-page special section "cover" use.

Technical notes: Two complete setups in a sports arena, requiring six to eight heads per setup, and two assistants. One scouting visit. Total time shooting: 15 minutes; total setup, breakdown, and waiting time: 3 hours.

The initial inquiry came via phone call and was followed with sample photos of large groups of people via e-mail attachments.

From: John Harrington Sent: To: To: To: To: To: To: To: To: To: To
-
Attached please find several examples of group photos I left out the several team portrait, as it was probably not along the lines of what you were looking for. Here are three, two from assignments with the several Foundation to photograph science contest winners for an ad that ran in several (note that one is actually a scan from the ad), and the third was of a large group of several on-air talent folks for the cover of a magazine, and it's the scan from the cover.
Let me know how you'd like to proceed or if you have any additional questions. I look forward to working with you on this project!
Best,
John

The next morning, the client responded:

From: Subject: RE: Group photo samples Date: 10:18:26 AM EST To:

Thanks John.

It turns out that there will be much fewer players in the photo than I thought. More like nine at the very most. So that should be much easier to work with and easier to set up something more creative.

You can have this assignment. So let's talk today.

I am out of the office. Let me know when is a good time to reach you or if I should just e-mail all the details now.

The words "you can have this assignment" mean the client won't be talking to whomever else she contacted. The next e-mail included mock-ups from the client:

John

1.23

Attached are files with details. I've included a variety of possible layouts just so you can see that I will design the page around your photo composition. I can have any amount of body text on the cover. Any questions please let me know via e-mail or you can reach me at

il Swit

I scheduled a time to scout the location, and e-mailed the client low-rez files from the scout. A truncated version of the dialogue follows:

CHAPTER 10

Today, I was finally able to get in to see the **see** at **see**, and scout out the arena. I've got some preliminary ideas and images to accompany them that I wanted to share and get your feedback on.

Option 1 – I see this as my favorite option....

Option 2 – I see this as a variation on #1....

Option 3 – In this, the players position themselves amongst the seats.... A strong vertical.

Option 4 – I see this as one of the least attractive options....

Option 5 – Originally, I thought this could be a dynamic option, but....

I'd like to think we could do two options—perhaps 1 and 3 to give you some variety, unless you feel you really like one over another.

Let me know your thoughts/preferences....

Best,

John

The client responded:

Thanks John.

I agree that #1 works best. I also like #3 as long as the **second** is visible on the floor. Will you have time to possibly do both variations? Attached are some rough layouts. Although I don't know if I will keep the **second** image in the headline, especially if there will be **second** in the photo.

With the client and me in sync, I was able to put together final paperwork. I sent along an e-mail with dates locked down. And then sent this e-mail:

As you can see from the other e-mail I just sent, we're all set for the set shoot now.	
A few notes for you:	
—Because we're lighting two areas within a huge gym and a large group, I need to rent supplemental lighting.	CHA
—Because we are in two scenarios within a short timeframe, we are bringing in a second assistant.	PTER
Let me know if either of these is problematic for you. Attached is our paperwork, now that we have a date and details. If you'd sign and fax it back, that'd be great.	10
Best,	
John	

Later that day, I received the following e-mail, affirming the contract and additions. This is important because although we had an affirmation of the contract and additions, we'd not actually received the signed contract back. We would not be releasing high-resolution files until this occurred, but felt that the "this should be fine" response to the contract I sent was also a contract approval, just not as final as a signature would be. She wrote:

Thanks John. This should be fine. Glad everything is set. Also, I just wanted to mention that the layouts I sent you were just some possible ideas. Please shoot what makes a great image and I will work it out from there.

Talk to you next week.

Following the shoot, I reported in:

The shoot went great. We were able to get both perspectives we discussed of the coach and players (and some variations within each), and I think you'll be pleased with the results!

You can view the images in a Web gallery at:

Please let me know which image(s) you select, and what dimensions and dpi you need, and I will reopen the raw files and produce optimized images, dust spotted, etc., at that size, and post them on FTP for you to download.

On a housekeeping note—if you would be so kind as to sign and fax the contract back that'd be great. I know you acknowledged in the last e-mail that it was fine, but having the signed paperwork is necessary for our records.

Thanks again for calling on me. I'd love to get a PDF of your mockups with these once you've played around with them some.

Sincerely,

John Harrington

Later that day, an e-mail came in along with a fax of the signed contract. The response was:

Hi John,

Photos look great. Just called your studio and asked for some larger jpgs to work with before I decide on a final. I'm also attaching some ideas that I am working on. What I'd really like to do is have the image bleed. So in the end the final image will probably be about 12×12 ". Hope there is enough resolution to do that.

We wrote back:

We're working on them now. I will have them to you as 12×12 , 300 dpi, 8-bit JPEGs. When you make the final selection, I will deliver it as a 16-bit TIF at 12×12 300 dpi. Thank you for the revised comps. I am excited to see their incorporation into the page.

Best,

John

A few days later, the client reported the final results:

John

The report is on the newsstands today. Looks great. Hope you like it, too. I'll send you some copies and a pdf at some point.

Thanks,

The front page of the contract follows. Since the back page is identical to the previous example, there's no need to include it.

Photography	Estimate and Contra		
2500 32nd Street, SE Washington, DC 20020			Jonuac
(202) 544-4578 Fx: (202) 544-4579	Date:	42006 427	
To: Tel#	Job #: A.D.	A2006-127	
	Art Buyer:		
Fax#	Client:		
EMail: EMail:	Client #:	CL2006-1485	
	nembers of t ups as discu	nmental portrait of the team for one tin ssed following scou gallery, and final hi	ting. Shoot to
Fees Main Illustration		\$2150.00	
			\$2,150.0
Production Charges			
Crew - 2 - Assistants;175 ea	300000000000000000000000000000000000000	\$350.00	
Lighting Rental		\$250.00	
Travel - Parking/Tolls/Gas/Mileage\$20; Miscellaneous - Expendables-\$30; Photographic Imaging Charges, Photographic Imaging Charges, Co		\$20.00 \$30.00	\$650.0
Photographic Imaging Charges Photographic Imaging Charges - Co \$250;FTP/Digital delivery-\$85;	mputer/Sys	stem Time -	
			\$335.0
Third Part Fees Billed Direct to Client: Falent:(Talent fees and the scope of releases are the sole responsibilit	ty of Client.)	Subtotal	\$3,135.0
Other:	_	Sales Tax Total	\$3,135.0
Torma: Final hilling will adopt actual and a final data and a state		Advance	
Terms: Final billing will reflect actual, not estimated expenses, plus applicable sales taxes. All fees and charges on this invoice are for service(s) & licensing described above. Fees for licensing of additional available rights will be quoted upon request.Late charge is 1 1/2% per month after 30 days.			\$3,135.0

CHAPTER 10

Case Study: Consumer Magazine

Contract: Major consumer magazine.

How they found us: Internet search engine.

Assignment: They needed a portrait of a subscriber who was participating in a fitness challenge. The initial dialogue began on a Monday, for an assignment the next afternoon, Tuesday. The film went to our lab Wednesday, and was shipped out Thursday for Friday delivery.

Deliverable: 120mm film

Technical notes: Two setups at a gym: one on client-specified color seamless, and a secondary image as an alternate of the subject using a piece of exercise equipment. Location was entirely in a gym, and it was two setups with a total of three lights for each.

We proposed a fee of \$925, they countered with \$450, and we settled on \$675. The client was specific about a backdrop color, and we included that in the estimate. Further, in the end, we purchased a second backdrop after the contract was signed, which was included on the invoice. Although the photo editor signed the contract, after we had received the signed contract from the PE, her assistant sent us the magazine's standard contract, which was highly objectionable. After the fact, we also were confronted by the client's demand for the receipts—we responded, and our issue was resolved.

The following correspondence includes:

- Our contract's first two pages, which include the dollar figures
- Their counter contract
- Our e-mail traffic regarding the negotiation over the photographer's fees
- Our e-mail to the client with the attached invoice, and their receipts problem
- Our e-mail response to the client regarding their problem, and their acceptance
- ▶ Our "receipt" for the expenses

NOTE

If we had agreed to their contract, we would not have been able to facilitate the best film processing, nor could we have made our copies for copyright registration, because they would have held the film for six months. From: John Harrington Sent: 2000 Sentematic State Stat

Thanks for calling regarding the shoot for tomorrow. I look forward to hearing back from you at your earliest convenience regarding the seamless. We'll need to send a courier up to the local supply house to get the #62 seamless, or we'll drop the seamless from this estimate if you have Setpaper ship the seamless to us from NYC. If you do, please have them ship it and "HOLD FOR PICKUP AT FEDEX LOCATION" in Washington DC. Attached is our contract. Please look it over, call with any questions/concerns, and sign and fax back to confirm.

Thanks!

From: Sent: State of the sent
Hi John: Everything looks good except your rate. We pay \$450.00 a day against page usage. At this point, we are only going to be doing one page, but since we are going to be following the progress of these women who lost weight, we will be shooting again down the line. Hope our rates work for you.
Thanks,
From: John Harrington
Sent: Monday, 3:39 PM
To: Subject: RE: Sterling VA Shoot-
Thanks for the info on the rate. If the shoot was right in DC, it would be easier to come down
to that rate, but with the travel time to/from Sterling (i.e. 1–1.5 hrs outbound, rush hour, and
1 hr back during non-rush time, it'll take a bit longer than our normal shoot. Can we meet in the middle between your \$450 and my \$925, at, say, \$675?
Thanks,
Iohn

CHAPTER 10

From:
Sent: Monday, 2000 3:52 PM
To: 'John Harrington'
Subject: RE: Sterling VA Shoot-
Works for me. Thanks!

From: John Harrington Sent: Monday, 3:47 PM To:

Subject: RE: Sterling VA Shoot-

Great. Attached is the revised contract! Please sign and fax back, and at your earliest convenience let me know about the paper....

Best,

John

From: John Harrington Sent: Monday, 3:56 PM

To:

Subject: RE: Sterling VA Shoot-

 $OK\-$ #62 works for you.... I'll get it sent down from the local supply house for me. Consider it done....

Best,

From: Sent: Monday, Sent 4:31 PM To: 'John Harrington'
Subject: RE: Sterling VA Shoot- Ok, I just wasn't sure if we spoke about that or not. It's been THE most crazy day here today Thanks for everything!

From: John Harrington Sent: Monday, **Science 5**:08 PM To: **Sectore** Subject: RE: Sterling VA Shoot-

Can you fax back the contract before you leave today? If not, I'll need it in the AM tomorrow. Thanks,

John

TO: John Harrington From: Sent: Monday, Sent: Monday, Sent: Monday, Senter 5:18 PM To: 'John Harrington' Subject: RE: Sterling VA Shoot-Ooops, will take care of it right now.

From: John Harrington

Sent: Monday, 2010 Sent: 5:21 PM

Subject: SHOOT DETAILS? Sterling VA Shoot-

When you can, would you also forward the address/name/phone#/etc. for the subject, and if you have a low-rez file of the other shots you want matched (i.e. lighting, full-length/half-length/etc.), that would be great.

Best,

To:

From: Exception
Subject: RE: SHOOT DETAILS? Sterling VA Shoot-
Date: Monday, 5:35:47 PM EDT
To: 'John Harrington'
Cc: [Introduces her colleague with whom I'll be working via a CC]
Can be considered send everything to you tomorrow? She's the one who's been working on this shoot, and she has the folder with her at home (she was out today). I'll make sure she gets it out to you first thing. That ok?

From: : Subject: RE: Sterling VA Shoot-Date: Tuesday. 10:48:19 AM EDT To: 'John Harrington'

Again, thank you so much for doing this photo shoot for us today. Attached please find our photographer's contract along with our model release. Note: Our contract has the special agreed fee of \$675. Please sign it and include it when you send us the film along with the signed model release. I will also fax you a copy of a layout that our Creative Director enjoyed-the way the angles are. Again, shot her on both the white background and also the purple background. These shots are all full frame. Have her sitting Indian-style on the floor. jumping up and down, arms crossed and uncrossed, just standing there smiling, and some not smiling. Again, we have to have the same shots on both backgrounds. This is very important. Then she will change her top and just do some exercises with her trainer. These shots are all environmental.

Please call me when you receive this note. I am at

From: John Harrington Sent: Tuesday, 5:04 PM To:

Subject: RE: Sterling VA Shoot-

Thanks for the model release-I'll present it to the subject for her to sign (actually, now, we've just spoken, and I will await the NEW release). I have already forwarded-and received back signed—our standard photography contract, from **sectors**. The variation between yours and mine in terms of layout and content are so different that marrying them together isn't possible, really.

Thanks,

John

CHAPTER 10

Date: Tu	RE: Sterling VA Shoot- esday, Manufacture 5:06:44 PM EDT n Harrington'
	again for everything. Here is the additional information. I'll call you tomorrow to find v everything went.
Sent: Fr To:	ohn Harrington riday, Margaret 1 9:54 AM Harrington : Invoice
and due take a le	d is a PDF file of our invoice from the portrait shoot. As this is an electronic original, e to US mail slowdowns, we are not forwarding printed invoices at this time. Please ook at the invoice, and call with any questions. If you require a printed invoice, please office and let us know, and we can either fax it to you or mail it out.
Thanks	,
John	
From: Sent: Fr To: 'Joh	riday, 1999 and 1999 and 1999

Subject: RE: Invoice

Thanks but I need the backup for the expenses. Accounting will not pay without receipts.

From: John Harrington Sent: Friday, **Sector 11:48** AM To: **11:48** AM

Subject: Receipt

I have attached the best receipt I can prepare for you. Our Web site states our policy regarding receipts, in that we do not turn over receipts as a part of the invoicing process.

To see this, please visit http://www.johnharrington.com/rates and click on the link, but the information on the Web site appears below:

We do not supply clients with receipts for any expenses. We do this for several reasons:

—We are independent contractors, not employees. When tax time comes, the IRS requires us to provide receipts to verify expenses on our Schedule C. The IRS does not require you to have those receipts on hand.

—It is critical to the success of our business to maintain a proprietary suppliers network—an absolute cornerstone of a profitable business, and in an insecure environment we do not wish our competitors to learn who our suppliers are. While this is less applicable on film and processing than on unusual items, and from time to time applies to assistants as well, it is nonetheless critical throughout our supplier chain.

We have a set fee per amount of supplies used, regardless of what was actually paid for it. This is done for several reasons: 1) We keep film on file to meet last-minute and unusual requests, therefore we sometimes discard film which does not meet our technical expectations or which have been through several passes of an X-ray machine; this cost must be split across the cost of actual film shot, and 2) Time is taken to investigate new films, test films before they are used in shoots, go to the various suppliers we use, and maintain the stock necessary. The cost for this time, billed by staff, must be spread across the cost per roll.

By way of example, publishing houses do not request receipts from printing plants for the cost of ink and paper, nor receipts for the wholesale prices paid on the repair of a copier, nor gasoline receipts from the delivery service who delivers the copies of the magazine.

Please discuss with us any issues you have with this policy beforehand.

The IRS does not require you to have any documentation other than our invoice, which serves as your proof of expense. Please confirm that our policy will not delay payment being made.

Best,

The attached Word document read as follows:

	ngton Services ngton DC 20020 (202) 544-4578
Backdrops - two @ \$72.00 each Kodak EPP 120 film, nine @ \$5.00 each E-6 Processing, nine rolls 120 @ \$37.00 each Courier service, Round-trip service Assistant's fee Expendables	\$144.00 \$ 45.00 \$333.00 \$ 23.50 \$175.00 \$ 25.00
	TOTAL \$745.50

From: :	
Sent: Friday,	12:08 PM
To: 'John Harrington'	
Subject: RE: Receipt	

We understand that some photographers will not turn over original receipts for tax purposes, which is why we do accept Xerox copies as backup. But, our accounting dept. has guidelines and has to adhere to the same rules and regulations when we have our annual audits. They need backup for every bill. What you sent me is fine. Please just send another one for your assistant. This is the only expense you did not include.

Thanks,

Sent: F To:	John Harrington Friday, 12:18 PM ct: RE: Receipt	
	, 9 just revised the previous receipt to include the assistant's fee. Thanks	
Best, John		

CHAPTER 10

While this concluded our negotiations, I think it's helpful for you to read the text of the proposal they sent over. In addition, note that we did the follow-up shoot for them two months later, without further objection as to pricing or receipts policy.

PHOTOGRAPHY COMMISSIONING AGREEMENT MAGAZINE Issue: July Special Fee: \$675 page plus expenses Photo Shoot: Challenge: Photographer: John Harrington (the "Magazine") welcomes the opportunity to publish your photographs. Quality photographs are an important factor in the Magazine's success. You and , on behalf of the Magazine, hereby agree as follows: 1. will commission you to take photographs on specific photo shoot assignments from time to time for use in stories appearing in the Magazine (the "Photographs") in accordance with the following terms and conditions for each assigned photo shoot (the "Photo Shoot"). a) will pay you a sum calculated at the Magazine's current standard rate per day of the Photo Shoot. of \$ b) In addition to the payment in paragraph 1(a), will pay you the difference, if any, between the sum calculated at the Magazine's current space rate of \$450.00 per page of Photographs used in the story, and the payment in paragraph 1(a), except as provided in paragraph 1(d). accepts one (1) or more of the Photographs for use on the Magazine's c) If Web site, currently located at , (the "Web Site"), in addition to the payment in paragraph 1(a), where will pay you a one-time fee of One Hundred Dollars (\$100.00). accepts one (1) or more of the Photographs for use on the cover of d) If the Magazine, in addition to the payment in paragraph 1(a), will pay you the difference, if any, between the sum calculated at the Magazine's current premium cover rate, and the payment in paragraph 1(a). e) If, for any reason, does not wish to use any of the Photographs, in full consideration for your services in connection with the Photo Shoot, in addition to the payment in paragraph 1(a), while will pay you the difference, if any, between a kill fee calculated at fifty percent (50%) of the Magazine's space rate for the space in the Magazine planned for the Photographs, and the payment in paragraph 1(a), and all right in the Photographs granted to pursuant to paragraph 2 will revert back to you. will also pay your expenses for the Photo Shoot according to its f) current practices, upon submission of copies of receipts. All payments made under this Agreement, including those for expenses, will be reported as income on your year-end 1099 tax form. In addition: continued

i. You must make all travel and hotel arrangements and car rental through corporate account unless account agrees otherwise in advance; ii. will pay the current IRS-allowable rate for mileage for use of your own car and its current standard rate, now \$_____ a day, for travel time; will arrange locations, studio booking and crew lunches; iii. iv. will pay its current standard rate, now \$175.00 a day, for an assistant; for more than one assistant, the rate will be paid as agreed in advance: v. Prior approval by the Magazine's photo editor (the "Photo Editor") is needed before renting any photographic equipment, which should be ordered, along with film and other photo supplies, through vi. You must process film with one of the Magazine's "approved" labs; and vii. You must deliver all film to the Photo Editor only through messenger service, the identity of which should be requested through the Photo Editor. 2. You hereby grant to **be a set of the following rights in each Photograph taken by you for a** Photo Shoot: a) The exclusive right to publish the Photograph in the Magazine prior to publication by any third party, in any form throughout the World, and the right to reproduce, use and distribute the Photograph as part of the issue of the Magazine in which it appears; b) The exclusive right to use the Photograph for a period of six (6) months from its first publication pursuant to paragraph 2(a); c) The ongoing right to publish and use the Photograph as well as your name, likeness and biographical information, to advertise and promote the Magazine and/or d) The ongoing right to publish, use and distribute the Photograph, as well as your name, likeness and biographical information, on the Web Site; e) The ongoing right to publish and distribute the Photograph in any special interest publication or book of the Magazine, or in any other magazine or publication published or distributed by upon payment of such publication's thenprevailing space rate; f) The ongoing right to include the Photograph in a print anthology with other material published in the Magazine, upon payment of ten percent (10%) of the original rate pursuant to paragraphs 1(a), (b) and (d); g) The ongoing right to license rights to publish the Photograph to other periodicals throughout the world directly or through a syndication company, upon payment of fifty percent (50%) of the net proceeds receives for such license; and h) If the Photograph is used on the cover of the Magazine, the ongoing right in all media to use the Photograph as it appears on the cover for editorial, advertising and promotional purposes, and to license third parties to use such cover upon payment continued

. for at least

of fifty percent (50%) of the net proceeds received for such license (in addition to the Magazine's current premium cover rate).

3. The original separations and all seconds will be kept by **Explored** for possible future use. The remaining film will be returned to you. You agree not to sell this film or photographs similar to any Photographs to any women's service magazine or related Web site, including, but not limited to,

six (6) months from the off-sale date of the issue of the Magazine in which such Photograph first appeared.

4. You will be credited in the Magazine, in any other **publication** publication in which any of the Photographs appear, or on the Web Site if the Photographs appear thereon, consistent with that particular publication's or the Web Site's style.

5. You should retain duplicate prints of the Photographs. **Second will take good care of** any original prints and color negatives while it has possession but shall be responsible for each only up to the rate paid for use under this Agreement.

6. You warrant and represent that the Photographs are original to you, you have the right to grant the rights granted herein, there has been no prior sale, publication or transfer of rights to the Photographs, and publication of the Photographs will not infringe upon any other person's copyright or other rights, including, without limitation, the rights of privacy or publicity. You agree to indemnify and hold **Exercises** harmless from any and all loss or expense suffered by reason of the breach of any of these warranties.

7. Upon request, you will furnish **and states with properly executed model releases on the** Magazine's standard form supplied by the Photo Editor.

8. Payment will be made upon separate invoice for each Photo Shoot. You shall include on each invoice (a) the name of the story for which the Photographs are taken and the Magazine issue in which such story is scheduled to be published, both of which shall be supplied by the Photo Editor, and (b) a list of fees and expenses incurred in connection with such Photo Shoot, separately itemized. You shall attach to each invoice model releases and copies of all receipts for fees and expenses. Payment will be made in the ordinary course of business after attached to the above.

9. The parties acknowledge that the services performed by you under this Agreement are performed as an independent contractor, not as any employee or agent, and that you are responsible for the payment of all federal, state and local personal income taxes and any other taxes arising out of payments made under this Agreement. You acknowledge that unemployment compensation will not be available as a result of services performed under this Agreement and that **services** is not responsible for obtaining insurance or other compensation covering accident or injury arising out of the performance of this Agreement or otherwise.

10. This Agreement shall be governed by the laws of the State of New York. This letter and the Magazine's schedule of current photography rates shall constitute the entire agreement between you and **second regarding its subject matter.** No amendment or waiver shall be valid unless it is in writing and signed by both you and **second regarding**.

continued

If the foregoing correctly states the agreement between you and states and , please sign and return both copies of this letter.	
Sincerely,	
Magazine	
ACCEPTED AND AGREED TO: Name: By: Date: Social Security Number:	

Chapter 11 Contracts for Corporate and Commercial Clients

"Corporate" and "commercial" photography are phrases that are often used interchangeably. Sub-types within those types of photography, including annual reports, PR, advertising, catalogues and brochures, executive portraiture, and internal communications materials, are among the numerous derivations of these two "parent" types of photography. One key thing to understand is that these types of photography are *not* editorial—someone has quantified a benefit to the bottom line, either in the short term or long term, by engaging photographic services. An editorial shoot ultimately has to benefit the bottom line of a publication by contributing to retaining existing subscribers or influencing new readers to subscribe, which will increase the eyeballs looking at the publication, which in turn will validate or increase ad sales. The cause and effect in editorial is not as distantly related (for the most part) as that of corporate or commercial types of photography.

What's the Difference between Corporate and Commercial?

Corporate photography is initially best defined as what it's not. It's not photography created to offer or promote a particular commodity. It is usually organizational statements, which seek to clarify an organization's "brand." The photographs tend to have more of a purpose beyond selling, and they are usually more serious in tone. Most (but not all) annual report work I would term "corporate," even though the imagery might seem to be of a product or service the company offers. Executive portraits of the CEO, president, CFO, COO, and other company officers used on the organization's Web site or intended to be made available to the press would fall under the corporate rubric. Also in this category would be "feel good" public efforts to establish a company as compassionate, caring, or connected to a community, as well as imagery for organizational communications that seek to inform or educate its internal audience of employees and vendors.

Corporate-type photography is by no means limited to corporations. Numerous other entities employ corporate photography, such as philanthropic organizations seeking to promote their causes or efforts to make the world a better place; organizations seeking cures to terminal diseases by illustrating the end stage, waypoint conditions, or how these diseases affect everyone; and disaster aid organizations who do good after a community or nationwide incident and document that work not only to justify their outlays to the disenfranchised, but also to ensure an ongoing influx of donations to maintain their existence and make a difference in the future. As a way to illustrate the separation of style from the use that the photography, schools that teach photojournalism use the work of Angus McDougall. McDougall produced photography for International Harvester's in-house publication, *International Harvester World*, back in the late '60s and early '70s. His work was stylistically photojournalism, but was, in fact, corporate work for what was termed a corporate magazine, following his work for the *Milwaukee Journal* and *Life* magazine.

Commercial photography is essentially photography created to offer or promote a particular commodity, from services of every form and type to physical products from A to Z. There are media buys in editorial publications, sales materials, consumer brochures, posters, billboards and transit ads, stills in television commercials, trade show booths, product photography, and the list goes on and on. One variation on this type of work is when you are working for a political campaign, which is definitely not editorial, but is used to promote the candidate, rather than a corporation. As noted in Chapter 17, "Resolving Slow- and Non-Paying Clients," make sure that you are paid in full before or upon delivery. It is standard that all work done for campaigns is paid without the extension of terms such as 30 days or 60 days.

It might be easiest to understand if you consider that when you're doing corporate or commercial photography, there will usually be many more people giving direction and signing off on the finished product. I have found myself waiting hours as a photo I produced at a public "news" event, which was covered by the news media, is pored over and an excruciatingly correct caption is written by a legal department. Coming from an editorial background, I know that the photo desk and a final editor are no doubt going to rehash the caption if it ever runs in the first place.

Consider an example, written by me, the editorial photographer assigned to cover the news event. This isn't a real caption from a real event—that should be obvious. It is, however, nearly identical to caption delay experiences I have had for corporate clients with whom and for whom I have worked.

As Anytown High School junior Gina Jones (left) looks on, Honda CEO Phil Albertson (right) explains how the new Acura runs off hybrid technology, Monday, February 29, 2006, in Detroit, Michigan. Jones won an essay contest that will award her the Acura, and Honda donated the car to the local Sierra Club chapter for the contest.

When lawyers and numerous other "communications" experts get involved, here's an example of what you might get:

Honda North America Consumer Division President and CEO Phillip E. Albertson Jr. (right) demonstrates the safety and clean-running features of the 2005 Honda Acura ELX Clario-Hybrid[™] technology, the first of Honda's USA-branded products to carry the technology, to Anytown, USA High School student and Sierra Club 2006 essay contest winner Gina Jones (left), who wrote about how the planet could be saved if more Americans looked to safer and cleaner fuel technologies, such as those that Honda has introduced, two years before the Congressional mandate to include the technology as an option. The 2005 Honda Acura, on display here in Detroit,

Michigan, is on a nationwide tour to demonstrate the technology and as an award to 10 students across the country. The tour began today, February 29, 2005, and runs through April 1, 2005.

From my perspective, I don't need to know much of the second example's sales lingo. I am not about to put a trademark symbol in my caption. My caption meets AP style, and mine would have made the East coast deadlines and been put into newspapers, whereas the second caption came two hours later and was approved by Honda's lawyers, Clario's lawyers, and the Sierra Club's vice president for communications, among others.

What a Corporate or Commercial Contract Must Have

Corporate and commercial contracts, on a basic level, must have the same things as an editorial contract—a signature, rights outlined, fees agreed to, and the like. For a more in-depth outline of those, see Chapter 10. However, there are other issues at stake. It's important to detail exactly who the end user of the images is.

If your client is Docomo Shoes, you were hired to cover their donation to the Race for the Cure footrace in your community, and all the shoe wearers are cancer survivors whose participation in the race is sponsored/underwritten by a pharmaceutical company, you have potentially three parties who could use your photos, but only one should be licensed to do so, unless you enter into a multi-party agreement. More on MPAs later in the chapter.

There must also be an understanding about who has final authority to sign off on the resulting imagery from an assignment. Suppose an AD is at the shoot with a PE, and the AD heads for a lengthy restroom break, and the PE gives you what you think is approval on two images with the phrase "looks good." But suppose you come to find out after the fact that the PE was offering his opinion, and only the AD could sign off before the next image. Now you've got a problem. Typically, my contracts state that the client must always provide someone on-site to approve images and, absent that, they agree that I may make the determination as to suitability of images and setups without penalty or withholding of payment.

You'll want to know if the process is A) a bid, which implies a fixed or "do not exceed" cost outline; B) a quote, which implies concepts similar to a bid, or C) an estimate. All the contracts I send out are estimates. They carry the understanding that there could be fluctuation in the costs when circumstances change. When the parameters or circumstances change for a shoot, so do (or should) the figures involved in the estimate. As with an editorial assignment, in which the concept of a "change order" is less common, change orders are a frequent necessity for corporate and commercial assignments. When the client adds an additional subject, look, or second setup "just in case," that additional time, effort, and creative energy carries additional charges and expenses. You'll want to make sure you understand and agree with who's booking (and paying) talent if models are necessary, and affirm that their usage is consistent with the client's. Back in the day, models were not concerned about usage; now they are.

Unlike editorial clients, who have their own contracts to send, most corporate and commercial clients do not and will expect you to send yours, which should be thorough and clear. One

thing that will get many an estimate nixed is when there is a six-hour shoot in some far-off location, and you have not included catering in the estimate. Is everyone supposed to just scatter to the four directions when they get hungry? Little things like this can illustrate to a client that you know what you're doing on an assignment.

If the corporate photography is "event-type" coverage of a press conference, an all-day symposium, an awards banquet, a foot race, or another activity-related photography, your start and wrap times are essential and must be outlined with ways to calculate overages when things run late.

If you're called into a law firm to photograph a dozen attorneys, make sure your paperwork details that it's for 12 portraits, and allow for additional portraits (time permitting) for an additional fee. I can't tell you how many times I have found myself called in for a dozen portraits, only to end up doing more than 20. Having a clear understanding of how this will affect the final bill means that the client is informed and minimizes the client's ability to object when the final invoice arrives.

How to Work through a Contract Negotiation for Corporate/Commercial Clients

Unlike editorial clients, who have a much higher tendency to object to expense types and levels, it has been my experience that corporate/commercial clients have fewer objections to expense line items. Although they might suggest that a star trailer or production trailer is not necessary for the assignment, and they will feel free to tell you so, they won't object to the other items that they know will contribute to a smoother, stress-free assignment. In fact, as noted about catering, leaving out things such as permits for the CEO's radio car to remain on location in a rush-hour lane of traffic during the on-location shoot or having a makeup person *and* stylist for their annual report portrait can leave the client wondering whether you're the right person for the assignment.

Negotiations for these types of assignments usually first center around the photographer's creative fee, which is also seen as their assignment fee or, as noted before, their day rate. Once the client moves past that, they'll be reviewing your usage terms and figures. I often try to get a feel for what the prospective client is looking for. Early on, I'll always pose the question, "What kind of budget are we working with for this project?" Responses usually are:

- "Our budget for the photography at the press conference is \$1,000."
- ▶ "We have \$4,500 for the three days of symposium photography."
 - "We need to keep this under \$5,000 for the ad."
- "Our entire budget for the assignment, including expenses, is \$8,000 per shoot, and there are five shoots."
- ▶ "We have \$15,000 to pay for you, the eight models over two days, and the printing for the brochure, soup to nuts."

These give me a good feeling for what the client is expecting and whether the budget is realistic. Just as with a low-budget editorial assignment, I will send an estimate for the project because I know when a stated budget is just too low and when I can't see how anyone would be able to satisfactorily complete the assignment for that figure. As such, I want the client to consider me, so I won't blow off the assignment estimate by thinking they'll never go for me. I send it, and often I get the assignment. Contrary to many people's opinions, money is not always the deciding factor. On many occasions I have been the most expensive photographer, but the client had confidence in my abilities based upon my experience, track record, or how I presented myself during our conversations.

Often, a client will say, "We need a buyout," or "We need all rights," or some other absolutely untrue or liability-laden ambiguous statement. Any proposed definition of "buyout" is a dubious one, and I can't fathom any company actually needing all rights, let alone needing any rights "in perpetuity."

What these clients want is protection. They want protection from you using the image in a manner they don't want, protection from being gouged on prices later when they need to extend or expand a licensing package, and protection from you suing them when they use a photo for something they genuinely think is within their license, but you believe is not. These concerns can be alleviated by an accurate and clear licensing agreement.

Here are some examples of workarounds for these types of circumstances:

- ▶ For the life of the campaign, photographer grants non-exclusive rights to use photography in all non-paid media placements in the United States.
- ▶ For 24 months following the conclusion of the symposium, photographer grants exclusive rights to client to promote future symposiums in electronic, printed brochures, and trade advertising client may produce, as well as "hand out" images as a part of a press kit to other trade press writing about the symposium.
- ▶ During the lifespan of the product, photographer grants client the exclusive right to use photographs produced to sell, promote, or advertise the product in print and electronic mediums, within the United States and the European Union.

Any of those workarounds would be far less egregious than "all rights," WMFH, or the dubious "buyout."

During the negotiations, you'll want to learn who the other stakeholders in the event are. If it's an awards ceremony at which three pharmaceutical companies are getting commendations for their good deeds, and you are working for the event, you'll want to make sure you're comfortable with these companies using your work in their press outreach for the event. If you're working for one of the companies, when the PR/communications person you're working with comes over and says, "Hey, make sure you shoot the CEO from the other two companies too," you'd do well to discuss with him at your earliest convenience that, although you are working for him/her, if the other companies are going to be using your work, you'll need to make those arrangements directly with them. These things happen when the other companies forget to bring a photographer (or decide it's not important), and then your client offers to split

your fees and expenses with them. This isn't fair, and you should preclude this from happening by clearly stating on your contracts that "Company X is granted the following rights." You could even state that the rights are not conveyable or transferable to third parties.

For advertising work, you will almost always be dealing with someone from an ad agency or a knowledgeable person in a company's marketing or external affairs department. You'll want to make sure they're providing you with comps (mockups or draft layouts) for the assignment, and ask what the media buy will be. Further, what other uses do they anticipate?

Realize that often the client has a favorite. Frequently I will ask, "Am I estimating this as a courtesy because you have someone in mind and need three estimates? Am I that person? Or are you open to seeing what you come up with on the estimates and awarding the work based upon that?" Many times the favorite is a repeat photographer for the firm or company, or someone they've wanted to work with now that they have the budget to afford that photographer.

I will also make a point of asking who else they are talking to, and most of the time they tell me. If I know I am bidding against a former assistant and a weekly newspaper photographer 10 years my junior, as with editorial clients, I am likely to let them know that they're not really comparing apples to apples, that there is a breadth of experience differential between us, and that I will more than likely not be the least expensive.

On the occasions when I do not win the assignment, I will ask a few follow-up questions. First, I will call the client and thank them for the opportunity to be considered. I tell them that although this may not have worked out, I hope to work with them in the future. I then ask whether the main criterion for choosing the photographer was price. With that answer (regardless of the answer), I'll ask who they chose. I make an absolute point of not being petty and finding fault with the choice, although it might be easy to do when I know that the photographer in question, while having a great Web site, just graduated from photo school and will have challenges I don't think he or she can surmount for this assignment. I close the conversation again with a, "Thanks again; I look forward to the possibility of working with you in the future." You'd be surprised by the number of times over the years that the client has come back a few days after the date of the shoot and hired me on an expedited basis because they did not get the results they needed from their first choice for the assignment. I am always gracious and enthusiastic about making the assignment happen. Not only was my initial observation correct (which I would never point out), but I know I have won a client for a long time to come. I have clients who have left over rights issues (in other words, they wanted all rights, and I didn't concede to that), only to come back after lackluster results from their choice, saying, "What do all those rights do for us if the photos are not as good as we need in the first place?"

One major caution when granting rights to event photography beyond editorial or "press" use: If you're licensing "all rights," which includes advertising, the Web (which can be a form of commercial, corporate, or even editorial use), brochures, and so on, you must be absolutely certain you have releases from everyone in the photos that grant you the authority to license those rights. Imagine a scenario in which you buy a car with an AM/FM radio. You drive it for three months, and then finally get around to listening to the radio, since you're mainly a CD person. You are greeted with a message that says, "The manufacturer of this car included the capability of FM broadcasts, but you must pay an additional licensing fee for the use of the patented technology that enables FM to work." You'd sue, and rightfully so—you bought a car with an AM/FM radio, but you can't use the FM without paying more. This is the same as a situation in which you agree to license all rights, and the client exploits that clause and uses the photos in brochures and such, and several of the subjects see themselves in these brochures or trade ads, so they contact the company. The company can easily stand behind the "we licensed all rights from the photographer" claim, and then the subjects will be hot on your trail for licensing rights that they never granted you, and then you're on the hook. If you have a model release, then by all means license away, but absent that, don't license to third parties rights you yourself don't have.

Additionally, when addressing the issue of use of photography on the Web, many editorial clients might try to stipulate that their Web editions are extensions of their print edition. The easiest way for you to stop this attempt at a connection is to illustrate that the advertising in the print edition is not the same as that of the online edition, and as such, the publication is charging separately for the Web edition's advertising. It is recommended that you handle both separately and bill for both separately. A clear example of this was the case of Jonathan Tasini vs. the *New York Times* that made its way to the Supreme Court and resulted in a finding in favor of the author, not the publisher.

Multi-Party Licensing Agreements

In more than one instance, I have been faced with circumstances in which my work, commissioned by one party for their non-transferable use, winds up being used by a third party without my permission. Here are two situations.

The first was a promotional campaign for an association that represents a number of similar industry-related companies. The photograph that I produced used an employee of one of the member companies depicted in a manner that placed the industry (and, as such, that company) in a positive light. Although the association had the right to use the images, no license existed for the member company, who decided to use the photograph in an advertisement, which I stumbled across one day by accident.

The second instance was an event I was photographing that included several prominent individuals from different companies. All were presenting their positions on a subject at the event, and as such, I was photographing all speakers. However, I was hired by only one speaker. My client representative, when approached by one of the other company's representatives, seemed to intimate that not only would they provide copies of all of the images, but that they would then just split the costs of my services. A delicate conversation ensued between me and the originating client representative.

In both of these circumstances, an amicable solution was reached. However, having the proper paperwork in place beforehand can eliminate misunderstandings and build a stronger case for you should you and the other parties fail to come to an amicable solution. Consider this extremely simplistic example: Your photography fees for client A are \$1,000, and your expenses associated with that assignment are \$500, for a total of \$1,500. By expanding the agreement to one that includes a second party, whereas their license could also be \$1,000, they would split

the expenses, so both parties would pay \$1,250. A variation on that is to extend to both clients a discount as an incentive to collectively license their own rights packages, and reduce each by a percentage, say 10%. So, this would reduce both parties to a \$900 assignment/licensing fee, and the split expense of \$500, for a total of \$1,150 for each party.

Multi-party licensing agreements frequently come into play where the initial client is the architectural firm, and the secondary client may be the builder, and even a third client may be the owner. Further potential licensing parties could be building management and major tenants. However, these are agreements that are entered into before the assignment occurs. Avoid the concept of allowing for a retroactive assignment for one of the potential parties who was unwilling to sign on before the assignment took place. That client should now be licensing the work you produced for the original client as stock. Offering additional parties an after-the-fact deal would be unfair to the other parties who assumed the risks inherent in commissioning the work beforehand.

Another school of thought is to establish the fee for the original shoot, and then add between 20% and 30% of the photographer/licensing fees per additional client, and then divide the total among the assigning clients. This works well when all clients have a similar rights package they need. Where clients' licensing needs differ between licensors, simply allocate fairly the base rights package as before, and then add in an additional licensing fee for the expanded uses.

It is critical for all agreements that all parties are signed on to the contract before the work begins. This means signatures from all parties, literally. Whether all parties sign the same document or you present to each separate documents, make sure that everyone understands what's going on. It is absolutely imperative that you are up front and clear about the terms among all clients. Fostering long-term and open relationships with all the parties ensures that no one feels that they are being taken for a ride. Further, although there is one school of thought among some photographers that one party can handle the overall sum and single contract with you, and the other parties can deal with them, I discourage that because it causes the one party to falsely believe they have some degree of ownership of the images. Moreover, should the other parties down the line wish to extend or expand a license, there is already a relationship between you and that party.

There's an important point, especially for architectural or fashion photographers, or for almost any circumstance in which what you are making images of is the work of another. When, for example, you are photographing buildings on assignment for the architect, you are not a part of the build/design team. You are utilizing your creative vision to provide your interpretation of their work, and that work is yours. Further, that architect may feel he can sublicense or transfer his license to other interested parties, so make certain that your language precludes this. Working with an attorney, you can, with limited expense, create boilerplate language that will be useful for a wide variety of situations.

Case Study: Law Firm Portraits

Client type: Law firm in need of portraits of several attorneys.

How they found us: A referral from one of their clients.

Assignment: Portraits against seamless, head and shoulders.

Deliverables: A CD including the selected image of each attorney, and one 5×7 .

Technical notes: This was a fairly straightforward shoot—single softbox front left, hair light rear right, litedisc reflector on subject's right to reflect back onto the subject the falloff from the softbox on the front, and a graduated background light on the five-foot-wide seamless. In addition, we had on location our laptop, which allowed for the preview and approval of each subject's image before he or she left the room.

Initial inquiry came via the following e-mail, and the dialogue continues after that:

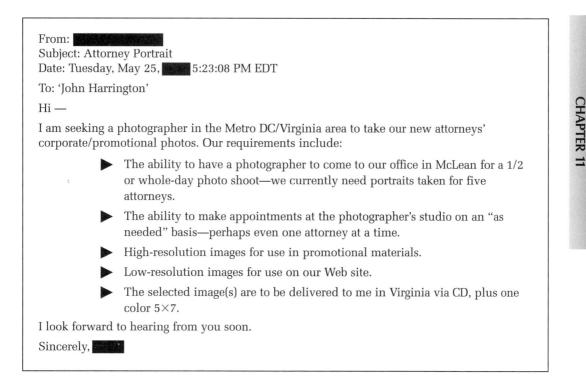

From: 'John Harrington' Sent: Wednesday, May 26, 2007 4:19 PM To: 2007 Subject: Requested Estimate for Attorney Portraits
Dear ear ,
Attached are two PDF files of the estimates you requested for eight portraits, with an additional "one-off" portrait estimate included. The location/additional information we have for this event is:
Please look the attached estimate over and call with any questions. Please let us know when you have a date, and we will send you a dated contract identical to those attached for your review and confirmation. While we are currently indicating we are available for the date and time you have requested, we don't guarantee or commit our photographers' time until we've received the signed estimate back.
Please ask the subject(s) being photographed, for men to wear solid-color shirts (preferably white) and suits that are not solid black, and for women to wear blouses that are not overly patterned. For men, they should plan to shave within 2–3 hours before the shoot, and women should bring their makeup for touchups just before the shoot will occur.
We strongly encourage the use of makeup services for this portrait shoot. For an explanation as to why, please review:
http://www.johnharrington.com/whymakeup
We look forward to working with you.
Best,
John

From: Subject: RE: Requested Estimate for Attorney Portraits Date: May 26, State 4:35:45 PM EDT To: 'John Harrington'

Thanks so much. How does June 7–9 look on your calendar?

From: 'John Harrington' Sent: Wednesday, May 26, 9:04 PM To:

Subject: Re: Requested Estimate for Attorney Portraits

Currently all three days are available. I have something in the evening on the 7th and midday on the 9th, although I do expect those days to book up probably midweek next week, as I often get commitments a week or so out.

I look forward to the possibility of working with you!

Best, John

From: Subject: RE: Requested Estimate for Attorney Portraits Date: May 27, State 3:36:50 PM EDT To: 'John Harrington'

Hi John —

Let's go ahead and book time—half-day probably—for June 8, a Tuesday. When would you like to start?

Thanks,

From: 'John Harrington' Sent: Thursday, May 27, 2017 PM

To:

Subject: Re: Requested Estimate for Attorney Portraits

2. 10x 1

Great! I am happy to be doing your firm's portraits! Let's arrive at 11am. It takes about an hour to set up, so we'll start with folks around noon. Plan 20–30 min (max) per person. Let me know if you'd like to get started earlier. Once you let me know that those times are okay, I'll forward the dated contract for your review and signature.

Best, John

From:

Subject: RE: Requested Estimate for Attorney Portraits Date: May 28, 6:34:11 AM EDT To: 'John Harrington'

I think that should be fine, but we will be lucky to get each person for 10–15 minutes—they tend to show up and run. :o) I will book them for 20 minutes apart, except for the challenging ones, which I will book 30 minutes. Can you tell me, the first photo will be at 11am? Thanks again,

From: 'John Harrington' Sent: Tuesday, June 01, 9:21 AM To:

Subject: Re: Photo Estimate for: Monday, June 7

We'd arrive at 11am, and the first appointment would be at noon.

From:

Subject: Contract

Date: June 1, 22:06:09 PM EDT To: 'John Harrington'

John —

Here is a scanned PDF of our signed contract. Can we give you a check on Monday for the full amount?

	Photography			
	Energia -			
	2500 32nd Street, Southeast Washington DC 20020-14 (202) 544-4578 (800) 544-4577 FAX (202) 544-4579	104		
•	v:	Мау		
via	e-mail			
Dea	u .			
Tha our	ink you for contacting me recently regarding your photographic availability and an estimate of the cost of securing photograph	c needs. This letter se nic services for covera	rves as an affin age of those ev	rmation of ents.
EVE	ENT SPECIFICS:	Our Arrival T		:45 AM
	TE: Monday,June	Shoot begin	10 ut	:00 PM
	CATION: Office in the VA	Event End Ti		00 PM
		# of Portraits	·. ·	
Once the we a	ASE SIGN ON THE SECOND PAGE AND FAX THIS ESTIM *(Note: increasing quantity of portraits will increase of e confirmed as an assignment from you and time of Photographer's fees and any expenses incurred pri- are able to re-book the time we have committed to	overall shoot fees ar committed, a cance for to cancellation	nd expenses) ellation fee o	of 100% of
Once the we a My e	*(Note: increasing quantity of portraits will increase of e confirmed as an assignment from you and time of Photographer's fees and any expenses incurred pri- are able to re-book the time we have committed to estimate of the cost for this job breaks down to:	overall shoot fees ar committed, a cance for to cancellation	nd expenses) ellation fee o	of 100% of
Once the we a My e	*(Note: increasing quantity of portraits will increase of e confirmed as an assignment from you and time of Photographer's fees and any expenses incurred pri are able to re-book the time we have committed to	overall shoot fees ar committed, a cance ior to cancellation you. tipulated below: e the cost to s on past due which require 30	nd expenses) ellation fee o	of 100% of
Once the we a My e	*(Note: increasing quantity of portraits will increase of e confirmed as an assignment from you and time of Photographer's fees and any expenses incurred pri- are able to re-book the time we have committed to estimate of the cost for this job breaks down to: Photographer's Fees Fee for Photographic services and Usage Fee for usage st Administrative Fee - We are now building into the invoice repeatedly follow up with accounts payable departments invoices, and float the cost of payment to our vendors, yo days payment. This fee is approximately 10% of this est is made within 30 days, you may deduct this amount.	overall shoot fees ar committed, a cance ior to cancellation you. tipulated below: e the cost to s on past due which require 30	nd expenses) ellation fee d will be bill \$1,310.00	of 100% of ed unless
Once the we a My e	*(Note: increasing quantity of portraits will increase of e confirmed as an assignment from you and time of Photographer's fees and any expenses incurred pri- are able to re-book the time we have committed to estimate of the cost for this job breaks down to: Photographer's Fees Fee for Photographic services and Usage Fee for usage st Administrative Fee - We are now building into the invoice repeatedly follow up with accounts payable departments invoices, and float the cost of payment to our vendors, yo days payment. This fee is approximately 10% of this est is made within 30 days, you may deduct this amount.	overall shoot fees ar committed, a cancel for to cancellation you. tipulated below: e the cost to s on past due which require 30 timate. If payment otographer's Fees	ad expenses) ellation fee d will be bill \$1,310.00 \$175.38	of 100% of ed unless
Once the we a My e	*(Note: increasing quantity of portraits will increase of e confirmed as an assignment from you and time of Photographer's fees and any expenses incurred pri- are able to re-book the time we have committed to estimate of the cost for this job breaks down to: Photographer's Fees Fee for Photographic services and Usage Fee for usage st Administrative Fee - We are now building into the invoice repeatedly follow up with accounts payable departments invoices, and float the cost of payment to our vendors, v days payment. This fee is approximately 10% of this est is made within 30 days, you may deduct this amount. Total Pho-	overall shoot fees ar committed, a cance ior to cancellation you. tipulated below: e the cost to s on past due which require 30 timate. If payment otographer's Fees Ills)	ad expenses) ellation fee o will be bill \$1,310.00 \$175.38 \$1485.38	of 100% of ed unless \$1485.38
Once the we a My e	*(Note: increasing quantity of portraits will increase of e confirmed as an assignment from you and time of Photographer's fees and any expenses incurred pri- are able to re-book the time we have committed to estimate of the cost for this job breaks down to: Photographer's Fees Fee for Photographic services and Usage Fee for usage st Administrative Fee - We are now building into the invoice repeatedly follow up with accounts payable departments invoices, and float the cost of payment to our vendors, v days payment. This fee is approximately 10% of this est is made within 30 days, you may deduct this amount. Total Pho- Post production fees - 100 to 250 images (Approx 3 - 7 ro	overall shoot fees ar committed, a cance ior to cancellation you. tipulated below: e the cost to s on past due which require 30 timate. If payment otographer's Fees IIs) delilvered to you): C	d expenses) ellation fee o will be bill \$1,310.00 \$175.38 \$1485.38 D-ROM	of 100% of ed unless \$1485.38 \$250.00
Once the we a My e	*(Note: increasing quantity of portraits will increase of e confirmed as an assignment from you and time of Photographer's fees and any expenses incurred pri- are able to re-book the time we have committed to estimate of the cost for this job breaks down to: Photographer's Fees Fee for Photographic services and Usage Fee for usage st Administrative Fee - We are now building into the invoice repeatedly follow up with accounts payable departments invoices, and float the cost of payment to our vendors, v days payment. This fee is approximately 10% of this est is made within 30 days, you may deduct this amount. Total Pho- Post production fees - 100 to 250 images (Approx 3 - 7 rol Output method of digital files (i.e. How will the images be of	overall shoot fees ar committed, a cance ior to cancellation you. tipulated below: e the cost to s on past due which require 30 timate. If payment otographer's Fees IIs) delilvered to you): C	d expenses) ellation fee o will be bill \$1,310.00 \$175.38 \$1485.38 D-ROM	of 100% of ed unless \$1485.38 \$250.00 \$175.00
Once the we a My e	*(Note: increasing quantity of portraits will increase of e confirmed as an assignment from you and time of Photographer's fees and any expenses incurred pri- are able to re-book the time we have committed to estimate of the cost for this job breaks down to: Photographer's Fees Fee for Photographic services and Usage Fee for usage st Administrative Fee - We are now building into the invoice repeatedly follow up with accounts payable departments invoices, and float the cost of payment to our vendors, v days payment. This fee is approximately 10% of this est is made within 30 days, you may deduct this amount. Total Pho- Post production fees - 100 to 250 images (Approx 3 - 7 ro Output method of digital files (i.e. How will the images be of Shipping - Proofs/CDs to/from lab and to client via: Fede Event Prkng/Misc - If Images delivered under	overall shoot fees ar committed, a cance ior to cancellation you. tipulated below: e the cost to s on past due which require 30 timate. If payment otographer's Fees Ils) delilvered to you): C eral Express Overnig	d expenses) ellation fee o will be bill \$1,310.00 \$175.38 \$1485.38 D-ROM ht - \$18.75	of 100% of ed unless \$1485.38 \$250.00 \$175.00 \$18.75
Once the we a My e	*(Note: increasing quantity of portraits will increase of e confirmed as an assignment from you and time of Photographer's fees and any expenses incurred pri- are able to re-book the time we have committed to estimate of the cost for this job breaks down to: Photographer's Fees Fee for Photographic services and Usage Fee for usage st Administrative Fee - We are now building into the invoice repeatedly follow up with accounts payable departments invoices, and float the cost of payment to our vendors, v days payment. This fee is approximately 10% of this est is made within 30 days, you may deduct this amount. Total Phe Post production fees - 100 to 250 images (Approx 3 - 7 rol Output method of digital files (i.e. How will the images be of Shipping - Proofs/CDs to/from lab and to client via: Fede Event Prkng/Misc - If Images delivered under this is the estime If payment is made within 30 days, you may deduct th	overall shoot fees ar committed, a cance ior to cancellation you. tipulated below: e the cost to s on past due which require 30 timate. If payment otographer's Fees IIs) delilvered to you): C eral Express Overnig normal two day ated total you will	nd expenses) ellation fee of will be bill \$1,310.00 \$175.38 \$1485.38 D-ROM ht - \$18.75 turnaround <u>be billed:</u> of: \$175.38	of 100% of ed unless \$1485.38 \$250.00 \$175.00

Please note:

We have estimated that we will produce between 100 and 250 digital images and the post production charges for the time spent processing and preparing those images will be \$250. If we produce a number of images greater than 250 digital images the post production charge will increase to : \$500.00. In addition the output charge would increase to: \$250.00. This would mean an additional cost of : \$325.00.

In addition to a CD-ROM, we can also provide proofs for an additional \$146, contact sheets for an additional \$70, and/or online delivery for an additional \$175, based upon the estimated quantity of images we'll produce. These figures will increase if we produce more than 250 digital images.

Expenses include but are not limited to film, processing, prints, parking, and shipping. The usage of images provided is for: 1)for use on Website 2) publishing images in newspapers and trade publications, and 3) in-house promotional use and press kits, for a period of one year. Images may be used for mementos, gifts, and other personal use without restriction. Should you have any questions regarding this please feel free to contact me so that we can negotiate any additional or alternative use. Use on the internet is not included for liability reasons unless specifically included in licensing above. For an explanation of this issue, please visit our website section on this - www.JohnHarrington.com/about-the-web.

Critical Note: Until a digital file is permanently written to a CD-ROM, it's existence (and thus, the portrait(s) we produced for you) is in a fragile state.Interferance such as x-rays, physical damage, viruses, system crashes, and other unknown issues can affect the archiving of imagery. We are more protective of the fragile nature of digital storage media than we are of canisters of film,however, our liability is limited to the waiving of cur fees in the event more than 50% of images from your portrait session are damaged otherwise, full charges apply.Normal turnaround time for post-production is 48 hours. Faster turnaround, including same day/ASAP service is available when necessary, but there are surcharges of 100% for 24 hour and 200% for ASAP service on the digital imaging workstation.This estimate and the rush charges do not include rush charges for proofs. Proofs have a two business day normal turnaround time, but can be accelerated for the same 100% and 200% rush surcharges.Please visit: www.JohnHarrington.com/reprints for a complete schedule of reprint fees, from quantities from 1 through 1,000, and offering pricing discounts for longer turnaround times.

Thank you for your time and consideration. I look forward to working with you.

Simpley

To confirm this assignment, please sign and fax this estimate back acknowledging the estimated charges, fees, and other contents.

We concluded the shoot, and the client was satisfied with the final results. During the course of the assignment, the client indicated they had more attorneys they wanted photographed because the ability to display and do light retouching as the subject watched (and approved) was invaluable, and the office manager no longer had to chase people around and get their approvals on photos after the fact. They asked us to follow up in a month or so, so we did. Here is that dialogue:

From: 'John Harrington' Sent: Wednesday, August 25, 11:55 AM To:

Subject: Portraits

Wanted to check in with you to see about the remaining portraits you have. You'd indicated back in June there were a few other attorneys that needed to be photographed, so I just wanted to check in with you.

Best, John

From: Subject: RE: Portraits Date: August 25, 11:53:02 AM EDT To: 'John Harrington'

Hi John —

Yes, we will have probably have another 12 or so to do in October. People just raved about your photos! What is your schedule looking like to the weeks of October 12 and October 25?

Thanks,

From: 'John Harrington' Sent: Wednesday, August 25, 12:01 PM To: Contract of the sentence of t

Glad to know they went over so well! I am wide open during both weeks. Monday and Friday mornings always work best for us, but when you're ready, let me know...I just wanted to check in.

Best, John

From: Distribution of the second sec	:54 PM EDT
Hi John —	
	me, that we have at least 17 people scheduled for the shoot on schedule. I hope it looks OK for your schedule. Please let me set up.
We will be in our new offices l	by that date. Our new address is:
Thanks much,	Time Name Phone Ext. 11am x x x x x x x x x x x x x x x x x x x

From: 'John Harrington' Sent: Tuesday, October 05, 531 PM To:

Subject: Re: 10/13 Photo Shoot

No problem, we're all set for the 13th. I think we had originally estimated for 17, but this shows 19. Is that the revised total and/or do you expect dropouts and add-ins throughout the day?

Thanks, John

From: Subject: RE: 10/13 Photo Shoot Date: October 6, 7:31:05 AM EDT To: 'John Harrington'

We had two new hires that I added. Sorry so last minute. I am hoping this is the total but you met our group—ya never know—they are not exactly predictable. ;o) Can we go with 19 and hang loose with the idea of a possible last-minute change or addition?

From: Subject: Confirmation 10/13 Photo Appt. Date: October 12, 12:24:21 PM EDT To: 'John Harrington'

Hi John —

We are looking forward to seeing you tomorrow and to the new photos!

I have you arriving around 9–9:30AM. Please come to the 1st floor reception area; my assistant will come down and show you to the conference room. She will also show you where a phone, kitchen, and bathroom are located and give you a list of appointments/extensions.

Everyone has been reminded of their appointments, and they should be on time. Just call anyone at their extension if they are late or dial 0 and ask to page them. I should be arriving in the office around 11AM.

Will you be giving me an invoice tomorrow? I would like to try to get your check cut by Thursday and overnighted to you if that is OK.

From:

Subject: Lunch? Date: October 12, 12:38:36 PM EDT To: 'John Harrington'

John —

One more thing—can we provide your team with lunch tomorrow? If appears you will be working thru lunch, and we would be happy to order something. Please let me know what you would like and at what time.

Thanks,

From:

Subject: Payment Date: October 20, 2007 6:33:59 PM EDT To: 'John Harrington'

Hi John —

Just want to confirm that you received our check. Also, do you think we will have the disk by next Monday? Thanks much,

Several months after the conclusion of this shoot, we received yet another request for our services from the same firm. After an initial inquiry for 10 portraits, they postponed early in the dialogue, then came back a few months after that seeking 20 to 25 portraits. The final estimate swelled to what ended up being 31 portraits. The dialogue continues below:

From: Subject: Scheduling Photo Shoot Appt. Date: July 27, 3:35:13 PM EDT To: 'John Harrington'
Hi John —
Our firm needs to schedule an appt with you to shoot approx 10 people. Please let me know what your schedule looks like. A few date options would be best. Hope you are having a wonderful summer.
Best, Best
From: Subject: RE: Scheduling Photo Shoot Appt. Date: August 8, 12:20:58 PM EDT To: 'John Harrington'
Hi John —
The firm has decided to postpone this photo session until October. Please advise of available dates for early that month. We will probably have about 15 people to do. Dates to available include: 10/03 and 10/10.
Thanks, Martin

From: Subject: 10/19 Shoot Date: October 11, 2010 3:21:58 PM EDT To: 'John Harrington'

Hi John —

Well, it appears we are filling up very quickly for the photos. Can you stay a bit longer that afternoon–'til 5 or so? I have 17 slots filled so far and may have as many as 20–25. I didn't expect such a response, but they love your photos!

In the end, the 20 to 25 estimate became 31, and we sent along a revised estimate for 31 portraits. This client continues to be one of several returning clients, from law firms, to associations, and other organizations in need of portraits for their Web site, and the occasional speaking engagement. The following two pages show the estimate we sent for the 31 portraits.

and the second	пу		
2500 32nd Street, Southeast Washing	ton DC 20020-1404		
(202) 544-4578 (800) 544-4577 FAX			
v:	August		
na o mano monimone in minison			
Dear Faula.			
Thank you for contacting me recently regarding our availability and an estimate of the cost of s			
EVENT SPECIFICS:	Our Arrival Time:	8:00 AM	
DATE: Wednesday,October 19, 2005		9:00 AM	
LOCATION: 31 Portraits at the offices,	Event End Time:	6:00 PM	
	# of Portraits:	31	
Droce confirmed as an assignment from you hotographer's fees and any expenses incur e-book the time we have committed to you. Ally estimate of the cost for this job breaks down Photographer's Fees Fee for Photographic services and Usac	red prior to cancellation will be billed unle to:	ess we are able to	
hotographer's fees and any expenses incur book the time we have committed to you. My estimate of the cost for this job breaks down	red prior to cancellation will be billed unle to: e Fee for usage stipulated below: g into the invoice the cost to ble departments on past due o our vendors, which require 30 days o fthis estimate. If payment is made		
 hotographer's fees and any expenses incursion incursecon incursion incursion incursio incursio incursion incursio	red prior to cancellation will be billed unle to: e Fee for usage stipulated below: g into the invoice the cost to ble departments on past due o our vendors, which require 30 days of this estimate. If payment is made pount.	\$478.10	53.10
 hotographer's fees and any expenses incursion incursecon incursion incursion incursio incursio incursion incursio	red prior to cancellation will be billed unle to: e Fee for usage stipulated below: g into the invoice the cost to ble departments on past due o our vendors, which require 30 days of this estimate. If payment is made punt. Total Photographer's Fees	\$4463.10 \$446	53.10 00.00
hotographer's fees and any expenses incur book the time we have committed to you. My estimate of the cost for this job breaks down Photographer's Fees Fee for Photographic services and Usag Administrative Fee - We are now buildin repeatedly follow up with accounts paya invoices, and float the cost of payment t payment. This fee is approximately 10% within 30 days, you may deduct this amo	red prior to cancellation will be billed unle to: e Fee for usage stipulated below: g into the invoice the cost to ble departments on past due o our vendors, which require 30 days of this estimate. If payment is made punt. Total Photographer's Fees	\$478.10 \$4463.10 \$450 \$50	Benarecognical and the second
 botographer's fees and any expenses incure-book the time we have committed to you. All estimate of the cost for this job breaks down Photographer's Fees Fee for Photographic services and Usag Administrative Fee - We are now buildin repeatedly follow up with accounts paya invoices, and float the cost of payment to payment. This fee is approximately 10% within 30 days, you may deduct this amount of the production fees -250 and 500 images Output method of digital files (i.e. How will Shipping - Proofs/CDs to/from lab and to payment to payment and the payment is provided to the payment of the payment. 	red prior to cancellation will be billed unle to: e Fee for usage stipulated below: \$ g into the invoice the cost to ble departments on past due o our vendors, which require 30 days o of this estimate. If payment is made bunt. Total Photographer's Fees a (7 - 14 rolls)	\$478.10 \$4463.10 \$425 \$25	00.00
 botographer's fees and any expenses incure-book the time we have committed to you. All estimate of the cost for this job breaks down Photographer's Fees Fee for Photographic services and Usag Administrative Fee - We are now buildin repeatedly follow up with accounts paya invoices, and float the cost of payment t payment. This fee is approximately 10% within 30 days, you may deduct this am Post production fees -250 and 500 images Output method of digital files (i.e. How will 	red prior to cancellation will be billed unle to: e Fee for usage stipulated below: \$ g into the invoice the cost to ble departments on past due o our vendors, which require 30 days of this estimate. If payment is made ount. Total Photographer's Fees a (7 - 14 rolls) the images be delilvered to you): CD-ROM	\$478.10 \$4463.10 \$425 \$25	50.00
Photographer's fees and any expenses incur e-book the time we have committed to you. My estimate of the cost for this job breaks down Photographer's Fees Fee for Photographic services and Usag Administrative Fee - We are now buildin repeatedly follow up with accounts paya invoices, and float the cost of payment t payment. This fee is approximately 10% within 30 days, you may deduct this amo Post production fees -250 and 500 images Output method of digital files (i.e. How will Shipping - Proofs/CDs to/from lab and to Event Prkng/Misc -	red prior to cancellation will be billed unle to: e Fee for usage stipulated below: \$ g into the invoice the cost to ble departments on past due o our vendors, which require 30 days of this estimate. If payment is made ount. Total Photographer's Fees a (7 - 14 rolls) the images be delilvered to you): CD-ROM	sess we are able to 3,985.00 \$478.10 \$4463.10 \$426 \$50 \$25 75 \$4 round	50.00
Hotographer's fees and any expenses incure- book the time we have committed to you. All estimate of the cost for this job breaks down Photographer's Fees Fee for Photographic services and Usag Administrative Fee - We are now buildin repeatedly follow up with accounts paya invoices, and float the cost of payment t payment. This fee is approximately 10% within 30 days, you may deduct this am Post production fees -250 and 500 images Output method of digital files (i.e. How will Shipping - Proofs/CDs to/from lab and to Event Prkng/Misc -	red prior to cancellation will be billed unle to: le Fee for usage stipulated below: \$ g into the invoice the cost to ble departments on past due o our vendors, which require 30 days of this estimate. If payment is made bunt. Total Photographer's Fees s (7 - 14 rolls) the images be delilvered to you): CD-ROM o client via: Federal Express Overnight - \$18. ges delivered under normal two day turna	3,985.00 \$478.10 \$4463.10 \$446 \$50 \$25 75 \$4 billed: \$5,25 78.10 \$4,10	00.00 50.00 46.00 59.10
Hotographer's fees and any expenses incure book the time we have committed to you. Aly estimate of the cost for this job breaks down Photographer's Fees Fee for Photographic services and Usag Administrative Fee - We are now buildin repeatedly follow up with accounts paya invoices, and float the cost of payment payment. This fee is approximately 10% within 30 days, you may deduct this amo Post production fees -250 and 500 images Output method of digital files (i.e. How will Shipping - Proofs/CDs to/from lab and to Event Prkng/Misc - If ima If payment is made within 30 days, y	red prior to cancellation will be billed unle to: le Fee for usage stipulated below: \$ g into the invoice the cost to ble departments on past due o our vendors, which require 30 days of this estimate. If payment is made bunt. Total Photographer's Fees a (7 - 14 rolls) the images be delilvered to you): CD-ROM o client via: Federal Express Overnight - \$18. ges delivered under normal two day turna <u>this is the estimated total you will be</u> ou may deduct the administrative fee of: \$4	sess we are able to 3,985.00 \$478.10 \$4463.10 \$4463.10 \$425 75 \$4 round billed: \$5,25 78.10 30.00 \$44,76	00.00 50.00 46.00 59.10
hotographer's fees and any expenses incur book the time we have committed to you. My estimate of the cost for this job breaks down Photographer's Fees Fee for Photographic services and Usag Administrative Fee - We are now buildin repeatedly follow up with accounts paya invoices, and float the cost of payment t payment. This fee is approximately 10% within 30 days, you may deduct this am Post production fees -250 and 500 images Output method of digital files (i.e. How will Shipping - Proofs/CDs to/from lab and to Event Prkng/Misc - If ima If payment is made within 30 days, y For accelerated turnaround on digital files If images a re delivered on the	red prior to cancellation will be billed unle to: a Fee for usage stipulated below: g into the invoice the cost to ble departments on past due o our vendors, which require 30 days of this estimate. If payment is made ount. Total Photographer's Fees (7 - 14 rolls) the images be delilvered to you): CD-ROM o client via: Federal Express Overnight - \$18. ges delivered under normal two day turna <u>this is the estimated total you will be</u> ou may deduct the administrative fee of: \$4 off your total invoice, which is estimated iles, following are priority digital workstat If images are delivered on the	sess we are able to 3,985.00 \$478.10 \$4463.10 \$4463.10 \$425 75 \$4 round billed: \$5,25 78.10 30.00 \$44,76	00.00 50.00 46.00 59.10
hotographer's fees and any expenses incur book the time we have committed to you. My estimate of the cost for this job breaks down Photographer's Fees Fee for Photographic services and Usag Administrative Fee - We are now buildin repeatedly follow up with accounts paya invoices, and float the cost of payment t payment. This fee is approximately 10% within 30 days, you may deduct this and Post production fees -250 and 500 images Output method of digital files (i.e. How will Shipping - Proofs/CDs to/from lab and to Event Prkng/Misc - If ima If payment is made within 30 days, y For accelerated turnaround on digital files (i.e. for accelerated turnaround on digital files for accelerated turnaround for a file for accelerated turnaround for a file file for accelerated turnaround for a file file file file file file file file	red prior to cancellation will be billed unle to: to: to: g into the invoice the cost to ble departments on past due o our vendors, which require 30 days of this estimate. If payment is made out. Total Photographer's Fees (7 - 14 rolls) the images be delilvered to you): CD-ROM o client via: Federal Express Overnight - \$18. ges delivered under normal two day turna this is the estimated total you will be out may deduct the administrative fee of: \$4 off your total invoice, which is estimated illes, following are priority digital workstat	sess we are able to 3,985.00 \$478.10 \$4463.10 \$4463.10 \$425 75 \$4 round billed: \$5,25 78.10 30.00 \$44,76	00.00 50.00 46.00 59.10

Upon request, we will digitally deliver images properly sized and encoded with metadata. Prepared images delivered via email are \$65ea, and images coded and prepared for publication that are posted via FTP download on our server are \$75ea, up for 7 days.

Please note:

We have estimated that we will produce between 250 and 500 digital images and the post production charges for the time spent processing and preparing those images will be \$500. If we produce a number of images greater than 500 digital images the post production charge will increase to : \$750.00. In addition the output charge would increase to: \$520.00. This would mean an additional cost of : \$520.00.

In addition to a CD-ROM, we can also provide proofs for an additional \$302, contact sheets for an additional \$100, and/or online delivery for an additional \$250, based upon the estimated quantity of images we'll produce. These figures will increase if we produce more than 500 digital images.

Expenses include but are not limited to film, processing, prints, parking, and shipping. The usage of images provided is for: 1) Submission to wire services, 2) publishing images in newspapers and trade publications, and 3) in-house promotional use and press kits, for a period of one year. Images may be used for mementos, gifts, and other personal use without restriction. Should you have any questions regarding this please feel free to contact me so that we can negotiate any additional or alternative use. Use on the internet is not included for liability reasons unless specifically included in licensing above. For an explanation of this issue, please visit our website section on this - www.JohnHarrington.com/about-the-web.

Critical Note: Until a digital file is permanently written to a CD-ROM, it's existence (and thus, the portrait(s) we produced for you) is in a fragile state. Interferance such as x-rays, physical damage, viruses, system crashes, and other unknown issues can affect the archiving of imagery. We are more protective of the fragile nature of digital storage media than we are of canisters of film, however, our liability is limited to the waiving of our fees in the event more than 50% of images from your portrait session are damaged otherwise, full charges apply.Normal turnaround time for post-production is 48 hours. Faster turnaround, including same day/ASAP service is available when necessary, but there are surcharges of 100% for 24 hour and 200% for ASAP service on the digital imaging workstation. This estimate and the rush charges do not include rush charges for proofs. Proofs have a two business day normal turnaround time, but can be accelerated for the same 100% and 200% rush surcharges.Please visit: www.JohnHarrington.com/reprints for a complete schedule of reprint fees, from quantities from 1 through 1,000, and offering pricing discounts for longer turnaround times.

Thank you for your time and consideration. I look forward to working with you.

John Harrington

To confirm this assignment, <u>please sign and fax this estimate back</u> acknowledging the estimated charges, fees, and other contents.

Print Name

Date

CHAPTER 11

Case Study: National Corporate Client

Client type: Regular client who represents a company having a corporate event in Washington.

How they found us: Existing relationship.

Assignment: All-day corporate symposium in a hotel ballroom.

Deliverables: CD, with a loose edit of images.

Technical notes: The stage was well lit, so on-camera flash was not necessary except for break periods, where candids and posed group photos would be taken.

The initial inquiry came via telephone, and during that time there was a dialogue about using images of company executives in a brochure. We advised them of the issue of model releases and received assurances that the images would only be of company executives in the company brochure. We recommended obtaining releases from each person participating, and were advised that they would.

Our dialogue with the client:

To:

Subject: Photo Estimate for: Thursday, June 8 Date: June 1, 3:15:29 PM EDT From: 'John Harrington'

Dear

Attached is a revised PDF file of the estimate you requested for your event on Thursday, June 8. Please note the added line item regarding brochure use of images from the event.

Please look the attached estimate over, call with any questions, and sign and fax it back to confirm. While we are currently indicating we are available for the date and time you have requested, we don't guarantee or commit our photographers' time until we've received the signed estimate back. Please fax it to **present the signed**.

Once you've confirmed the assignment, please forward at your earliest convenience a schedule/timeline of the events and/or a copy of the press release for the event so that we may best prepare coverage plans. While not a requirement, it helps us to know what to expect. Please e-mail it to this address:

We look forward to working with you and a second again.

Cheers, John

From:
Subject: Fw: Images from Thursday's Event Date: June 12, 10:12:14 AM EDT
To:
John:
Thanks for your time this morning. Attached is the e-mail from our client at provident of requesting photos of provident of . Secretary provident , and provident . Below are their titles, and attached is a copy of one of the final drafts of the show/program provident which should help as you go through the images.
Begin bulleted list w/in e-mail
 Senior Staff Vice President
Secretary secretary, Keynote Speaker
 Division President, National
Please e-mail or call me with any questions.
Thank you, Karen
From:
Subject: Emailed Photographs
Date: June 12, 12:19:15 PM EDT

To: 'John Harrington'

Thanks for your help on this and the quick turnaround. Thanks,

The following figures show the contract and invoice for the assignment. Note that the client called and ordered three e-mails and a second copy of the CD via telephone, and those additional items are reflected on the final invoice.

JOHN HARRINGTON			
Photography Photography			
2500 32nd Street, Southeast Washington DC 20020-1404			
(202) 544-4578 (800) 544-4577 FAX (202) 544-4579			
v: 202-			
via e-mail			
Dear and the second s			
Thank you for contacting me recently regarding your photographic ne			
our availability and an estimate of the cost of securing photographic s			
EVENT SPECIFICS:	Our Arrival Tir Event Starts a		
DATE: Thursday,	Event Starts a		
LOCATION: How How Hotel, Grand Ballroom	Event Enu Til	ile. 0.00	* ***
Once confirmed as an assignment from you and time committed, Photographer's fees and any expenses incurred prior to cancellat re-book the time we have committed to you. My estimate of the cost for this job breaks down to: Photographer's Fees Fee for Photographic services and Usage Fee for usage stipul Administrative Fee. We are new building into the inverse theory	tion will be billed	e of 100% of the	State of the second sec
Photographer's fees and any expenses incurred prior to cancellat re-book the time we have committed to you. My estimate of the cost for this job breaks down to: Photographer's Fees Fee for Photographic services and Usage Fee for usage stipul Administrative Fee - We are now building into the invoice the or repeatedly follow up with accounts payable departments on pa invoices, and float the cost of payment to our vendors, which r payment. This fee is approximately 10% of this estimate. If pay	a cancellation fee tion will be billed ated below: cost to ast due equire 30 days	e of 100% of the unless we are \$1,500.00	State of the second sec
Photographer's fees and any expenses incurred prior to cancellat re-book the time we have committed to you. My estimate of the cost for this job breaks down to: Photographer's Fees Fee for Photographic services and Usage Fee for usage stipul Administrative Fee - We are now building into the invoice the or repeatedly follow up with accounts payable departments on pa invoices, and float the cost of payment to our vendors, which re payment. This fee is approximately 10% of this estimate. If pay within 30 days, you may deduct this amount.	a cancellation fee tion will be billed ated below: cost to ast due equire 30 days yment is made	e of 100% of the unless we are \$1,500.00 \$310.80	able to
Photographer's fees and any expenses incurred prior to cancellat re-book the time we have committed to you. My estimate of the cost for this job breaks down to: Photographer's Fees Fee for Photographic services and Usage Fee for usage stipul Administrative Fee - We are now building into the invoice the or repeatedly follow up with accounts payable departments on pa invoices, and float the cost of payment to our vendors, which re payment. This fee is approximately 10% of this estimate. If pay within 30 days, you may deduct this amount.	a cancellation fee tion will be billed ated below: cost to ast due equire 30 days	e of 100% of the unless we are \$1,500.00	State of the second sec
Photographer's fees and any expenses incurred prior to cancellat re-book the time we have committed to you. My estimate of the cost for this job breaks down to: Photographer's Fees Fee for Photographic services and Usage Fee for usage stipul. Administrative Fee - We are now building into the invoice the or repeatedly follow up with accounts payable departments on pa invoices, and float the cost of payment to our vendors, which re payment. This fee is approximately 10% of this estimate. If pay within 30 days, you may deduct this amount. Total Photog	a cancellation fee tion will be billed ated below: cost to ast due equire 30 days yment is made rapher's Fees	e of 100% of the unless we are \$1,500.00 \$310.80 \$1810.80	\$1810.80
Photographer's fees and any expenses incurred prior to cancellat re-book the time we have committed to you. My estimate of the cost for this job breaks down to: Photographer's Fees Fee for Photographic services and Usage Fee for usage stipul Administrative Fee - We are now building into the invoice the or repeatedly follow up with accounts payable departments on pa invoices, and float the cost of payment to our vendors, which or payment. This fee is approximately 10% of this estimate. If pay within 30 days, you may deduct this amount. Total Photog Post production fees -250 and 500 images (7 - 14 rolls)	a cancellation fee tion will be billed ated below: cost to ast due equire 30 days yment is made rapher's Fees	e of 100% of the unless we are \$1,500.00 \$310.80 \$1810.80	\$1810.80 \$500.00
Photographer's fees and any expenses incurred prior to cancellat re-book the time we have committed to you. My estimate of the cost for this job breaks down to: Photographer's Fees Fee for Photographic services and Usage Fee for usage stipul. Administrative Fee - We are now building into the invoice the or repeatedly follow up with accounts payable departments on pa invoices, and float the cost of payment to our vendors, which re payment. This fee is approximately 10% of this estimate. If pay within 30 days, you may deduct this amount. Total Photog Post production fees -250 and 500 images (7 - 14 rolls) Output method of digital files (i.e. How will the images be delived	a cancellation fee tion will be billed ated below: cost to ast due equire 30 days yment is made trapher's Fees red to you): CD-R(e of 100% of the unless we are \$1,500.00 \$310.80 \$1810.80	\$1810.80 \$500.00 \$250.00
Photographer's fees and any expenses incurred prior to cancellat re-book the time we have committed to you. My estimate of the cost for this job breaks down to: Photographer's Fees Fee for Photographic services and Usage Fee for usage stipul. Administrative Fee - We are now building into the invoice the or repeatedly follow up with accounts payable departments on pa invoices, and float the cost of payment to our vendors, which or payment. This fee is approximately 10% of this estimate. If pay within 30 days, you may deduct this amount. Total Photog Post production fees -250 and 500 images (7 - 14 rolls) Output method of digital files (i.e. How will the images be delived Shipping - Proofs/CDs to/from lab and to client via: Courier Event Prkng/Misc - Brochure use: \$140 x 6, 10k-20k press If images delivered under	a cancellation fee tion will be billed ated below: cost to ast due equire 30 days yment is made trapher's Fees red to you): CD-R(run normal two day to	e of 100% of the unless we are a \$1,500.00 \$310.80 \$1810.80 OM	\$1810.80 \$10.00 \$250.00 \$18.00 \$840.00
Photographer's fees and any expenses incurred prior to cancellat re-book the time we have committed to you. My estimate of the cost for this job breaks down to: Photographer's Fees Fee for Photographic services and Usage Fee for usage stipul. Administrative Fee - We are now building into the invoice the or repeatedly follow up with accounts payable departments on pa invoices, and float the cost of payment to our vendors, which or payment. This fee is approximately 10% of this estimate. If pay within 30 days, you may deduct this amount. Total Photog Post production fees -250 and 500 images (7 - 14 rolls) Output method of digital files (i.e. How will the images be delived Shipping - Proofs/CDs to/from lab and to client via: Courier Event Prkng/Misc - Brochure use: \$140 x 6, 10k-20k press If images delivered under	a cancellation fee tion will be billed ated below: cost to ast due equire 30 days yment is made rapher's Fees red to you): CD-R0	e of 100% of the unless we are a \$1,500.00 \$310.80 \$1810.80 OM	\$1810.80 \$500.00 \$250.00 \$18.00
Photographer's fees and any expenses incurred prior to cancellat re-book the time we have committed to you. My estimate of the cost for this job breaks down to: Photographer's Fees Fee for Photographic services and Usage Fee for usage stipul. Administrative Fee - We are now building into the invoice the or repeatedly follow up with accounts payable departments on pa invoices, and float the cost of payment to our vendors, which r payment. This fee is approximately 10% of this estimate. If pay within 30 days, you may deduct this amount. Total Photog Post production fees -250 and 500 images (7 - 14 rolls) Output method of digital files (i.e. How will the images be delived Shipping - Proofs/CDs to/from lab and to client via: Courier Event Prkng/Misc - Brochure use: \$140 x 6, 10k-20k press If images delivered under this is the estima- If payment is made within 30 days, you may deduct the ad	a cancellation fee tion will be billed ated below: cost to ast due equire 30 days yment is made rapher's Fees red to you): CD-R(run normal two day tu ated total you will ministrative fee of:	e of 100% of the unless we are a \$1,500.00 \$310.80 \$1810.80 OM urnaround be billed: \$310.80	\$1810.80 \$10.00 \$250.00 \$18.00 \$840.00
Photographer's fees and any expenses incurred prior to cancellate re-book the time we have committed to you. My estimate of the cost for this job breaks down to: Photographer's Fees Fee for Photographic services and Usage Fee for usage stipul. Administrative Fee - We are now building into the invoice the correpeatedly follow up with accounts payable departments on payinvoices, and float the cost of payment to our vendors, which repeatedly follow up with accounts payable departments on payment. This fee is approximately 10% of this estimate. If pay within 30 days, you may deduct this amount. Total Photog Post production fees -250 and 500 images (7 - 14 rolls) Output method of digital files (i.e. How will the images be delilved Shipping - Proofs/CDs to/from lab and to client via: Courier Event Prkng/Misc - Brochure use: \$140 x 6, 10k-20k press If images delivered under this is the estimate. If payment is made within 30 days, you may deduct the ad off your total images	a cancellation feet tion will be billed ated below: cost to ast due equire 30 days yment is made rapher's Fees red to you): CD-R(a run normal two day to ated total you will ministrative fee of: voice, which is esting	e of 100% of the unless we are a \$1,500.00 \$310.80 \$1810.80 OM urnaround be billed: \$310.80 mated to be:	\$1810.80 \$500.00 \$250.00 \$18.00 \$840.00 \$3,418.80
Photographer's fees and any expenses incurred prior to cancellat re-book the time we have committed to you. My estimate of the cost for this job breaks down to: Photographer's Fees Fee for Photographic services and Usage Fee for usage stipul. Administrative Fee - We are now building into the invoice the or repeatedly follow up with accounts payable departments on pa invoices, and float the cost of payment to our vendors, which re payment. This fee is approximately 10% of this estimate. If pay within 30 days, you may deduct this amount. Total Photog Post production fees -250 and 500 images (7 - 14 rolls) Output method of digital files (i.e. How will the images be delilved Shipping - Proofs/CDs to/from lab and to client via: Courier Event Prkng/Misc - Brochure use: \$140 x 6, 10k-20k press If images delivered under this is the estimated off your total im For accelerated turnaround on digital files, following are pr	a cancellation feet tion will be billed ated below: cost to ast due equire 30 days yment is made rapher's Fees red to you): CD-R(a run normal two day to ated total you will ministrative fee of: voice, which is esting	e of 100% of the unless we are a \$1,500.00 \$310.80 \$1810.80 OM Urnaround be billed: \$310.80 mated to be: station	\$1810.80 \$500.00 \$250.00 \$18.00 \$840.00 \$3,418.80
Photographer's fees and any expenses incurred prior to cancellat re-book the time we have committed to you. My estimate of the cost for this job breaks down to: Photographer's Fees Fee for Photographic services and Usage Fee for usage stipul. Administrative Fee - We are now building into the invoice the of repeatedly follow up with accounts payable departments on pa invoices, and float the cost of payment to our vendors, which repayment. This fee is approximately 10% of this estimate. If pay within 30 days, you may deduct this amount. Total Photog Post production fees -250 and 500 images (7 - 14 rolls) Output method of digital files (i.e. How will the images be delilved Shipping - Proofs/CDs to/from lab and to client via: Courier Event Prkng/Misc - Brochure use: \$140 x 6, 10k-20k press If images delivered under this is the estima If payment is made within 30 days, you may deduct the ad off your total im For accelerated turnaround on digital files, following are pr If images a re delivered on the If images NEXT BUSINESS DAY,	a cancellation feet tion will be billed ated below: cost to ast due equire 30 days yment is made rapher's Fees red to you): CD-Re run normal two day tu ated total you will ministrative fee of: voice, which is estii tority digital work are delivered on SAME DAY/ASJ	station the of 100% of the unless we are s \$1,500.00 \$310.80 \$1810.80 \$310.80 mated to be: station the AP,	\$1810.80 \$500.00 \$250.00 \$18.00 \$840.00 \$3,418.80
Photographer's fees and any expenses incurred prior to cancellat re-book the time we have committed to you. My estimate of the cost for this job breaks down to: Photographer's Fees Fee for Photographic services and Usage Fee for usage stipul. Administrative Fee - We are now building into the invoice the or repeatedly follow up with accounts payable departments on pa invoices, and float the cost of payment to our vendors, which re payment. This fee is approximately 10% of this estimate. If pay within 30 days, you may deduct this amount. Total Photog Post production fees -250 and 500 images (7 - 14 rolls) Output method of digital files (i.e. How will the images be delilved Shipping - Proofs/CDs to/from lab and to client via: Courier Event Prkng/Misc - Brochure use: \$140 x 6, 10k-20k press If images delivered under this is the estim If payment is made within 30 days, you may deduct the ad off your total im For accelerated turnaround on digital files, following are pr If images a re delivered on the If images NEXT BUSINESS DAY,	a cancellation feet tion will be billed ated below: cost to ast due equire 30 days yment is made rapher's Fees red to you): CD-R(a run normal two day to ated total you will ministrative fee of: voice, which is esti iority digital work as are delivered on	station the AP, arge	\$1810.80 \$500.00 \$250.00 \$18.00 \$840.00 \$3,418.80 \$3,108.00

Upon request, we will digitally deliver images properly sized and encoded with metadata. Prepared images delivered via email are \$65ea, and images coded and prepared for publication that are posted via FTP download on our server are \$75ea, up for 7 days.

Please note:

We have estimated that we will produce between 250 and 500 digital images and the post production charges for the time spent processing and preparing those images will be \$500. If we produce a number of images greater than 500 digital images the post production charge will increase to : \$750.00. In addition the output charge would increase to: \$520.00. This would mean an additional cost of : \$520.00.

This estimate outlines the cost of the time we will be committing to you. Should your needs be extended, additional time is billed hourly at \$150 per hour thereafter if we are available to extend our time. Further, for pre-shoot meetings or extensive conference calls, the fee for that time is billed at \$150 per hour, with a two hour minimum.

In addition to a CD-ROM, we can also provide proofs for an additional \$302, contact sheets for an additional \$100, and/or online delivery for an additional \$250, based upon the estimated quantity of images we'll produce. These figures will increase if we produce more than 500 digital images.

Expenses include but are not limited to film, processing, prints, parking, and shipping. The usage of images provided is for: 1) Submission to wire services, 2) publishing images in newspapers and trade publications, and 3) in-house promotional use and press kits, for a period of one year. Images may be used for mementos, gifts, and other personal use without restriction. Should you have any questions regarding this please feel free to contact me so that we can negotiate any additional or alternative use. Use on the internet is not included for liability reasons unless specifically included in licensing above. For an explanation of this issue, please visit our website section on this - www.JohnHarrington.com/about-the-web.

Critical Note: Until a digital file is permanently written to a CD-ROM, it's existence (and thus, documentation of your event) is in a fragile state.Interferance such as x-rays, physical damage, viruses, system crashes, and other unknown issues can affect the archiving of imagery. We are more protective of the fragile nature of digital storage media than we are of canisters of film, however, our liability is limited to the waiving of our fees in the event more than 50% of images from your event are damaged, otherwise, full charges apply. Normal turnaround time for post-production is 48 hours. Faster turnaround, including same day/ASAP service is available when necessary, but there are surcharges of 100% for 24 hour and 200% for ASAP service on the digital imaging workstation.This estimate and the rush charges do not include rush charges for proofs. Proofs have a two-business-day normal turnaround time, but can be accelerated for the same 100% and 200% rush surcharges. Please visit: www.JohnHarrington.com/reprints for a complete schedule of reprint fees, from quantities from 1 through 1,000, and offering pricing discounts for longer turnaround times.

Thank you for your time and consideration. I look forward to working with you and

again.

John Harrington

To confirm this assignment, <u>please sign and fax this estimate back</u> acknowledging the estimated charges, fees, and other contents.

Signature

Print Name

CHAPTER 11

JOHN HARRINGTON P h o t o g r a p h y 2500 32nd Street, SE • Washington, DC 20020 Office: (202) 544-4578 • Fax: (202) 544-4579 Email: John@JohnHarrington.com Bill To:		Date	Invoice Invoice No.
Descripti	P.O. No.	Terms NET 30	Due Date
Assignment: Photo coverage of event at the Photo Fees Post production-250-500 images (retouch/color correct/file con Fee for digital output to CD of 250-500 images 2nd CD (1/2 cost of original CD output) Image prep, production & coding (metadata) via e-mail, 3 e-ma on Parking Courier shipment, 1 way to Brochure usage: \$140 x 8, 10k-20k press run			1,810.80 500.00 250.00 125.00 195.00 20.00 18.00 840.00
Federal ID #		Total	\$3,758.80

Case Study: Regional Corporate Client

Client type: Local/regional company.

How they found us: Client referral.

Assignment: Company was looking to showcase their "human capital" in one or two full-page ads in a trade magazine read by non-political decision makers in the federal government, hoping to win future government contracts. Photograph was to be of key company staff.

Deliverables: Single image chosen from film produced.

Technical notes: Shoot required four heads. Two on softboxes to light the front of the group, and two to light the background, and a hair light provided on the backs of the subjects.

The initial inquiry came via telephone, and we were advised that we were the sole photographer considered for the assignment. I asked the question, "Do you have a budget for this?" The client advised me that he'd like to come in around \$5,000 for the project, and this was a reasonable figure for the scope and usage of the work. We prepared an estimate and sent it along. It was signed within two days and returned. Following the successful completion of the assignment, the same company called us again the following year for another assignment of a similar type for a similar use.

	Photography 2500 32nd Street, SE Washington DC 20020-1404 Local Office: 202.544.4578 National Office: 800.544.4577 Fax: 202.544.4579		Estimate	and Contract for	Photographic	Services
This is an:	Estimate and Contract			Client:		
Version:	1.0			Agency:		
Time:	4:20 pm			Agency Contact	:	
Date:				Art Director:		
of the comp	otograph of group of 6 or 7 company exe any to a government reading audience. Ir	nage sh	ould have	ly stylized and bri e a "high fashion :	style" look.	e for promotion
of the comp Usage: Usage in tw and use for NOTE: Fee which the p	otograph of group of 6 or 7 company exe any to a government reading audience. In to issues as a full page advertisement in a period of one year on the company web s for usage do not include scouting time f hotography will be produced. All location	nage sho osite.	ions (if r	e a "high fashion : Magazine, w necessary) nor loc	style" look. with a circulat ation fees for handled by cli	ion of 66,000, the venue in tent or agency.
of the comp Usage: Usage in tw and use for	o issues as a full page advertisement in a period of one year on the company web	nage sho osite.	ions (if r s (where	e a "high fashion : Magazine, w necessary) nor loc	style" look. with a circulat	ion of 66,000,
of the comp Usage: Usage in tw and use for NOTE: Fee which the p	any to a government reading audience. In to issues as a full page advertisement in a period of one year on the company well s for usage do not include scouting time the hotography will be produced. All location	nage sho osite. for locat n permit	ions (if r s (where	e a "high fashion : Magazine, w necessary) nor loc	style" look. with a circulat ation fees for handled by cli	ion of 66,000, the venue in ient or agency. Sub-Totals
of the comp Usage: Usage in tw and use for NOTE: Fee which the p Category	any to a government reading audience. In to issues as a full page advertisement in a period of one year on the company well s for usage do not include scouting time the hotography will be produced. All location Description	nage sho bsite. for locat n permit Qt y	ions (if r s (where Rate	e a "high fashion : Magazine, w necessary) nor loc	style" look. with a circulat ation fees for t handled by cli Fees	ion of 66,000, the venue in ient or agency. Sub-Totals
of the comp Usage: Usage in tw and use for NOTE: Fee which the p Category Fees	any to a government reading audience. In to issues as a full page advertisement in a period of one year on the company well s for usage do not include scouting time the hotography will be produced. All location Description Photography - On Location -	nage sho osite. for locat n permit y 1	ions (if r s (where Rate 4420.	e a "high fashion : Magazine, w necessary) nor loc	style" look. with a circulat ation fees for t handled by cli Fees \$4,420.00	ion of 66,000, the venue in ient or agency. Sub-Totals
of the comp Usage: Usage in tw and use for NOTE: Fee which the p Category Fees	any to a government reading audience. In o issues as a full page advertisement in a period of one year on the company well s for usage do not include scouting time the hotography will be produced. All location Description Photography - On Location - Film/Processing	nage sho bosite. for locat n permit y 1 5	ions (if r s (where Rate 4420. 42.	e a "high fashion : Magazine, w necessary) nor loc	style" look. with a circulat ation fees for thandled by cli Fees \$4,420.00 \$210.00	ion of 66,000, the venue in ient or agency. Sub-Totals \$4,420.00
of the comp Usage: Usage in tw and use for NOTE: Fee which the p Category Fees	any to a government reading audience. In to issues as a full page advertisement in a period of one year on the company well s for usage do not include scouting time the hotography will be produced. All location Description Photography - On Location - Film/Processing Polaroids/per pack -	nage sho osite. for locat n permit Qt y 1 5 1	ions (if r s (where Rate 4420. 42.	e a "high fashion : Magazine, w necessary) nor loc	style" look. with a circulat ation fees for thandled by cli Fees \$4,420.00 \$210.00 \$38.00	ion of 66,000, the venue in ient or agency. Sub-Totals \$4,420.00
of the comp Usage: Usage in tw and use for NOTE: Fee which the p Category Fees Film/Lab:	any to a government reading audience. In o issues as a full page advertisement in a period of one year on the company wells for usage do not include scouting time the hotography will be produced. All location Description Photography - On Location - Film/Processing Polaroids/per pack - Digital Scans	nage sho bsite. for locat n permit y 1 5 1 0	ions (if r s (where Rate 4420. 42.	e a "high fashion : Magazine, w necessary) nor loc	style" look. with a circulat ation fees for thandled by cli Fees \$4,420.00 \$210.00 \$38.00 \$0.00	ion of 66,000, the venue in ient or agency. Sub-Totals \$4,420.00
of the comp Usage: Usage in tw and use for NOTE: Fee which the p Category Fees Film/Lab:	any to a government reading audience. In to issues as a full page advertisement in a period of one year on the company well s for usage do not include scouting time the hotography will be produced. All location Description Photography - On Location - Film/Processing Polaroids/per pack - Digital Scans Location Manager	nage sho osite. for locat n permit Qt y 1 5 1 0 0 0	ions (if r s (where Atte 4420. 42. 38.	e a "high fashion : Magazine, w necessary) nor loc	style" look. with a circulat ation fees for t handled by cli Fees \$4,420.00 \$210.00 \$38.00 \$0.00 \$0.00	ion of 66,000, the venue in tent or agency.
of the comp Usage: Usage in tw and use for NOTE: Fee which the p Category Fees Film/Lab:	any to a government reading audience. In to issues as a full page advertisement in a period of one year on the company web s for usage do not include scouting time the hotography will be produced. All location Description Photography - On Location - Film/Processing Polaroids/per pack - Digital Scans Location Manager Wardrobe 2 half-days	nage sho posite. for locat n permit Qt y 1 5 1 0 0 2	ions (if r s (where 4420. 42. 38. 300.	e a "high fashion : Magazine, w necessary) nor loc	style" look. with a circulat ation fees for t handled by cli Fees \$4,420.00 \$210.00 \$38.00 \$0.00 \$0.00 \$600.00	ion of 66,000, the venue in ient or agency. Sub-Totals \$4,420.00

	Lighting			\$0.00	
	Generator			\$0.00	
	Production Vehicle			\$0.00	\$0.00
Travel	Parking/Tolls/Gas			\$0.00	
	Meals			\$0.00	\$0.00
Misc.	Catering			\$0.00	
	Messenger/Shipping	3	22.50	\$67.50	
	Gratuities			\$0.00	
	Long Distance Phone			\$0.00	
	Mobile Phone			\$0.00	
	Expendables	1	30.	\$30.00	\$97.50
Talent	Adults - See separate estimate			\$0.00	
	Children			\$0.00	\$0.00
Insurance	Certificates Liability				
Insurance Grand Tot	Liability al:	To Terms and	l Conditions Belov		\$0.00
Grand Tot	Liability al:				\$0.00
Grand Tot his agreen lient) its s his agreen ghts to ph	Liability al: Subject	n John Harring tions of John H larrington Pho	gton Photography Harrington Photogr tography, Client a	and and a second s	\$0.00 \$6,115.50 (hereafter acquisition of hotographs
Grand Tot his agreen lient) its s his agreen ghts to ph tpressly or reto.	Liability al: 	n John Harring tions of John H Harrington Pho nbodies all of t	gton Photography Harrington Photogr tography. Client a the understandings	and and a second s	\$0.00 \$6,115.50 (hereafter acquisition of hotographs
Grand Tot his agreen lient) its s his agreen ghts to ph (pressly of rreto.	Liability al: Subject nent will serve as a contract betwee uccessors and assigns. nent sets forth the rights and obliga otographs to be provided by John F n the following conditions which en	n John Harring tions of John H Harrington Pho nbodies all of t	gton Photography Harrington Photogr tography. Client a the understandings	and and a second s	hotographs

Updated Contracts

On a regular basis, we review and revise our contracts to reflect client feedback in terms of clarity, our own needs for ease of use, the transition from word processor to our FileMaker database we wrote, as well as changes in contract law that would reveal that perhaps there was a loophole or other cause for concern in the contracts. Following are our latest contracts (as of late 2006) that we have put into use. We engaged our attorney to review existing contract language, terms and conditions, and such and to apply his knowledge to the laws in Washington, DC—the jurisdiction where we'd need to enforce the contract if there was a dispute—as well as to apply his expertise in contract and copyright law.

I encourage you to review these contracts and the boilerplate contracts that are available through trade organizations such as the American Society of Media Photographers (ASMP), the Advertising Photographers of America (APA), the National Press Photographers Association (NPPA), Editorial Photographers (EP), and the Professional Photographers of America (PPA), among others. All have guidance and suggestions, and you should have their language reviewed by your attorney and modified to comply with the laws of your state and locality because each is different. A few hundred dollars of attorney time can save you from a loophole in your contract that is created by state law invalidating one of your contract terms. And, the client who has unjustly enriched themselves with your work won't be able to drive a truck through the loophole all the way to the bank, impervious to your claims.

Following is the basic outline of job-specific details and the terms and conditions for the work we perform for the client. This layout can be blended with the PR/Event contract and modified to satisfy editorial and commercial clients as well.

My logo appears at the top, followed by the job-specific information collected and outlined on page 1 of each contract. Here's the information:

Authorized Representative Client Name Client Address Telephone	
*	ESTIMATE
Event Information Date Time Arrival Start End Location Description of Services:	
Deliverable Material(s) Schedule Media Date Deliverable	
Permissions: Media Duration Territory Term CMI:	
Fees Services Administrative Fees Post Production Output Shipping Misc. Same Day Next Day	
	See Terms and Conditions Attached
JHP signature	
Client Signature	

CHAPTER 11

That concludes page one. It's important that pages one and two have places for the client to sign. This signature acknowledges that they've seen both pages.

Page two, the "terms and conditions," follows. Although we used to have this document as a single page, doubled-sided form, 100% of our contracts are e-mailed PDFs now. As such, they become two pages.

1. Invoices. Client shall pay JHP invoices upon receipt. There will be a 1.5% late payment charge on amounts due and unpaid within ten (10) days of the mailing of the invoice. On all amounts thereafter due and unpaid there will be a 1.5% per month interest charge, accruing daily, until the amount due is paid in full, not to exceed the maximum amount permissible by law. Client shall be solely responsible for the payment of applicable sales, use, personal property, and other taxes assessed upon the Estimated and billed services and expenses, and shall hold JHP harmless for and from any liability assessed therefore. All fees shall be paid in U.S. Funds without deduction for any applicable foreign taxes withheld at the source

2. Services & Costs. Estimated amounts are only for the services and costs described in the Estimate. There will be additional charges for any additional services and costs rendered or incurred for performance. Additional charges will be invoiced to Client.

3. Cancellation, Postponement, Delay, And Additional Time. If Client postpones or cancels services or expenditures once this agreement has been confirmed, and time committed, the full amount of the photographer's fees and any expenses incurred that are associated with this assignment shall be due and payable to JHP as a cancellation or postponement charge. The Client will be charged the full amount of the Estimate, in addition to the cancellation or postponement charge, where the Estimated services or expenditures are performed or incurred after a cancellation or postponement. The Client will be charged for any delays in performance which are not the fault of JHP, and as set forth in the Estimate. In the event that JHP services which are Estimated for any day extend beyond eight (8) consecutive hours in such day, there shall be additional charges to Client for assistants and crew members, which shall be one and half times their hourly rate for more than eight and up to twelve hours, and which shall be double their hourly rate for more than twelve hours in such day.

3. Approval. Client's authorized representative shall be present during photography to approve JHP's photographic services and changes thereto. The client shall not participate in or interfere with JHP 's performance of photographic services, and JHP shall be solely responsible for and shall exercise its sole discretion, for determining the artistic content, composition, audience appeal, and outcome of the work performed. Work which the Client does not reject, or which Client does not request JHP to correct during the performance of photography, at the time the services are being performed, shall be deemed accepted.

4. Photographic Material. The photographic materials referenced in the Estimate are deliverable only in the format therein specified. The photography services performed by JHP will be those of JHP or its employees or contractors. JHP shall make a good faith effort in the performance of all services. No release exists and none shall be provided by JHP for any other component of the photographic material including without limitation those for models, minors, rights of publicity, privacy, property, trademarks, copyrights, patents, misaffiliation, defamation or for any other cause for liability or otherwise, unless expressly listed in the Estimate and provided in writing by JHP at the time of JHP's delivery of the photographic

continued

material. JHP may but shall not be required to keep archives or copies of the photographic materials. Except for those expressly identified as being for permanent transfer to Client, and unless otherwise specified by the express terms of the Estimate, all photographic materials, remain the property of JHP and shall be redelivered to JHP within thirty (30) days of first publication, or within sixty (60) days of delivery, whichever occurs first. Client shall destroy all digital files within one week of first publication, or at the conclusion of the term that the rights have been licensed for. As reasonable liquidated damages, Client agrees to pay JHP \$2,500.00 for any original image which is lost by Client, its carriers, consigns, and bailees, unless JHP has a high quality reproducable duplicate of such original image.

4. Limitations on Liability. The photographic material is deliverable in the specified format. AS IS, where is, at the place designated in the Estimate, or if none, at JHP's principal place of business. Except as provided for in the Estimate, the photographic materials will not be insured. JHP shall not be responsible for the risk of loss for the photographic materials while the same are in JHP's posession or in the hands of any carrier, beyond the amount of any insurance, if any, procured by JHP for Client at Client's written request and expense as shown in the Estimate. Except as expressly provided for in the Estimate, JHP shall obtain no independent insurance for the Photographic materials. JHP makes no warranties, express or implied, with regard to the deliverable photographic materials. ALL WARRANTIES OF MERCHANTABILITY AND OR WARRANTIES OF FITNESS FOR A PARTICULAR PURPOSE, AND ANY AND ALL OTHER WARRANTIES EXPRESS OR IMPLIED, ARE EXPRESSLY DISCLAIMED to the fullest extent permitted by law. In the event that JHP work becomes lost, unusable, or damaged due to equipment malfunction, processing, or technical error prior to delivery, JHP shall at JHP's sole election be provided by Client with a reasonable opportunity to perform the photographic services to replace the lost, unusable or damaged work; and JHP may require that JHP first be paid in full for such work. JHP's liability to client for any acts or omissions arising out of or in connection with this agreement shall not, in any event, exceed the amount paid by Client to JHP under this agreement. In no event shall JHP be responsible for incidental, or consequential damages. Client shall indemnify, protect, hold harmless, and defend through Counsel of JHP's choosing, JHP from and for any and all claims, demands, actions, proceedings, and costs (including without limitation reasonable attorneys fees, court costs, and litigation related expenses) which arise out of or in connection with JHP's performance of services for Client, or Client's use of JHP work, except where the same arises solely from JHP's own negligence.

5. Rights. Except as expressly licensed in the Estimate, all right, title, and interest, in and to the photographic materials, including without limitation the copyrights, design patents, publicity, attribution (and other rights in the photographic materials), including without limitation any renewals or extensions thereof, now or hereafter arising, shall be and shall remain except as may be subsequently licensed by JHP the sole property of JHP in perpetuity, throughout the world. All permissions must be signed by JHP in writing and are otherwise invalid. Permissions granted to Client are expressly conditioned upon payment in full; absent full payment such permissions shall be deemed void ab initio. Except as expressly licensed in the Estimate, permission to include JHP work in a collective work includes the work only in the stated media and excludes permission to include the work in other media, or any revision of the collective work or later series. The client is not authorized to remove copyright management information from JHP work, and any authorization granted to client to use JHP work is conditioned on the Client's inclusion of the copyright management information

continued

which is designated in the Estimate, which in no event shall include less than JHP's authorship designation and copyright notice, and such other information as would permit through a reasonably diligent search the identification of JHP as copyright owner. Permissions granted may not be assigned or sub-licensed.

6. Disputes. In the event of a dispute arising under this agreement such dispute shall at JHP's election be resolved exclusively by binding arbitration in accordance with the rules of the American Arbitration Association. The arbitrator shall determine the prevailing party and shall order that they be reimbursed their arbitration fees, arbitration costs, and legal fees and costs incurred for and in connection with the arbitration. The arbitration shall be conducted in Washington, DC and the decision of the Arbitrator shall be final, binding, and enforceable in any court having jurisdiction. The parties consent to the personal jurisdiction and exclusive venue of the courts of the District of Columbia for any litigation commenced under or in connection with this agreement. The laws of the District of Columbia, without regard to its rules for conflicts of law resolution, shall apply in the construction of this agreement. Actual attorneys' fees and all actual costs shall be awarded to the prevailing party against the losing party in any such litigation.

JHP Signature:

Client Signature:

This is the end of page two. Note that you might want to change term 6 from binding arbitration to the courts in your jurisdiction.

Chapter 12 Contracts for Weddings and Rites of Passage

There are numerous types of rites-of-passage photography. Several of the major ones are weddings, births, deaths (yes, deaths), christenings, brises, sweet sixteen parties, bar and bat mitzvahs, senior portraits, engagement parties, honeymoon photography, anniversary parties, and school reunions. There are countless other types of photography—horse shows, dog shows, school portraits, family portraits, sports league photography, senior prom photography, and many others. I have known many "true photographers" who disrespect their brethren who earn an excellent living doing these types of photography. Frankly, I find this plain wrong. What I have seen occur, however, often gives me a chuckle in the "watch what you say because someday you might have to eat your words" category.

NOTE

People who consider themselves "true photographers" are usually among photojournalists, corporate/commercial, and advertising photographers. I'd recommend a reexamination if this is your perspective. To me, this perspective is bad karma.

From Time to Time, Even the Non-Wedding Photographer Will Cover a Wedding or Rite of Passage

Usually this situation happens with a relative the photographer knows who is getting married. The photographer hears that a family member or close friend of the family is getting married, and the couple has budgeted \$2,000, \$3,000, or \$5,000+ for photography. "Are they out of their mind?" is usually what the photojournalist will wonder out loud. "Tell them to give me the names of the photographers they're looking at, and I'll tell them which one will be the best for them." In short order, the photojournalist has a list of five or so names and is surfing to their Web sites. At the first one, they look at the price list and are incredulous. By the fifth, they are saying to themselves, "Hey, I can do *that* type of photography almost with one eye closed.

Maybe I'll look into this more." And they do. Along the way, the photographer will make a recommendation based on the quality of the photography, but there's so much more that goes into being a wedding or rite-of-passage photographer that it's an education unto itself.

For those of you who are looking to focus on rites-of-passage photography, there are several good books on the subject, and I'll list a couple at the end of this chapter. Further, there are excellent traveling road shows put on by the likes of legends Monte Zucker, Dennis Reggie, Gary Fong, and others, all of whom will school you in weddings. The Professional Photographers of America have schools, books, and other materials that will help you to grow that type of business correctly. However, this book cannot, in one chapter, provide the breadth and depth that all of them bring to the table. What I will do is give you some tools and insights into the business and encourage you, ever so strongly, not to dive into the business doing weddings for a few hundred dollars as side income on a Saturday or Sunday (or other days when rite-of-passage photographers. They have enough "Oh, the bride's uncle owns a camera and he's pretty handy," or "At \$1,500, heck, I'll get my cousin Joe who's a photo student to take a family portrait for a quarter of that" type of problems—they don't need you, dear reader, contributing to that. So please recognize that being a photographer whose business is serving those rites of passage is truly a full-time business.

It's a full-time business because many brides (I'll use them as the example for all rites-of-passage participants) experience sticker shock when they see a \$3,000 price tag on a wedding. "For \$3,000, that photographer better be frickin' Annie Leibovitz" is something I've heard brides mumble (or write on bridal chat forums) until they have a bit of an attitude adjustment. And, for the record, while I highly doubt anyone could convince Ms. Leibovitz to photograph a wedding, her assignment fees range from the mid-five figures to sometimes as high as six figures for the work she chooses to accept. That, in the commercial/corporate/ad world, is something worth aspiring to.

What takes some time to learn—and what a skilled photographer will give insight into—is that it's not \$3,000 for the single day; there's myriad other work that goes into the photography aspect of the bride's day, just like everything else. There's pre-production, client interviews, re-interviews, then client meetings, then harried/concerned phone calls from the bride/bride's mother/groom/groom's mother that need to be handled. Sometimes the package price will include an engagement portrait. And then, there's post-production, just like in all other types of photography. Then post-ceremony bride meetings sometimes occur, and there's uploading to an online service and preparing an album. Some of these things can be outsourced, but many photographers keep the work in house. I'd say that a wedding photographer has about the same number of days off as any other photographer and is working just as hard. Further, their business (as with all rites-of-passage photo businesses) is seasonal. A responsible wedding photographer will not book more than one wedding a day (from my perspective) and can only really count on two a weekend at the maximum. Sure, every weekend someone somewhere is getting married, but the "high season" is usually May/June, September/October. I think that most wedding photographers would like to do between 20 and 40 weddings a year. Some might do more because they have to make their revenue requirements in volume. However, the wedding photographer who does 20 a year at \$5,000 a day is going to be fresher on each day than the guy who's a "wedding mill" and does one Saturday morning, one Saturday afternoon, and another

on Sunday, doing 50 to 80 a year at \$1,000 to \$1,500 per wedding. That photographer is going to burn out, and I don't want him or her anywhere near a couple I know because it's just one more gig to that photographer...something to get through. I want the photographer to be excited (or at least enthusiastic) about being there.

So make sure that when you realize there is good money to be made doing this type of photography, you enter into this field the right way. Consider all of the business models, such as "I can only really count on working on Saturdays and maybe some Sundays" if it's weddings you're looking to do. This means a maximum of 52 Saturdays and maybe a maximum of 24 Sundays that are available to you. Although the norm for many photographers looking to fairly evaluate their CODB figures 100 days of shooting, clearly that's just too much for the wedding photographer. For prom season, it's Friday and mostly Saturday nights during April, May, and June. You get the picture: Think through what your potential days are and combine work types to achieve a good mix of the types of services you offer.

What a Wedding or Rite-of-Passage Contract Should Look Like

A rite-of-passage contract will be a lot simpler than your standard editorial/corporate contract. These photographers worry more about their clients using scanners and about Wal-Mart minilabs absconding with their print revenues—taking a \$40 8 \times 10 and having it printed poorly for 99 cents from Wal-Mart—than they do with rights packages and usage. The worst part about the client who tries to get his or her proofs enlarged to 8 \times 10 is that, as you know, the print will look soft, contrasty, and usually not like the right colors because the lab is neither color managed nor professional. And then, the bride says, "My photographer was John Harrington," and the viewer (while saying to the bride, "Wow, that's nice!") is mumbling under his or her breath, "I'll never use him; that photo looks like crap! Heck, my uncle takes better photos than that!"

The contract should include the following terms:

It is understood and agreed to that John Harrington Photography is the exclusive official photographer hired to provide photographic services for the wedding day.

These terms are necessary so the photographer doesn't show up and have uncle Joe posing the bride before and after the ceremony, and otherwise taking time away from and interfering with the job the photographer is trying to do. Morever, this wording ensures that the bride isn't hiring three photographers without each of the others knowing it. Although this clause may be struck in that instance, this ensures that the photographer will be alerted to the circumstance. In fact, some photographers have been known to include the clause:

Bride and groom agree that no guests may be permitted to take photographs while the official photographer is taking photographs.

To me, it's either just plain egotistical or greedy if the photographer doesn't want family and friends snapping away during the posed photos and taking away their reprint sales. The argument could be made that with other guests taking photos, it's possible that eyes will be averted away from the official photographer, but this is usually resolved by having the assistant

ask that guests pause their own photo-taking during the time that the photographer is taking photos. Further, there are some photographers who rely on slave triggers that are not infrared or radio, and instead react to any flash firing, and they may be trigged moments before they are supposed to be by a guest's point-and-shoot strobe. Thus, the flash pack is not recharged for the needed image. I've known, however, more than one photographer who has been more than happy to let his lighting kit go off while guests are snapping away, with his attitude being that none of the photos will come out because of the overwhelming flash output of their flash kit. I think this is a bit over the top.

> Orders, either in part or in full, shall not be delivered until the balance due is paid in full.

I think this is fair, especially for reprints. Unlike businesses, it's time-consuming to track down a deadbeat individual—especially one who has quite likely gone into deep debt to pay for a wedding—and you don't want to be in line with the rest of the creditors.

Negatives, raw digital files, and proof/preview prints remain the property of the photographer.

This makes sense, just as it does in the editorial/corporate world.

Photographer reserves the right to use photographs taken during the course of their work for display, advertising, or other promotional use.

Couples can be funny about this one. I once had a bride who was a lawyer, and she rewrote this entire clause, which was fine by me.

Should the wedding be cancelled or postponed, all fees and deposits paid are non-refundable.

It happens, and it's regrettable. However, you've lost the ability to earn an income on one of the few days you can during the year, and you should not be left holding the bag. Further, caterers, locations, and other vendors involved also have similar cancellation clauses. If you'd like to soften it, you can try something like this:

Should the wedding be cancelled or postponed, all fees and deposits paid are nonrefundable, unless Photographer is able to rebook the date he has committed to you for an equal (or greater) contract.

This next term is critical:

Photographer represents that extreme care is taken with respect to capturing, developing, digital processing, storage, and delivery of images. However, in the event that Photographer fails to comply with the obligations of this contract, for any reason, including but not limited to events outside of the photographer's control, the photographer's liability shall be limited to a refund of all payments.

This protects you in the event your cards fail, your hard drive fails, your camera fails, and so on. It protects you in the event that you're in a car accident and can't make it. And the phrase "for any reason, including but not limited to" also means you could technically bail for a higher-paying wedding and just refund them their deposit. But that's just plain wrong, unethical, and unfair. Don't do mean things like that. The couple (or you, proactively) might wish to remove these words, but make sure you're protected for the things that could go wrong outside of your control.

Unless specifically requested, and stated on this contract, all images will be produced digitally.

Some brides might still be expecting film. This makes it clear you're not shooting film.

The contract should also state that obtaining your commitment for the date requires a signed contract and deposit paid. Further, I require final payment of the package price seven days before the service. On their big day, I don't want to have the couple fishing around for their checkbook or forgetting it and wanting to pay me after the honeymoon. However, I have been known on occasion to adjust this to "day of" payment. But payments for the package on a date following the ceremony are a deal breaker for me.

I also ask for the bride's address, the groom's address, and their address following the wedding. Further, the contract includes the place where they want me to report to, as well as where the ceremony and reception sites are. I then detail their package—whether it's a time-limited event; approximately how many images they can expect; whether albums, reprints, or engagement portraits are included; whether a second photographer will be used; and so on.

The last detail that I ask is that both the bride and groom sign the contract. Until they are married, one cannot legally engage the other into a contract or obligation. Having them both sign precludes problems down the line and makes for a cleaner contract.

There are many forms available through professional organizations that you can use. I know of several photographers who outline on a two-page letter, with places for signatures at the bottom, the dates, the times, and the package elements.

Negotiation with the Bride, Groom, and (Often) Paying Parents

The negotiations with the decision maker in terms of who the photographer will be are significantly different than when such negotiations are engaged with a publication or organization. In the latter instance, you are dealing with someone with line items and budgets, and it's somewhat impersonal. In contrast, the dialogue with the "media buyer" for a rite of passage is 100-percent personal. Of course you have to be capable, but I can't imagine someone reading this book who isn't. You must connect with the prospective clients, and they must like you, get along with you, and think you're an easygoing person. Prima donnas are just not going to get the assignment.

The dialogue and where it occurs—the interview/meeting—is all about these issues. This is a job interview, only it's for one day's work. Dress for success. If your meeting is in the exclusive community in your area, you must not turn up in jeans or business casual. A business suit is appropriate, especially if the meeting is with the bride's parents or the parents for a rite of passage for a child. If, however, you are meeting with a couple in their apartment, then business

casual is most appropriate. I can't imagine any circumstances in which jeans and polo shirt would be appropriate for a meeting.

Prior to the meeting, there should be no surprises. The clients should know your pricing structure. Nothing is worse than putting the couple in the predicament that after they listen to you tell them all about what you can do for them, you start quoting \$3,500 packages when they are dealing with a maximum budget of \$1,500 or \$2,000. There's no way you can move them to \$3,500, like you might be able to if their ceiling was \$3,000. That is an insurmountable gap. Further, you'll want to make sure that they know what your style is (mostly posed/setups versus photojournalism/reportage style). The "media buyer" should have pre-qualified you down to a small group of providers who are available, capable of meeting the style and client needs, and within the client's budget. If any of those factors is not met, you're out of the running. Avoid wasting your time and theirs.

Many photographers have packages for rite-of-passage photography, and often there may be a gap when the client considers all of the items you're offering and what he or she can afford. I recommend you consider what the rock-bottom price you're willing to shoot for is—perhaps photography/expenses only, and the client can review the proofs (although they are not a part of the package), and they must be returned after the order. Or, perhaps they can only view the photos via an online service that carries watermarked screen-resolution images for their review. What would you charge? If your \$3,500 package includes a 15-page album and 10 8×10 s, plus eight hours of your time, are you backing out \$800 for the album and \$400 for the 8×10 s, and making your rock bottom-rate \$2,300? Consider this as an option, or at least a point for negotiation. Perhaps the rock-bottom price is \$2,600, and if they were to order the prints/album after the fact, it would give you a \$200 premium. Many people order these in the end, so the extra work is compensated for with this premium.

You can expect that people are more interested in negotiating when it's their own after-tax money they are spending for you.

Protecting Yourself from Liability

When you sign a contract to render your services, most photographers take the approach that, "They signed, the deposit's arrived, great. That's one more locked assignment for the year to make my annual goal." What these photographers are not focused on, however, is their obligation to provide those services. Yes, there's the clause, "*However, in the event that Photographer fails to comply with the obligations of this...the photographer's liability shall be limited to a refund of all payments,*" that may protect you, but in the end you'll have to refund the monies and suffer a loss of your reputation.

Many families will ask the question, "What happens if you're sick and can't come? Do you have a backup photographer?" What this question is really asking is, "Do you have someone as capable as you that you are guaranteeing will be available at the last minute, and won't be booked themselves, to cover for you *just in case* you fall sick?" That's a fair question. You can say all you want—"I've never missed a ceremony in 10 years"—but that won't make them much more comfortable because their fear is about *their* ceremony. Engaging the services of someone capable or maintaining one or two regular assistants you work with and who, in an emergency, could step in could mean saving yourself and your clients a great deal of angst.

In addition, you'll want to look into insurance that would cover you in the event that something goes wrong. Shoot insurance or a general liability umbrella policy could be the protection you need. There have been legendary stories of photographers having their film go bad, and then paying to fly every wedding party member back to the wedding site, renting tuxedos for them, and reshooting the photos. Would this happen today if a Flash card was to crash? Establishing a system (which I will go more into depth about in Chapter 20, "Office and On-Location Systems: Redundancy and Security Beget Peace of Mind") will give you a workflow to point to when after the fact, someone calls into question how serious your protections are to make sure that valuable photos are not deleted/corrupted/ruined.

Multi-Photographer Events: Calling the Shots and Taking Control

One thing I often find funny (yet understandable) is when I am at a news conference or other event where there are multiple photographers, and they all have gathered/clumped themselves into one area—all essentially getting the same photograph from a nearly identical perspective. I find it understandable because in many instances, that is the best view/angle that juxtaposes multiple elements into the frame. Of course, I encourage photographers to think beyond the expected and do something unexpected. That will be how you differentiate yourself. Sometimes that means forgoing the best angle for something offbeat or unique. For a rite-of-passage ceremony, such as a wedding, the kiss is usually followed by the "down the aisle" procession, so when you're a one-person show and that's such an expected photograph, you really need to capture it. For an event where your newspaper has assigned you to cover something that you know will have the wire services on hand, the thoughtful photographer will look for the unique angle and allow the wire services to get the head-on or 45-degree angle shots. In this way, you can get something different. Of course, the risk is that the paper will run a wire photo instead of yours, but in the end, establishing a body of work (clips) that show you can think differently will make a difference in your marketability down the line. I'd treat their existence and the angles they are shooting from as a known quantity and work around that.

In a similar fashion, if a client hires multiple photographers for an event, they are all going to want to get the same angle/shot. Yet, if you're the photographer who subcontracts the others, you are in charge—you choose coverage perspectives and, as such, you can significantly enhance the event coverage. I have covered major news events as the photographer for the event organizers, and I have been responsible for directing multiple others. In those instances, I can assign someone to stick with the VIPs, someone to get crowd participation, someone to make sure to document corporate sponsorship logos/signage to validate that they had a major presence there, someone on the finish line of a foot race, and so on. For a multi-photographer wedding, you can direct someone in the balcony shooting head-ons and wides of the overview, someone in the front of the church at an angle getting the "cutaway" shot of the bride/groom when their backs are to the audience, and someone getting reaction shots of the family in the front pew, and so on.

The challenge is convincing the people hiring you—whether the bride and groom, parents (in the event of a wedding or other rite of passage), or others—to have you be in charge. Much of this is moot if you're the only person covering the event, but for large ceremonies, it's not uncommon to have multiple photographers. If you're not the one in charge, make certain that your role is specifically defined. When you are working for a fellow photographer verbal direction makes sense, but if you're working directly with the client, and they are then essentially directing each of the photographers, make sure your contract spells out these things. It may be that in the example of the kiss and walk down the aisle for a wedding, the bride wanted the insurance of two photographers in the back or wanted the feel of paparazzi as they exited the church. I would always try to be the one in charge so that I could choose the photographers I was comfortable working with and who I felt were best for the job.

Recommended Reading

Cantrell, Bambi and Skip Cohen. *The Art of Digital Wedding Photography: Professional Techniques with Style* (Amphoto Books, 2006)

Sint, Steve. Wedding Photography: Art, Business & Style (Lark Books; Second Edition, 2005)

Chapter 13 Negotiations: Signing Up or Saying No

Were it so that clients paid our stated rates with no haggling! Were it that car dealers didn't try to get you to pay extra for the superior underspray versus the standard underspray. During a college summer, I took a job for one day selling cars. I spent the day in training, learning how to convert a \$6,000 car to an \$11,000 sale, and that the difference between the standard underspray and the superior underspray was that the aftermarket service the dealership paid a pittance to do the spray had a worker stand on one foot when spraying the superior spray. I kid you not. At the end of the day, I decided I could not stomach being a car salesman even for a summer during college, so I did not return for the remaining training days. However, I learned more about car sales than I ever thought I would—how they adjust your interest rate based upon the value of your trade-in and how they get you to pay overpriced charges. Car dealers make haggling over prices almost a requirement of buying a vehicle. But negotiating is a way of life, and, in truth, you can negotiate almost anything. The key is knowing your parameters—what are you actually negotiating for and negotiating away as a part of the process? If you are someone who's adamant that you will not execute a copyright transfer of your work, yet you agree to:

...an unlimited grant of rights for an unlimited period for an unlimited number of media...

not only have you done the same, but you've precluded yourself from using the images because one of the rights that was not limited was the exclusive versus non-exclusive. When you license to a client exclusive rights, they, for the period of time, control those rights. This means you cannot license the same rights to another party, nor use them yourself. A non-exclusive granting means just the opposite. You can license the same images to other parties for the same rights. Instead, try:

...a non-exclusive unlimited grant of rights for an unlimited period for an unlimited number of media...

This alone not only grants you permission to license the work to others, but to also use it yourself. But one thing's missing—you've granted them the right to re-license the work to third parties. Instead, try:

...a non-exclusive unlimited grant of rights for an unlimited period for an unlimited number of media, for the sole use of XYZ corporation...

Your terms in the contract should also stipulate that rights are transferable only with the sale of client's company to another company. Following is a clause in one of our contracts. This clause in our contract was inspired by, and based in part on, terms and conditions from the Advertising Photographers of America boilerplate language.

The licensed rights are transferred only upon: (a) Client's acceptance of all terms contained in this Agreement.... Unless otherwise specifically stated on the front of this Agreement, all licenses are non-exclusive. Client shall not assign any of its rights or obligations under this Agreement. This Agreement shall not be assignable or transferable without the prior written consent of Licensor and provided that the assignee or transferee agrees in writing to be bound by all of the terms, conditions, and obligations of this Agreement. Any voluntary assignment or assignment by operation of law of any rights or obligations of Client shall be deemed a default under this Agreement allowing Licensor to exercise all remedies including, without limitation, terminating this Agreement....

But I'm getting ahead of myself. The point here is to know what you're negotiating before agreeing to anything. Know the value of what you have.

Negotiating from a Position of Strength

When you're hungry with an empty pantry or you feel as though you don't have two sticks to rub together, it's definitely not the time to try to effectively negotiate prices and rights for an assignment. You're much more likely to give in when your senses are affected. Consider this: When you go grocery shopping and are hungry, how often do you find that there are more "immediate gratification" purchases lining your shopping cart than the sundries you came looking for? I have often bought a soda and sandwich from the grocery store deli and eaten it, and *then* gone shopping. The cost of the sandwich ends up being far less than all the chips, snack foods, and other items I'd have bought while shopping on an empty stomach. Yes, yes, I know—have a little self control. But the problem is I was negotiating with myself from a position of weakness. No biological instincts are more powerful than hunger, which is a sub-instinct of the self-preservation instinct. The drive for sex runs a close second, but that's another book and another type of negotiation.

As photographers, positions of strength come from a number of areas:

- An award-winning photographer will negotiate for better rates and more control over the direction of a story being considered, especially right after the <u>conveyance of the award. Years later, the sheen of the award will have worn off</u> and self-doubt will return.
- A photographer with numerous bookings will negotiate for better rates and be able to put off rights demands.
- A photographer with a roof over his or her head and full pantry will negotiate better than one with a stack of collections notices in the mailbox.

► A photographer who has other resources to draw from to cover expenses, such as a part-time job or a full-time job that allows for weekends free to provide ritesof-passage types photography, will negotiate better.

NOTE

Some photographers are independently wealthy. These photographers are in an enviable position, but one that carries a responsibility to the profession. Just because you don't have to worry about making a minimum monthly income/profit level, that doesn't mean you can take assignments for the pleasure of seeing your photo credit. Doing so sets a standard that is unattainable by those who do have to make monthly minimums to survive, and you do those you admire as fellow photographers a disservice and make their lives miserable. This may be one legitimate reason why the phrase "trust fund photographer" came into parlance and is used in a derogatory manner. But one photographer, who worked in the field of photography early on, did a service to the community as a "trust fund photographer"—Alfred Stieglitz. He worked diligently to improve the gallery showings, pay, and general circumstances of his fellow photographers. Those with similar good fortune would do well to follow his lead. A documentary on his life and exhibitions of his work are ways to learn more about him.

There are many photographers I know who made pictures and waited tables to pay the bills in the early stages of their careers. Waiting tables, they could make \$200 a day before taxes, and they wouldn't take off a day to do an assignment that paid less. This makes sense, and it allowed them to accept only appropriately paying assignments.

My situation was somewhat different. After several years as a staff photographer at a magazine, I was told that another photographer and I would be offered a single full-time position to split. When the other photographer said he couldn't do it, I thought for sure I'd get the work he said he couldn't take, but instead of offering me the full-time position, the managing editor sought to keep me at the part-time level. At the time, I was very unhappy about this, yet looking back it was very beneficial to me. It was this income that paid my bills, and allowed me to grow my business by turning down bad deals and securing long-term clients who were reasonable on rights and rates.

Practice makes perfect. Although you know that's true for dealing with difficult subjects, challenging lighting setups, driving, and everything else in the world, somehow people believe that they can never be good at negotiating. This just isn't true. Really.

Whatever your position, do everything you can to ensure that you're not negotiating "on an empty stomach" and you don't end up taking bad deals just because you're hungry. Further, you should never find yourself in a position where the loss of any assignment would put you out of business. If you are in that predicament, you need to reevaluate your business model.

In his book *You Can Negotiate Anything*, Herb Cohen talks about three factors that govern most negotiations—an "imbalance in information, apparent time pressure, and perceived power." If you are the only person available within two hours of a location and it's a last minute event, you're more likely to be able to set your terms—if you have some way of knowing this or the

editor happens to mention that everyone else is booked and it's an important assignment. Now you have perceived power from the prospective client's time pressure and the information that you're the only one.

If you say, "Great, I don't have anything to do today," you're diminishing your position. When you quote your price of, say, \$750 to cover the assignment, the editor will say, "Oh, we can't pay that. Our rate is \$300." The editor is attempting to equalize the situation by using what Cohen terms "the power of precedent," and the learned knowledge that you're not committed to something else. Surely you, the photographer, wouldn't dare to ask more than they're offering or have paid others in the past. The editor didn't even say "Our rate is *usually* \$300" or "We *try* to pay \$300 an assignment," which might give you some insight into wiggle room.

Instead, you could have said, "You know, I've got several projects I am working on, but I think I can rearrange those commitments to take this assignment for you." Because you're always doing *something*—looking for new clients, working on marketing materials, reading about the latest equipment, reviewing other photographers' work online, or just generally doing busy work that needs to get done, you do, in fact, have to rearrange *something* to take the assignment.

Cohen further says:

In any type of negotiation, quick is always synonymous with risk.... Undue haste puts one party in potential jeopardy. Who takes the risk in a quick settlement? The person who is less prepared and cannot determine equity. Let's say that I cannot ascertain, based upon my data and observation, that your proposal is fair. Instead, I must rely totally upon your representation.

Sound familiar? "Every other photographer we deal with has signed this 'all rights in the universe...' contract." Or how about, "I am leaving for vacation and need this buttoned up before I leave, so can you do the assignment at this rate?"

First, get off the phone. I almost never give a quote over the phone because I haven't had a chance to think it through, nor have I done any research on this "over the transom" inquiry. Take the time to think through the specifics of the request and come to an understanding of what you'd like to get. Then put it in writing. Things in writing are usually perceived as being less negotiable then things simply said over the phone. When you've drafted your estimate, send it along and follow up with a phone call to begin the negotiations. For a broader review of negotiations and how you should approach them in general, consider that there are effective rules that you should apply when negotiating.

NOTE

I refer to clients who have come to me through no direct effort of mine as "over the transom" inquiries. The phrase "over the transom" has its roots in publishing. A small window that could be opened overtop a door was called a transom. Unsolicited proposals and manuscripts would be dropped through the open transom at a publisher's home or place of business. One other origin suggests that the phrase stems from the Copper Kings in Montana bribing officials by tossing payoffs through the transom into their hotel rooms. Before you begin the negotiation process, consider what Leigh Steinberg, author of *Winning with Integrity: Getting What You Want without Selling Your Soul*, defines as "the twelve essential rules of negotiation" (followed by my application of them to aspects of photography):

1. "Align yourself with people who share your values."

This means photo editors you admire and publications whose reporters you trust and whose stories you respect. In the instance of companies or organizations, perhaps it's humanitarian aid organizations or the philanthropic arm of a corporation. For example, suppose a company such as Ford has a separate charitable organization, the Ford Foundation, that does good in the name of Ford.

2. "Learn all you can about the other party."

This is applicable not only to the photo editors as individuals, but also to what potential contract terms you might face and have objections to, and the state of the company (flush with profits or facing cutbacks and recent staff layoffs, and so on).

3. "Convince the other party that you have an option."

If they're not sure you're capable of the assignment, convey past successes (without appearing to boast), working relationships with other editors they may have worked with in the past, or your track record in a challenging assignment type (underwater, aerials, and so on).

4. "Set your limits before the negotiation begins."

I made the point earlier about negotiations that are too quick being a possible risk, but so too can long, drawn-out negotiations. You don't want to look back at a multi-part negotiation and realize that you'd never have agreed to the deal had you not been incrementally moved to the point you are now at.

5. "Establish a climate of cooperation, not conflict."

Begin, as has been noted in earlier chapters, by engaging the client about the project—let them know that you're interested in the project, are excited to talk through some ideas you have, and so on. If conflict is going to come in the form of "take it or leave it" contract language, it's going to come. Further, there may be a dozen clauses, three which just need clarification and two with potential deal-breaker points in them. Resolve the first three first—getting repeated "yes, that's fine" answers to your requests will make resolving the final two problematic clauses easier when you are operating from the initial spirit of cooperation instead of starting with conflict out of the box.

6. "In the face of intimidation, show no fear."

When faced with "Every other photographer has signed...," I often *think*, "Well, why are you calling me then?" or, "I'm not every other photographer," but of course, I'd discourage those smart-aleck remarks from actually passing your lips. Yet it's a mindset that can drive a more reasonable dialogue with the client. Try responding with, "It has been my experience that signing contracts with those terms isn't conducive to a good working relationship, and is against my policy without reasonable modifications to the contract."

7. "Learn to listen."

Although this might seem obvious, pay attention to what the other party is saying, rather than preparing your next objection. I have found many a creative solution by listening to what people are saying and offering a solution.

8. "Be comfortable with silence."

If you make an offer or respond to the client's request for a concession, and then there is silence, do not speak just to fill the void. By doing so, you begin to negotiate with yourself because you feel that silence is non-acceptance of your offer or response.

9. "Avoid playing split the difference."

Suppose your estimate is \$4,500 for an assignment, and the client says they only have \$2,500, so you suggest, "How about \$3,500?" You're setting yourself up to appear as if you were padding your estimate by \$1,000. If you're going to come down, there needs to be a good reason why. Perhaps you can eliminate an assistant, or catering, or extensive retouching, or perhaps you can learn that the client does not need five years, and only two are necessary.

10. "Emphasize your concessions; minimize the other party's."

Outline how you'll cover the expenses without an advance, with a delay until payment upon publication, with an extended rights package, and the like.

11. "Never push a losing argument to the end."

There's no reason, really. You hope next time to deal with this person either at this organization or another down the line. If you know that they demand WMFH and they have never negotiated that, then don't waste your time or their time. Many times, a photo editor who is requiring WMFH knows that it's bad for you, and there's no sense debating the issue, but saying something nice like, "I understand that's your policy, and mine is counter to that. I hope that in the future it will change, or that should you find yourself at another organization down the line, you'll consider calling on me when that term is not etched in stone." This will let the PE know that you're a reasonable person, and the editor will respect you for that. Further, let the photo editor know that you'd be happy to talk further down the line if he or she is unsuccessful in finding a satisfactory photographer who will agree to those terms. And lastly, when you object to a term and the call ends, there are times when the client will call back to offer you something better. Most publications have "tiered contracts," and everyone gets offered the most egregious one first and the more equitable ones after they object to the first one.

12. "Develop relationships, not conquests."

This is absolutely true in the photographic community and is a great follow-up to my comments from the last rule. The community of people who contract with photographers is very small, and as you evolve your business, ensuring you've not burnt bridges or taken advantage of a client's circumstances will ensure your own longevity and respect among prospective clients and peers.

Creative Solutions in the Negotiation Process

There are numerous ways to get to 10: one plus nine, two plus eight, and so on. All achieve the number 10. Similarly, there are numerous ways to achieve an agreement to makes pictures on behalf of someone. For me, WMFH is the equivalent of *pi*. Given the infinitesimal nature of *pi*, no matter how hard I try, I can't get to 10. If I turn a blind eye or compromise *pi* to 3.14, then of course I can get to 10, but that's including a fudge factor. Absent my *pi*—my deal breaker—I can usually get to 10. You'll need to define your parameters to achieve an agreement, and then operate within those parameters, yet be open to suggestions that a client might offer, as they should be open to yours.

NOTE

For the curious, in September of 2002, a professor at the University of Tokyo calculated *pi* to 1.2411 trillion digits, a world record. For more fun facts on *pi*, visit www.joyofpi.com.

Suppose your client is a small design house, and they have to print something for a client that is $8.6"\times13"$. and the press they need to be on runs 12"- and 24"-wide paper. Because the client has been presented with the added costs to go from 12" to 13" and approved it for their own reasons, they'll need to be on 24" paper stock, leaving roughly 11" of waste all along the job. In lieu of the additional \$1,000 you wanted for the job, you could propose to the client to gang up a promotional piece 10" wide that you are looking to have done alongside the client's job, making that waste beneficial to the client and to you. If you don't, chances are the client will print some of their own promotional material in the waste area, so this is not an unusual request.

NOTE

The truly critical photographer might find this "ganging up" of print jobs objectionable because the client's piece will be what they are watching the color on, and your promo piece might come out slightly different than you'd wanted. Print houses frequently gang print press jobs and know how to maximize the quality of both jobs—but yes, yours might suffer.

You might find that a magazine may not be able to pay you an extra \$300 for a cover assignment, but you might be able to negotiate that they send you 100 copies of the magazine where your photo is featured attractively on the cover. In turn, you can send these copies out to other prospective clients, which might garner you future work for other publications. Because the newsstand price of that magazine is \$3.95, you're ahead—or, if the magazine is \$2.95, you've at least broken even.

One creative "solution" often suggested by a client is "do this one for me, and I'll make it up to you next time." The problem is, in 16-plus years of photography, I have never heard of any client making good on this offer. The experience becomes one in which the PE shops around to all the photographers, never making it up to anyone, and when they do have an assignment that

pays well, they go to the photographer they've always wanted to use but could never afford...*until now.* That person should be you. Further, the client won't respect you if you agree to this "solution." It's a wholly different thing if you've done five or six covers at \$1,300 each for a client, and then they come to you to do an inside image for \$400 or \$500, or a cover for \$1,000 because there's \$300 in modeling fees for this particular cover, and they don't have a budget for it. This might give you pause to consider doing it, but you could counter with, "Okay, but I'd like to hire models, which will allow me to shoot additional images of them that I can then use as stock."

In response to the "cheap one now, paying one later" query, I've found myself, as I see the end stages of the negotiation arriving with a breakdown point being price, making the following offer:

Client: "I'd really love to have you do this assignment; I just don't have \$500 for it. The most I can pay is \$400. We do plenty of assignments in your area, and I'm glad to have your name because I am sure I can make it up to you next time."

Me: "My fee to shoot that assignment would be \$500, and we're about 20% apart. How about this? Since you're sure to use me frequently in the next year, why don't you pay me the \$500 for the next four assignments, and the fifth one will be free. I'll even memorialize that in the contract and keep track of it in each subsequent contract. Because you'll no doubt need me that often, at the fifth assignment they'll all have averaged out to \$400, and your photo budget will be where you say it needs to be when the end of the fiscal year arrives."

Think that has ever worked? Nope. They get it. I get it and I am polite about it. And sure, you bet—if I make that offer and someone takes it, I'll keep up the terms of the agreement. What I'd want to know is, who have they been using for all those previous assignments in my city, and why aren't they using that person now?

Often, I've had calls from clients in which the dialogue is along these lines:

Client: "Wow, your Web site is great; I love your portraits. How much would you charge for a portrait?"

Me: "Let's see, a few questions first—tell me about the magazine. Name, circulation, is this for the cover or inside, and did you have a budget you were trying to work within?" (For a corporate client, it'd be, "Tell me about what the portrait is for," and then a follow-up about annual reports, Web site, PR, and so on.)

Client: "We're *Widgets Today*, we publish monthly, our subscribers are in the trade, and we have a circulation of about 14,000. It's a portrait for inside the magazine. We fairly frequently have assignments in DC, so we are glad to know about you now. Oh, and we normally pay \$250 for this type of assignment."

Me: "Have you been pleased with the results of the other photographers you've called in DC?"

Client: "No, not really, which is why we're happy to find you. I really like your style and use of light."

Me: "Thanks! The thing for me is, I think part of the reason you've not been happy is that the photographers you're working with, and paying \$250 to, have not been producing satisfying results, and I hear that happening often. I am happy to send

along an estimate for the assignment, but the concern I have is that you're expecting the quality of the work I produce for \$250. I'll do the best I can with my estimate, but I don't think I can make that figure."

Client: "Okay, well, send me the estimate, and I'll see what I can do."

Then, I do my research and find that with that circulation, a fair rate would be \$650 plus expenses for an inside portrait, so I send that along. Those who have been doing those assignments for \$250 would be surprised at how many times clients assign the photography at the rates I am providing.

Recently, I negotiated a license from a series of images I produced of a helicopter in flight. It was air-to-air work, which has its own set of challenges. One of the parties associated with the aircraft (not the original assigning party) wanted to obtain the images. They'd appeared on the cover of two aviation magazines, and therefore had a value established for them from their perspective. Here's the actual dialogue that took place via e-mail, which had creative options that produced a solution that appealed to the client:

Client: "We have varied needs for photos like this, as you can imagine. Do you offer a cost for purchasing the photographs outright or for unlimited use?"

Me: "As I mentioned, my work is licensed for use, and typically companies have logo changes, color/style changes, and changes in products in use, which would age the photography. So, from a value-to-use standpoint, licensing the images for an unlimited period of time isn't cost-effective both from that standpoint and the standpoint of an overall cost.

"For example, use of a single image for a period of six months in a full-page trade magazine ad would run around \$2,500. For use in tradeshow displays, a three-square-foot panel for one show ranges from \$400 to \$750, and a six-square-foot panel usable for 36 trade shows would range from around \$2,800 to \$5,600. Continuing to add brochures, sales materials, Web sites, and such for one to five years can begin to add up.

"A few figures for your review, single image:

- ▶ Unlimited non-exclusive use by your company in all print and electronic media formats, worldwide, for the term of Copyright: \$25,000.
- ▶ Unlimited non-exclusive use by your company in all print and electronic media formats, worldwide, for the life of the helicopter: \$21,000.
- ▶ Unlimited non-exclusive use by your company in all print and electronic media formats, worldwide, for 10 years: \$17,000.
- ▶ Unlimited non-exclusive use by your company in all print and electronic media formats, CONUS, for the term of Copyright: \$22,400.
- ▶ Unlimited non-exclusive use by your company in all print and electronic media formats, CONUS, for the life of the helicopter: \$19,200.
- ▶ Unlimited non-exclusive use by your company in all print and electronic media formats, CONUS, for 10 years: \$14,600."

NOTE CONUS stands for *Continental United States*.

These terms gave the client several options and allowed them to make their decision based upon a choice. I also made a point of outlining for the client just how broad a use they would have for the image. Further, I specified "non-exclusive" because my initial client wanted use of the image as well, and I expected other broad uses of the image. The illustration of the extensive scope of use could also serve to have the client pare down their use if they wanted five years, three years, or all company materials except paid advertising placements, and they didn't want to pay the proposed figures.

Defining Your Policies

Policies work both ways. Your policy is to charge more on any given day than it costs you to be in business for that day. Period. Herb Cohen, author of *You Can Negotiate Anything*, illustrates the points of policies, which can manifest themselves as a part of the "power of legitimacy" discussed earlier in the chapter, with an example of the Holiday Inn.

The Holiday Inn has a sign stating their checkout time, which is 1:00 pm. The sign appears not only at the registration desk, but also on the inside of the door next to the fire route map, and often on your registration paperwork. When Cohen was asked how many people actually check out by that time, he thought about it and answered, "Forty percent." Later, he learned from Holiday Inn themselves that "roughly between ninety and ninety-five percent" check out by that time. I often ask for, and almost always receive, an extension on my checkout time for no additional charge. Although it is necessary to have policies about how your business will function, it is necessary to know when there needs to be an exception to a policy.

Almost everyone I know has run up against an adamant customer service person who says (imagine a nasally voice here), "I'm sorry, sir. Our policy is that—and we just can't do that. Is there anything else I can help you with today?" We're frustrated and hoping that *something* can be done—an exception made, a rule bent. However, we accept the notion that our request is a special one, not to be expected. Even credit card companies can be convinced to waive a month's interest charges and penalties if your payment's a day late and you have a history of paying off your card every month. (Really, they do! I've been successful at that request.) However, they keep notes on every call you make to them and all requests made (even when declined), so don't try it to often. The point is, once you establish your policies, make sure you know where exceptions can be made and, more importantly, where they cannot.

Don't make exceptions on your ethical, moral, or legal policies. I subscribe to a point made by Norman R. Augustine, Chairman Emeritus of Lockheed Martin and Professor of Mechanical and Aerospace Engineering at Princeton University. When speaking to a group of business leaders, when he said that "there is no higher responsibility than ethics, and ethics are founded on truth, and ethics is followed closely by one's own reputation." You may make policy exceptions to a rate structure, a pro bono client, a late payment penalty, and such, but make sure you consider the exception and let the client know that you are making an accommodation, and why.

The problem is, too many photographers fail to believe that they can have policies in the first place. Several seemingly silly policies that you probably have are:

- ▶ I will not set the lights and set up the camera to its proper settings, and then hand it to the client to make the photos.
- ▶ I will not give a prospective client the names of my competition who will do the job for cheaper than me.
- ▶ I will not shoot an assignment naked. (It may be just me who has this one.)
- ▶ I will not be treated like a child or an imbecile by any client.

With those in mind, you undoubtedly have other policies that you've not stated, put in writing, posted for clients to see, or otherwise formalized. Once you outline your policies and you feel that, outside of the scope of a specific assignment's dealings, they are fair and reasonable, then you can begin to live by them. You'll be surprised by how a client reacts when you say, "It's not our policy to...." As was evidenced in Chapter 10 with an editorial magazine and elsewhere in this book, clients understand policies—they have them too.

Deal Breakers: What Are Yours?

Everyone has deal breakers. Mine involve my "no naked photography" policy and no WMFH. Back in the dot-com era, I learned that high-tech companies need to pay in full before an assignment is completed, so my deal breaker for high-tech companies is "no pay, no play." This also extends to my work for political campaigns.

Deal breakers are similar to policies, but they are usually encountered in the negotiations process. Setting aside ethical, moral, and legal policies, which are given deal breakers, here are a few more:

- ▶ I won't work for a company that sells tobacco products or things I consider addictive. Having had loved ones die from cancer-related illnesses makes this a deal breaker for me.
- ▶ I won't sign a contract that includes a clause requiring binding arbitration unless, in rare cases, I feel it's in my best interests to do so.
- ▶ I won't sign a contract whose governing law is not workable for the client *and* me.
- ▶ I won't sign a contract that requires "all rights throughout the universe." That's just a stupid and offensive clause.

NOTE

Dictionary.com defines *stupid* as "marked by a lack of intelligence or care, foolish or careless," and goes on to another definition of stupid as "pointless; worthless."

I won't deal with a client who thinks a photographer is an overpaid buttonpusher.

Those are some of my deal breakers, among others. In the end, it's necessary to define your terms and what you will and won't accept, and then to stick to it.

Why "No" Is One of Your Most Powerful Tools

It's true: If there weren't any no's in a negotiation, then you'd have an agreement. Your position is different than prospective clients', and your objective is to overcome as many of their no's as possible, while minimizing the no's that you concede to. There are few true negotiations in which no's can't be surmounted. Sometimes a prospective client says, "Sorry, the contract's nonnegotiable—take it or leave it." Then you've been given an ultimatum, and if you aren't prepared—you have a zero bank account and an empty pantry—then you're at a steep disadvantage. You might as well take it...or leave it. Your fear of losing the assignment will reveal itself in how you discuss the assignment with the client, and your negotiations will be handicapped.

NOTE

A "take it or leave it" contract is not a meeting of the minds and can become what was mentioned in a previous chapter-a "contract of adhesion."

Saying, "No, I just can't accept the assignment on those terms," or "No, I won't ask my assistant to also be the makeup/stylist," or "No, you can't just do anything you want with the photos" can often be what changes the direction of the negotiations. Sometimes the client is just trying to see what they can get out of you, and sometimes it's a legitimate need they have to stay within a budget that might work in smaller Midwest towns, but couldn't work in a major metropolis. Being polite during the "No, I can't" process is important. Be certain that during the conversation, you say something like, "But I'd be interested in working with you in the future on an assignment; please consider me then. Further, if the photographer you do end up with doesn't meet your expectations, I am happy to see whether we can accommodate a last-minute assignment for you."

A final point about "no." As Dick Weisgrau, the former Executive Director of the American Society of Media Photographers, once said during the first ASMP "Strictly Business" traveling program that I attended early in my career, "No photographer went out of business after saying 'no' to a bad deal, but many have done so by saying 'yes' to the bad deals." Weisgrau has written an extensive and well thought-out book, The Photographer's Guide to Negotiating, which is a must-read for a thorough examination of photographer-specific techniques and strategies for achieving success in negotiations.

Studying the Aftermath of a Lost Assignment

On one occasion, six or seven years ago, I got a call from the premier association of physicians in the US for press-conference coverage on Capitol Hill. They'd regularly used a photographer who was not available, and the work bounced from him to two friends, then finally to me. I quoted my normal event rate, which for a press conference ran into my minimum rate of around \$650, including expenses, with a normal two-day turnaround of the proofs. Consistent with the Associated Press' charges to scan and transmit an image for someone who walked in off the street of \$100, I, too, would charge that rate upon request of a scan, and this was outlined in my contract. Further, my rate for same-day delivery of the proofs was a 200% surcharge on top of my normal \$35/roll charge, meaning \$105 per roll, and I'd shot three rolls at the press conference. Following the event, the client called for two scans to be transmitted and wanted the CD the same day, incurring the 200% charge as well. This assignment blossomed from \$650, adding \$200 in scans and a rush charge on the three rolls that added \$70×3, or \$210, for a total of \$1,060. The bill was sent and paid on time.

When they called the next time, they commended me for doing a great job the last time, and I made a point of asking whether they'd contacted their primary photographer. I make it a point not to steal a client referred by a colleague from the referring photographer. I just think that's bad form. The client said they had contacted their primary photographer (which I verified before sending the estimate), and I said it'd cost the same as last time, which they said was fine. I sent along another contract, which was signed and returned, and again, same charges.

This happened a total of four times. The client was happy, and I was too. I also made a point of conveying these figures back to the initial photographer, who'd only charged them a flat rate of \$300 for everything for which I'd charged \$1,060. I then learned, through a mutual friend, that the initial photographer was upset with me. Why? Because that association's photo budget was wiped out, and they couldn't hire photographers for another six months, so he had to wait for their new fiscal year before they could hire him (or anyone else) again. I don't get it! This photographer should have, instead, learned how little he was charging and just how much the client was prepared to pay for the same services, and then considered that perhaps he could/should raise his rates. Further, the client would have legitimate cause to go to their budget people and outline how their photo budget for the previous year was not enough, and they had several events they couldn't cover as the result of that. This would then allow for a strong argument to raise the budget—something that would benefit everyone.

Although this example is the analysis of a colleague's lost assignment from the standpoint of the photographer who ended up with the assignment, he failed to do what I am recommending: Think though what your experience was regarding the assignment, and how you could have steered it to a different conclusion. Sometimes, the impasse is just too big; other times perhaps there isn't a full outline of the needs and your understanding is different than the reality.

The first thing I do when I learn a contract didn't come through is ask, "Who'd you end up going with?" Most of the time they tell me. I then ask, "Was it a matter of price?" And when they say yes, I ask, "How much of a difference was there between the other photographer and me?" When they say they thought the other photographer's approach was different or more in line with their vision, I can accept that.

When there is a substantial price disparity or the other photographer "gave away the farm" for the assignment, that's when you might consider a cup of coffee with the other photographer. However, that might come across as sour grapes if not handled correctly or you don't know the other photographer well. What I'll do is wait for a client we both were in a dialogue with and who selected me as the photographer for the assignment. Learning from the client who the other photographers were that vied for the contract, and that the client ultimately selected me without shopping for the lowest price gives me an opportunity. Without taking a holier-than-thou approach, I'll take this opportunity to share my figures with the photographer who didn't get the assignment, who may have feared raising his or her rates. At no time do I say, "You need to raise your rates," or "We should agree to..." anything. The fact that the photographer is looking at a contract that was awarded to a more expensive colleague may well give the photographer the fortitude to raise his rates the next time around, whether or not he is competing with me.

Whatever the circumstances surrounding a lost assignment, I encourage you to make a point of learning why each one was lost and what steps could be taken to avoid that outcome in the future.

Case Study: Science Competition

Several years ago, I was contracted to photograph an event in Washington—the awarding of a science medal to two students during a competition. The license was my standard one for events, and it expired after a year. On the reverse of the photographs was my copyright notice, phone number, and roll and frame numbers. A science book publisher, obtaining those proofs, wanted photographs of the students for a textbook on science and contacted me by telephone.

The initial inquiry came into my office while I was out on an all-day assignment. My office manager called to give me the details of the inquiry. I asked her to research pricing through the software resources we have, and I reached the conclusion that for the use they initially stated they were looking for pricing on, I'd quote \$275 per image, or \$550 total. The back and forth begins below, and note how when we provide a quote based upon the expanded usage, the media buyer for the organization steps in to attempt to negotiate downward. The end result that they wanted to spend was between \$450 and \$500. In the end, for both, they ended up paying just over \$1,900.

Here, we've forwarded to them a selection of five images because they only had two in hand. The dialogue begins with that e-mail:

From: 'John Harrington' Subject: Other images of the **Example 1** Date: February 27, **Example 1** To: **Example 2** ('Photo Editor')

Here are the images we have...they can be further enhanced/scanned, if you'd like. Best, John

From: **Construction of the Editor**'} Subject: Re: Other images of the **Editor**'} Date: February 28, **Editor** 10:50:22 AM EST To: 'John Harrington'

Thank you for sending the images. We are going to use images 16 and 22 and we would love to get hi-res scans of them! Below is our intended usage...I just need your e-mail Ok.

The rights we are requesting for image use are:

- Non-exclusive, World English language distribution including DODDS military schools;

- Student Edition/Teacher Edition combined units of 60,000;

- Minor revision granted for six (6) years (minor defined as less than 10% of the photo content changes from the original product), or until a major revision, whichever comes first.

Thanks again,

From: 'John Harrington' Subject: Re: Other images of the **Sector** Date: March 1, **Sector** 1:59:25 AM EST To: **Sector** ('Photo Editor')

The rate I quoted you of \$275 was for 60,000, English language only, US, as I mentioned, and your request, as outlined below, is broader than that. Here are adjusted numbers based upon your request, in an a la carte manner, with some additional options.

Media Use/Rights Licensed (PER IMAGE):

Use in one edition of textbook: Non-exclusive, editorial North American (including DODDS military schools) English language rights as follows:

- SE/TE print edition, press run = 60,000 1/4pg inside 275.00
- Minor revision editions (<10% of contents) for 6 year period 185.00
- ▶ WORLD RIGHTS: 100% for world rights in one language, 200% for world rights in all languages. Expanded rights package discount available if licensed together (10%).
- ► ADDITIONAL LANGUAGES: 25% for each additional language and/or each additional country.
- ▶ *SE/TE CD-ROM, Adobe PDF Format 72dpi non-printable 255.00
- *Internet/extranet, 72dpi 225.00

It appears as if you're not asking for CD/PDF/Internet, so, while those wouldn't apply, they also are not included. In the event you are planning on those, or end up wanting that use, please let us know. For your request—print edition only, minor revisions editions for six years, you are looking at \$275 + \$185 = \$460, and world rights adds 100%, totaling \$920, less a 10% discount for multiple rights types, or \$92, bringing the per image total to \$828.

continued

Clearly, you've requested a much broader use of the image than our original conversation. If you want to add in the CD/PDF/Internet, let me know. We can provide images 16 and 22 via FTP, at 1/4 page specs— 3×4 , 300dpi.

Let me know if you'd like us to proceed with the high resolution scans—the costs for those, and any retouching, is included in the above figures, and will commence once we get word that these adjusted numbers are approved. Credit should read "© John Harrington" for both images.

Sincerely, John Harrington

From: **Constant of Section** (Permissions Coordinator) Subject: RE: Other images of the **Section** Date: March 3, **Section** 10:25:55 AM EST To: 'John Harrington'

Dear John,

I am a Permissions Coordinator with second s

From: 'John Harrington' Subject: Re: Other images of the **Exercise** Date: March 3, **11**:42:50 AM EST To: **Exercise** (Permissions Coordinator)

Thank you for writing. As you know, these are images are not available through any other sources. As you are licensing two images, I will reduce the per image figure from \$828 to \$750, provided payment is received within 30 days—preferably by credit card—a savings of over \$150 of the previous quote. Understand, also, that we did not charge a research fee to locate and retrieve the images from our archives, and are not charging any scanning or delivery fees.

Please let me know if you would like us to forward an invoice. The invoice will reflect the \$828 per image licensing fee, the licensing language below, with a note outlining the deduction for timely payment that will reflect \$750 per image. As noted earlier, Credit should read to 2001 John Harrington". Sincerely, John Harrington

From: Second and Secon

John — Thank you for your response. I am forwarding this on to **service states** who is also working on the project. She will contact you if our editorial group is still interested in using your images in our project. If so, we will use your original quote of \$828 per image. Regards,

From: 'John Harrington' Subject: Re: Other images of the **Sector** Date: March 3, **Sector** 4:45:35 PM EST To: **Sector** (Permissions Coordinator)

— That's fine—it sounds as if you cannot make payment within 30 days, and thus would not be able to take advantage of the \$150+ savings I was offering. If not, that's unfortunate; however, I look forward to hearing back from you. Sincerely, John Harrington

From: 'Photo Editor'} Subject: Re: Other images of the Date: March 6, 12:19:45 PM EST To: 'John Harrington'

John — We would like the Hi-res of IMG 22 and IMG16. Thank you very much! —

From: 'John Harrington' Subject: Re: Other images of the **Particular** Date: March 6, **Particular** 2:04:43 PM EST To: '**Photo Editor**'

Lisa — Attached are the two images, scanned from the film. Please let me know if you would like any additional adjustments/size changes/etc. Sincerely — John Harrington

From: 'Subject: Re: Other images of the Subject: Re: Other images of the Subject: March 7, Subject: 8 PM EST To: 'John Harrington'
John,
Editorial has changed its mind and now they want to use the second in jeans instead of them being given the award. May I have the hi-res of the attached image? Many thanks, second

From: 'John Harrington' Subject: Re: Other images of the **State of** Date: March 8, **State** 3:28:45 AM EST To: '**State of the State** '(Photo Editor')

— Here are the two from that setting...I think one has better "eyes" than the one you were looking for, but here are both, 4"×6" at 300dpi. Best — John

From: 'House Content of 'Photo Editor'} Subject: Re: Other images of the House Content Date: March 8, House 4:36:13 PM EST To: 'John Harrington'

John — Thank you for the speedy turnaround!!

(Permissions Coordinator)

Subject: Invoice 94 Date: May 4, 964 4:22:39 PM EDT

To: 'John Harrington'

Dear John,

From: '

I'm writing in regards to your invoice # 1994 for our project **second second se**

Best regards,

CHAPTER 13

From: 'John Harrington' Subject: Re: Invoice 94 Date: May 04, 99:21 PM To: 'Permissions Coordinator}

We can and will forward you the details of that additional usage Friday. We will revise the invoice # 94, unless you have already submitted it for processing, in which case, we will invoice for the difference, and provide you with invoice # 94A for that purpose.

Regards, John

From: ' Permissions Coordinator' Subject: Re: Invoice 94 Date: May 05, 23:45 PM To: 'John Harrington' Hello John, Your invoice has not been submitted for processing. You may revise invoice # 94 for the total amount with the extended terms. Please let me know the details for these terms as soon as possible. Best regards,

From: 'John Harrington' Subject: Textbook invoice Date: May 11, 11:03:12 AM EDT To: 'Lease 'Photo Editor'} CC: 'Lease 'Permissions Coordinator'

Attached is the revised invoice for the usage of the images in your textbook with the higher press run, totaling \$1,904.40. Please let me know if there is anything else I can do for you.

OHN HARRINGTON			Invoice
h o t o g r a p h y 500 32nd Street, SE • Washington, DC 20020 Office: (202) 544-4578 • Fax: (202) 544-4579 mail: John@JohnHarrington.com		Date	Invoice No.
Bill To:			
	P.O. No.	Terms	Due Date
		NET 30	04/05/
Descriptio	'n		Amount
Student Edition/Teacher Edition combined units of 100,000, Min (6) years (minor defined as less than 10% of the photo content cl product), or until a major revision, whichever comes first. Image 2 Non-exclusive, World English language distribution including E Student Edition/Teacher Edition combined units of 100,000, Mi (6) years (minor defined as less than 10% of the photo content cl product), or until a major revision, whichever comes first. NOTE: If payment is received in the next 30 days you may pay	hanges from the original DODDS military schools, nor revision granted for hanges from the original	0.	952.20
Federal ID #			

Recommended Reading

Cohen, Herb. You Can Negotiate Anything (Jaico Publishing House, 2004)

Steinberg, Leigh. Winning with Integrity: Getting What You Want Without Selling Your Soul—A Guide to Negotiating (Three Rivers Press, 1999)

Weisgrau, Richard. The Photographer's Guide to Negotiating (Allworth Press, 2005)

Ziglar, Zig. Secrets of Closing the Sale (Revell; Updated Edition, 2004)

Chapter 14 Protecting Your Work: How and Why

The thing about copyright is that it's your right. Hence "copy" and "right." You have been given a limited monopoly over your creative endeavors to give you the incentive to create more. After you're gone, and then after 75 years, your work belongs to your family or estate, and they can continue to benefit from your genius. Later, it becomes wholly owned by the public, and anyone can do whatever they want with your endeavors.

I think this is pretty great. I have been given the incentive to be a photographer. And I own my work. I can recall with great detail the environment surrounding almost all of the photos I've made. Often I can recall the weather, the challenges of the client, the lighting setup, and who was on that shoot, whether colleagues or assistants. That means the shoot is a piece of me, and I feel protective about these little pieces of me and how someone might use them.

It's the Principle of the Thing for Me

Don't confuse my incentive to be a photographer with greed or anything of the sort. I'd make images without being paid—although it's work, it's definitely not a job. However, when someone wants to exploit my work—pieces of me—for their own gain, I expect to be compensated for their use of my work.

For most editorial magazines, if they have 30 pages of advertising and 30 pages of editorial content, it's those 30 editorial pages that the subscriber/reader wants to see. They've agreed to page through the 30 pages of ads because the value of the editorial content is enough for them to do so. In some cases, such as a fall fashion magazine or an annual automotive magazine with the next year's line of cars, the ads may be a draw; however, these circumstances are the exception rather than the rule. So, if I have contributed a full-page image from an assignment, I have directly contributed to the value of the publication, and thus I should be compensated. If the magazine sells ad space at a rate of \$18,000 for a full page, that means they earn \$540,000 per issue from advertising. It's fair for me to be appropriately compensated for my contribution. In the circumstance of a corporate/commercial shoot, I am directly contributing to the sale of their product or the public perception of their company, and, again, compensation commensurate with their benefit is appropriate.

As a freelancer, the notion that these companies want to own the copyright, feel they deserve the copyright, feel they are entitled to it, or take the attitude that "I paid for it, so I own it" shows ignorance about the intent of the framers of the Constitution and the law today. Let's take a look at an example. If, when driving through New York City, a Californian comes to a stop at a stoplight, and then makes a right on red, that driver will get a ticket. You can't expect that your explanation to the issuing officer ("But officer, I didn't know I couldn't do that!") will mean you don't get or don't deserve the ticket. Further, an infrequent Manhattan driver in Manhattan might make the same claim.

Someone who has never licensed photography is similar to the aforementioned California driver in Manhattan. For the driver, there may be some room to get a warning ticket. For the photographer, he may be afforded an explanation by a copyright owner about how he can and can't use the work created.

In the case of the infrequent Manhattan driver, he lives in New York City and is obligated to know his city's driving rules—just as the ad agency or publishing conglomerate must know about the rules of copyright and the consequences for an infringement.

To give you an understanding about just how much the founders of the United States valued the concept of copyright, consider this. The Constitution begins "We the People," and the first section—the *first*—stipulates what legislative powers are held by the Congress, as well as who can be a member of Congress and who can be a Senator. In Section 8, the Constitution stipulates that Congress *shall*:

...promote the Progress of Science and useful Arts, by securing for limited Times to Authors and Inventors the exclusive Right to their respective Writings and Discoveries;

This limited exclusive right is the basis for US copyright. At the end of the chapter, I'll include suggested books that go into detail on how the US copyright is based upon English law. These books are excellent resources to understand the birth of copyright. This exclusive right delineation comes before a discussion of who can be the president and how. It comes before the rules and obligations of the states. Further, it comes before Constitutional corrections—things they forgot about or were wrong about and needed to fix or add—the Bill of Rights, ending slavery, the right to bear arms, and such, which became the various amendments to the Constitution. I say this because I hear all too often how copyright is not important to some photographers, and that they don't really care or enforce their copyright.

Just as I get incensed over violations of a citizen's civil rights or prejudice against race or sex, I get angry on principle when people infringe on my right, given to me at the same time as senators and representatives, and before the president, and before the states, and before the right to bear arms, and before the numerous other amendments. The framers, hundreds of years ago, and throughout time since, have recognized the value of "useful arts" and sought within the first 1,600 words of a document that, without amendments, is approximately 4,500 words in length. When I hear a fellow artist say, "Oh, I really don't care about copyright," I find that offensive. I think that if "copyright" were to be substituted for "the right to keep and bear arms" or "the abolition of slavery" or "equal rights for men and women," almost everyone else would be offended by the artist's statement of disinterest. Yet it was these rights that were *amendments* to the Constitution. The basis for copyright was not an amend-ment; it was in the beginning of the Constitution. So I encourage anyone who "doesn't care" about copyright, who is willing to sell it for a minute fraction of what it's worth, or who looks at someone who is enthusiastic about protecting their own copyright with disdain to rethink their own principles and perspective. Yes, I believe in copyright laws, and you should too!

Don't Steal My Work, Period

With the position I've described, I've found myself in several situations in which my work has been infringed. *Stolen* is a better word, but *infringed* is the technical term. To that end, use the term in dialogues when you're infringed. To that point, your work *will* be infringed. If you're displaying it, sharing it, or otherwise distributing it, I can practically guarantee that you will be infringed upon. If I told you that I could provide the same guarantee that you would have someone break into your house, would you buy an alarm? How about a guarantee that you'd have an auto accident at some point in your life—would you get insurance? I suppose the answer is the same in both cases. Trust me—you will have your work infringed. To that end, protect yourself.

That said, if you're unhappy about Adobe's requiring you to activate your software, thank the thieves. In an April 2005 interview with the *San Francisco Chronicle*, Adobe CEO Bruce Chizen reports that one third of their revenue is lost to software thieves. I encourage you to learn more about piracy in general at sites such as www.bsa.org/usa/antipiracy, because piracy of software has similar arguments and issues as infringement in photography.

The software fotoQuote, which was the precursor to fotoBiz, was almost put out of business because photographers were stealing the software. Photographers steal Photoshop. They steal FTP software—even software that costs less than \$40 is being infringed. I cannot see my way clear to demand one cent from someone else who has stolen my work if I were infringing upon others' creative endeavors, whether software, movies, music, or the like. Further, if I can't afford something so absolutely integral to my business as Photoshop, then there are significant problems with my revenue totals—so much so that I can't afford an initial \$600 and upgrades of \$200 or so every 18 months for something I use for extended periods of time almost every day. Further, it is important to note that Adobe, as a normal part of their file handling process, generates a unique document ID for every image it handles for you. This generated ID is unique to you—or more specifically, your registered version of Photoshop—because it integrates the serial number of the program into the ID. And, as any program evolves, you can expect this handling of your files and the legality (or lack thereof) of your installed version of Photoshop (as well as other applications) to be a growing issue as all software companies seek to combat piracy, just as you would like as many tools as possible to protect you from people stealing your photography.

Copyright: What Is It, When Is It in Effect, and Whose Is It?

Copyright is exactly that—the "right to copy." And, it includes the converse—"the right to preclude a copy." Copyright is also, as noted previously, the right to display (that is, present—or not—in a gallery, on a Web site, and so on); the right to perform and the converse (prevent a performance of), which is not as prevalent an issue for photographs; the right to distribute or opt not to allow distribution; and a variation of the right to copy—that is, make a derivative (or,

again, to preclude someone else from doing so). For photographers, producing work now causes your work to be copyrighted the moment the shutter closes and the image is fixed in a Flash card chip (or on film if you're still so inclined). Were someone to steal that card and publish your work, you are protected—not as well as if you'd registered the work, but you're protected because you've been infringed. All you'd have to do is secure the file, compare the metadata that includes the camera's serial number in it, and then sue not just for infringement in federal court, but also for theft of physical property in civil court.

NOTE

In this instance, if the infringing publication did so within 90 days and you did not have the CF card, you could actually register the image within that 90 days and still sue for statutory damages.

Registering your works gives a greater extent of protection, and there are multiple books that go into great detail as to what the differences are between registered and unregistered work, so I will not endeavor to detail that in this book. I will simply state that you should register your work.

Although it might seem obvious, it's worth repeating: In almost all cases, unless you signed a "work made for hire" document before the work was completed and fell into one (or more) of the nine categories previously enumerated in Chapter 5, as well as all the other conditions, the work is owned by you. If you instead signed a document that stipulated copyright transfer, then your work is not owned by you. If you are an employee of a company as a photographer, then the work you do for them on assignment is theirs, regardless of whether you signed or didn't sign anything. However, this book is geared more toward the freelance photographer (or the staffer who freelances on the side or wants to leave their employment for the freelance world).

Pre-Registration: How to Protect Your Work

Pre-registration has great promise for a number of different types of photography—movie set work, advertising that goes through multiple revisions or approvals, and such. It is a new service of the copyright office, and it is done online. You do not need to provide copies of the work; you just provide a description and other details about the assignment, and at least one of the images for the work that will ultimately be copyrighted has to have been made. For more information, visit www.Copyright.gov to learn more.

Registration: How to Register Your Work Systematically

This section provides an example of how we register my work. I encourage you to consider whether this registration will be similar to yours, because this system might demystify the problems photographers have with filling out the forms. For a vast majority of registrants who shoot on assignment, Figure 14.1 shows approximately the way the front side of your Form VA will look. You can download this version at my Web site: www.Best-Business-Practices.com/ form_va_sample.pdf.

The document also includes comments as a form of "stickies" that will give you guidance as to how to enter the fields.

or current ebsite at 1	Office fees are subject to change. fees, check the Copyright Office <i>ww.copyright.gov</i> , write the Copy- or call (202) 707-3000.	Form VA For a Work of the Visual Arts UNITED STATES COPYRIGHT OFFICE
		VA VAU EFFECTIVE DATE OF REGISTRATION
		Month Day Year
	DO NOT WRITE ABOVE THIS LINE. IF YOU NEED MORE SPACE, USE A SEPARATE	CONTINUATION SHEET.
4		E OF THIS WORK V See instructions
	John Harrington Miscellaneous Published Photographs May 2006 (Ref# P0609), 4,378 files on 2 cds containing 4,378 photographs	GROUP REGISTRATION/PHOTOGRAPHS 4,378 Photographs
	Previous or Alternative Titles 🔻	
	Publication as a Contribution 1f this work was published as a contribution to a periodical, serial, or collect contribution appeared. Title of Collective Work ▼	tion, give information about the collective work in which the
	If published in a periodical or serial give: Volume V Number V Issue	Date V On Pages V
	NAME OF AUTHOR V	DATES OF BIRTH AND DEATH
2 :	John Harrington	Year Born ♥ Year Died ♥ 1966
	Was this contribution to the work a Author's Nationality or Domicile	Was This Author's Contribution to the Work
JOTE	LISA	Anonymous? Yes No If the answer to either of these questions is
der the law, e "author" of	□ Yes OR Citizen ofON	Pseudonymous? Yes Y No "Yes," see detailed instructions.
r hire" is merally the nployer, not e employee ee instruc- ons). For any ort of this ork that was	Nature of Authorship Check appropriate box(es), See instructions 3-Dimensional sculpture Map 2-Dimensional artwork Photograph Reproduction of work of art Jewelry design	
ade for hire" eck "Yes" in e space ovided, give	Name of Author V Dat	es of Birth and Death Year Born ♥ Year Died ♥
e employer r other irson for	Was this contribution to the work a Author's Nationality or Domicile Work made for him?'? Name of Country	Was This Author's Contribution to the Work
nom the work	"work made for hire"? Name of Country Yes OR Citizen of	Anonymous? Yes No If the answer to either of these questions is
as prepared) "Author" of at part, and	□ No On { Domiciled in	Pseudonymous? Yes No "Yes," see detailed instructions.
ave the bace for dates	Nature of Authorship Check appropriate box(es). See instructions	
birth and sath blank.	3-Dimensional sculpture Map Technical draw	ving
	2-Dimensional artwork Photograph Text Demonstration for the formula	
	Reproduction of work of art Jewelry design Architectural v	VOTK
3 a		<u>Iay Day 01-31 Year 2006</u>
		The second se
Л	COPYRIGHT CLAIMANT(S) Name and address must be given even if the claimant is the same as the author given in space 2.	APPLICATION RECEIVED
	2500 32nd Street, SE	ONE DEPOSIT RECEIVED
e instructions fore completing s space.	Washington, DC 20020	TWO DEPOSITS RECEIVED
	Transfer If the claimant(s) named here in space 4 is (are) different from the author(s) named in space 2, give a brief statement of how the claimant(s) obtained ownership of the copyright. ▼	FUNDS RECEIVED

CHAPTER 14

Figure 14.2 shows the first field you'll enter (and this is one that will change with each registration—more on that later in this chapter). This field is for the title of your work. Here's mine. I will go into detail as to why later in the chapter.

Figure 14.2

Title of This Work V

John Harrington Miscellaneous Published Photographs May 2006 (Ref# P0609), 4,378 files on 2 cds containing 4,378 photographs

Figure 14.3 shows the second field you'll enter—the nature of the work. Technically, you'd just need to write "photographs"; however, if you are doing a group registration (that is, a registration of works published on more than one day) and using this form, copyright regulations require that you'll need to use the two words "Group Registration" at some point within this Section 1. I have chosen this area of Section 1 because it makes the most sense. I have also chosen to include the quantity of images I am registering. Note that although I refer to them as "images," the copyright office best recognizes the word "photographs." The one caveat is that you'll need to modify the PDF that the copyright office makes available to allow for two lines—one for that text, and then a second line that indicates the quantity and type, if you choose to do that. To do this, you'll only need to open the blank PDF once and change the field information. I have done this already, and you can download it from the link above.

Figure 14.3

NATURE OF THIS WORK ▼ See instructions GROUP REGISTRATION/PHOTOGRAPHS 4,378 Photographs

Fig 14.4 is fairly straightforward—type your name.

Figure 14.4

Figure 14.5 is also fairly straightforward. Note that when you click into the box, this small checkmark is entered. This is the way that the LOC form handles a check for their check box. I'd prefer an X that fills it, but this certainly works. You'll note this is the same elsewhere in the form. Because it was not a WMFH, nor will any of your other registrations be, checking this once and then leaving it as your default is easy.

Figure	14.5
inguic	14.0

Was this contribution to the work a "work made for hire"?
□ Yes
🗹 No

Figure 14.6 is also self-explanatory. However, if you are a foreign citizen living in the US, you can register your work for protection. For more information on limitations/restrictions for foreign citizens, see the LOC instructions for this field.

Figure 14.6

Auth	or's National	lity or Domicile	
OR	Citizen of _	USA	
<u> </u>	Domiciled in		

The form section in Figure 14.7 is obvious, and because you're interested in registering the work in your name, choose "No" for the contribution details. Note again the small checkmarks.

Figure 14.7

DATES OF BII Year Born ♥		ear Died	
1966			
Was This Auth	or's Cont	ribution	
Anonymous?	🗌 Yes	🗹 No	If the answer to either of these questions is
Pseudonymous?	🗌 Yes	No No	"Yes," see detailed instructions.

Figure 14.8 is again an obvious choice. Even if you're photographing jewelry design, you, as a photographer, are registering the photograph, not the design, nor the work of art, and so on. Enter once, and leave it.

Figure 14.8

Nature of Authorship Check appropriate box(es).Se	ee instructions	
3-Dimensional sculpture	🗆 Map	Technical drawing
2-Dimensional artwork	Photograph	Text
Reproduction of work of art	□ Jewelry design	□ Architectural work

Figure 14.9 changes, as is obvious, once a year. This is not when the work was published, but when the work was completed.

Figure 14.9

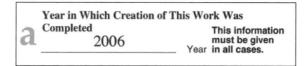

There is one other field, in Figure 14.10, that will change for each registration of published works. If unpublished, these fields are blank. However, if you are indicating "group registration" in Section 1, then you'll need to indicate the range. It does not need to be monthly. For example, you could enter "April–June" in the month field and "28–11" in the day field. The month field is limited in the content, and the day field is also limited, in the LOC version, to two characters. I have modified mine, which you can download, or you can do that yourself. These dates should be the date of publication. Further, the Copyright Office will accept (and you should seriously consider including above the date field) the terms "approximately," "not before," "not

after," and "on or about." We have begun adding these additional descriptors and permanently including them on the registration form separate from the modifiable month/date fields. Adding in this information will provide for greater clarity should you wind up in court and the dates are challenged. I'll address the arguments of published versus unpublished, and how I, in consultation with my attorney, derive the date "date of publication" at the end of this chapter, in the section entitled "Definitions: Published versus Unpublished—the Debate."

Figure 14.10

 Date and Nation of First Publication of This Particular Work
 Approximately

 Complete this information
 Month
 May
 Day
 01-31
 Year
 2006

 ONLY if this work
 Month
 May
 Day
 O1-31
 Year
 2006

Although the field in Figure 14.11, too, is obvious, here's a note to consider. You'll want to choose an address that will change as infrequently as possible. Further, there is a system within the copyright office to file a change of address form with them.

Figure 14.11

COPYRIGHT CLAIMANT(S) Name and address must be given even if the claimant is the same as the author given in space 2. ▼ John Harrington 2500 32nd Street, SE Washington, DC 20020

Here we are on page 2, as you can see in Figure 14.12. It's a fairly easy back-of-the-form entry, and the main thing that will change is the date that accompanies your signature.

Figure 14.13 applies when you're trying to do advanced registration types beyond what I am hoping you'll achieve—a general registration of your work in the first place. There are numerous reasons why these fields are valuable and important; however, if you're doing anything other than choosing "no," you'd do well to follow the instructions accompanying the form, available from the LOC Web site. In presenting this, I am taking the position that you are systematically registering work you shoot on assignment or on spec, that you are not registering work as published that you previously registered as unpublished, that you are the copyright claimant and that someone else (in other words, your agent or coauthor) did not previously register the work, and that you're not registering a retouched version of a work previously registered.

Figure 14.14 is applicable if you have a deposit account. I do, and it's under my name, but I've blanked the account number so hooligans don't start charging their registrations to my account. Set up your own account; it's easier than sending in a check every time, and you can easily replenish it with a credit card.

In Figure 14.15, if the copyright office has a question or concern, this is the address and other contact information they will use to correspond with you about it. Otherwise, this field will not really be used for anything.

For Figure 14.16, if you're having someone legally act on your behalf to fill out and sign the form, they should choose "authorized agent," or if you have rights to the work being registered, choose the "other copyright claimant" or "owner of exclusive right(s)." In all likelihood, you'll choose "author" and be done with it.

		EXAMINED BY	FORM VA
		CHECKED BY	
			FOR COPYRIGH OFFICE USE ONLY
	DO NOT WRITE ABOVE THIS LINE. IF YOU NEED MORE SPA	CE, USE A SEPARATE CONTINUATION	SHEET.
Yes ☑ No □ This is the □ This is the □ This is a c	EEGISTRATION Has registration for this work, or for an earlier version of th If your answer is "Yes," why is another registration being sought? (Check appro first published edition of a work previously registered in unpublished form. first application submitted by this author as copyright claimant. hanged version of the work, as shown by space 6 on this application. ""Yes," give: Previous Registration Number ▼ Year of R		5
	E WORK OR COMPILATION Complete both space 6a and 6b for a deri faterial Identify any preexisting work or works that this work is based on or inco		a see instruction
. Material Ad	ded to This Work. Give a brief, general statement of the material that has been a	dded to this work and in which copyright is claimed. Ψ	
DEPOSIT AG	CCOUNT If the registration fee is to be charged to a Deposit Account establish Accou	ed in the Copyright Office, give name and number of <i>b</i> ant Number ▼	Account.
John Harri	ngton		2
	NDENCE Give name and address to which correspondence about this applicat		
2500 32nd Washingto	Street, SE in, DC 20020	Executive (202) 544.4	b
Area code and d	Street, SE	Fax number (202) 544-4	b
2500 32nd Washingto Area code and d Email John	Street, SE n, DC 20020 aytime telephone number (202) 544-4578 n@JohnHarrington.com TION* 1, the undersigned, hereby certify that I am the check only one	author Other copyright claimant Owner of exclusive right(s)	b 1579 8
2500 32nd Washingto Area code and d Email John CERTIFICA	Street, SE n, DC 20020 aytime telephone number (202) 544-4578 n@JohnHarrington.com TION* 1, the undersigned, hereby certify that I am the check only one	author other copyright claimant owner of exclusive right(s) authorized agent of Name of author or other copyright cla	b 1579 8
2500 32nd Washingto Area code and d Email John CERTIFICA	Street, SE n, DC 20020 aytime tetephone number (202) 544-4578 n@JohnHarrington.com TION® I, the undersigned, hereby certify that I am the check only one ► entified in this application and that the statements made by me in this application in space ted name and date ▼ If this application gives a date of publication in space	author other copyright claimant owner copyright claimant owner of exclusive right(s) authorized agent of Name of author or other copyright cla lication are correct to the best of my knowledge. Se 3, do not sign and submit it before that date.	b 1579 8
2500 32nd Washingto wea code and d Email John CERTIFICA of the work id Typed or prim John Harri Har	Street, SE n, DC 20020 aytime telephone number (202) 544-4578 n@JohnHarrington.com TION* 1, the undersigned, hereby certify that I am the check only one ► check only one ► ted name and date ▼ If this application gives a date of publication in spa- ington ndwritten signature (X) ▼	author other copyright claimant wher of exclusive right(s) authorized agent of Name of author or other copyright cla tication are correct to the best of my knowledge. Se 3, do not sign and submit it before that date.	b 1579 Imant, or owner of exclusive right(s)
2500 32nd Washingto wea code and d Email John CERTIFICA of the work id Typed or prin John Harr	Street, SE n, DC 20020 aytime telephone number (202) 544-4578 n@JohnHarrington.com TION* 1, the undersigned, hereby certify that I am the check only one ► check only one ► ted name and date ▼ If this application gives a date of publication in spa- ington ndwritten signature (X) ▼	author other copyright claimant wher of exclusive right(s) authorized agent of Name of author or other copyright cla tication are correct to the best of my knowledge. Se 3, do not sign and submit it before that date.	b 1579 Imant, or owner of exclusive right(s)
2500 32nd Washingto Area code and d Email John CERTIFICA of the work id Typed or prin John Harr Hai X Certificate will be	Street, SE n, DC 20020 aytime telephone number (202) 544-4578 n@JohnHarrington.com TION* I, the undersigned, hereby certify that I am the check only one \blacktriangleright of the check only one \blacktriangleright of the check only one \vdash of the check on the chec	author other copyright claimant owner of exclusive right(s) authorized agent of Name of author or other copyright cla tlication are correct to the best of my knowledge. se 3, do not sign and submit it before that date. Date University	b 1579 Imarit, or owner of exclusive right(s) A ine 00, 2006 USTR INSTR I
2500 32nd Washingto Area code and d Email John CERTIFICA of the work id Typed or prim John Harri Har	Street, SE n, DC 20020 aytime telephone number (202) 544-4578 n@JohnHarrington.com TION* I, the undersigned, hereby certify that I am the check only one ► entified in this application and that the statements made by me in this application in spatington ndwritten signature (X) ▼ Name ▼	author other copyright claimant other copyright claimant where of exclusive right(s) authorized agent of where of author or other copyright cla tication are correct to the best of my knowledge. tication are correct to the best of my knowledge. te 3, do not sign and submit it before that date. Date United State	b 1579 mart, or owner of exclusive right(s) A re 00, 2006 UST we dimensary spaces rapplication in space 8 ALL OF ELEVENCE SAME PACKAGE SAME PACKA

CHAPTER 14

For Figure 14.17, enter your name as you'll sign it below. For the date, we leave the "00" in the field, just to remind us that it's not complete, until we know when we are going to the LOC to drop off the package. If you're registering work and mailing/shipping it to the Copyright Office, enter in the date you signed the document. The actual date of registration is the date the copyright office receives the form. For me, I sign it the day I am taking it down and dropping it off to them by hand, so the effective registration date and this date match.

Typed or printed name and date 🔻 If this application gives a date of publication in space 3, do not sign and submit it before	e that	date.
John Harrington	Date	June 00, 2006

Figure 14.17

Figure 14.18 is important because it is this field that will show through the window of the envelope they use to send back your completed registration form. So, type clearly and include your ZIP+4 zip code (obtainable at http://usps.com) to make it arrive faster and more efficiently. Further, when you key in your address to get your Zip+4, you'll get how the post office prefers to have your address look. Follow their lead on this.

Figure 14.18

Name ▼ John Harrington
Number/Street/Apt ▼ 2500 32nd Street, SE
City/State/ZIP ▼ Washington DC 20020-1404

At this point, you have your own PDF template. Save it as such. You'll more than likely never go back to change almost all of the fields, save for the ones we are about to outline. This makes these few changes fast, simple, and efficient. Now, on to the fields for which there are changes.

Title of the Work

I considered a number of methodologies to determine my nomenclature for naming my registrations. I consulted a number of people on the subject, most notably photographer Jeff Sedlik, who is also an expert in copyright litigation. He's not an attorney, but when it comes to copyright, he's an invaluable resource if you are taking someone to court and need an expert on the subject. I considered the following titles for my registrations, when cataloging an entire year's worth of work:

- ▶ John Harrington 1999 Collection 01 11,841 Photographs
- ▶ John Harrington 1999 Catalog 01 11,841 Photographs
- John Harrington 1999 Volume 01 11,841 Photographs

Although technically the title of your work does not matter to the Copyright Office, and further it does not affect the rights you have, there's a problem with these titles. Using the words "volume," "catalog," or "collection" might cause the person you're suing (or more correctly, his or her lawyer) to attempt to make the claim that their infringement of six of your photographs from that registration is only a single infringement of a collective work, which would limit your statutory award to a maximum of \$150,000, whether it's six or sixty images infringed from that registration. Although this is not likely—in fact, I'd go so far as to say it'd be unlikely—avoiding that risk simply by being clearer in your title would be beneficial.

NOTE

A word about the inevitable infringement you'll experience. Although there is no case law I am aware of, and you are technically protected just as much by registering a single image as you are 10,000, this argument—that multiple images infringed that were a part of a single registration only qualify as one infringement of one work—regardless of titling, could be a method of diminishing your damages. Further, where there is a maximum award of \$150,000 per infringement and you registered 1,000 images in that single registration, an attorney on the other side might try to divide \$150,000 by 1,000 and argue to your attorney, and perhaps a less than knowledgeable judge, that you should only be entitled to \$150 per infringed image. I think that this argument is dubious at best, and more accurately, fatally flawed. It's the only reason (in addition to the "collective work" claim) that I can find to not register as many images in one registration as possible.

For works, I resolved to use the following titling nomenclature, for an entire year's worth of work:

John Harrington Miscellaneous Unpublished Photographs 1999 (ref#U0608), 1,102 files on 2 CDs containing 11,841 photographs.

This naming nomenclature—annually delineated—is how I handled the titling when I needed to go backward to register work previously unregistered. Note the difference between the number of files and the number of photographs. In this case, the file was a single image of a 20-slide page, and it was important to note that the file is not "the image," but that the file/image is a functional device to document the 20 images on the page, so I wanted to draw that distinction.

NOTE

It's important to note that each slide page contained from one to twenty images, and when the caption changed, the slide page changed. This allowed for maximum flexibility in my filing system. Therefore, each page had a date associated with when the image was produced, and this was the filename it would be assigned. Often, it was a news event with the date of the news event on the slide mount caption label. Where there may be some ambiguity in the exact date, see the Figure 14.22 notes later in this chapter. In a clear case in which a page of photographs was taken on May 1, 1994, the filename would be 19940501_NW_001.jpg," where I assigned "NW" to refer to the images' category "Newsmaker Washington," and others for other types. A submission, even with that file name, was followed up on by the copyright office, who requested a date associated with each file, so I produced a word processing document that included the filename along with the date, and included that as a part of the submission. This satisfied the Copyright Office examiner. They might have preferred the

continued

official continuation form they offer, but it was not required. Yes, this took some time, but I was able to do it during downtime on assignments when waiting for a subject, assign it to someone who works for me when they had spare time while watching a batch process complete, or do it on trips from point A to point B.

Once I had caught up, I then registered images by month. In the instance that I was publishing *unpublished* work, each month was named as follows:

John Harrington Miscellaneous Unpublished Photographs May 2006 (ref#U0605), 4,378 files on 2 CDs containing 4,378 photographs.

In this nomenclature, the "ref#U0605" is my own assigned reference number. The "U" indicates the images were unpublished, "06" is the year, and "05" indicates it was the fifth registration for 2006. To remain consistent with the "by year" registrations and because someday I might need to again register more than one photograph per file, I continue to notate the number of files and photographs separately. Further, I indicate that there are two CDs so that they do not mistakenly believe that there duplicates, but rather, that each contains separate files.

I fill in that entire title in the Form VA "Title of Work" field, as in Figure 14.19.

Figure 14.19

Title of This Work **V**

John Harrington Miscellaneous Published Photographs May 2006 (Ref# P0609), 4,378 files on 2 cds containing 4,378 photographs

With respect to published work:

John Harrington Miscellaneous Published Photographs May 2006 (ref#P0605), 4,378 files on 2 CDs containing 4,378 photographs.

Note the "P" within the reference. In this, the "P" is not a published subset of the "U" registration, but rather, just an example of how I would do the same registration were it a group of published photographs.

Nature of This Work

Section 202.3 - Registration of Copyright, section b, subsection 9, part vii, states in part, "The applicant must state 'Group Registration/Photos' and state the approximate number of photographs included in the group in space 1 of the application Form VA." Now, I have indicated that I place that text under "Nature of This Work"; however, part vii goes on to stipulate "under the heading 'Previous or Alternative Titles' (e.g., 'Group Registration/Photos; app. 450 photographs')." In a meeting I had with examiners of the Copyright Office, I questioned the clarity of this point, because this is descriptive and not a title, and they stated that the text "group registration/photos" or "group registration/photographs" appearing anywhere within Section 1 of the application would meet the regulation. As such, I notated that in the "Nature of This Work" sub-section of Section 1, as you can see in Figure 14.20.

Figure 14.20

NATURE OF THIS WORK ▼ See instructions GROUP REGISTRATION/PHOTOGRAPHS 4,378 Photographs

I encourage you to make your own determination as to what you want to do with this information and these insights in mind.

Year in Which Creation of This Work Was Completed

This is pretty straightforward. Of course, there are always exceptions. If the assignment started December 31, suppose your assignment was to document the change of the New Year. In that case, your assignment would be completed on January 1, at say 1:00 am. Although I would register the images with a date of January 1 because that was when it was completed, your attorney might feel differently. Ask your attorney, since he would be the one defending the infringement on your behalf. Figure 14.21 shows this field on the form.

Figure 14.21

Date and Nation of First Publication of This Particular Work

If you're registering unpublished work, leave this section blank and skip over this text. For published work (and I make the assumption that it's published in the USA), as previously noted, a range is acceptable (see Figure 14.22). There is, again, an indication that you may use the continuation form, but it is not required.

Figure 14.22

h	Date and Nation of First P Complete this information ONLY if this work has been published.	ublication of Month	This Particular May	Work	01-31	Year	2006	
υ		United States of America						Nation

This, from the Copyright Office:

The Office recognizes that some commenters have previously expressed the view that photographers sometimes have difficulty knowing exactly when—or even whether—a particular photograph has been published. With respect to date of publication, it should be noted that the Office's longstanding practices permit the claimant some flexibility in determining the appropriate date. See, e.g., Compendium of Copyright Office Practices, Compendium II, Sec. 910.02 (1984) (Choice of a date of first publication).... The Compendium of Copyright Office Practices, Compendium II, Sec. 904 states the Office's general practice with respect to publication, including that "The Office will ordinarily not attempt to decide whether or not publication has occurred but will generally leave this decision to the applicant." 1) Where the applicant is uncertain as to which of several possible dates to choose, it is generally advisable to choose the earliest date, to avoid implication of an attempt to lengthen the copyright term, or any other period prescribed by the statute. 2) When the exact date is not known, the best approximate date may be chosen. In such cases, qualifying language such as "approximately," "on or about," "circa," "no later than," and "no earlier than," will generally not be questioned. Further in the regulations, it states "The date of publication of each work within the group must be identified either on the deposited image, on the application form, or on a continuation sheet, in such a manner that one may specifically identify the date of publication of any photograph in the group. If the photographs in a group were not all published on the same date, the range of dates of publication (e.g., January 1-March 31, 2001) should be provided in space 3b of the application."

Further, this from the Copyright Office's 37 CFR Part 202, [Federal Register: July 17, 2001 (Volume 66, Number 137)] [Rules and Regulations][Page 37142-37150]:

Each submission for group registration must contain photographs by an individual photographer that were all published within the same calendar year. The claimant(s) for all photographs in the group must be the same. The date of publication for each photograph must be indicated either on the individual image or on the registration application or application continuation sheet in such a manner that for each photograph in the group, it is possible to ascertain the date of its publication. However, the Office will not catalog individual dates of publication; the Copyright Office catalog will include the single publication date or range of publication sheet to provide details such as date of publication for each photograph, the certificate of registration will incorporate the continuation sheet, and copies of the certificate may be obtained from the Copyright Office and reviewed in the Office's Card Catalog room.

Sign and Date

Again, the field in Figure 14.23 is pretty obvious, but it's a field you can't overlook! Make sure to sign and date the form!

Typed or printed name and date 🔻 If this application gives a date of publication in space 3, do not sign and submit it before that date.							
John Harrington	Date	June 00, 2006					

Figure 14.23

Archival

We have a system for how we archive our registrations. Each registration submission form is filed in its own file folder, along with a duplicate of the CD that was submitted to the Copyright Office. When we receive the final certificate, that original document is filed in the file folder, and they are stored safely. If you are someone who has a fair amount of spare time, scanning and converting both sides of the document into a PDF might serve you well in the future. Further, there is a significant fee to have another original registration form produced from the Copyright Office, so treat these as valuable as a birth certificate. In a way, that's one of the things it stipulates—who the images belong to and when they were created.

Definitions: Published versus Unpublishedthe Debate

Language on the Copyright Office Web site, derived from the copyright regulations, defines publication as such:

"Publication" is the distribution of copies or phonorecords of a work to the public by sale or other transfer of ownership, or by rental, lease, or lending. The offering to distribute copies or phonorecords to a group of persons for purposes of further distribution, public performance, or public display, constitutes publication. A public performance or display of a work does not of itself constitute publication. 17 U.S.C. 101.

This means that displaying your work in a gallery is probably not publication. My position, and one which my attorney has stated he is comfortable defending, is this:

I undertake assignments for which I am paid. There is a part of the contract that requires the client to pay, and there is also a part of the contract that grants rights to the client that allow them to further distribute the work to their clients, subscribers, viewers, or the like. We offer to our clients all images produced under the assignment, and their purpose is to further distribute that work, or display it publicly, and thus, meets the requirement for publication. As such, at the conclusion of each month, we begin the process of burning a CD of all the images we produced on assignment for clients, stipulating the dates as the first date of the first assignment and the last date of the last assignment—since we offer to clients the opportunity to have the images delivered to them same day, and they dictate when they would like to receive them.

My recommendation is that you establish a relationship with a good copyright attorney and solicit from him or her guidelines for your specific circumstances that the attorney is comfortable defending on your behalf.

As to "group of persons," there is little significant case law that I am aware of that properly defines this term. That group could be two or three photo editors, or a photo editor and another

designer, or it could be the entirety of the staff of the publication, since they have access to and are participating (on various levels) in the distribution of the work to the public.

In the event that I am shooting work for a photo agency—even supposedly speculative assignments—*their* intent, as well, is to further distribute it. Further, the posting of images on a Web site in and of itself does not constitute publication, especially if it's a hidden section of your Web site. However, if it's in a section, such as a PhotoShelter or Digital Railroad section, where there is an offering to license the work for a fee, that would constitute an offering for the purposes of further distribution and meet the "published" requirements.

Further, the rulings in many cases state that the distribution of just a single copy to a single company or individual can constitute publication. Although case law deals with differing degrees of use and the inevitable inconsistencies among the various courts as to interpretation, an overarching guideline is whether a copy (and a copy can include an original) was distributed with restrictions on the further distribution or use of the copy. The only real reason that "published" mattered was that the origins of federal copyright required work to be published in order to enjoy the benefits of copyright, and that is the basis for much of the confusion that exists today.

Recommended Reading

Duboff, Leonard D. *The Law, In Plain English, for Photographers* (Allworth Press; Revised edition, 2002)

Krages, Bert P. Legal Handbook for Photographers: The Rights and Liabilities of Making Images (Amherst Media, 2001)

Lessig, Lawrence. Free Culture: How Big Media Uses Technology and the Law to Lock Down Culture and Control Creativity (The Penguin Press HC, 2004)

Litman, Jessica. *Digital Copyright: Protecting Intellectual Property on the Internet* (Prometheus Books, 2000)

Patterson, Lyman Ray. Copyright in Historical Perspective (Vanderbilt University Press, 1968)

Thierer, Adam D. and Wayne Crews. *Copy Fights: The Future of Intellectual Property in the Information Age* (Cato Institute, 2002)

Vaidhyanathan, Siva. *Copyrights and Copywrongs: The Rise of Intellectual Property and How It Threatens Creativity* (New York University Press; Reissue edition, 2003)

Chapter 15 The Realities of an Infringement: Copyrights and Federal Court

As noted in Chapter 14, copyright infringement is not a matter of "if," it's a matter of "when." Knowing this, like the value of knowing that you will have your home broken into, allows you to plan for this eventuality. Photographers covering a football game will, in addition to their long lenses on monopods, also wear (usually around their neck and at the ready) a body and a wide lens, planning on the likelihood that a pass will come their way and they'll want the shot. We carry more than one memory card in case we need it, and we have numerous other solutions that mean protection from the unknown eventuality. That said, you'll want to be prepared for what you can expect.

What to Do When You're Infringed

When you discover an infringement, get upset. Someone has just stolen something from you. Surely you get upset when your wallet is stolen, or your car, your money, and any other asset you've worked hard to earn. One day, I was walking the halls of Congress with John Sebastian, a well-known musician, and I was accompanying him to then-Rep. Sonny Bono's office for a meeting on protections for songwriters. I asked him how he handled copyright infringements. He responded that infringements are like water in a sieve: "You'll never catch them all, but when you do, go to the hilt to protect yourself and your work." I thought this was pretty good advice.

Now that you've gotten all worked up, stop and think about how it occurred. Was it lifted from your Web site or your agent's Web site, or was it a client who assigned you to shoot something for a prescribed fee and associated license, and then used it beyond that scope, either maliciously or accidentally?

I often find that the infringement is a use by a preexisting client who was not versed in the limitations of their license. However, I have experienced outright theft of my work. Typically, my approach is to consider the facts of a situation and either call an attorney or, without limiting my "down the line" options, send my own cease-and-desist letter if the use is ongoing. If I am going to seek compensation, I will weigh very carefully my predilection to send a demand for \$X compensation of some sort, because the establishment of that figure could hinder

future negotiations. Further, as John Sebastian pointed out, you may not fully know the extent of the infringement until you inquire informally (via e-mail, correspondence, and so on) or you learn through discovery (the legal procedure).

When you've gotten yourself together and given the situation some thought, begin to gather all the facts you can. These facts range from contracts signed by the preexisting client, to e-mail dialogues between you and the client, to proof of the infringement when it's ongoing (for example, a PDF printout of the Web site), to photographs of a billboard that has your image, and so on. Collect whatever proof you have that your work was infringed.

The most important thing will be to obtain your Copyright Registration Certificate for the registration that contains that image. You didn't have it registered? Well, register it right away. I mean today. That registration is your ticket into federal court. Without it, you may not file a copyright infringement suit, and the first thing that will happen when your attorney contacts the client's attorney is that the client's attorney will ask, "Was the alleged infringing image registered?" Once the Copyright Office has received the paperwork, as of that date the work is registered, so the truthful answer will be, as of the day after it was sent via overnight express, "Why yes, that image was registered." Of course, the next question will be "When?" And your attorney will have to then defer this answer, if possible.

This brings me to the "should I get an attorney" question, and the short answer is an emphatic yes! The long answer is also yes, but more on how/why/when later in the chapter. If you go it alone you'll be at a disadvantage because you will be dealing with an attorney on their side, who knows all too well how to distract, evade, diminish the value of your work, and collect statements from you that could come back and have a negative impact on your case.

Timeline of an Infringement Suit

First things first: You become aware of the infringement. Whether you stumble across it or search for it because you thought it might exist or a colleague tells you about it, the genesis of your circumstances is your awareness of it. This, however, should not be confused with when the infringement began or the extent of it. The infringement could have been going on for some time, in many areas and in numerous media. Do not assume that the first time you became aware of it is when the infringement started.

Types of Infringers

Because there are numerous types of infringers, I would first reach out to the infringing party. The following sections discuss the most likely ones, but is by no means complete. They are simply the ones you are most likely to encounter and my approach to them.

The Preexisting Client

For preexisting clients, the infringement may be an oversight. I tend to take a lighter approach to dealing with these types of infringements. Usually, an amicable resolution can be achieved, especially when it's fairly easy to see what the original terms were, and a reasonable person will

conclude that the infringement is outside of that scope. However, the settlement is not typically the same fee you'd have charged had they negotiated this use in advance. The settlement is for a "retroactive license," and is much more costly than if things had been handled correctly in the beginning.

The Third Party Who Legitimately Obtained Your Image but Is Using It Outside of the Scope of the License

In some instances, you might have licensed a portrait to a client for publicity surrounding an event. As a result, the client distributed the image to the news media, who may have legitimately used the image in a story about the client, but then two years later, when that individual leaves the company or is at another company, your photo may reappear outside of the term of the license time-wise or not in conjunction with the original commissioning party. When you point this out to the publication—often a newspaper—they will begin by stating their file photo policy, but that doesn't mean that the policy can be the basis for protection from an infringement, especially if there was a sticker or imprint on the reverse of the print with your name/contact information/rights granted/term of granting, or that same information was in the metadata of a file. You will also likely find yourself settling these types of infringements.

Case Study: A Quickly Resolved Infringement

I was photographing the inventor of a device that almost every American uses at least three to four times a week. This device was being inducted into a museum, and I was contracted by a party affiliated with the device to photograph the induction ceremony. I did, and the images were distributed to the news media. Although it was appropriate to use the image of the inventor with the device, repurposing the photograph into an online encyclopedia that one media conglomerate had was not consistent with the rights granted. A brief dialogue with the infringing party resulted in a reasonable settlement agreement.

A Licensor Who Stated One (or a Limited, Smaller) Use and Who Is Using the Image in a Much More Expansive Way

These folks can sometimes be deceitful. They may decide they only want to pay a few hundred dollars for a quarter-page one-time use in a 5,000 press run brochure, and so make that statement. Then, they run off tens of thousands of brochures, or use the image in more than one brochure, or in a larger size. Sometimes with a change of personnel there might be an attempt to suggest the infringement was innocent or accidental, but even in an accident such as between two cars, someone has to pay the wronged party. I feel that for this type of infringement, especially when it was a lower press run that turns into a larger one, a much more aggressive approach should be taken. Depending upon the extent of the infringement, although a settlement is likely, it might take a formal filing of an infringement claim to force constructive settlement talks.

A Potential Client Who Reviewed/Considered Your Work and Stated They Were Not Using It, but Then Did

This type of infringement is, in my book, worse than outright theft. To me, there's outright malice in this infringement. In short, more often than not they lied to avoid paying you, and you

caught them. Sure, I accept that there are circumstances in which an "innocent" mistake or oversight might have occurred, but that doesn't mean there are not ramifications of this. I'd be much more inclined to bring a claim early because I don't take kindly to thieves.

The Outright Thief

These folks often—especially with online uses and blogs—misappropriated your work from your Web site. Sometimes a cease-and-desist letter is all that is really necessary (discussed in Chapter 18 "Letters, Letters, Letters: Writing Like a Professional Can Solve Many Problems"). However, sometimes an aggressive approach directly to the legal department and a call to your attorney are warranted sooner rather than later.

But there are others, such as the company who contacted you for stock use of an image and who stated that they'd just shoot their own when you quoted your licensing fee—and theirs is really a copy of yours. And, there are a number of other infringers.

From this point, you'll come to a determination that a settlement or a formal court filing is necessary. A settlement is going to be most likely when the infringing party recognizes their error, and you then go through the motions of coming to an understanding of the scope of the misuse. There is then a determination on your part of what you would have charged and what you feel is fair as a retroactive licensing fee. A court filing will come into play if the infringing party feels they had the right to use the image or is otherwise unwilling to be reasonable in their negotiations with you.

Rather than try to spell this out as 1) You'll file, 2) They'll respond with a request for dismissal, 3) You'll respond, 4) There will be depositions, 5) There will be pretrial motions, 6) There will be a trial, 7) There will be a verdict. I'll try to explain it somewhat differently.

An infringement suit will take years to resolve. All the while, you will be incurring charges for every e-mail exchange your attorney has on your behalf with you, the defendant, as well as all their time reviewing case law and drafting memorandums, and so on. The expenses of an infringement suit can easily grow to \$50,000 to \$100,000 when all is said and done. In the end, when the images are registered, all these bills are often paid by the infringing party (as is allowable by law for registered images), but are not a factor when the image was not registered beforehand, save for your inclusion of consideration of the bills when engaging in settlement talks. Thus, the cost and difficulty of registering are grossly outweighed by the successful conclusion of even one case of infringement.

When to Engage an Attorney

The short answer to the question of when to engage an attorney is as soon as possible. Because you'll be a "newbie" to the process, at least for the first infringement you have to handle, an attorney will use their years of experience to ensure that you (and your rights) are not trampled on or limited. In all candor, an attorney's willingness to take the case will in large part be based upon whether you've registered your images in a timely manner prior to the infringement in question.

An attorney will know to ask about other uses. He will not make statements such as, "We'll be charging three times the original licensing fee" because that will limit your ability to make a larger claim later. He will appropriately press for other infringing uses, and he will be taken seriously when he calls the infringing party's legal counsel. In most cases, a call by you will not be taken seriously, or even routed to the proper company officials. You will be at a disadvantage.

Before an infringement occurs, take the time to find a local attorney. Usually, meeting with the attorney the first time is free, when you simply are indicating you'd like to be able to call upon the attorney when you're infringed. This first meeting gives you a chance to decide whether you like this person, and the attorney can decide whether you're someone he'd want to represent. This preliminary meeting should cost you nothing, but it should give you peace of mind, knowing just who you'll actually call when you write to an infringing party, "You'll be hearing from my attorney."

There are several resources that can assist you in hiring an attorney. My first recommendation would be to seek out word-of-mouth recommendations from colleagues. If you are not satisfied with those recommendations or you are not getting the information that way, I would recommend contacting a professional association you are a member of (such as ASMP, APA, NPPA, PP of A) or reviewing ads in photo-related trade journals, such as *Photo District News*. Typically, attorneys who have aligned themselves with photo-trade organizations or are actively pursuing that line of business are likely to be more aware of photo-related infringement issues and case history.

Settlement Agreements

A settlement agreement takes a basic form:

- We did nothing wrong, and this agreement does not admit wrongdoing.
- > You've made a claim, and this agreement does not validate that claim.
- ▶ We both agree that a settlement for \$*XX*,*XXX* is in both parties' best interests to resolve this matter.
- You agree not to sue us about this ever again.
- (Optional) We both agree to the non-disclosure of this agreement's terms or payment.

During a settlement agreement, you'll want to make sure you can bite your tongue over the "we did nothing wrong" clause. That's pretty standard, and the likelihood that you'll get an admission of wrongdoing in your settlement agreement is very slim. Further, the non-disclosure clause is one to which you must adhere. Make sure that it includes "shall not further disclose" because in the course of your negotiations, you have no doubt consulted with colleagues and shared terms of the proposed agreement, and you cannot be responsible for their non-disclosure.

In just a moment, you'll see the basic outline of a settlement agreement, in which the infringement was by a preexisting client. Understand that whatever you might get from their legal department will likely not look as fair as this one, at least initially. Usually their company

will want a clause that "saves and holds harmless" them, should you do something you shouldn't, but they won't initially include that same precaution for you. Further, in term 3 of the agreement, make note of this information:

Photographer does hereby forever release and discharge *infringer*... from any and all claims... **now known**, and *Photographer* hereby states *Photographer* knows of no other disputes, claims, causes of action, ... as of the date of the execution of this agreement, arising from or related to the use of the Photographs by *infringer*.... [bold added]

This is an important term, and one that probably won't be in their proposed agreement because it's beneficial to you. Specifically, it protects you in the event that you only brought to their attention the one infringing use you found, and it agrees to a settlement for that infringement. Should you become aware of other infringements down the line, they are not protected.

Further, the "collectively party" definition below should be your last name and their company name, not the generic terms I've used for this example, where a preexisting client had infringed.

So, without further ado, here it is:

RELEASE, SETTLEMENT AND LICENSE AGREEMENT

This "Release, Settlement and License Agreement" (the "Agreement") is effective as of the date on which this Agreement is executed by all of the parties (the "Effective Date") by and among: [infringing party and address] on behalf of itself and its subsidiaries (collectively "*infringer*," [your name and address], an individual, (collectively "*Photographer*").

WHEREAS, *infringer* entered into an agreement with *Photographer* to photograph [x, y, and z, as applicable] and to license *infringer*'s use of those photographs for [original terms of contract];

WHEREAS, on or about [initial date of infringement], *infringer* [uses stated that were not a part of the original contract];

WHEREAS, in [date of first contact with infringer], *Photographer* contacted *infringer* objecting to the use of the Photographs;

WHEREAS, *infringer* immediately acceded to *Photographer*'s demand and *infringer* ceased the objected uses of the Photographs by *infringer*, and

WHEREAS, the parties desire to amicably resolve the controversies between them by this Agreement.

NOW, THEREFORE, for good and valuable consideration, the receipt and adequacy of which is hereby acknowledged, the parties hereto agree as follows:

Photographer hereby grants *infringer* a non-exclusive, non-transferable, license to use the Photographs for [initial non-contractually allowed infringing use]. *Photographer* represents and warrants that (a) *Photographer* owns all copyrights in the Photographs necessary to grant the License to *infringer*. *Photographer* shall at all times indemnify and hold harmless *infringer* from and against any and all claims, damages, liabilities, costs and expenses, including reasonable outside counsel fees, arising out of the breach by *Photographer* of the aforementioned representation and warranty.

(2) *infringer* hereby represents and warrants that their exercise of any license of the Photographs has not, nor does not, infringe on any third party right, including but not limited to individuals depicted in the Photographs, and that *infringer* is solely responsible for securing any releases, permissions, or other paperwork necessary to effect releases or permissions for any individuals depicted in the

Photographs, and is responsible for any payments to depicted individuals that result from the aforementioned releases or permissions. *infringer* shall at all times indemnify and hold harmless *Photographer* from and against any and all claims, damages, liabilities, costs and expenses, including reasonable counsel fees, arising out of the breach by *infringer* of the aforementioned representation and warranty.

(3) *Photographer* does hereby forever release and discharge *infringer*, their respective parent companies, subsidiaries and affiliated business organizations, successors, present and former employees, officers, directors, assigns, agents and representatives from any and all claims, causes of action, losses, disputes, liabilities and demands of whatever kind or character, now known, and *Photographer* hereby states *Photographer* knows of no other disputes, claims, causes of action, losses, disputes, liabilities or demands as of the date of the execution of this agreement, arising from or related to the use of the Photographs by *infringer* (hereinafter "Claims").

(4) *infringer* agrees, within five (5) business days of the Effective Date, to provide a single payment to *Photographer* in the total amount of \$XX,XXX.XX U.S. dollars via wire transfer. *Photographer* has provided *infringer* with the bank account information required in order for *infringer* to effect such a wire transfer payment to *Photographer*. *Photographer* acknowledges that *infringer*'s provision of the foregoing consideration is made in full settlement of all Claims referred to herein and *Photographer*'s license grant in Section (1) above.

Effective as of the Effective Date, the parties hereto agree not to disclose the terms of this Agreement to anyone. This is a material provision of this Agreement. In furtherance of this material provision, the parties agree that they shall not at any time publicize or cause to be publicized, by any oral or written communications to any third person whatsoever, the facts or circumstances surrounding the claims resolved by this Agreement, or the terms, conditions, or negotiations of this Agreement. The parties agree, however, that the confidentiality provisions contained herein do not apply as to any inquiry by federal or state tax authorities, or in response to a discovery request in litigation, lawful subpoena or court order.

(6) It is understood and agreed by the parties that this Agreement is in compromise of a disputed claim and that consideration paid is not to be construed as an admission of liability on the part of *infringer*.

(7)This Agreement contains the entire agreement of the parties with respect to the matters covered by this Agreement. No other agreement, statement or promise made by any party, or any employees, officer or agent of any party, which is not contained in this Agreement shall be binding or valid.

(8) If any term, provision, covenant, or condition of this Agreement is held by a court or regulatory body of competent jurisdiction to be invalid, void, or unenforceable, the rest of the Agreement will remain in full force and effect and shall in no way be affected, impaired, or invalidated. Furthermore, in lieu of such illegal, invalid, or unenforceable provision, there will be added automatically as a part of this Agreement a provision as similar in terms to such illegal, invalid, or unenforceable provision as may be possible and legal, valid and enforceable.

(9) The parties agree that this Agreement may only be modified by an instrument in writing duly executed by an authorized representative of each of the parties hereto.

(10) The parties hereto state that they have carefully read this Agreement, that they fully understand its final and binding effect, that the only promises made to them in signing this Agreement are those stated above, and that this Agreement is executed freely and voluntarily after consideration of all relevant information and data.

(11) This Agreement shall be construed and interpreted in accordance with the laws of the State of [your state, or theirs, depending upon how you negotiate].

continued

(12) This Agreement may executed in multiple counterparts, each of which shall be an original as against the parties who signed it and all of which shall constitute one and the same document. Any facsimile signature of any party hereto shall constitute a legal, valid and binding execution by such party.

IN WITNESS WHEREOF, the undersigned have executed this Agreement on the dates specified below. [They sign, you sign.]

One final note about settlements. Corporations typically have insurance or a sizeable bank balance that will cover them in the event of a loss that results from an infringement claim. Do not let your settlement negotiations become personal. The company can outspend and out-lawyer you tenfold. Be fair and be reasonable when considering settlement offers and making responses to them. I'll paraphrase the movie *Top Gun*, where the lead character Maverick was dangerously showing off during a flight school demonstration and was admonished, "Don't let your ego write checks that your body can't cash." So, too, don't let *your* ego write checks that your bank account can't cash.

Chapter 16 Handling a Breach of Contract: Small Claims and Civil Court

Before you begin tossing around, "I'll see you in court" (at which time, you've probably lost the person as a client), you need to actually know which court you'll be seeing that person in—federal, criminal, civil, or civil's little sister: small claims. Because we're not talking about criminal (in almost all cases), and federal will most likely apply to copyright suits, instead, you're dealing with civil or small claims. Often, these courts can prove to be a more expeditious way of resolving your dispute.

First though, it is important to understand the different types of breaches. There are a few types of contractual breaches:

- ▶ **Fundamental breach.** This breach is so significant that not only can the contract be terminated, but the wronged party may bring a suit against the other party or parties. An example of this might be a circumstance in which models are contracted for and flown to a distant tropical island for a fashion catalog shoot, and upon their arrival they demand additional consideration (such as pay, workload lightening, and so on) or they will refuse to participate, bringing the entire shoot to a halt and thus delaying the catalog's production.
- ▶ Anticipatory breach. This breach may be fundamental, material, or minor, and must indicate with certainty that a party to the contract shall not perform to the contract's specifications when called upon. An example of this might be a publication that, after they sign your contract and you perform the photographic services, states that they won't pay you unless you sign their contract. Although the statement of non-payment for services already rendered is anticipatory, there are some complications in that additional—likely unsatisfactory—terms are being demanded by the client. However, this is an anticipatory breach.
- ▶ Minor breach. This breach is only a partial breach, such as a payment in 45 days instead of the contractually obligated 30. Although this may be deemed a material breach in that an interest penalty might have been applied to the \$5,000 invoice, in this circumstance only the wronged party's actual damages can be collected. In this instance, the actual damages on an 18% APR interest penalty would amount to approximately \$37, and thus this would be the maximum damages that could be collected.

▶ Material breach. This breach is more substantial. If, for example, you are contracted to shoot an assignment with Nikon cameras because of a relationship your client has with Nikon, and you instead use Canon, your client can either compel you to use Nikon or collect damages that could include all the costs to reproduce the shoot, plus any expenses involved in rush charges to get the project back on track to accommodate for the delays your breach caused.

Why You Might Be Better Off in Small Claims or Civil Court

For many photographers, bringing their case before a civil court can be less expensive and faster than a federal case. The details of how you handle your contracts will provide you with remedies as the aggrieved party.

Should your contract stipulate that unauthorized uses of your photographs are copyright infringements, then federal court is the place you'll end up, and if you try to bring a suit in civil court, the defendant's attorney will file to this effect, insisting that the case be tried in federal court. They would, of course, be doing this to force you to give up the claim because of the timeline and expense of federal court over civil court.

However, if you allow for the possibility of adjudication in civil courts, for these same uses, in certain circumstances, you may be at an advantage. In cases that fall below a state-specified threshold, your case might wind up in small claims court. Ceilings for claims range from \$2,500 to \$10,000 depending upon the state, but there are benefits to small claims. For example, you are not required to have an attorney represent you, and in some states you are precluded from doing so. The exception to this in almost all circumstances is when you are suing a corporation. In this case, it is not the officers of the company who appear, but rather their corporation counsel or designated attorney.

This can work out to your advantage. If you are suing for a few thousand dollars, the company might decide that, although you may well have a case and they feel they did nothing wrong, the cost to them in attorney's fees will exceed the expense they hope to avoid. Instead they might offer you 25%, 50%, or even 75% of the amount you are suing for, just to settle the claim. Because you do not have an attorney, the benefit of traveling this path is substantial for you, and should be considered.

What to Expect and How Long It Will Take

You can expect that the defendant will do everything in his or her power to diminish your claim, attack your credibility, seek a pre-trial dismissal of the suit, and, usually at the eleventh hour, seek a settlement. Settlements can occur in as little as a month, and trials can take several years, especially in complicated cases. And, at any point during the trial, up to the moment before the jury has reached a verdict, both parties can come to settlement terms and the case is dismissed.

In fact, many states have mandatory arbitration/settlement talk requirements before a judge will even see you. In this situation, you and those you are suing (or their representatives), will sit down with an impartial mediator, who hopes to get both of you to come to an agreement. If this occurs, in many instances the court will enforce the settlement agreement as if it was a decision of the court following a trial.

The first thing you'll do in small claims court is to file your claim. All small claims courts have easy-to-follow forms and instructions, and your total cost to file the claim will likely be less than \$50, recoverable should you be the prevailing party, plus interest. The defendant will respond, and a court date will be set. Usually after the date is set, an attorney for the other side (if a company) will likely reach out to you to try to settle the case. If it is another individual—say a bride and groom who haven't paid you—you'll likely just wait for your day in court.

Absent something very unusual, your case usually will be resolved the day it is heard. You will present your contract, signed by both parties, and the defendant will have a hard time outlining a material or fundamental breach of the contract that would allow him to not pay you or to try to force his contract on you after yours has been signed. There is no jury in small claims, and it's up to the judge to understand the case, ask thoughtful questions, and render his decision.

When the case is decided in your favor, the judge will order payment terms, which include court filing costs and (in many states) interest from the date you filed your claim. Typically, this is a 30-day term, sometimes within seven days. Other judge-stipulated timelines can be imposed. If necessary, you can return to the court to order liens placed on property owned by the parties who owe you money. A nominal fee usually totaling less than \$50 will allow you to have an Abstract of Judgment-Civil issued, as well as cover the cost to send that Abstract of Judgment to the County Recorder's office in the county where your debtor owns, or is likely to own, real property. Although you will not automatically be paid, interest will continue to accrue on what you are owed. Whenever your debtor tries to sell or refinance that property, your lien will stop that entire process in its tracks. The debtor must pay you, and you must then remove the lien before the sale or refinancing can take place.

Case Study: A Textiles Company

One year, I was contracted by a magazine to produce a portrait of three owners of a major textiles company in Washington, DC, for an article on this family-run business. Following the article, for which I was paid, the design company for the subject's company contacted me to review the transparencies from the assignment. I personally delivered the images, along with a delivery memo. While the delivery memo was never signed, the design company's actions—specifically, having seen the delivery memo and not objecting and returning the images to me—accepted the terms by holding and reviewing the images.

After several months went by, I contacted the firm. Presuming that my work had been used without my permission, I posed the question, "So, how many images did you use?" To which the response was "Oh, only one." I then asked, "And, when were you going to contact me to obtain permission to use that image?" Then the design firm said that the company that had hired them and whom I had originally photographed had committed to doing that. When I asked that company about this, they said that I had already been paid by the magazine, so I was

not entitled to be paid again for the use of the photograph, and that although they might have paid a few hundred to use the photo, there was "no way in Hell" they were paying \$700, let alone more than that.

I prepared an invoice for the company. The original use fee would have been around \$700, provided that I was contracted beforehand, but that had not occurred. The contract called for a triple penalty in this instance, as well as holding charges for all the images that had not been returned to me. With numerous images, the figure began to mount. Then, when I turned up at the company's offices to collect my transparencies, I learned that one image—the one they had used—was missing. When all was said and done, I submitted an invoice to them for \$4,200. They refused to pay or even return phone calls on the matter. Some time passed, and I would often see their delivery trucks on the streets of Washington. Each time, I would get angry at myself and swear that I needed to do something. Finally, six or so months passed, and I finally filed my case in small claims court, which had a ceiling of \$5,000 at the time.

Significant back-and-forth exchanges between their attorney and me ensued. At first, they offered \$600 to settle. Next they offered \$1,200. Then, they had the gall to suggest that I had no right to license commercial rights to the company because I did not have model releases from the company. I laughed and said that it was the officers of the company who had looked to secure the rights to the image in which they appeared, and as such, that was tacit permission for the use of the photograph.

With each lengthy phone call, I was aware that this attorney's time was accruing expenses, while I was not expending anything other than my spare time. The Friday before the Monday trial, their attorney called to say that their final settlement offer was being made. He outlined a slight error in my reading of my own contract, which meant that the maximum I could hope to actually get was near \$2,600. He offered \$1,800 and said that their offer to settle would diminish over the weekend as he expended expenses on behalf of his client, who would be more likely to make it go away by paying that money to me. Thus, I agreed to the settlement offer, not only because it was a fair offer, but moreover, because it was significantly more than the "no way in Hell" amount that one of the company's owners had emphatically, and with bravado, stated he'd pay. Now when I see those same trucks making deliveries, I express my satisfaction in knowing that a wrong was righted.

Chapter 17 Resolving Slow- and Non-Paying Clients

Every client for whom I provide photography services signs a contract with me, and this contract always stipulates the timeline for payment. Almost always, the contract is the one I presented, but in circumstances in which a client-presented contract contains nothing objectionable, I am comfortable signing theirs. The payment timeline varies. Sometimes it's "due upon receipt," "due in 30 days," or requires "full payment prior to publication." However, despite this fact, we have found over the years that when it comes to our deliverables, time is always of the essence, yet I have more than my fair share of slow-paying clients. When this happens, there is a well-worn path between my office, the accounting department, and the originating individual within the client's company.

An important rule—in fact, I'd say one of *the* most important rules—is, in the endeavor to collect on the unpaid invoice, do everything within your power to ensure you don't lose the client in the process! Remember to be polite. Later in this chapter, in the "Collection Services: An Efficitive Last Resort" section, there are examples of how a collection service works and contact information for one.

How to Engage the Client and the Accounting Department

More often than not, the client has received the invoice and just forgot to take action to begin the payment process. When we mailed invoices, we always heard, "Oh, I never got it." So, we began delivering invoices in the envelope that included the deliverable. Then, we'd get, "Oh, I didn't see it in there. Can you resend it?" So, we began to actually wrap the deliverable with the invoice, and we'd get the same response. Faxing always seemed an excuse for the client to say their fax machine was down or they still didn't get it. One solution has proven to be far less susceptible to these excuses. (Or are they explanations?)

E-mail. If they didn't get it, you'll get a bounce-back telling you so. If your e-mail program includes a return receipt function and you enable it, you'll know when the client opened the e-mail. (We don't actually do this, though, because we think it's annoying.)

Back when accounting departments stipulated that they wouldn't pay faxed invoices, we began referring to our invoices as "electronic originals," and that seemed to suit the accountants just fine. We produce an Acrobat PDF document that we attach with our correspondence.

NOTE

For Apple users, the Save as PDF option appears whenever you use the Print function in any application. For PC users, the full Adobe Acrobat application is necessary to create a PDF.

Although you're more than likely using some form of invoice-generating software, if it's just a word processor, understand that the accounting department will want the word "Invoice," the invoice number, the date, and your full address on the invoice somewhere. When an invoice is missing these things, it will often be the culprit of a late-paying client.

The subject line we use is usually "Photo Invoice — Widget Ad Photography." This makes it clear that there's something important in the e-mail. Lines such as "Greetings again," "Hi there," or "Nice working with you" will almost always be overlooked, and moreover might end up in the Spam folder. Many e-mail applications allow you to flag an e-mail as high importance, which can reduce the likelihood that it will end up getting lost or be considered spam by their spam filters.

My e-mail usually goes something like this:

Dear Client,

Attached is invoice #12345 for the Widget Ad we produced for you last week. If you have a Purchase Order number for us, please forward that for our records. Please let me know if you need anything else or if you have any questions.

We look forward to working with you again in the future!

Regards,

John

John Harrington John Harrington Photography 2500 32nd Street, SE Washington DC, 20020 (202) 544-4578 email: John @ JohnHarrington.com

This is short, sweet, and to the point. It also reminds the client to get a PO number if their company requires it. If we've already received the PO number, I am sure to include that on the invoice.

At this point, the next time you contact the company, your best call is to the accounting department. Depending upon my workload, I will try to call the accounting department two weeks or so after we've sent the invoice. If it's a small company, then a call to the originating individual is warranted, but almost always it's a larger company with people dedicated to paying invoices.

The conversation usually goes something like this:

THEM: "Accounts payable, how can I help you?"

ME: "Hi, this is John Harrington Photography calling regarding an invoice that is coming due soon. We were calling to make sure it is in your system and set to pay."

At this point, we get one of the following:

THEM: "Yes, but we need a W-9 from you."

THEM: "You're talking to the wrong office. You need to call...."

THEM: "No, we have no record of having received your invoice."

If you get the first response, offer to e-mail *that* person your PDF of your W-9. If you get the second response, make a note of the new information (because you'll probably need it), and then start from the beginning. However, you'll usually get the third response. So, the dialogue continues:

ME: "Okay, well, we performed the services for the company more than two weeks ago, and we forwarded the invoice the next day to the person who hired us. If I can get your e-mail address, I will send it directly to you."

THEM: "Sure, please do."

ME: "Great. I'll send it now, and I will follow up with you in a few days to see where we are."

The point about following up lets them know you're going to be calling again, so they don't think you are being annoying, but rather, firm in your inquiries. Remember, be *polite*, but also be *firm*. Doing so also gives the client or accounting department an indication that they'd be best served by handling this one sooner rather than later. I'll also print out the invoice and put it in a folder on my desk that reads "Payment Issues Ongoing." I hand-notate every e-mail, phone call, and message left, reminding me of who it was with and what was said, so that for seriously delinquent invoices, we have a trail of notes and dates to back up our story. This is especially important when the originating individual has left the company, and you have to deal with his or her replacement or boss.

Then, when we send the invoice, we make a point of CCing the e-mail to the originating individual. Because ultimately the accounting department will need to get an approval from the originating individual anyway, having their e-mail as a part of the dialogue facilitates that. Plus, when the originating individual gets the CCd e-mail, he or she can simply reply to the accounting department that the invoice is approved. That e-mail usually looks like this:

To: Jane Doe, Accounting Department CC: Sally Doe, Originating Individual Subject: Missing Invoice — As we discussed

Dear Jane —

Thanks for taking the time to look into this invoice. As we discussed, the invoice is not yet late; however, we wanted to call proactively to ensure that it was in your system, and we are glad we did. We understand that time is necessary for you to process payments, and our terms for timely payment are 30 days. With that date coming up in just over a week or so, we wanted to call to check. Sally, who is CCd on this e-mail, was our original point of contact, and we forwarded the invoice to her back when the work was completed. Perhaps it ended up in her Spam inbox or there was just a simple oversight. Either way, please let me know if there's anything else you need from us to get this into your system and approved for payment. I or someone in my office will follow up with you in a few days to make sure you've received this e-mail and to find out whether payment can still be received on time. Perhaps an expediting of the check could take place?

Regards,

John

This lets the originating individual know—politely—that she overlooked us and gets the ball rolling in the right direction. Then, a few days (or a week) later, a follow-up call to the accounting person usually results in the invoice at least being in the system and sometimes awaiting approval. We continue to stay in contact with them until they say, "It will go out in this check run on Thursday, so if you don't have it by next week, give me a call back." And then it does arrive, with few exceptions.

You Delivered on Time, and Now They're Paying Late

Every client who signs a contract with me agrees to a payment schedule. Almost always it's the one I presented—30 days—but in some circumstances it might be longer. Sometimes, it's 45/60/90 days, sometimes it's "pays on publication," and for rites of passage, there is usually a 50% deposit when the contract is signed, with the remainder due a week before the ceremony.

In the end, we deliver the client's images on time every time—we bend over backward to make sure this is the case. We beg the overnight service to open the door so we can give them our packages, we miss dinner with the family to work on images, and we even sometimes serve as courier, traversing town at rush hour to ensure that the package arrives before the client's office closes.

However, it seems all this is often forgotten when it comes time to pay the bill on time. I cannot tell you how frustrating this is. In the end, it reminds me that we are doing business, and it's not personal. I don't take it personally, but I also will work to make sure that payment is received,

and I do my darnedest to make sure I do it in as friendly a manner as possible. Remember: *Be polite, but be firm.* The all-important rule that is worth repeating is this: In the endeavor to collect on the unpaid invoice, do everything within your power to ensure you don't lose the client in the process!

Many times, photographers (and my contracts include this) stipulate that a license to publish the image is contingent upon payment in full. When push comes to shove, this is a large stick you can wield against a non-paying client.

Statistics of Aging Receivables, and the Likelihood of Collecting at All

There are some fairly solid statistics regarding the likelihood that you'll be paid as the bill gets older and older. However, as with all statistics, the basis for those numbers is always where things can skew. For example, if you're doing business direct to businesses (that is, B2B), your likelihood of being paid is greater than when you're dealing with business-to-consumer (B2C). Further, a B2B engagement in which you are working with major corporations or media conglomerates means the statistics skew again. With all of this said, the statistics are important to look at and understand so that you can be sure to stay on top of the bills that will ultimately allow you to pay your own bills.

Statistics show that an invoice more than 60 days old has only a 70% chance of being collected in full. After 90 days, the chance of collecting the invoice in full drops to 45%, and after 120 days, it falls to 20%. It diminishes further beyond that. So, make sure you get paid sooner rather than later.

Late Fees: A Good Idea?

Late fees are quite a challenge to enforce, in my opinion. It's easy to apply late fees when you are a credit card company, the electric company, or you have significant leverage with the client on an ongoing basis. In the end, when a client receives an invoice for \$1,300, and then 60 days later gets the same invoice with \$40 or so tacked on, I think the likely response will be a negative one, and you will run up against accounting departments who attempt to state that they don't pay late fees, or that their policy is to pay in 60 or 90 days and that you're out of luck. If you are in a field of photography in which you can effect late fees and it won't cause a strain on client relations, then perhaps it will work. However, my solution, which I have employed for over a decade, has worked very effectively.

My Solution to Late Fees for Some Clients

There are benefits to offering to take credit cards as a tried-and-true method of being paid on time. This does, in fact, work very well—however, many of our clients just don't want to pay with a credit card. So, I modified a standard concept in accounting—a discount for timely payment.

I remember learning about an accounting term, "2/10 net 30," during a course when I was in college. This essentially meant that for a bill that was, say, \$1,000, the entire amount was due in 30 days, but for payments received within 10 days, a 2% (or \$20) discount would be taken off the entire bill. Some firms use "1/10 net 30," and there are numerous variations—"2/15 net 30," "3/15 net 40," or any combination thereof.

If you'd like to offer a discount, the US Treasury has an interesting discount calculator, which advises government employees if the discount offered by a vendor is in the government's best interest. The URL is www.fms.treas.gov/prompt.

For example, the government has concluded that they should pay a 2/10 net 30 invoice in the discount period, and, as such, Federal Acquisition Regulations advise them to do so. However, I decided to reverse and modify this concept.

NOTE

Wonk Alert: The Code of Federal Regulations (CFR), Title 5, Part 1315 — Prompt Payment directs, for certain government agencies, how they should handle bills, whether of small or large amounts. Section 1315.7 outlines the procedures for taking discounts.

For all corporate and commercial clients, as well as a number of editorial clients, I have employed a pre-billed late fee, incorporated into the estimate and initially added to the invoice. And, the discounting of the total due is only allowed when payment is received in 30 days. My contracts stipulate:

Administrative Fee — We are now building into the invoice the cost to repeatedly follow up with accounts payable departments on past-due invoices, and we float the cost of payment to our vendors, which require us to request 30-day payment. This fee is approximately 10% of this estimate. If payment is made within 30 days, you may deduct this amount.

So, as illustrated in Figure 17.1, if the photography fees are \$450, expenses are delineated as \$455, and the administrative fee is \$90.50. We advise the clients that they'll be billed for the larger, administrative fee–inclusive figure, and further indicate that the administrative fee may be discounted if payment is made within 30 days.

<u>I cannot recall the last time a prospective client, when seeing this on the invoice, objected, and we lost the assignment. On the rare occasions that clients have objected, our friendly response</u>is, "No problem—paying on time means that doesn't apply to you." This circumstance has one added benefit—the inevitable calls from "non-profits." Now, I am not going to go into the fact that that is a tax status, not a license to lowball every vendor they come in contact with. Instead, I am saying that when a client asks whether I have a non-profit discount, I respond with, "You may take a 10% discount if you pay on time, and this will be reflected in the estimate we are going to send you." They get excited and are adamant that they'll pay on time. Then, lo and behold, they don't, and they lose the discount. And, as such, we have built into our paperwork and pre-billed that administrative fee, and we have been very upfront about it.

Photographer's Fees Fee for Photographic services and Usage Fee for usage stipulated below:	\$450.00	
Administrative Fee - We are now building into the invoice the cost to repeatedly follow up with accounts payable departments on past due invoices, and float the cost of payment to our vendors, which require 30 days payment. This fee is approximately 10% of this estimate. If payment is made within 30 days, you may deduct this amount.	\$90.50	
Total Photographer's Fees	\$540.50	\$540.50
Post production fees -100 to 250 images (Approx 3 - 7 rolls)		\$250.00
Output method of digital files (i.e. How will the images be delilvered to you): CD-ROM		\$175.00
Shipping - Proofs/CDs to/from lab and to client via: Courier		\$18.00
Event Prkng/Misc - Parking		\$12.00
If images delivered under normal two day tu <u>this is the estimated total you will</u>		\$995.50
If payment is made within 30 days, you may deduct the administrative fee of: off your total invoice, which is esti		\$905.00

One last point: This fee does not have a ceiling. On some estimates, we have \$3,500 to \$4,500 figures for PR portraits in quantity, or even \$1,800 for longer days shooting and expenses, and that means \$350, \$450, or \$180 in administrative fees. If you're looking for a way to validate the expense of hiring an office manager whose job it is to send and collect on invoices, just a few invoices late per week will more than cover the costs of paying for the office manager, and will mean less time for you sitting in front of the computer doing paperwork.

Collections Services: An Effective Last Resort

I have been fortunate that, in more than 16 years in business, I have had fewer than 10 clients who have welched on their responsibility to pay. I have, however, had a few who, after all the courtesy calls, friendly reminders, and resending of invoices, have become non-responsive. With all, I have found there to be a 90% success rate in using a collections service. Once it was a political candidate, once it was a non-profit, and once it was a major public affairs firm. When all else fails, in my book, it's time to call in the best threat—a blemish on the client's credit and, where warranted, a legal proceeding.

We use Dun & Bradstreet's Receivable Management Services collections. Understand that sending a client to collections is a serious matter. You can opt, when you use the service I use or a similar one, to have just a letter written, or phone calls and letter. Either way, engaging collection proceedings against a company is a serious action that may result in a "Placed For Collection" notice in your client's D&B business report.

The letter, on Dun & Bradstreet letterhead, essentially reads:

Dear Client —

John Harrington Photography has placed your account with us for further collection processing. If the amount shown above is just and correct, and unless you dispute the amount, we ask that you send your check directly to John Harrington Photography for this amount.

If you'd like to discuss this account with John Harrington Photography, you may contact John Harrington at (202) 544-4578.

Next, they'll send something like:

Dear Client —

Because you have not responded to our previous notice, we request that you send your check to avoid further collection activity.

Please mail your payment directly to John Harrington Photography for this amount.

If you'd like to discuss this account with John Harrington Photography, you may contact John Harrington at (202) 544-4578.

And it goes on. Understand that when a letter comes from Receivables Management Services, a partner of Dun & Bradstreet, accounting departments who may have previously ignored demands for payment will usually stand up and take notice.

There are two basic ways to go. You can pay for the letter writing service, or you can use their "contingent upon collection" fee-based service. We opt for that option, which ends up being around 28% of the total. I have sent a client to collections for as little as \$100. That one was a wealthy woman in a tony part of town who just had to have a print that was a 5×7 cropped in deep into a much larger film frame that, had the entire negative (800 iso) been enlarged, would have been a 30×40 . I warned her that it would be grainy, but she just had to have it. So, we delivered. And she then balked. The total was around \$100, including the cost of the print, couriers to/from the lab, and a courier to her.

Here are the (relevant) terms from Dun & Bradstreet's form regarding their services, contingent upon collection:

a) Collection services. D&B will make written, telephone, and/or personal demands for payment. Charges contingent upon collection are 30% for the first \$501 to \$3,000 collected, 27% of the next \$3,001 to \$10,000 collected, 22% of amounts collected in excess of \$10,000 with minimum charges of \$150 on collections of \$301 to \$500, and 50% on collections of \$300 or less. On accounts where the oldest invoice is more than one year old, a rate of 33.3% will be charged. If customer withdraws an account, settles directly or accepted returned merchandise, the customer may be charged these rates.

b) Forwarding service. D&B will forward accounts to attorneys on the customer's behalf in accordance with the customer's instructions. Charges contingent upon collection for services of D&B and attorneys are the same as outlined in section (a) above. There may be additional charges by attorneys when suits or other legal proceedings are authorized by the customer, consisting of an administrative charge, suit fee, advance costs, and in some cases, a retainer.

All you have to do is fax a form to Dun & Bradstreet with the name of the debtor, the address, the city, the state, the zip, the phone number, the amount owed, and the date of their last invoice. You do not need to provide a copy of the invoice (in the beginning) or any documentation that the debt is valid, unless/until the issue escalates or the debtor states that they do not owe any money to you.

This service is available through what D&B refers to their Receivable Management Services partner. You can find more information on their Web site. As of this writing, the URL is http://smallbusiness.dnb.com/collect-debt/browse-products.asp.

Further, you also might be able to submit your debt claim online, once you set up an account (free, as I recall) at the RMS site: www.rmsna.com/khome.htm.

From my experience, unless the bill is more than about \$2,000, for the amount of time involved in letter writing, phone calls, e-mails, more letter writing, and so on, as well as the mental anguish of being upset that someone to whom I delivered on time and as required services is now ignoring me, I just go with D&B. Typically, I send them \$600 to \$1,400 past-due invoices, and with rare exceptions, they get results. At that point, it is worth it for me to give them a few hundred dollars, not only for all the hassle they saved me, but for the knowledge that there is now a black mark on the client's credit, and the wrong has been righted on principle. In the end, I'd happily send D&B a \$200 past-due bill, let them go through all the hassle of writing letters and so on, and in the end net \$100, because it's more than likely \$100 more than I'd get from someone who won't return my calls or who objects. When the client gets a collection notice, they pay attention to it.

Having been through small claims (and federal) court, I can say that although they are rewarding, when you have to give up a day (or more than one day if there is a continuance at the last minute) and turn away assignment(s) for that day to be in court, you often lose the amount you might have won in court from the lost assignments. So, farming out the collections with the muscle of D&B just makes the most sense.

Chapter 18 Letters, Letters, Letters: Writing Like a Professional Can Solve Many Problems

Letters, correspondence, notes, and such are truly the foundations of communication. Battles waged, lives lost, and unintended consequences have all resulted from poor writings. The importance of good and accurate letter writing cannot be underestimated. The misplacement of a comma by Lockheed Martin cost them \$70 million in a contract for their services. On June 18, 1999, the Associated Press reported that "An international contract for the U.S.-based aerospace group's C-130J Hercules had the comma misplaced by one decimal point in the equation that adjusted the sales price for changes to the inflation rate." In Europe, commas are used instead of periods to mark decimal points. "It was a mistake," the newspaper quoted James A. "Mickey" Blackwell, president of Lockheed's aeronautics division, as saying. But the customer, who Lockheed refused to name, held them to the price.

Consider this circumstance. Suppose your assignment was to produce images for a brochure for a resort. In your correspondence, which accompanies your contract, you write:

Photographs shall be produced that illustrate guests in the following capacities: relaxing, dining, sleeping, exercising and recreating in resort facilities.

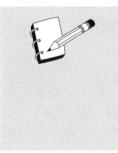

NOTE

Avoid the use of "shall." Writers, especially lawyers, have an addition to the word, and its use is unsafe. The California Supreme Court has said, "It is a general rule of construction that the word 'shall,' when found in a statute, is not to be construed as mandatory, unless the intent of the legislature that it shall be so construed is unequivocally evidenced." Use words such as "must" or "is," or omit the word altogether instead. Is that *four* images as a deliverable or *five*? You might consider exercising and recreating to be a single thing, such as playing tennis or jogging. However, the resort may have just put in a \$2 million state-of-the-art gym, and when you deliver images that do not include a guest using the gym, you've got a problem. I can see myself standing outside a gym during a scout visit, looking in and thinking, "Yes, they're exercising, but not really recreating, so let's skip that," and combining the two.

Instead, include the comma and change "shall" to "will":

Photographs will be produced that illustrate guests in the following capacities: relaxing, dining, sleeping, exercising, and recreating in resort facilities.

When counseling attorneys on the importance of good grammar, Richard Wydick, author of "Should Lawyers Punctuate," from a 1990 issue of *The Scribes Journal of Legal Writing*, illustrates the point thusly:

Maligned though it may be, punctuation can affect the meaning of an English sentence. Consider, for example, the [U.S. Constitution's] Fifth Amendment's due process clause. As punctuated by its drafters, it reads:

"[No person shall] be deprived of life, liberty, or property, without due process of law...."

Guided by the punctuation, our eyes quickly tell us that the phrase "due process of law" modifies the verb "be deprived." Thus, the Fifth Amendment requires due process if one is to be deprived of life, liberty, or property. But suppose the drafters had omitted the comma after "property." That would permit a lawyer to argue (in defiance of the provision's long history) that "without due process" modifies only "property." "Thus, the Fifth Amendment would forbid deprivation of property without due process and would absolutely forbid both incarceration and the death penalty. Such is the power of a comma.

Your correspondence between you and a client or vendor should follow a standard path. For nearly a decade now, I have had an intern program in my office, and all of my interns have sent cover letters as a part of the application process. It is almost a guarantee that you will not be considered if your cover letter/e-mail is poorly written, contains spelling errors, or doesn't follow the common letter format.

E-mails contain dates, author name, and such by their very nature. However, in attached word processing files, these items are often missing. Make certain you include your name, company name, address, city/state/zip, and phone number, along with the date, in all such files. For faxes, and in some cases, within the e-mail itself, there is value in including the *time* that you wrote it.

When I am writing formal correspondence that I print out and mail, via postal, overnight, fax, or as an attachment, it is important to include the method of delivery, below the recipient's address and above the "Dear Mr. Smith" salutation, usually in italics, as such:

Via Facsimile: (202) 555-1212 Via Postal Mail Via Overnight Express Via E-Mail: [recipient's e-mail address] By Courier By Hand

When transmitting your letter via fax or e-mail, there should be a disclaimer or notice on the cover page or within the body of the e-mail, somewhere along the lines of:

NOTICE: This facsimile [or e-mail] contains privileged, confidential, or proprietary information, and is intended only for the person or persons named. If you are not that person, or a representative of that person, your use, distribution, dissemination, or reproduction of this or any attached documents is prohibited. This notice also hereby requests you notify us immediately by return facsimile or collect-call telephone at (202) 555-1212.

There may be some who would contend that this notice can be easily overturned; however, it is my opinion that there is value in having it, and thus, we use it.

Further, it is important that you actually call, especially for faxes. Unless you are certain that the fax machine is right next to this person's desk, has paper, and won't jam when printing your fax, call to confirm complete receipt of all pages.

When you are writing, it's okay to use jargon, but make sure that the recipient will understand it. If you're not sure, then explain it or use laymen's terms. And make sure you're writing in active voice, not passive.

The word "including" can also be dangerous when not used properly.

In addition to the photographer's fees outlined on the attached contract, client is also responsible for expenses, including assistants' fees, mileage, and meals.

What is should say is:

In addition to the photographer's fees outlined on the attached contract, client is also responsible for expenses, including, but not limited to, assistants' fees, mileage, and meals.

Or:

In addition to the photographer's fees outlined on the attached contract, client is also responsible for expenses, including, for example, assistants' fees, mileage, and meals.

This way, when you have a parking garage expense or you have to buy seamless or a prop, you'll not risk having the expense reimbursement denied.

Also, be consistent with words and terms. For example, don't say "this contract," and then later on say "the agreement." Throughout this book, I make recommendations for reading that I consider to be useful for a further understanding of the chapter's topics. One online solution, however, is free. It is William Strunk's 1918 classic, *The Elements of Style*. It can be found at www.bartleby.com/141 as of this writing; however, if the URL changes, a search of the Internet should turn it up, or you can turn the pages of it in paperback form if that's your preference, by picking up a copy from your preferred bookseller. The book contains many rules that you should employ to make your letters clear and concise. Some examples include:

- "Make the paragraph the unit of composition: one paragraph to each topic."
- "As a rule, begin each paragraph with a topic sentence; end it in conformity with the beginning."
- "Use the active voice."
- "Put statements in positive form."
- "Omit needless words."
- "Avoid a succession of loose sentences."
- "Express co-ordinate ideas in similar form."
- "Keep related words together."
- "In summaries, keep to one tense."
- "Place the emphatic words of a sentence at the end."

E-Mail: The Current Default Communications Tool

E-mail is often the fastest route to get directly to someone, and it has emerged as the mainstream form of communications, usurping faxes and letters by a long shot. An exceptional book on how to best communicate via e-mail is *The Elements of E-Mail Style: Communicate Effectively via Electronic Mail*, by David Angell and Brent Heslop. It is a follow-up to Strunk and White's *The Elements of Style*, and it explains how to properly write an e-mail, what proper e-mail etiquette is, how to make your messages simple and yet powerful, and how to ensure that your tone is not misconstrued.

E-mail can bypass even the most protective secretary or assistant, provided you have the right e-mail address (which is usually as simple as figuring out the e-mail nomenclature). You can be certain that it's not left on a fax machine or in a junk-mail pile.

Suppose, for example, you are looking to do business with Smith and Jones Advertising, and their Web site is sjadvertising.com. Do a search on the Internet for "@sjavertising.com," and invariably it will turn up numerous names, so you learn that the e-mail address for Richard Smith is Richard_Smith@sjadvertising.com, or maybe rsmith@sjadvertising.com, or some variation thereof. However they structure it, you can then use that same naming convention to reach the person you are trying to without much problem at all. This works about 95% of the time, save for when a firm uses just the person's first name and there's more than one person with that name, or when it's a major corporation and you are trying to reach John Smith, as there is likely more than one person with that name.

Be very judicious about how you reach out to people with whom you've not been in a previous dialogue or with whom you've not interacted in some time. You do not want to end up on a spam blacklist. As such, the art of subject lines, salutations, and the first few sentences are critical to ensure that your e-mail doesn't get trashed.

Also, it is possible to take something written out of context because it lacks vocal tone. So many people become incensed at reading an e-mail that was written in haste. This can be avoided if you simply read the e-mail back to yourself to ensure it says what you want it to say.

For example, when we send a client an estimate, the subject line is something like:

- ▶ Photo Estimate for: Wednesday, February 29, 2006
- ▶ Photo Estimate, as requested
- ▶ Photo Estimate for cover assignment of CEO Portrait

When we send invoices as PDFs via e-mail, the subject line is something like:

- ▶ Invoice for photography on Feb29-2006
- ▶ John Harrington Photo Invoice #12345

And when we correspond with the client regarding past-due invoices, the subject line is something like:

► Checking in RE: past-due photography invoice(s)

And in instances in which we are re-sending an e-mail, we use the subject line:

▶ RESEND: Photo Estimate for cover assignment of CEO Portrait

When we have, as the result of a dialogue with the client, made adjustments to the estimate or invoice that was previously sent, we use:

▶ REVISED: Photo Estimate for cover assignment of CEO Portrait

These e-mails result in maximizing the possibility that the message will be seen and noticed as something other than spam, and thus, read.

Of the utmost importance is the change in the attached file's name. Knowing that the files will go into the same Attachments folder that the client's e-mail uses or will be saved to a desktop, you don't want your current attachment to overwrite the original one. Further, when the file is on the client's desktop, although it might make sense to you to give it the client's last name or company name, the client probably has numerous other files comparatively named. Choosing a name such as "JHPhoto-Inv1234" or some variation thereof will give the client instant recognition of what the file is and what to do with it (hopefully pay it!).

Elsewhere in this book, there are numerous examples of my e-mail style, and what my salutation, e-mail body, and closing look like, so I will not rehash it extensively here. However, it should be something like:

Dear [client's first name] — Thanks for taking the time to talk with me regarding.... ...I look forward to the possibility of working with you and [company name] on this project. Best, John

I would encourage you to use the client's first name, instead of "Mr. [client's last name]." You're on equal footing with this client, and the "Mr." sets a tone that is just a bit too formal. There are circumstances when it is appropriate (such as when you are writing to someone who stole your work, the head of an accounting department who's not paying your bill, or such), but most client correspondence, for me, is slightly less formal than that which calls for a "Dear Mr." to precede the client's name.

That said, a study cited in another must-read book on e-mail etiquette and style, *Business E-Mail: How to Make It Professional and Effective* by Lisa A. Smith, details the importance of e-mail professionalism. "Research by Christina A. Cavanaugh, a professor of management communications at the University of Western Ontario, shows that the major cause of e-mail stress in the workplace is in its inappropriate use as a communication tool, not its volume," and she goes on to conclude that correspondence via e-mail is "heavily judged on their appearance and the care taken in their construction."

Smith goes on to talk about templates. "Clients feel depersonalized when they realize you are serving them with templates.... It pays to pay attention to such details; they generate goodwill by pleasing clients and customers."

And one last note about being professional in your correspondence. Just as with voicemail, clients expect to hear back from you within a day, if not sooner. Disregarding their attempt to contact you to get answers or fulfill their requests could very well result in them calling someone else, if not on this assignment, certainly on the next. If you don't have answers for them, at least let them know you will get back to them shortly with an answer. That way, they know you have received their request and are working on it.

Signatures-and Not with a Pen!

You see e-mail signatures all the time, usually coming from clients. They look like this:

John Doe Creative Director Talented Professionals Cooperative 1234 Main Street Anytown, USA 12345 (800) 555-1212 — Office (887) 555-1212 — Fax www.TalentedPros.com John_Doe@TalentedPros.com

They appear at the bottom of everyone's correspondence to you, but are you using one during your correspondence? All of it? If not, you should. Mine reads:

John Harrington John Harrington Photography 2500 32nd Street, SE Washington, DC 20020-1404 National: 800-544-4577 Local: 202-544-4578 Fax: 202-544-4579 e-mail: John@JohnHarrington.com http://www.JohnHarrington.com

It's important that you indicate your name, even if it's in your company name. Further, in the event that you have people working for you, they should use the same signature, just with a different e-mail address and, if applicable, direct-dial phone numbers.

After I've exchanged e-mail with a client a few times, I may shorten my signature to look something like this:

John Harrington John Harrington Photography Local: 202-544-4578 John@JohnHarrington.com

This will still give them information, just not to the detail that the first signature does. In addition, I often will include my cell phone number in the signature because I want clients to be comfortable calling me there too, although that information is also on my voicemail message.

Lastly, a number of mail applications allow for the inclusion of a graphic—usually a JPEG or GIF—that is a part of the signature. When I am sending an estimate to a prospective client, I will use a signature specific to that estimate type—portrait, ad, event, and so on—that includes a montage of images that's about an inch and a half tall and about seven inches wide. This montage includes images that will further sell me as the best choice for the assignment. Here's how one would look for a portrait estimate request:

John Harrington John Harrington Photography 2500 32nd Street, SE Washington, DC 20020-1404 National: 800-544-4577 Local: 202-544-4578 Fax: 202-544-4579 e-mail: John@JohnHarrington.com http://www.JohnHarrington.com

The graphic appears below the last line of the signature. It's wide enough to be appreciated, yet small enough not to bog down the transmission due to a huge file size. The graphic varies from assignment type to assignment type.

It might also be appropriate to include the "Notice" disclaimer mentioned earlier below your signature, but as a part of the signature. However, in the end, the use of a signature will improve the professional look and appearance of the correspondence you send via e-mail.

Summary Letters: What We Discussed

All too often, there is a miscommunication resulting from a telephone call between you and the client. Usually, people do not intentionally misremember points of a conversation—they just honestly don't remember.

Although we talk with clients all the time about various things, when there is a point about changes in location, clarifications on stylistic details of an assignment, or other things that could adversely affect the outcome of the assignment, a letter summarizing the conversation can assist by providing a point of reference in the future. This is also helpful when, for example, an accounting department person says they are going to get the check cut "this week."

Further, should you end up in court, summary letters—more than likely summary e-mails—are admissible as evidence in most circumstances. So, if nothing else, write a CYA summary to send to the client. It will make your life so much easier—and the resolution so much swifter—if you have the letter in your archives.

Following the same style for e-mails (or letters) mentioned earlier in this chapter, the body could read something like this:

Dear Jane —

Thank you for taking the time to clarify the style you are looking for as we produce the portrait of the CEO. As I understand it, you would like the portrait to take place outdoors, but still be attractively lit with lights. Further, since it's for the cover, we will produce most, if not all, of the images as verticals and leave enough room at the top for the magazine's name and such.

For the image of the CEO on the production line, we recommended we use some colored gels to spruce up the equipment's appearance in the background, but you've indicated that your Editor-in-Chief dislikes this type of photography, so we will use no gels, and make a more natural-looking portrait indoors in an environmental fashion, not against seamless. I understand you are looking for almost all of these images to be horizontals, as your magazine's style is to open an article with a half-page image of the subject, eyes forward. Once we feel we have a variety of choices from this set up, I may try a few subtly-gelled variations—time permitting, of course.

Should there be any additional changes or updates, please don't hesitate to call. I am looking forward to completing this assignment for you!

Sincerely,

John Harrington

That will make sure that the client knows that you're doing "almost all verticals" for the cover idea and "almost all horizontals" for the inside idea. It also puts them on notice that you're not going to use gels (well, maybe a few subtle ones), and it keeps the communication lines open between the two of you. This e-mail also gives the client peace of mind that you heard what he or she was saying. And, it is a professional way to bring closure to the pre-shoot dialogue.

CCs and BCCs: How and When

It's important to be very thoughtful of who the message is to and who should get a CC and a BCC. In case you're not aware of what these mean, CC means "carbon copy" and BCC is "blind carbon copy." These terms originated when business correspondence was all via paper and everyone receiving the correspondence needed to know who else had received it, and those BCC'd needed to know that others didn't know they had seen it. Today, with e-mail, the CC indicates everyone who's copied on the message, and a BCC hides the recipients.

Be extra careful—many a problem has arisen when someone BCC'd hits Reply to All and reveals that they have seen the message. Instead, use the Forward feature to forward the e-mail to those you were going to BCC, in order to avoid this potential revelation.

Ask yourself, though, does everyone in the To, CC, and BCC lines need to see the e-mail? Also, how would you feel if the contents of the e-mail became public knowledge?

CCs are typically done for legal reasons, to ensure a broader paper trail, and to keep a colleague or client abreast of developments associated with what you're working on.

I typically use the BCC when I want my office manager or production manager to see that I made a promise to a client about a deliverable, a change to paperwork, or another internal issue that needs to be done on behalf of whomever I was sending the e-mail to. I will, though, use the Forward option if I need to pass along guidance to those in my office, rather than use the BCC. If you are sending out a mass e-mail, (and be careful about that!), especially to a group of unrelated recipients, make darn sure that you use the BCC field. Perhaps it's a promotional e-mail to existing clients and fellow photographers. If you did that in the To field or the CC field, all your clients would know who the others were, and your colleagues could learn who your clients are. Not cool.

One last point: Some corporate e-mail servers handle CCs, and especially BCCs, very carefully. CCs usually get through, but BCC is the preferred method of most spammers. One solution is to send the e-mail to yourself in the To line, and then include the string of recipients in the BCC line.

Thank-You Notes: How Much They Do and How Right They Are

In this fast paced world, the use of a simple handwritten thank-you note has all but vanished from the mail-scape of interpersonal communications. As such, a written note by you to a client, thanking them for the assignment, will almost without exception be well received and regarded as a thoughtful reminder of your work and you.

Here's an example of a thank-you letter:

Dear Client,

Thank you for choosing me as your photographer for the portrait assignment. I was excited to receive your request initially, and feel that the finished work illustrates that.

If you have any other needs regarding this assignment (such as additional retouching or a change in the image selected), please don't hesitate to call or e-mail. It is you, my client, who I want to ensure is completely satisfied with the work done, as each assignment is undertaken with the intent to produce work that meets *and exceeds* your expectations. Your assignment and kind referrals are examples of the trust you put in me and my work, and I look to honor you as a valued client whose repeat business is greatly appreciated. Should you have any questions about this or future assignments, please don't hesitate to call!

Sincerely,

John Harrington

In Robert Solomon's *The Art of Client Service*, he makes this important point. "It's amazing how much power those two words have. A simple thank you...to clients for their business should be a given. Yet it often is not. People assume that others know they are grateful.... Go out of your way to say thanks, for the smallest favor, for the biggest help, and for anything in between." In today's busy world, when do you find the time? The same way you find the time to surf the Web

or shoot the breeze on an assignment. I recommend you make the time and make a difference in a client's day when they get the note and think well of you.

Recommended Reading

Griffin, Jack. How to Say It at Work: Putting Yourself Across with Power Words, Phrases, Body Language, and Communication Secrets (Prentice Hall, 1988)

Kirschman, DeaAnne. *Getting Down to Business: Successful Writing at Work* (LearningExpress, 2002)

Kramon, James M. You Don't Need a Lawyer (Workman Publishing Company, 2002)

Smith, Lisa A. *Business E-Mail: How to Make It Professional and Effective* (Writing & Editing, 2002)

Sterne, Jim and Anthony Priore. *Email Marketing: Using Email to Reach Your Target Audience and Build Customer Relationships* (Wiley, 2000)

Strunk, William Jr. and E. B. White. The Elements of Style (Longman; Fourth edition, 2000)

CHAPTER 19

Chapter 19 Attorneys: When You Need Them, They're Your Best Friend (or at Least Your Advocate)

The best time to engage an attorney is prior to actually needing one. Whether it's for contract language review, queries about how to register a copyright, the legality of running a business from your home, or myriad other reasons, taking the time to learn what an attorney can do for you prior to actually needing one can save you time, money, and a lot of headaches.

Consider this: A respected and well-off businessman in the community receives a message from his lawyer, quite insistent on a meeting at the businessman's earliest convenience. Having been in meetings and unreachable all day, this message has floated to the top of his message stack. Upon turning up at his lawyer's office, he makes his way directly to see his attorney.

"I have really bad news and terrible news. Which do you want to hear first?" posits the lawyer.

"Usually, I look to the good news to cushion the bad, but if those are my options, I'll take the bad first."

The lawyer responds, "Your wife has found a photograph worth at least a million dollars."

The businessman is puzzled and bemused. "Bad news? How's that bad news? What on earth could the terrible news be?"

The lawyer states, "The photograph—it's of you and your secretary."

Everyone has a good lawyer joke—this one was inspired by a similar joke, the author of which is unknown. People love to poke fun at lawyers until they need them. Then an attorney is the only thing that will keep you from jail, a bankrupting judgment, and theft of your intellectual property, to name just a few things. Although this chapter won't deal with how you might resolve criminal proceedings brought against you, nor civil proceedings resulting from your car crash or your dog that bit the neighbor, it should shed some insight into how a good attorney (or an attorney who specializes) will be one of the better investments you can make.

NOTE

Disclaimer: My attorney advised me to tell you, dear reader, that I am not an attorney, nor have I played one on TV, and as such, the counsel in this chapter, the chapters on copyright, and in fact this entire book is to be construed as general advice. Should you need legal advice on any matter, you should consult with a qualified attorney licensed to practice in your jurisdiction and preferably in the jurisdiction(s) in which you may be forced to bring your suit, should the defendant be successful in forcing a change of venue for whatever reason.

Whew.

What Attorneys Can Do for You

Attorneys abound in every town, from the southern tip of the Florida Keys (albeit probably semiretired attorneys) to the oil fields on the North Slope of Alaska, and probably wherever two roads intersect between those two points. Some are generalists, dealing with all sorts of law, but a photographer in business will usually need an attorney familiar with (or preferably specializing in) contract law, intellectual property, and copyright. Usually one attorney or a firm can handle all of these, provided they also don't do divorce, family law, or personal injury. Those attorneys usually don't handle the types of cases that a business will likely need.

Contract Review and Negotiations

NOTE

Almost all professional organizations make available to their members boilerplate contracts that are exponentially better than what almost any photographer could produce staring at a blank word processing document. Yet, these boilerplate contracts are just starting points.

For example, many states have a requirement that a "liquidated damages" clause will be deemed invalid unless specifically agreed to in advance and/or initialed by the assigning (hiring) party. Other clauses in a contract may be inconsistent with state law and, as such, could create holes in the terms under which you and the client undertook and commissioned the work. You may provide to your attorney the boilerplate agreements and ask him or her to affirm that they are consistent with state laws and to make revisions where it is in your best interests to do so. This might also serve to reduce your costs for the review because they are editing a document, rather than crafting one from scratch.

You might be most familiar with "liquidated damages" in reference to your credit card bill or mortgage, in the form of a late fee. In other words, the "liquidation" is the contractually agreed-to amount of damages that shall be paid, regardless of what the actual damages are. So, for example, if you and a bride agree to a liquidated damages amount not to exceed what you were paid to provide wedding

continued

photography, she cannot come back and sue you for the costs to recreate her wedding (from renting the venue, to tuxes, to flying guests back in, and so on) when you fail to deliver the photography services you were contracted to. But be careful—unless the groom also signed the contract, he is a separate entity from the bride until such time as they are married, and even then may still be deemed legally separate based upon the date of the contract. This means he could sue you outside of the limitations of the wedding contract unless he signed it as well.

Further, you might find that, especially when negotiating with a client who wishes to engage your services under a retainer, having an attorney draft the agreement and negotiate legalese (leaving fees, expenses covered, and rights to you) may make for a better final document.

NOTE

Whereas you might be more familiar with retainers when you are paying them, they can just as easily apply to your services. For example, if there is a local theater that needs photography of all its performers and images of their dress rehearsals for promotion of the plays, a retainer whereby you agree to provide a certain number of days of photography in exchange for a monthly payment by the theater might be optimal for both you and the theater.

Lastly, where there is an infringement, it might be best for your attorney to be the one to write the letter or make the call to the soon-to-be-defendant's counsel to begin what, at that point, will be a serious dialogue. During that call, be sure that you've given your attorney some guidance about what you hope to get (a quick payment without further discovery of other unknown infringements, cease and desist, and so on), so that he can effectively convey the scope of the situation to his counterpart.

Writing and Revising Your Current Contracts

If your photographic specialty is unique or you've found significant objection by clients to certain terms of your contracts, an attorney can be your best resource for revising your contracts or writing them from scratch. Further, many existing trade organization contracts have been the basis for litigation in the past, and case law "holes" may have been found that could diminish the validity of certain terms. A lawyer you engage could write you new clauses (or a whole contract) based upon his own present-day knowledge of case law, so that your contract is as up to date as possible.

Advising You on Legal Matters

There are many legal matters beyond contracts and copyright on which your attorney can advise you or direct you to a colleague who is versed in those areas. From sales tax issues, to zoning for a business, to labor laws, to estate planning, numerous issues could have an adverse effect on you and your business, and could be avoided simply by engaging the services of an attorney for a few hundred dollars to get the right answers specific to you and your business. And, in the end, if you find yourself in court about that issue, your attorney will be the one you'll want to call on to defend the position in which his advice placed you.

Taking a Case

If you have a relationship with an attorney, he'll be more likely to take a case that, had you wandered in off the street, he would have turned down. In either case, the issue you have may be equally of concern to you, but without that preexisting relationship, the attorney will be less inclined to help.

Understand also that when you have the attorney you want, you are his client, and when there is a dispute between you and *your* client, if the attorney has a preexisting relationship with your client (or even a distant past relationship), he might find that it is a conflict of interest and turn down your case. Although the availability of intellectual property attorneys and contract lawyers may be high in major metropolitan areas, in smaller parts of the country, there may be just a few who are best-suited to accomplish what you need. In one instance, for example, I had a dispute in California and sought to engage an attorney in the municipality where the infringing party was incorporated. However, because the three firms in that city had, at one point or another, provided legal services for the eventual defendant in the case, none could take on my case. I had to hire an attorney nearly a hundred miles away.

What You Can Expect to Be Billed

One of the eye-openers when first hiring a lawyer is the variety of things you are billed for. Although it might come as a surprise; instead, it could give you an insight into how you might consider your own billing. One charge I began to apply to clients was the "pre-event conference call" or "site visit" for assignments that either did not really need one or for which I did not initially include a line item. These were inspired in part by bills for 15 minutes of conversation with my attorneys. I thought, "If they're doing a professional billing like this, it stands to reason that I can too, and, in fact, I should be doing the same." You'd be amazed at how many conference calls I no longer have to participate in and how much more active I was for the ones in which I did participate.

Retainer Fee

Here's how a retainer might look (in part):

LEGAL SERVICES RETAINER AGREEMENT

This Agreement is entered into by and between the {firm name} (hereinafter "Attorney") and {your name} (hereinafter "Client"). Client hereby retains the services of Attorney, its staff attorneys, paralegals, law clerks, and any other employees or independent contractors, at Attorney's discretion, at present, or in the future, to perform the following work:

Case Staffing

Attorney, at their sole discretion, has the exclusive right to take on additional attorneys to assist in the case. Client does hereby assign to all lawyers, paralegals, law clerks, and others who are now, or may be during the course of the case, the power to work on this case. Attorney shall not perform any work or service for or on behalf of client unless specifically outlined in this Agreement.

Control of Case

Client does hereby assign to Attorney all rights necessary for this case that Attorney deems worthwhile, including the filing of claims, suits, motions, or other legal papers. Where Attorney determines it is best to do so (as in, waivers, for example), Attorney will accede to client to make decisions.

No Guarantee of Results

At no time, has, or will ever, Attorney make any guarantees to Client as to the outcome or success of the case.

Billings

Attorney shall bill, and Client agrees to pay legal fees, as outlined below:

Client agrees to pay Attorney a minimum, non-refundable retainer fee of \$2,500. This retainer fee provides for time to be set aside by Attorney, on behalf of client, to take on this case. This payment is for services to be rendered, and shall not be held in trust on behalf of Client, and in the event less than this fee be used in performance of Attorney's duties, no refunds of any remaining amounts shall be made.

All work done by Attorney shall be billed against the retainer, at an hourly rate of \$200 per hour. This is the billable rate whenever Attorney works on this case. This includes, but is not limited to research, interviews, preparation of legal documents or court appearances, depositions, phone calls, expert meetings, waiting time, and any other work performed for this case, at the sole discretion of the Attorney. Any work performed on this case which takes place after 6pm or before 8am during the work week, on federal holidays, or weekends, or otherwise on a "rush" basis, shall be billed at an hourly rate of \$350 per hour.

Where Attorney engages the services of a law clerk, legal aide, or paralegal, the following rates apply: For Law Clerks - \$125 per hour, for Legal Aides - \$90 per hour, and for Paralegals - \$140 per hour. The same basis for these applies-i.e., any time they work on the case with, or on behalf of, Client at Attorney's direction. Further, it is understood that any conversations between Client and these individuals is not legal advice.

Fees and Expenses beyond Retainer

Client has reviewed in full this Agreement, and understands that the final fees and expenses will almost certainly exceed the retainer paid under this Agreement.

continued

Non-Payment by Client

It is Attorney's policy that bills are payable as denoted on invoices, usually 30 days from date of invoice. Attorney is willing to make fair and reasonable arrangements for Client to establish a payment plan following the exhaustion of the retainer. In the event that Client fails to make timely payments of invoices presented, or make suitable arrangements for a payment plan, Attorney shall effect a Motion to Withdraw at the soonest possible time, and make efforts to collect payments for all billed fees and expenses, in addition to late fees, whether by collection service or lawsuit.

The retainer agreement would go on to make other recitations and further define what's being done for you, and what they will not do. Don't be put off by the document; they're usually pretty fair and are a cornerstone of all work done for you.

Phone Calls

Attorneys and those who work for them will be billing you for any phone calls "of substance." This means that if you call to set up a conference call or ask that the attorney call you back, or if you call to discuss with the attorney when you will be coming in to sign documents, you won't be billed. But if you call and ask a question about a case or you call asking for the definition of, say, "published" versus "unpublished" for purposes of submitting an accurate copyright registration, you can expect to be billed, usually in 15-minute increments, for their time. So, unless you're in a hurry, save up two or three questions to ask all at once. However, you should be watching the clock, or you might find yourself learning a lot during the conversation, but spending more time (and money) on the phone than you'd expected.

Copy/Fax and Other Miscellaneous Charges

You can expect to be billed for numerous seemingly insignificant expenses that are, when combined over the course of the month, actually significant. The attorney's receipt and cursory review of a fax from you will likely incur an expense. If the attorney has to make photocopies for you or your case, they'll probably cost around \$0.20 per page. That might seem insignificant at first blush, but consider that over a month, those items could become several hundred dollars as a line item expense.

Many attorneys have a "case establishment fee," which means that when the attorney takes a case for you, there is an initial \$75 to \$250 (or much higher) fee for the attorney to get you set up in his system for accounting, filing cabinet space, and such. Just as you should take the approach that whenever you are working on behalf of your client for an assignment, it should be billable (or at least accounted for when preparing your quote), your attorney will follow the same principles.

When you establish a relationship with an attorney and use him with some degree of consistency, some of these fees may be waived (as in the case establishment fee, and so on). Further, there will be less time spent by the attorney familiarizing himself with you and your work if he has worked with you consistently, so savings can occur in that instance as well.

Ask Your Attorney Whether It's Economically Sound to File Suit

Sometimes one of the more difficult things to do is to *not* file a case. You've been wronged, you know it, and the potential defendant knows he or she was in the wrong, but is it worth it? Maybe it's a missing or illegible signature on contract language in dispute, maybe you didn't register your copyright, maybe you did but the use will be argued as the amoebic "fair use," or maybe your life at that point is personally too troubled to withstand the demands of your time and mental energy required to take the case. Or, perhaps you have the best case in the world, but you don't have the resources to see the case through to the end or to a likely point where a settlement offer may be made.

Cases are decided all the time based upon economics. The suit I filed, as discussed in Chapter 16, was almost certainly settled (to my benefit) for these reasons. The attorney could not have been clearer about his client's willingness to settle being in part based upon whether I agreed to their settlement offer prior to the weekend because the attorney would have to incur a significant amount of billable time, and these monies could instead be applied by the company to the settlement figure. Because, as I outlined, I was in small claims court and not paying an attorney, and their offer was certainly fair, I accepted. This company made their decision on the economics of the suit, not on whether they were right.

When these or myriad other potential circumstances apply, asking your attorney about the case's viability and likely outcome might net you the best counsel they can provide. Although there are a few attorneys who will salivate over taking on your case, almost all will give you objective advice, especially if you have all your ducks in a row. If the attorney doesn't take your case, it's likely he has other cases, so he's not looking at you as his next meal ticket. (Beware those attorneys who are!)

Why Attorneys Are Reluctant to Take Cases on Contingency (and When They Will)

This brings me to taking your case on a contingency—that is, for a piece of the pie. Most personal injury lawyers take cases on contingency, and this is usually because whomever they will be representing will be suing a person with assets or an insurance company, and the likelihood of a settlement is extremely high because the "economics of a trial" (as noted previously) are much higher than the formula for calculating a settlement.

Other reasons for taking a case on contingency are notoriety (in other words, how much free publicity the attorney will get by representing you) or service to the downtrodden (that is, you were the aggrieved party from some big corporate conglomerate and you can't even begin to defend yourself, or you've had your civil rights violated or something along those lines). Sometimes, attorneys will take a case on contingency out of the goodness of their heart. Ultimately, the attorney (or his or her firm) will be the sole arbiter of the choice to take you on contingency. For copyright, a usual "contingency deal breaker" is the lack of registration, and for contract law it might be the absence of evidence of a "meeting of the minds" (whether a signature, correspondence indicating agreement, and so on).

CHAPTER 19

NOTE

"A meeting of the minds (also referred to as mutual assent or consensus ad idem) is a phrase in contract law used to describe the intentions of the parties forming the contract. In particular it refers to the situation where there is a common understanding in the formation of the contract. This condition is often considered a necessary requirement to the formation of a contract.... It is only when all parties involved are aware of the formation of a *legal obligation* is there a meeting of the minds." This was the definition from Wikipedia as of late 2006, and while that body of text may change, this definition is exceptionally well stated in this incarnation, so it warrants citing here.

Even in cases taken on contingency, you, the plaintiff, will usually have to cover court costs the costs of discovery and depositions. Except in rare circumstances in which the law firm bankrolls every expense (as in many personal injury cases, in which the plaintiff is practically indigent), these costs are significant. The "contingency" part almost always only covers the law firm's billable time for attorneys, legal researchers and assistants, and other staff time.

When you ask an attorney to take a case on contingency, you are asking him or her to take a gamble on you and your case. Attorneys are, by their very nature, mostly adverse to risk, so you'll need to make a compelling case or find that needle in the haystack who has a soft spot for the wronged photographer.

When You Pay for Advice, Heed It

There is an old adage that advice is worth what you pay for it; this is usually attributed to those who offer unsolicited advice on life's trials and tribulations. Although this adage is questionable, the converse is certainly true. When you're paying an attorney to make objective determinations and the resulting counsel, heed that counsel, or at the very least consider it when making your own tactical and strategic decisions. Either way, you will be billed for that advice, so make it worthwhile.

Oh, and one last point. It is a sad fact that photographers have one of the highest divorce rates in the world. Respected photographer and fellow espouser of good business practices, Rick Rickman, now a professor at Brooks Institute of Photography, penned an article in 2002 on photographers and divorce rates. Rickman, in a conversation with David Burnett, co-founder of Contact Press Images and an icon in the photographic community, reported that "he [Burnett] sometimes felt as though his career had been slowed by the fact that he devoted time to his family, but that he wouldn't change his life in any way." I will touch more on Rick's and David's sentiments in Chapter 25, "Striking a Balance between Photography and Family," but know that you might also find yourself in the position where a divorce attorney is needed if you don't pay attention to the more important aspects of your life—family. I do hope that this is never the case, but if it is, at least it's not in the same league as our lout from the beginning of the chapter.

Part IV Storage and Archiving

Chapter 20 Office and On-Location Systems: Redundancy and Security Beget Peace of Mind

The simple fact is you have office systems and camera systems. If you are absolutely certain that at no time will any of those systems fail, nor be hacked, then you can consider skipping this chapter. You can also go to Las Vegas and put your entire fortune on red or consider living life without health insurance or savings for a rainy day. Skip this chapter at your own peril.

In May 2006, the Small Business Administration reported that "a University of Texas study reports that 43 percent of companies experiencing a catastrophic data loss never recover, and half of them go out of business within two years. So businesses, and for that matter anyone who owns a home computer, should back up financial records and other vital information stored on hard drives." Although this message was intended for those preparing for natural disasters, the statistics, without equivocation, apply to our everyday business activities. So, in the event that you have a catastrophic data loss, a 43% chance of your business shuttering is statistically close to betting the farm on red.

Redundancy: What Is It?

Redundancy, when referring to data, office, or photo equipment, is a state in which you have duplicative systems and storage so that should one fail, the other may be drawn upon to restore or recreate valuable data. If you're speaking of duplicate cameras, you can complete the assignment with the second camera if need be. There are numerous systems to employ, some of which you may be doing already. It might be simple things, such as making copies of an important receipt or installation serial number for Photoshop, or creating a CD with all your best portfolio images. Maybe you even clicked Yes in the occasional pop-up window from your accounting software, prompting you to back up your financial data. I hope.

Communications Networks

In my office, every day we transmit images directly to clients, to our own FTP servers where clients can retrieve them, and to online galleries for client review prior to the delivery of final images. All of this is in addition to the lifeline that is the sending and receiving of e-mail. Of

late, we have also switched to Voice Over IP (a.k.a. VOIP) telephone service. I have contracted with the fastest cable modem provider available to me. Yet, should that service go down—for weather reasons, a service provider outage, or a tree falling on the cable line—I will be dead in the water. With a single cable modem line costing \$60 to \$90 a month, that equates to about \$2 to \$3 a day. If my service were to go down for even two days, the costs to my business would far and away exceed the cost for several months of service.

As a result, because my location offers at least two Internet service providers, I have contracted with both to provide Internet access. This gives me peace of mind, knowing that I will be able to continue to function should one of my providers fail. As a last resort, the cellular modem I have can be configured to provide a third level of service. And, as a redundancy for the laptop, I have a no-monthly-fee (pay-per-use) WiFi service provider, so I can find a wireless access point when traveling and take care of e-mail and file transfers where necessary.

Firewalls and System Security

Firewalls are hardware and/or software whose purpose is to prevent unwanted access into your internal office/studio network from the outside. The term *firewall* came from safety walls in construction, but you might be more familiar with it in relation to your car, where the firewall is the wall between the engine compartment and the passenger compartment designed to minimize (or hopefully prevent) a fire from the car's engine from making its way to the passengers.

It is a fact that every second of every day, hackers are scouring the Internet looking for "zombie computers." These are computers that are hacked not because the hacker thinks you have any valuable information on it (although if you do, they'll exploit that too), but because they can take control of your computer, allowing them to launch attacks that look like they are coming from your computer. A *PC World* article by senior writer Tom Spring reports that between 50% and 80% of all spam polluting the Internet is generated by these computers. Law enforcement traces will turn up you, not the hacker, and it is your bandwidth that is being used to send all the e-mail, not theirs. One of the significant benefits of using a Macintosh computer is that there are few known viruses attacking and thus taking control of this operating system. PC users beware, though.

Nowadays, almost every router from the more reputable manufacturers has some degree of a software firewall, and can be configured easily. If you're looking for sophisticated hardware firewalls, I encourage you to contact a local network engineer; the demands of setting such a firewall up are not insignificant, but the end result is valuable.

<u>Consider the critical importance of securing your network from the outside.</u> Take the time to protect yourself now, so that you are not stuck with authorities knocking on your door or your financial data being compromised.

Port Forwarding: Port What?

Before I go into what port forwarding is, you need to know what a port is. You might wonder how you can surf the Web, send an e-mail, and FTP down a file from a remote computer all at the same time, without the data from each conflicting with the data from the other. Your use of the Internet travels via a port. An http request typed into your browser travels on port 80, for example, and an ftp request travels on port 21. Gaming software uses other ports. E-mail typically travels over port 25; however, some Internet service providers, in an attempt to get you to use only their e-mail service, will block that port, and a savvy secondary ISP—usually the one with which you have your Web site hosting—will offer a secondary port number. This is the case with my ISP.

Ports can also work to route traffic to where you want it. For example, suppose your cable modem/DSL provider provides you with a static IP address of 128.176.0.12. As you might be aware, every Web site name is actually a representation of an IP address, and every time you type in Google.com, for example, your Web browser goes to an Internet "address book," retrieves the IP address for that name, and returns it. Then, your browser requests of your ISP that you be connected to that IP address anywhere in the world. All of this happens in a split second. The IP address just mentioned is one of Google's IP addresses. If you were outside of your office and wanted to connect to your home computer, all you would need is the IP address your ISP provided you with and one additional configuration—port forwarding.

NOTE

An IP address is the address that you are assigned by your Internet service provider. For example, using the White House, presume that every street in Washington DC has a numerical representation—1st Street is 01 and, say, Pennsylvania Ave is 132. And, with 50 states in the US, say the District of Columbia is 51, and the zip code for the White House is 20500. That would mean that 1600 Pennsylvania Ave, Washington DC, 20500 would translate into an IP address of 1600.132.51.20500. Now, this is a concept only, since IP addresses are between 0 and 255, but you understand the concept. A generic IP address is something like 192.168.102.1. For your computer to make a request for a Web site, the Web site has to know where to send it. The IP address your ISP assigns you, whether static (that is, unchanging) or dynamic (meaning it can change every time you log onto the Internet), is how that information is delivered to you.

In your network router—the box that connects your computer to your cable or DSL modem you can configure various ports to do various things. Typically, all ports are closed from external access into your home or office network. You must turn them on, and then configure them to do what you want. There are two sets of IP addresses—internal (or *intranet*) addresses and external Internet addresses. Although the international governing body of the Internet assigns blocks of IP addresses to every ISP on the planet and you cannot choose or set your external/Internet address, you are that governing body for your internal/intranet IP assigning. The most common IP ranges are the 192.168.xxx.xxx and 10.0.xxx.xxx. For the sake of clarity, I will use the 10.0.xxx.xxx range for this example.

Suppose you have a cable modem router—this is where the IP addresses are determined. You may choose 10.0.1.1 for the cable modem. The first computer on your network will then likely be 10.0.1.2, the second computer will likely be 10.0.1.3, and so on. Once you know these

numbers, you can go into the port forwarding section on your router and assign all requests for Web sites (http or port 80) to be forwarded to the second computer on your network—10.0.1.3. Thus, all views of your Web site are delivered to the World Wide Web directly from your computer in your office.

Although I would caution you against doing this for bandwidth and other reasons, there is a reason to use port forwarding: You can allow clients to securely access a folder on your computer where they can FTP images directly to themselves from you. This means that you do not need to e-mail image(s) to them or upload them to your own offsite FTP servers. You need only e-mail them the link: ftp://192.168.102.1/clientfile.zip. When that request is made, it reaches your router, and your router, seeing the "ftp," looks up the port forwarding number for port 21 (the FTP port) and finds the address of 10.0.1.3. It then sends that request directly to the computer in your office, which will then verify that "clientfile.zip" is in that folder and begin to deliver it to the client. This does, however, potentially create a whole host of security concerns. For security, you should have hard-to-remember passwords and such on your computers, and you should change them regularly.

There is one other benefit of knowing what and how port forwarding works. Using applications such as Timbuktu on the PC or Apple Remote Desktop on your Mac, you can access your computer at home from anywhere you have Internet access (at a decent speed). All you need to do is configure port 407 on your router for Timbuktu, or for Apple Remote Desktop, 3283, 5900, and 5988. Both applications allow you to modify the port number(s), and there are other applications besides these two that can provide this functionality for you. The beauty of this is that you can access all your data at home, send e-mail from your home computer, and even help an assistant figure out a problem working on your computer in your office if you're at a remote location. The benefits of this functionality should not be underestimated. If you have ever been out of the office and realized you left a document, file, or image on the computer at home, this is a lifesaver.

Back Up, Back Up, Back Up!

A study by the Gartner Group reveals that 60% of backups are incomplete, 50% of restores fail, and only 25% of backups are stored off site. The study further indicates that 64% of small and mid-sized businesses maintain their backups on site. This is a catastrophe waiting to happen. It is imperative that you establish and implement a routine backup solution, preferably for all your systems, but at least for your critical data.

Here are some sobering statistics from their report:

- Eighty percent of all business data resides on computers.
- Thirty-two percent of all data loss is the result of user error.
- Ten percent of all laptops are stolen each year.
- Fifteen percent of all laptops suffer a hardware failure each year.

For my mission-critical data (other than digital images), I utilize my .Mac service. Each night, my computer connects to .Mac and uploads the last accounting software file, my address book, my calendar of assignments, my e-mail accounts and settings, and a few other pieces of data that I

cannot live without. For PCs, there are off-site solutions with which you can accomplish a similar level of protection. Although I am not familiar with the brands, I can tell you that for around \$100 a year, it's one of the better investments you can make in your backup plan. Additionally, I carry a thumb drive that can hold 2 GB of data for a very reasonable price. I can carry with me all my financial data (encrypted with password protection in case I lose the thumb drive), my address book, disk images of my critical applications (such as Photoshop and others), plus my serial numbers in the event that I have to reinstall my software in some remote location.

Backing Up Your Desktop

Setting aside for the moment the loss of data, there is another very important reason to ensure that your desktop computer is entirely backed up—the cost of restoration. No doubt you have spent a great deal of time personalizing your computer, from the mundane (such as bookmarks in your Web browser), to installed programs, to the settings of those programs. If you've ever had to erase a computer and start all over from scratch, it usually takes at least a day, and then you spend a great deal of time reinstalling small applications or Photoshop plug-ins to do what you normally do. There are numerous solutions for backing up your desktop computer, and the benefit is that if your hard drive or other equipment fails, all you need to do is make the necessary replacement, and then use the Restore Backup feature of the software, and your computer will be just like it was the last time you backed up. A truly safe computer user will have two backups, one that it does weekly and one that it does nightly. Although I think hourly backups are overkill, there are some who find them comforting.

The important thing is to establish a backup solution, and then be vigilant about maintaining it.

Backing Up Your Laptop

With the figures mentioned earlier in this chapter, you have a one in ten chance of having your laptop stolen and a one in eight chance of it crashing. With odds like those, how soon do you think it will happen to you (or happen again)? And, do you think you'll likely be on the road, without access to your home computer for a period of time when this happens? My solution, as with my desktop, is to maintain a vigilant backup plan for my laptop as well. The one difference is that I always take my nightly backup on the road with me—it is a 100-GB pocket disk drive that takes up little space. Further, should my machine fail, with my Mac I can find any currentmodel Apple and reboot, holding down the Option key, and choose my backup pocket drive as the boot volume. Then, I'm up and running on my system, with my data, on someone else's hardware. Even the desktops at an Apple store will do. (You will probably incite a bit of consternation from the employees, but it should be only for a few minutes or while you are waiting for them to ring up your replacement laptop!) Plus, when you boot the laptop-again a benefit of Macs—you can, within just an hour or two, transfer all the settings from the drive to your new machine. PCs have comparable software from companies such as Symantec and others that will provide a similar level of backup and restore capability. This would mean that you could be back up and running when you wake up the next morning after your restore was completed, if not between lunch and dinner.

NOTE

As a kind of "the gods are watching" aside, at 2:00 this morning I found myself needing to get up from my laptop to attend to my daughter, who was having a bad dream. As I moved away from my laptop, my foot caught the power cord, and the laptop went crashing to the floor. Fortunately, it was a carpeted floor and no damage was done; however, it was an eerily coincidental occurrence while writing this chapter.

Backing Up Your Work in Progress

In addition to keeping two backups of every digital file I create (as I will outline in a moment) one that I keep on site and one that I keep off site—I also keep a backup of my working drive. I have one computer in the office that I dedicate to doing post-production. That computer has two internal drives, one of which contains the operating system and all the applications. The second one is what I refer to as the "working drive." Keeping a single physical drive dedicated to your data benefits you in two ways. One, you're not causing severe fragmentation of your drive as you save, open, close, save, delete, and then save other files, nor are you taking up scratch disk space from applications such as Photoshop. Second, in the event that your machine *does* fail, you can simply remove the "working drive" hard drive, put it into a secondary machine, and continue working. That drive is backed up to an external drive every night, so that should it fail, not only will I have a backup of the work, but I'll also have a backup of all the work that I've done to the file since I ingested it into the computer.

THE 12 STEPS OF PHOTO ARCHIVERS ANONYMOUS

- 1. Admit that you have a problem and are not backing up images.
- 2. Understand that you do not know how to best resolve your problem.
- 3. Agree to establish a system that works specifically for your workflow.
- 4. Review the size and scope of your current archive, and know what you're dealing with.
- 5. Contact/research friends/colleagues/services who might be able to help.
- 6. Choose whose system you'll use and acquire the equipment, then schedule a time to begin the problem solving and archiving.
- 7. Document your workflow so if you forget, you can refer back to your own diagram and thoughts.
- 8. Get your drives up and running, and test them (nightly backups and so on) before beginning the full organization.
- 9. Start with your new system from the first day of a month forward, and begin the move to your new system, verifying each copy to ensure they're properly copying. (An application such as zsCompare will do this just fine.)
- 10. Locate and integrate stray image folders into your image archiving system, updating and fine tuning your own workflow documentation as you use it to be more clear and concise.

continued

- 11. Review and research ways to tweak your system to improve it based on your own specific needs as you better learn how it works.
- 12. Spread the gospel of proper image archiving and pay forward your knowledge, because it is only through the teaching of a system that you begin to truly understand how it works and how you can continue to improve on its functionality and clarity. Continue to practice the gospel of proper image archiving.

I put together a set of PDFs from the variety of talks I've done. It illustrates graphically my entire workflow, from ingestion to final archiving.

You can access this set of PDFs at ftp://best-business-practices.com/harrington_archive_system.zip.

Further, as images are ingested into my working drive, they are simultaneously being ingested into a second location—a drive I have labeled "redundancy drive." That drive's purpose is solely to be available should the working drive fail before the images make it to the image archive drives outlined in a moment or are archived that night. The working drive contains newly ingested files and those that have not been worked on, works in progress (such as a conversion from CR2 to DNG, full-rez JPEGs, deliverable files, and so on), images that *have* been delivered to the client but not stored on the Image Archive 00x drive, and lastly, my most recent assignments, which have been stored on the Image Archive 00x drive. This way, when I switch to a new pair of drives at the end of a second month, I still have the last 10 to 20 assignments available "live" on my working drive. The nightly archive of the working drive is intended to ensure the security and integrity of my post-production work, not to ensure against the potential loss of the images altogether. (Although it *does* ensure against a loss of the images, that's not its original intent.) The redundancy drive *does* ensure against the potential loss of the images altogether should the working drive fail and the cards have been wiped/shot over.

One solution would be to use something called Network Attached Storage (NAS), which would reside on your network, usually within your intranet. NAS is simply a hard drive that is accessible over a CAT5 (or CAT6) Ethernet cable. If you want to use NAS, make sure that it supports 1000mb/sec (a.k.a. gigabit Ethernet) and, most importantly, your computer's network adapter is also capable of handling that speed.

Further, with correct configuration or the use of dedicated in-office servers, these images could be available from a remote location as well. Keep in mind that you'll be quite limited, to about 350kb/sec access, because that is probably your up speed on DSL/cable modems, and the up speed will be your limiting factor.

Dual Backups of Image Archives, On Site and Off

Every job/assignment folder has an exact copy residing on a duplicate hard drive that is stored off site. In the event of a disaster rendering my office inaccessible or destroyed, my images will be safe. We only access those drives for three reasons:

- 1. When the on-site drive fails and we need to restore it
- 2. Every few months to "spin up" the drives so that the drive bearings and lubrication do not degrade
- 3. When we migrate from that storage type (in other words, hard drives) to the next generation of storage type (as yet, unknown)

Due to the current use of drive space, we are consuming one set of 250-GB drives per month, or half a terabyte of storage.

Dual Cameras on Assignment

With all this talk of office equipment, it's easy to forget about the redundancies that should be employed when you are on assignment. Just as you should take extra batteries and Flash cards, you should also have a secondary flash and camera on hand, in the event that your working camera fails. More than once, I have had a camera fail mid-assignment. It's easy to simply put that one down and pick up the backup camera to continue the assignment.

Other times a flash will break off. It might be just the hot shoe on the flash, but on one occasion, the hot shoe remained in the flash attachment, and the entire top of the camera broke off. In the former circumstance, you'll want to make sure you can continue the assignment with the secondary flash.

If you are traveling to a distant location, it might be of value to bring some secondary lenses as well. Planning for the worst will give you peace of mind, especially when you drop your prime lens off the starboard side of the boat you are working from or down a ravine during a hike to the location you selected at the top of the mountain.

Excess Lighting Equipment: Don't Take Three Heads on a Shoot That Requires Three Heads

A fairly standard lighting setup for a headshot is a main light at about 45 degrees off axis to the left, a reflector on the right to fill in the right side of the subject, a hair light opposite the main light behind the subject, and a light on the seamless backdrop. That's three lights. Ask yourself, which one can you do without? I suppose the hair light, but then you lose much of the separation and dimension of the image. Now, this isn't a complicated lighting setup, and perhaps you could do without one head, but there are a number of shoots where that's just not the case.

When you arrive at the shoot, perhaps a clumsy assistant will drop the light case. Perhaps it's just the time in that flash tube's life to go to light-bulb heaven. Perhaps the light stand will be knocked over by the client and the head will go crashing to the floor. Or, perhaps the power pack will receive a surge of electricity from the wall outlet. For lighting kits in which a pack feeds multiple heads, you'd be best served to have more than one pack, if for no other reason than that stretching the cords to their maximum lengths to get the lights where you want them can often be difficult and risky. But should a pack go down, you won't be dead in the water. For

lighting kits in which each head is its own self-contained pack and head (sometimes referred to as a "monobloc"), you'll want at least one additional backup head should a head fail.

Taking these precautions will mean you are minimizing the likelihood that your shoot will be scrubbed because of lighting equipment failure.

It Only Takes One Flight: Carry On Your Cameras

I am often amazed at the lack of thinking that goes on in the minds of the flying public. There was a recent reality television show that documented the behind-the-scenes trials and tribulations of an airline as they dealt with difficult passengers, delayed flights, and lost luggage. Time and time again, passengers depicted on the show reported that they had packed their medication in the luggage that was checked and now missing, routed to a distant location, or that didn't make it onto the plane. And this wasn't medication for a headache; it was medication for heart ailments, allergies, and other life-threatening ailments. Medicines like this are so small that they can easily fit in a purse, pocket, or even the smallest carry-on bag. You are often told not to pack jewelry, cash, or other valuables that could be missing upon your arrival at your destination—this includes cameras.

And don't pack your cameras in bags that scream, "I am a camera bag; steal me!" Some current models of camera bags are nondescript. Some look like generic satchels, some like school backpacks, and some like your basic carry-on bag, which brings me to my point. It used to be that when I would travel with cameras and film, the cameras and lenses were the absolute "must have," and the hundred-plus rolls of film could be replaced if necessary. However, on my return flight, I would never let the exposed film leave my sight or proximity. You are allotted one carry-on and one personal item—a purse or laptop case. Thanks to the hard work of American Society of Media Photographers, the Transportation Security Administration now allows you to have a second piece of carry-on luggage, provided it contains photographic equipment. However, the baggage must still conform to size and weight restrictions, and there are times when the overhead bins may be full. But you should carry on the things you can't live without—medication, your laptop, money, client contact and trip information, and your cameras and lenses.

If you have a significant amount of equipment, carry on the primary body and lenses. If the flight attendants tell you that the overhead bins are full, on most airlines you can carry on a camera that is not considered your allotted personal item or carry-on bag. Although this rule is meant more for a point-and-shoot or small SLR, a professional-grade body with a 300mm lens attached to it falls into that category. So carry that on the plane on your shoulder, and put several of your lenses into pants and jacket pockets if you have to. Somehow, you should get the most critical pieces of equipment on board and fit them under the seat in front of you. Aside from theft, there are baggage loaders who seem to have a constant disregard for luggage marked "fragile"; it'll get tossed around just like all the other bags.

One final solution is to ask that your bag be "gate checked." This is what happens to strollers and children's car seats. At the bottom of the jetway, an attendant takes your bag and gives you a claim check. When you get off the plane—even if you're in a connecting city—you wait in the same place after you deplane, and a baggage handler will bring your bag up when he or she brings strollers and other "gate-checked" items, thus minimizing the risk to the bag. Although attendants accept gate checks without a moment's thought for strollers, it might take a courteous request or two before they take your camera bag. Make sure when they do take your camera bag that it will come back up to the arrival city jetway, rather than being sent to baggage claim.

With the changes that continue to evolve regarding airport security, make certain that whatever carry-on bag you have can survive as checked baggage. You may find that during heightened states of security, you might not be allowed to carry on any baggage, and this may happen mid-trip or be different when you depart a domestic city en route to an international city, where carry-on luggage is allowed upon your arrival, but disallowed in that same international city upon your return home. Lowe Pro and Think Tank are among the manufacturers that have excellent solutions for protected carry-on baggage that meets airline standards and is able to be checked and survive.

Software Validators and Backup Solutions

For many computers, when you select a number of files or a folder containing a number of files and drag-and-drop your selection onto a destination, you usually cannot discern exactly which file caused an error. In fact, you also cannot know that all the images were copied perfectly. I trust the zsCompare application to verify the integrity of copied data, and also to perform the manual mirroring of my dual archive drives—Image Archive 00x and Image Archive 00x Backup. The software can test for numerous exacting details—data forks, total bytes, checksums, and so on. This application is a Mac and PC program, and a 30-day trial is available. From their Web site:

zsCompare runs on Mac OS X (10.3 and later) and all modern versions of Windows including Windows XP/2000/NT/ME/98/95/Server 2000 and Server 2003. For best results, we suggest using Windows XP, Mac OS X, or Windows 2000.

Their Web site is http://www.zizasoft.com/products/zsCompare.

I am almost certain that the functionality of this application is available in other applications, but for less than \$50, it has become an application that is used almost daily in my office, and it gives me peace of mind that I have two true and accurate copies of each image.

The Aftermath: How Do You (Attempt to) Recover from a Disaster?

There are solutions for the physically-failed hard drive—two of the most notable are DriverSavers and Ontrack. The cost is somewhere between \$900 and \$3,500 depending upon the work involved. In addition, the crash might be a corrupted directory, and there are applications and companies, such as Data Rescue II, Disk Warrior, Tech Tools Pro, and Symantec, that offer solutions as well.

Know, though, that you will spend a significant amount of time restoring your files, software, images, and such. It can easily take a week to get one computer back to where it was before a

crash. Having a secondary computer in your office for this purpose, as well as having this same computer to turn to when your primary machine is running a processor-intensive task, such as converting images from RAW to DNG, will minimize the effects of a computer crash and, as a fringe benefit, make you more efficient.

Do not underestimate the potential risk to your business from natural disasters or a terrorist incident. Have a plan of action not only to evacuate yourself, your pets, and your family, but also to reestablish your business—whether temporarily or permanently—in a new location. The annual arrival of hurricane season (and tornado season for those in the Midwest), and the ongoing earthquake "season" I grew up with in California means few areas of the country are immune from a natural disaster. Moreover, just as the priceless negatives of Jacques Lowe, President Kennedy's personal photographer, were destroyed in the vault of JP Morgan underneath the World Trade Center, numerous photographers lost their entire photographic collections following Hurricane Katrina, as well as others before her.

Other solutions outlined previously in this chapter—off-site data storage of invoice records and redundancy of image archives—will be your saving grace when a crash happens. Note that I said *when*, not *if*. With statistics such as those outlined in the beginning of the chapter, you won't be able to dodge a bullet or a lightning striking forever.

Chapter 21 Digital and Analog Asset Management: Leveraging Your Images to Their Maximum Potential

During the days of film, there were a few ways the images we produce generated assets. We would deliver them to a photo agency, such as mine—Black Star—or all assignments would be in response to an assignment request, delivered to the client, and then returned to us and filed away. There was little to be done save for promoting your library of images to magazines, who would then call and request that you overnight the images to them, and then return them to the agent again.

With digital files, there's no physical representation of the images unless you open and view the images, and the files compound every day, with every assignment. Moreover, multiple versions of the same file emerge, causing more confusion.

By aggregating your image assets, and then employing solutions to make them viewable to a photo buyer, you can exploit their value and earn more from each assignment—an idea that is the cornerstone of copyright.

Throughout this book, I have placed the recommended reading section at the end of most chapters. This is in no way meant to diminish the critical value of doing the homework, but, in continuation of the school concept, this is "in class" homework. In this instance, there is a book that is a milestone in the development of a workflow to handle your image assets.

Recommended Reading: The DAM Book

Peter Krogh has written an exceptional book on the subject of digital asset management, *The DAM Book: Digital Asset Management for Photographers—DAM* for short. In it, Peter sets forth a solution—relying on Adobe's Bridge and, at the time, iView Multimedia's iView MediaPro. This application is now a Microsoft product, and is expected to become a PC application as well.

Krogh outlines the critical value of metadata, including proper captioning, ownership information, and the ultimate in metadata value—the keyword. The more thoughtful you are

about including in the keywords not just the who, what, when, where, and why, but also conceptual ideas, the higher your return on the images will be.

For example, consider an image of a young man and his father out fishing. The caption might read, "Father and son go fishing." But keywords for that same image could be "parenting," "quality time," "bonding," "lake," "fatherhood," and on and on. These are the search terms that photo buyers start with—common sense thoughts—and then they will progress from there should their search results not yield images that meet their needs.

Krogh goes on to discuss hardware systems to properly accomplish the workflow goals set forth—everything from drive sizes, types, and quantities (for redundancy), to the promotion of DVDs as archive solutions.

Solutions beyond *The DAM Book:* Adapting the Principles to a Variety of Workflows

When *The DAM Book* was written, Peter made a thoughtful and, in my opinion, thorough review of the software available and integrated those into the book's workflow solution. I already had several of his ideas in place, and I gained more than a few insights into how I could improve my workflow. I applied that knowledge to make my post-production operations more efficient.

Since the book's publication, several additional—and I dare not yet say better—applications have arrived, including Adobe's beta version of Lightroom and Apple's Aperture. Both products hold great promise, not only in the level of service they can offer, but also, in light of Microsoft's acquisition of iView, a solid field of competition among well-funded developers, all of whom recognize the importance of image asset management.

The message in Peter's book about the workflow for which he has put forth a blueprint can be modified and applied to these other applications, as well as for the use of other raw file browsing applications.

Much of Peter's book deals with the in-office, back-at-the-office, or in-studio scenarios. One of the challenges is in adapting those processes to work in the field. Often, the client is on hand, looking over your shoulder and demanding that you deliver finished files—or at least mid-point images—on the spot. Further, although most clients will be comfortable with whatever file-naming convention you've chosen, there have been times when clients have insisted that we use their file-naming conventions, which are significantly different than what we were using.

I have found myself in more than one instance in which a CEO has wanted to see the images on our on-site digital workstation 10 seconds after having his photo taken. One solution would have been to use our wireless transmitter to deliver the JPEGs to the workstation as I was shooting, but that wasn't set up beforehand. Instead, we mounted the card and, without proper ingestion, dragged the entire image folder onto our browsing software to let the subject see the take. The CEO wouldn't wait around for even five or six minutes for ingestion.

If we get some push back on whether the CEO likes the images, we find that it's often because of wrinkles, bags, or blemishes. We then, from the card, open the image in Photoshop and demonstrate some very rough retouching. This holds great appeal to the CEO, and on more than

one occasion it has resulted in return engagements for other company executives. Is there a risk in browsing images on the card? You bet. Is there a risk in opening images from the card without ingestion? Ditto. But, many circumstances have you working on the fly, and the ability to improvise and give the clients what they want when they want it, and to minimize the risk, means a happy client.

NOTE

A word about our digital workstation. Although we could turn up with a G5 and a 30" monitor, in the end it's our laptop, but one that is set up to get online, process images, and such. We diminish the value of having such a powerful machine on site when we refer to it just as a laptop. So, by referring to it as a digital workstation, it is given its proper due, and it is then accepted as a line item charge "Digital Workstation - \$xxx" on the invoice.

As mentioned before, in some instances clients have their own naming system. Mine for, say, an IBM CEO portrait would be:

YYYYMMDD_IBM_CEO_001.JPG

However, the client's might be a unique internal job number, followed by his employee number, and then a sequence number. How do you integrate that? For me, on site, I make note of their system and apply it if I have to deliver more than one or two images. Back in the office, I use my own system, but utilize the metadata to store the client's file name so that when they call to locate the original image, to request retouching, or the like, instead of searching the file names for that information, I search the metadata fields, and the image turns up. I'll do the work on the file, save it as a variation (Krogh refers to these variations as *derivatives*) using my file-naming structure, and then we deliver the images via FTP or on CD/DVD with the client's naming structure applied.

There are some limitations to file naming that you should be aware of as you alter the system to suit your own needs. From Controlled Vocabulary¹, a system developed by David Reiks:

[T]he most important thing that a filename can do for your image collection is to provide a form of unique identification (or UID) for each digital "asset." However, if you wish to be able to exchange your image files with clients or colleagues (often using different computer operating systems), then you need to observe some standards for cross-platform compatibility to ensure maximum portability. Here are some recommendations to avoid potential problems.

Files should only contain numerals, letters, underscores, hyphens (in some cases), and one period. Some file-naming systems are cAsE

¹Controlled Vocabulary, at www.ControlledVocabulary.com, is primarily a system for keywording, but the Web site contains a large number of resources for establishing systems, keywords, and other metadata information. A review of the site for those looking to maximize their return on their image assets is mandatory.

sEnSiTiVe, so be sure to be consistent. In addition, there are limits to the length of file names, directory/path lengths, and such.

The most significant limitation to file naming is a legacy system that is running an operating system such as Windows 95 or others that use what is technically referred to as *ISO9660, Level 1*. These operating systems limit you to eight characters, plus a period, and then three additional characters. Older, pre-OS X Macintosh computers have a 31-character limit, and ISO9660 has extended character lengths up to 64 characters. Most computer systems nowadays are Windows 2000/Windows XP or some flavor of Mac OS X. These systems allow for a maximum of 255 characters. Be careful, through: The total length of the file name and all the directories from the very top level down to the end of the file name cannot safely exceed 256 characters.

There are also systems for working with large volumes of images—25 GB, 100 GB, or more. I often find myself out on assignment for days at a time, generating 50 to 100 GB for one assignment. In those instances, the ingestion of the files can take all night, as well as the proper saving of the files to two external drives—one that always stays with you and one that stays in the hotel room or, in some instances, is shipped back to the office for post-production to begin.

The key, in my opinion, is to read the book and consider the principles and thoroughness of the workflow. Then, where it does not work for you and you've thought about how to change it, make those changes so that you are using your workflow in a way that suits your needs.

I fully expect that Krogh's *DAM Book* will be updated, and that others will perhaps come out with other systems and workflows. Until that happens, this book is a well-done basis from which to operate, and then to evolve as your needs do.

Evaluating the Cost of Analog Archive Conversions to Digital: Is It Worth It?

How much are your analog images worth? If no one knows they exist, then not only are they not generating revenue, but they are depreciating. How's that? A photograph of a streetscape from, say, 1970 will immediately be recognizable as such, if for no other reason than the appearance of the cars. Photographs of the New York City skyline that include the World Trade Center immediately date the images as pre-9/11, so a travel guide looking for images of the skyline will opt for something more current. At some point, images become historic and are no longer suitable to illustrate timely people and events.

To evaluate an analog archive, you'll want to consider the subject matter. If you have close-up images of plants with their genus and species, those will hold their value for some time. Images of someone using a cell phone will be worth much less five years from now than they are now. Consider the use of a businesswoman in a suit using a portable cellular phone that is so large it's in a bag, or one from the first generation of Motorola flip phones.

In my office, I took the time to review nearly 100,000 transparencies and to determine which had potential. I made it a priority to convert the images from analog to digital, apply correct captions, and develop keywords that would maximize the potential licensing of each image.

Scanning your analog images once you select them from your overall collection of images can be done yourself, or you can outsource the service to one (or more) of several different service bureaus. The costs can range from \$10 or so for a 60-MB 8-bit file to \$40 or so for the same file from other providers. Some differentiate by using drum scanners; others use different scanners to accomplish the same task. Should you opt for one service, first try them out for 10 or 20 images and see what the results are. Negotiate a rate by committing to the chosen vendor a consistent quantity of images over a certain period of time, or one large quantity of images. Consider the economics: If you choose your best 100 images and negotiate a rate of \$10 per image, although that expense is \$1,000, the investment should pay for itself with just a few licenses. After that, you can reevaluate an additional investment or await a sum that would allow you to have your archive self-fund its conversion.

Immediate Access to Images Means Sure Sales in a Pinch

The production of images and their proper keywording and captioning means that within a few moments, your clients should be able to locate and license images from you. In addition, you should be able to locate your images within your own office archives. The ability to do so can mean the difference between a license and a loss. There are a number of solutions, but I have come to the conclusion that the software offered by Controlled Vocabulary (www.ControlledVocabulary.com), for less than \$100, is among the best to generate captions.

Chapter 22 Stock Solutions: Charting Your Own Course without the Need for a "Big Fish" Agency

So, you've preserved your rights to exploit your images beyond the original assignment. Perhaps you've got a large library of analog images that have been gathering dust and depreciating, as outlined in the last chapter. Determining the best outlet for your images is crucial to having your images seen by photo buyers and generating revenue.

Nowadays, there are a number of solutions. Prior to the Internet and digital files, most photographers delivered their images to one (or a select few) agents. The physical distribution of these images was time-consuming and costly. Further, to make the most out of your stock, the images had to be originals or high-quality duplicates in order to make the sale. Now, the wide variety of domestic and international outlets for images to be viewed and licensed has grown to a point where you have several options.

What's the Deal with Photo Agents These Days?

When photo agencies were handling physical images, there was a large amount of back-end work. Often the agent handled processing, writing captions, affixing those caption labels to slide mounts, categorizing them, and filing them in their library, integrated into the tens or hundreds of thousands of other images. Each time a request came in, someone had to review the request, go around to all the file cabinets, pull the images, place them in slide pages, make a photocopy of the page, put it in an overnight package, and ship it. Then they had to call to determine usage, secure the safe return of those images, and re-file them for future licensing. During this time, those images were unavailable to other prospective photo buyers, and for timely news stories, the photo agents would produce duplicates of the images, splitting the cost of them with you against future sales. They would then re-caption and re-categorize the duped images. This was a considerable amount of time and effort and warranted a significant percentage of all licensing fees.

Times have changed. During the analog days, the common split for licensing fees was 50%, although if you had leverage, you could negotiate a 60/40 split in your favor. Although I considered these percentages high, there was little I could do beyond accepting them. Today and for the last five-plus years, online digital archives have become the norm. By some estimates,

less than three percent of images licensed in the last year involved the handling of original film. Most (save for the unique or larger revenue) licenses are handled 100% electronically, with no person actually doing all of the legwork that created overhead costs. Servers in secure facilities house these images and generate revenue, and the agents have kept their percentages as high as when they had all that human overhead cost to contend with.

As analog agencies went out of business or were bought, photographers seem to have forgotten that without them, the acquiring corporation was simply buying empty filing cabinets. As such, the photographers signed "under new ownership" contracts that waived the new companies' liability against lost images. In some cases, the "agents" whose responsibility it was to look out for the photographers' best interests were doing just the opposite.

Only in rare circumstances are these agents looking out for the interests of the photographers they are charged to represent. Quoting from the 2000 Annual Report of Getty Images:

Our business model transfers seamlessly to the Web. Due to the nature of our product, our customers are able to search for the imagery they need, determine pricing, complete their purchase and have the product delivered—anywhere over the Internet. We don't need to acquire inventory, we don't need to maintain expensive warehouse space and we don't need to depend on a shipping service to deliver our product.... Getty Images reaps the promise of the Internet because our product cycle is completely digital—from the first customer inquiry to the final payment—enabling a pure e-commerce process.... For both Getty Images and our customers, it means increased productivity and lower costs.

Further, and in successive years, Getty on one hand points to their major expense as being royalty payments to photographers, and a few sentences later, they talk about working diligently to reduce their major expenses to increase margins and profits for the shareholders. Can you blame them? Although there is nothing wrong from a business sense with taking this approach, they are truly no longer looking out for the best interests of their photographers; instead, the bottom line is for shareholders. Further, they are not the only "agent" looking to do this; it's just that as the largest publicly traded company, they make a lot of public statements that bring this to light.

So how exactly are the large photo agencies looking to reduce the royalty payments they make to photographers? Well, if they have images of scenic vistas of cities around the world that were taken by photographers who provided those images to their agents, and then their agents were acquired by the larger agencies, those images—which are often very similar (for example, shots of the US Capitol or the blue sky during spring)—are being licensed by them, and they are paying a 50% royalty on that. Why not hire photographers as employees in each of these cities, and when they are not completing assignments, they can be instructed to shoot scenics of their locality's most popular "postcard-type" destinations. In fact, by using aggregated data to show which subjects are selling best in each city, they could provide a prioritized list of subjects. When those images come in, because each image licensed from that group would not have the obligation of a royalty at all, 100% of each license would be returned to the "agency."

Armed with metrics that show 90% of photo buyers don't click past the second page of search results, and given that each page can show 15 thumbnails, assigning a higher ranking to these "wholly owned content" images so that they appear on the first and second pages means that

the photographers whose work the agencies "represent" will be shown first, only where no wholly owned content exists. As the agencies create the images, they can then bump stock images for which they pay a royalty to the second page, and then to the third page. Because all "agency" contracts have stipulations that all captions, keywords, and metadata they assign to your images are theirs, they can freely duplicate the captions and keywords that return the best results and legitimately assign them to employee-generated works.

Although this example discussed "scenics" in some detail, "concept" images—from handshakes, to people on cell phones, to youths in activities—are quickly becoming full-blown production shoots by employee and overseas photographers, based upon sales reports showing which ideas and concepts are selling the best. The high-dollar advertising sales that were being split 50/50 with photographers are now being reshot—carefully, to skew so it's just shy of infringement—by those who get paid a "work made for hire" day rate. Then, these reshots are owned by the agency. Then, images that are wholly owned in these categories replace the lowerrevenue-to-the-agency images. Sure, the 50/50 images still turn up, but deeper into the search results, where statistics show few photo buyers will drill down to.

So that's the deal with "agents" who work for "photo agencies." They're looking out less and less for those they are charged with representing, and more and more to the bottom line for owners and shareholders. What's a photographer to do?

Personal Archives Online

There are a number of resources available to take charge of the licensing of your images, but it will take a bit of effort on your part. First, for those of you who have not bothered to caption or keyword your images, you'll need to start. In the previous chapter, I address the methods to best prepare your images with the proper metadata. There are, however, scores of articles and other information available from trade groups, such as the American Society of Media Photographers (ASMP), Stock Artists Alliance (SAA), Advertising Photographers of America (APA), as well as numerous other resources to get you thinking like a photo buyer, conceptually as well as literally, so you can understand what your image represents in both realms.

I have chosen to make my images available through several online service providers. Rather than suggest one is the better than another, I would like to outline some of the features of each and encourage you to continue your own research to make the choice that best suits your needs. The key, though, is to actually make the choice and take action that will empower you to grow your stock licensing revenue. All three options discussed in the follow sections offer localized and geographically redundant protections (an important point that we discussed earlier in this chapter), so your data is safe from not only drive crashes, but also from natural or manmade disasters.

Digital Railroad

Digital Railroad (www.digitalrailroad.net) was among the first (if not *the* first) well-established self-managed photo archive services, and they charge a single membership fee with storage, plus you can add per megabyte of storage needed. They offer the ability to customize the front page, with many customizable elements to model the look and feel of your own existing marketing

Web site with colors, graphics, and such. The site can serve as a portal for clients to log in privately and review images you shot on assignment or for stock, or you can assign groupings of images to be viewable by the public. As a result, someone visiting your site can search for "scenics" and turn up several—provided, of course, that you've shot them, uploaded them, assigned adequate captions and keywords, and made them publicly viewable. In many cases, the site has an integrated look and feel so that clients and prospective photo buyers do not feel as if they've left your site. Further, Digital Railroad has members in more than 50 countries and has a registered body in excess of 20,000 photo buyers, 30 photo agencies (from the prestigious VII, to Marcel Saba's Redux, Grazia Neri, and NCAA Photos), and more than 600 photographers at the time of this writing.

"We continue to develop unique technology that gives more control to photographers and agencies, to enable them to minimize production costs and maximize sales around the world," says Evan Nisselson, founder and CEO of Digital Railroad. Tom Tinervin, director of ASP sales (Application Services Provider), puts Digital Railroad's market position this way, "DRR is not simply an ASP but rather a team of photographers, editors, buyers, researchers and educators invested in creating solutions from a keen understanding of all facets of the industry. Through our partnerships with the APA, WHNPA, PLUS Coalition and the like we are creating opportunities for photographers and buyers alike to take control of their creative business."

Digital Railroad will, as of the end of 2006, be offering the ability to enable image buyers to search across all archives that are handled by Digital Railroad. As an opt-in service, you can make all or specific galleries of images available through their portal, which is promoted as the "Marketplace." Nisselson goes on to say, "The Digital Railroad Marketplace will continue to allow members to maintain their personally branded archives, while giving them the most efficient method to simultaneously publish images through an aggregated marketplace."

Fees for monthly service are based upon a basic fee of just under \$50 and can increase from there for larger collections or ones in which multiple photographers are represented. In addition, Digital Railroad will collect, through an e-commerce module, licensing and royalty fees so that you can be out shooting and uploading, and images can be found moments later—a significant value for breaking news stories. They have a one-year contract requirement and offer discounts for prepaid annual charges, as well as a free trial period.

Digital Railroad not only is easy to use and set up, they are responsive to client feedback about fixes, changes, and new features.

PhotoShelter

PhotoShelter (www.PhotoShelter.com) arrived as an option shortly after Digital Railroad. They have a similar system to Digital Railroad. They also offer a customized home page model. You can assign (or map) a URL from your Web site to theirs. So, if your Web site URL is Amazing-PhotosByMe.com, you can assign, through your ISP that hosts your Web site, library.Amazing-PhotosByMe.com to link to your customized front page on PhotoShelter. As with Digital Railroad (where you can do the same thing), clients will still feel as if they are on your Web site.

Grover Sanschagrin, co-founder of PhotoShelter, puts his service this way, "More than just the ability to change a font and a background color and insert a logo—PhotoShelter can actually match the look/feel and page geometry for a truly seamless integration. We worked hard to

develop a very unique system that allows photographers to add special PhotoShelter tags ("widgets") into their HTML, which allows them to insert PhotoShelter functionality into their design. If you compare several of the customization examples, you'll see just how different they can be." Sanschagrin goes on to address an important point about their archive system as a "true archive," contrasting the limits of other providers with theirs, saying, "Ours can handle 400+ image formats, including all RAW files and Photoshop documents."

PhotoShelter currently offers a cross-photographer search result from their own PhotoShelter.com portal, as well as their sister Web site—Sportsshooter.com. As a PhotoShelter member, you opt into their virtual agency service—for a fee—and your images are returned during search queries. PhotoShelter continues to evolve and grow this offering, with new images and features that make it easy to use. Among PhotoShelter's clients are Contact Press Images and Major League Baseball, as well as the Eddie Adams Workshop.

PhotoShelter started out first with an e-commerce capability and continues to evolve it in response to client and photo-buyer feedback. You can also opt-in to offer images as prints—you set the pricing for the images, and PhotoShelter does the fulfillment, or you can opt to handle it yourself. Their monthly fees begin at less than \$10 a month and increase as the size of the files you have online increases. The additional charges for the customized homepage option will add on approximately \$20 per month. They do not have an annual commitment requirement, and they offer a free trial period.

PhotoShelter is also easy to use and set up, and they are responsive to client feedback on feature requests, bug fixes, and other changes.

IPNStock

IPNStock (www.IPNStock.com) was founded in 2000 by Aurora, a traditional photo agency combined with "new media" capabilities that started with a well-regarded collection of talented photographers. Within a fairly short period of time, IPN was handling a dozen photo agencies and nearly 50 high-end photographers, and was acquired by VNU, the parent company of Photo District News, which provided the needed marketing reach. Not long after, similar services, such as Digital Railroad and PhotoShelter, began offering their own style and level of services to photographers. IPN is different in that they operate very much like a photo agency with a quality approval process to enter, and they present many marquee photographers who use their service. In addition, they advertise heavily in photo-buyer publications and are making a significant outreach to the photo-buying community.

They present themselves as a premium service, with exclusive imagery. IPN's co-founder, Brad Kuhns, outlines IPN's capabilities and functionality this way: "IPNStock is the only truly custom integrated solution. Almost all photographers and agencies migrate their current sites away from their current hosting providers. IPN adds its extensive technology capabilities behind the photographer's existing website, all with the photographer's custom branding. If a photographer does not have an existing site IPN, designers work with the photographer to create a site. The technology has been developed over the past six years and has been honed by the high volume needs of major agencies like images.com, Aurora, and Robertstock, who completely rely on IPN technology for all their needs."

They allow for up to 2,000 high-resolution images and ask for between a 48-MB and 60-MB file, which is then saved as a JPEG. They will, however, take smaller files, and their monthly charge is just under \$200, with just under \$600 in setup charges. They require a two-year commitment. This works out to about a \$5,400 required investment over two years, and IPNStock takes a 20% commission on all net revenues from licensing of images through their site. IPNStock is very similar to a collective photo agency, and there is an approval process—mostly qualitative—so that, say, amateur or erotic photography does not make its way into search results alongside your images.

Others

There are outlets other than these three. One solution is to make the expense and go it alone. Marketing your images of a particular niche subject—say, plants via www.PlantStock.com or aerial images from around the world of cityscapes and landscapes via www.AerialStock.com. Both solutions, when marketed properly and established with an effective back-end database, can produce lucrative results. The key is in finding a solution that works for you and employing it so that your images are out there and can be found and licensed to generate revenue. Otherwise, they are an under-utilized asset that is likely depreciating in value and taking up space in your filing cabinets or on your storage media.

There are also outlets that I recommend avoiding. They are services where you are competing for a "stock sale" of an image that has not been created yet and covering all the production expenses of doing so, for a small chance of being paid for that work. These agencies or services suggest that they are representing you, and then send out the same request for an assigned image to produce. In the end, not only is there no guarantee that any of those who produced images will get paid for their work, but if the work is chosen to be used by the end client, then *and only then* will the selected producer of the images be paid, and the rest will not. Another problematic roadblock to a long and illustrious career as a photographer is the microstock business model, where images are licensed for a dollar or two, or even pennies, for a one-time payment. Clients of some of these microstock services can download images in large blocks—250, 500, or 750—once and never have to pay again, for fees of \$100 to \$300 (or more) a month. Photographers earn less than a dollar—sometimes just 25 cents, sometimes 20% of the \$1-plus download fees—only when their images are downloaded These models are among those I recommend avoiding if you intend to remain in business for the long term.

Part V The Human Aspect

Chapter 23 Care and Feeding of Clients (Hint: It's Not about Starbucks and a Fast-Food Burger)

Before I begin this chapter, let me dispel a myth. In fact, I shall go so far as to say it's a lie. The customer is *not* always right. Author Steve Chandler, who wrote the best-selling book *9 Lies That Are Holding Your Business Back...and the Truth That Will Set It Free*, and I are in agreement on this. He presents it this way:

You don't want every customer for your business. A lot of small-business owners make a big mistake by thinking that they should try to get any customer they can.

The customer is always right—it's a lie. I mean, that's a huge lie. And that's something that small-business people have to really work against, because the customer isn't always right. Sometimes they're very wrong, and sometimes they're not just wrong, they're downright dangerous to you.

There is another impact on this too...that I think is important in turning away a customer. And, that is the boost in morale if you have employees or partners or co-workers, and they witness that you have declined the business of a customer because that customer does not treat people correctly.

After you've sent a client the contract, and they've signed it and faxed it back, and then they call to say, "Oh, you need to sign off on our contract before we can pay you," *are they right*?

When a client says, "Gee, you're the first photographer I've spoken with who's had a problem with our contract. We need copyright to the work since we're paying you for the work," *are they right*?

When a client says, "I can find two photographers to do the assignment for what you're asking. I can't imagine it could, or should, cost that much for what I am asking you to shoot," *are they right?* (Maybe on this one, but that's another point discussed in an earlier chapter about pricing.)

Or this one: "I paid you to take the photographs, so I own them. You're out of your mind if you think I am going to pay you *again* when I want to reuse the photographs in the future." *Are they right?*

In my office, I have people working for and with me who are aspiring photographers and interns, and they are involved heavily in putting together contracts, handling client calls, and delivering final images. They all know my position on work-made-for-hire, copyright demands, all-rights grabs, and even demands that reprints from magazine articles be included in the assignment fee already agreed to. All are deal breakers. But it's not my employees' role to convey this; I do it. In fact, there is sometimes a keen relishment among my staff when telling me about a call, and my need to call them back to resolve the issue. We have a policy in our office that those in the office may request to be on the line when that conversation takes place, so that if I'm not available to handle the issue at a later date, my employees and interns are versed in how to pinch-hit, and they then learn how to engage their own clients on the issue when they "leave the nest" to run their own businesses. They all know how the call will end—either I will succeed in conveying how those needs are not consistent with our policies, or we will part ways. My employees and interns enjoy hearing how circuitous the route can be to either destination. It's important that you make sure your employee goals are in line with your business goals, or you will have problems.

NOTE

I suppose everyone has his or her price. I have had clients indicate that they wanted all rights forever to an image. My quote of \$25,000 to \$30,000, along with the encouragement to reconsider their request first by limiting the geography to where their company does business, then by limiting the time frame to, say, five years, and then limiting again to all uses except paid advertising placements has often still resulted in a comma in the licensing figure and a deal being struck that is acceptable to both parties.

We do turn away a quantifiable amount of business each month because of these demands. We—I—want clients who respect the value we bring to the assignment. Clients who demand copyright are dangerous. Clients who insist they must have all rights are wrong, and clients who insist that reprint rights be included without an additional appropriate fee are not right. I don't want these clients in my sandbox. None of them is playing fair.

They're Your Clients: Treat Them Like Gold

You must do everything within your power to honor the convenience of the client. When I get an unusual request from a client, I always respond, "I am more than happy to make that happen for you. That said, here are some options for you to consider." The first words out of my mouth are an affirmation that I will work to achieve what they've requested. Then, I outline alternatives, such as those that are a lower cost or a better choice they may not have considered. In this instance, when clients make a choice, they do so having considered options they might not have thought about before.

For example, suppose I am on assignment and a client representative is there, but he or she is not the final arbiter or there are multiple stakeholders. At the end of the shoot, the

representative might say, "We need three sets of CDs; can you ship them to these addresses?" My "I am more than happy to" ensues, then I outline an option. I'll suggest, "Here's a more efficient and more cost-effective solution: Why don't I put up a Web gallery of images. That way, all the people involved can literally be on the same page at the same time, and then we can deliver (or retouch) just the images you need. It will cost less and save time." Frequently, the response will be, "Wow, that's a great idea!" And sometimes, the client really does need multiple CDs, and this dialogue also informs them that there will be additional costs associated with this request. It's a two-fer, because it attempts to solve a client's needs *and* it advises them of additional potential costs in a non-threatening manner, so they don't feel as if they are being nickel-and-dimed on additional charges.

Further, remember this: Once someone says he or she is your client, always treat that person like a client. Whether or not you're up for more work with them in the future, make sure you always hold that respect for their position. I can see in very rare instances that the client extent of the relationship might disappear and be replaced by a personal one, but those situations usually involve an exchange of rings and vows.

Oh, and one more thing about gold: Knowing how and from where clients came to you is of the utmost value. It allows you to determine where to continue mining for that gold, and, in turn, you can return their trust in you to complete the assignment by treating them like the gold that they are to your karmic and financial bottom line.

How to Improve the Odds That Your Clients Will Come Back Again

There are a number of things you can do to ensure that your first-time clients will become repeat clients. The first thing to do is figure out what role you are playing: Are you their first choice, fallback choice, or a benchwarmer called in when the first-stringer gets sick?

Steve Chandler discusses client growth—and retention—this way:

If price is your only selling feature, you are in a losing battle...one in five customers doesn't need to fret about price. We have all bought things that were expensive but worth it. Price is just a detail, not the deal itself.... According to the latest income surveys, 20% of the population controls 47% of the disposable income. That means that one out of five people has so much money to buy things with that, relatively speaking, they're not concerned about the price at all. Does it make sense to focus your ad's message on something that doesn't concern them? [T]hose 20% are your ideal customers. Money is not the main factor in their decision to shop with you. You are. You are the main factor in their decision, and that's how you want it to be. Your quality, your service, your commitment to them. That's where you want it to be, because that's where your profit margin is, and that's where your database of lifelong customers comes from. Not from one-time price shoppers.

If you are the client's first choice, they are likely a return client. Simply continue to deliver at or above your last assignment, and the likelihood that this will continue is great. If they found you on the Internet or via a referral, then you'll want to be able to demonstrate that what you offer will meet and exceed what they are looking for. This will maximize the chances of their becoming a repeat customer.

If you're their fallback choice, tread carefully. Perhaps the client thought they could afford someone more expensive than you (perish the thought that these photographers exist!), but could not, and now you're the because-we-couldn't-get-so-and-so photographer. You have a bit of an uphill battle in this instance, but relish the challenge. I take the position that the masses stop at the mountain's base, but there is plenty of elbow room at the summit. Here, too, meeting and especially exceeding the client's expectations means that you could have a new repeat client.

On more than one occasion I have been asked by a client, "Are you available tomorrow? Our photographer came down with [*insert virus here*]." Here I am the second-stringer. Sometimes the referral came from the photographer who's sick, but often I am some off-handed random referral or search-engine find. This type of client is almost always just grateful to have a body with a working camera on hand. The bar of success is set so low that it's an easy win. That said, don't sit back and coast through the assignment. Treat the client as if he or she is a regular one with high standards, and then meet those standards.

Think long and hard on this one: If you can offer a unique service that no one else has thought to provide or can provide, then you have a "hook" that surpasses the other photographers that the client might consider, and this will further diminish the role that price plays in the decisionmaking process.

Steve Chandler makes this point in *9 Lies* on why customers return. They do so "...for many reasons other than price. Once you believe this you will attract customers that will continue to prove it to you and verify your belief. Higher-value customers who like your unique offer are the ones that stay with you.... [T]he two car brands with the highest repeat-purchase rates are Lexus and Cadillac. Is that because of the price?"

If you seek to attract customers shopping you on price, they are not customers that will continue to contribute to you in the long run. These clients will continue to look (and will find) someone cheaper. You want customers who are willing to pay a premium for your services, but, more importantly, who will refer others who will do the same. Why grow your roster of clients with low-price shoppers that will consume all of your creative energy, leaving little time for well-paying customers—the ones you've always hoped to land?

Sometimes it's beneficial to let the client or art director feel that the idea you pitched is theirs (if you've secured the assignment—otherwise it's not kosher). In one instance, I came into a creative meeting with the job's art director, and her boss, the senior AD of this very reputable firm, joined us. He was extremely skeptical of me and what I brought to the shoot. I had been a "must have" from their client because I had a track record of delivering in previous work for them. During the meeting, I could feel the disdain directed toward me until I came up with a concept that was beautiful in its simplicity and met the client's messaging needs. The senior AD flipped like a switch and decided I was okay for the project, and then left the room. It was clear to me that his role there was to garner ammunition to shoot me down to the client, but by

keeping my composure, I was able to win him over. Subsequently, I was in a conversation with the client, who had initially alerted me to the fact that the firm was questioning my appropriateness for the assignment. I recounted the situation and when the switch flipped. The client stopped me and said, "That's a great idea! It was yours?" I said, "Yes, why?" She then said that in a recent meeting the senior AD had pitched that idea as his. Although my client, with whom I work frequently and closely, was happy to learn the facts, she never revealed that she knew it to anyone else, nor did I. As Robert Solomon, author of The Art of Client Service, notes by devoting an entire chapter to the subject, "Credit Is for Creative Directors." Another point on ensuring that clients return: Manage client expectations from the outset and as the assignment progresses. If you're called upon to shoot an image of a speaker at a podium, and the podium has no signage on the front or behind it that you can include in the frame, I always say "Gosh, do we have any logos or other visuals that we can include on the podium or background? When I make these photos, the speakers could have been anywhere." This ensures that when they get the photos, it doesn't just look like a bloke at a box with a microphone, when they were expecting something more dynamic. Usually, the client can do something about it, but when they can't, I've let them know I am thinking about these details and that they now have a better idea of what they'll get. If during pre-production meetings or calls the client is always talking about the importance of beautiful morning light, and then during the scout the day before we learn that there are large buildings or trees precluding that warm light or the forecast calls for a foggy or overcast morning, I'll make a point of saving, "Well, let's see what we can do to warm up the light on this image, because Mother Nature's not going to come through with that morning light we wanted." Then I try to make whatever adjustments I can to the image with gels, front-of-lens filters, camera Kelvin adjustments, or tweaking in Photoshop as a last resort. However, I have managed the client's expectations here as well.

When there is a problem or issue that arises, it is at this time that you can demonstrate a style of communication that will keep clients coming back. Although many times you will be remembered because you were successful at troubleshooting issues related to what was in the frame, often your repeat business will come from how you handle issues unrelated to image content. By this, I mean client interaction. As I stated at the outset of this chapter, the customer isn't always right. Even when they are wrong, what they need more than being right is a feeling that you heard what they said, considered it thoroughly and thoughtfully, and looked them straight in the eye with sincerity when responding. How you handle the mistakes and misunderstandings that arise is an opportunity to distinguish yourself and earn (and earn back) clients who respect how you dealt with the issue.

CHAPTER 23

Nadia Vallam, photo editor for *W* magazine, in a summer 2006 interview in *Picture* magazine, had this to say when asked what it takes for a photographer to get repeat business from them: "First the film. But I think beyond their eye, they must be good socially, because dealing with publicists, editors, and subjects can be tricky. And they must be confident, not cocky. In the photography world, everyone is vying for the same jobs, and while we hire for talent, it's very important that they're likeable."

In the restaurant business, less than stellar food can be offset by exceptional service, but even the best meal can be ruined by an unpleasant or unfriendly waiter. The general manager of the renowned Prime Rib restaurant serving the lobbyists and power brokers along the venerable K Street corridor summed it up this way when I asked him about it: "I can hire anyone and train them to take and deliver your order as well the details and the nuances of doing that properly. What I can't do is teach someone to be kind, courteous, warm, and friendly. We cannot hire a waiter and train him to be a gentleman, but we can *and do* hire gentlemen and teach them to be waiters."

Do Something Unexpected, Something Value-Added

Before you do something unexpected, it is imperative that you begin your client relationship understanding just what the client expects from the assignment. Ask questions: Is this a brand awareness campaign or are you selling a particular product or service? Who is the audience consumer or business-to-business? Are the images being produced as part of an ongoing campaign, or is this a one-off production? These questions and numerous others help you define what will be defined by the client (and hence you) as success.

Sometimes when I am working with an editorial client for the first time, I will get to the assignment and set up and do assistant stand-in tests. Firing up the digital workstation (a.k.a. laptop), I will hop online (for editorial clients) and e-mail low rez's. A note is included about stand-ins and how I see this image fitting into the client's request. I then call to follow up as the assistant is resetting the equipment cases so that they are not all over the place, and we present a professional and organized appearance when the subject arrives. Often there is a "Wow, that looks great," and every so often there is a suggested change, which I accommodate. This creates buy-in with the client, and they can often use the image as a comp for the layout while we are preparing the final files for review and delivery once back at the office. Further, this can be a value-added service that will cause you to be remembered by the photo editor or art director in the future. In addition, if this is your first time working for this client, it immediately gives them peace of mind that they made the right choice in selecting you.

Other times, especially if there is an art director or photo editor on site, I will make an effort to do a group photo of the subject(s) with the crew and client. It's usually a fun photo, and it almost always signifies the end of the shoot. When I'm home and the initial images have been delivered, I will make a point of making prints for the crew, but more importantly, a print for the client and AD/PE. I send those prints along with a note thanking the client for the opportunity to work together and telling them that I look forward to working with them again. Not only do they almost always post the photo on their wall or in an easily viewable location, which reminds them of the shoot (and me), but it is a conversation starter with their colleagues, who say "Oh, that looks like a fun/cool/interesting shoot," which usually ends up with the AD/PE saying complimentary things about my easygoing style of work and such, causing more word-of-mouth marketing. Solomon again devotes a chapter of his book to the notion that "Great Work Wins Business; A Great Relationship Keeps it." In the chapter, he's not talking about the lunching kind of relationship, but the kind in which there is trust and collaboration, and your counsel is not only sought, but valued.

There are numerous things you can do for your client that can make a difference. Another example from my own experience is that I will leverage my status as a top-tier member of several frequent flyer programs to the client's benefit. Most airlines typically extend upgrades to

first class to members of these programs. On some airlines it's free, and you can confirm 24 to 72 hours before departure. On others, you pay a nominal \$50 to \$100 per direction, depending upon distance. (Any coast to Chicago, for example, can be \$50, and coast-to-coast can be \$100.) Knowing that the client is traveling alone, I will indicate to the airline that the client and I are travel companions, and then we are both upgraded to first class. Now, traveling on the same flight with a client in this capacity has a risk to it: If there is only one first-class seat, you *must not* accept it and leave your client in coach! Also, as noted earlier, make sure that if your client is an agency, their client is not traveling on the same flight. That would make you and the agency AD look like over-spenders! Used judiciously, this tactic can be a really amazing way of letting the client know that you value them. Of course, you'll be covering whatever charges for the upgrade. You should have that much wiggle room in your overhead to do this for them.

Feeding Clients: Fast Food and Takeout Coffee Won't Cut it! Cater and Bill for It!

There are a number of different assignment types, from rites of passage, to editorial assignments, to corporate/commercial assignments, and numerous others. For a number of high-end assignments, you can easily lose the assignment for no other reason than that you didn't include catering. This service is sometimes called "Kraft services," after the company that feeds crew and stars alike on movie sets. If you are going to be doing an assignment that crosses a mealtime with an art director, photo editor, your client, or *their* client (who is also your client), make darn sure you include catering *as a line item*. It can always be struck, but it lets the client know that you are going to be taking care of them and you are paying attention to the details. There are other things that may also go into this, such as a production trailer (a.k.a. motor home) where clients and art directors can relax while on location and where you and these stakeholders can review images from the shoot while crew and talent are outside prepping for the next assignment. Sometimes it is necessary to have the production trailer for makeup to be applied and such. Again, having a production trailer or catering as a line item as well indicates it can be struck, but also reiterates the idea that, "We're thinking about you and want to ensure you're comfortable while on set."

On-set lunch is not fast food, nor carryout from the corner deli (but at least that'd be a step up from fast food), nor homemade foods—unless you or your spouse is a gourmet chef who knows presentation and healthy recipes. Further, after winning the assignment, don't overlook the importance of the not-so-little details. Call the client and ask about particulars: Is there a vegan, a vegetarian, a low-carb dieter, or someone who requires that their meals be kosher? Then, call a catering service. It doesn't have to be one that's used to doing banquets (but it could be). It can be a gourmet delicatessen or a well-regarded restaurant in the local area. Call around where you are shooting, or if it's local, call places you know. Ask whether they can prepare meals and dishes to go or as platters that can be opened and set up by you (or, more likely, the assistants). Many will be more than happy to prepare their lunchtime-menu sandwiches, cold salads, and fruits and cheeses for you in an attractive manner. A gourmet coffeehouse can provide the coffee (and tea assortment!) and will make sure you have enough cream, sugar, stirrers, and cups to go around. Yes, Starbucks can and does do this, but there are also other options. For

early shoots, breakfasts are often fruit, bagels, coffee and tea, danish, and donuts. Don't skimp and stop at 7-11 or a gas station food mart. Go the distance! It makes a difference, and you are billing for it, as the client expects you to.

NOTE

A point about Starbucks: They did not start up their business looking to undersell the local coffee shop. Instead, they tripled the price of a cup of coffee by delivering a better customer experience with more choices and amenities and services than anyone else—by a long shot. Clients more often than not have a strong desire for a premium service and are willing to pay a premium for it.

If the shoot ends and the client suggests getting dinner (or lunch), you should already have a few suggestions about nearby and convenient options. Going so far as to have a faxed copy of the menu is definitely something to make the client remember you—even though some may suggest this is over the top. It would take no more than 10 minutes to do research on the Internet with a Zip code from a guide such as Zagat or a localized guide from the city's newspaper, and then print out some menus and have them as a part of your shoot materials. You should be prepared to pick up the bill, and an approximation of that may well have been in your estimate under "meals" or some variation of that. If not, offer to pick up the bill to make a good impression on the client. This means you should be the first one to reach for the bill when it hits the table or as it is coming to the table. If, as you do, the client says, "Oh, I'll take that," a courteous and sincere, "Are you sure?" will be followed by a "Yes, I'll take it" from the client. Then, it is critical that you accept and not argue about it. Just say thank you. There is only one circumstance in which it is correct to split the bill, and that is when you are doing an assignment for a government agency or a private company that has a government agency contract. Many contracts stipulate the importance of these things as a part of what a government client or a company representing the government can legally accept, but do what you can to be the magnanimous one. The client(s) will remember it.

Deliver When You Say You Will or Sooner

Deadlines. Why is it that so many people have such little regard for deadlines? They're not maybe-lines, if-it's-convenient-lines, or whenever-you-want-lines—a deadline is a deadline. Period. If you can deliver sooner, and especially if it benefits the client, then do so.

For many of our clients, we started with a two-day turnaround, but then clients who had their photographs produced on a Friday wanted them Monday. So we changed that to "48-business-hour" turnaround. That means an assignment completed Friday evening at 9:00 pm will be ready by Tuesday evening at 9:00 pm, which is too late to make an overnight delivery or courier service, so it's usually scheduled to go out Wednesday morning via courier. However, for overnight service we will ensure that the images are done in time for those service pickup times.

Sometimes a client will say, "I need you to rush those images, and I know there are rush charges." That's fine. Sometimes a client will say, "It'd help to have them tomorrow, but we can't afford the rush charges." It's these clients that will most appreciate an early delivery of your work.

Editorial clients typically do not want all the images at high resolution. They usually want a Web gallery and final selects. We typically try to deliver these images within the PE's stated deadline, and often we'll do a quick Web gallery the evening after the assignment. Because these are very low-rez files, there is usually little work (spotting and so on) that needs to be done for that size, so a batch action can make the galleries without much problem. This is appealing to many clients who arrive at their desks in the morning to find a gallery for their review.

Return E-Mails and Send Estimates ASAP

One thing that really cheeses me off is when I send a time-sensitive e-mail and the recipient sits on it. I am sure that clients feel the same way. In fact, I can be certain that I have received numerous assignments for no other reason than I sent my estimate within 10 minutes of the end of a phone call or e-mail inquiry. Many of these times I get e-mails back saying, "Wow, that was fast—thank you for this. We have a meeting on this in an hour, and having your paperwork will make a difference." Or, "I contacted two other photographers and have not gotten anything back from them. Thanks. The assignment is yours."

E-mails generated by you following a telephone call or in-person meeting are also critical. The subject line could be "Meeting Summary and Action Items," "Conference Call Summary and Action Items," or "Review of Meeting Decisions and Next Steps." Then, without rehashing the points, go through and list single-line items that were agreed to and the next steps to be taken. This creates an audit trail in the event that there is a misunderstanding later down the line. If both you and the client thought that the other was going to arrange for a special prop or background, and you both arrive on set without it, the finger-pointing will begin.

Here's an example of a recent e-mail I sent:

SUBJECT: Review of Meeting Decisions and Next Steps

Dear Client —

As discussed, here's where we are on the project:

- We arrive in Houston Saturday night and will be departing late Wednesday that same week. Our tickets will be booked by COB today.
- We will await your decision on hotel and will make our own arrangements. Please advise when you have.
- We are traveling with two assistants and hiring a local makeup artist and stylist.
- ▶ The basic outline of our schedule is scout day/shoot day, and then scout day/shoot day for the second shoot.

You've made contact with the location and personnel and have approved their wardrobe and look, or we will accept what we find during the scout and make the necessary adjustments once on site.

continued

- ▶ The proposed creative of a large quantity of people with signs on sticks has been replaced by the smaller group of people with a large flag in the background.
- The procurement of the background flag and ballot box prop we both will do on the scout day.
- Our first preview gallery is due by COB Friday of that week.
- ► Final retouched and ready-for-press images are due by COB the following Friday, and are dependant upon your own internal review, which will give us a minimum of two days for final post-production work, delivered in the Colormatch RGB colorspace, with guide print.

Please let me know if there are any changes to this. Thanks, and I am excited to work on the project!

Best,

John

Recommended Reading

Beckwith, Harry. *What Clients Love: A Field Guide to Growing Your Business* (Warner Business Books, 2003)

Chandler, Steve and Sam Beckford. 9 Lies That Are Holding Your Business Back...and the Truth That Will Set It Free (Career Press, 2005)

Checketts, Darby. Customer Astonishment Handbook (Cornersone Pro-Dev Press, 1998)

Solomon, Robert. The Art of Client Service (Kaplan Business, 2003)

Chapter 24 Education, an Ongoing and Critical Practice: Don't Rest on Your Laurels

It might come as somewhat of a surprise to some, but the fact is, I am not a graduate of a prestigious photography school or program. I do, however, have a four-year degree from a really great university, and I am certainly proud of that accomplishment. Much of my lighting experience came through trial and error on staff for a magazine that hired me more for my ability to make the impossible possible than my technical capabilities with a 4×5 or my knowledge of how to use a Wing-Lynch rotary tube processor. Once on board, I made every waking hour a study in how to light. I did this by reading books, talking to friends who knew much more than I did, and testing how soft-box sizes made a difference in transfer edges, as well as just what five degrees of change in temperature makes in the color of E-6 processing, not to mention the pH level of the city water!

Although I have lectured for more than six years at trade association meetings and tradeshows on a variety of subjects, I still relish the opportunity to learn from the presentations I am not giving, and even then, I hope to learn something from the audience questions that might cause me to view in a different light something I presented. When that happens, I make a note to myself to follow up on that or to reflect further afterward.

The worst thing that could happen would be for me to sit back and think, "Oh man, I don't need to know nothin' more!" Even physicians, who spend the better part of a decade learning how to save lives or make them better, attend annual seminars on the latest techniques that will make them better doctors. Lawyers do the same, learning about the latest precedent-setting cases, and how those cases will affect their clients. All photographers should look to have a plan to regularly learn and grow from the knowledge bases of others.

Tony Luna, author of *How to Grow as a Photographer: Reinventing Your Career*, has this to say about education:

I have had the honor of being involved...showing portfolios.... There is one thing I can categorically say about those presentations: no one has ever asked me to show them a diploma of the talent I was representing... never asked where the talent I represented ranked in their graduating class. They just wanted to know if that talented person could produce the work on time and on budget and infuse it with unique vision. Of course, if the talent had a solid, formal education in photography, the work should display a high level of professionalism, right from the start.... Education-scripted or by total immersion sets the patterns for work ethic and discipline.... Douglas Kirkland gave this advice based on how he handles the subject [of education]: "Explore the latest technology. What I do is the following: I keep looking at pictures all the time, everywhere. I keep trying to extract from them. I don't want to copy them but I want to get some nourishment from them."

Continue the Learning Process: You *Can* Teach an Old Dog New Tricks!

Steve Chandler, noted in the last chapter as the author of *9 Lies That Are Holding Your Business Back...and the Truth That Will Set It Free*, cites "Lie #8: I don't need help":

This lie has you setting yourself up to fail. It has you insisting you've got what it takes. It has your ego and pride interfering with the success of your business.... You have to put the success of your business ahead of false pride. You have to put the success of your business ahead of whether you might "lose face" or look weak.

Most people are not fully committed to success; they are committed to looking good in the eyes of others. They may be somewhat committed to making a living, but that's a completely different thing!

Tiger Woods uses a coach. When he got rid of his original coach, saying he could do it on his own, his game went downhill fast. Bob Nardelli, CEO of the Home Depot, has said, "I absolutely believe that people, unless coached, never reach their maximum capabilities."

One example of an "old dog" not only learning a few new tricks, but also helping grow them is photographer Tim Olive. Tim took years of experience and feeling burnt out, and he turned that around (after a lot of personal reflection) into Success Teams, which is a part of APA's offering to its members. Small groups of photographers (usually seven, local to one another, but not always) gather on a regular basis to inspire and help grow each other's work, along with a professional coach. I highly recommend you check out the APA National Web site for this, http://www.apanational.com, and grow your career with the help and support of your fellow colleagues.

In 9 Lies, Chandler goes on to say:

No professional athlete would dream of going a day without coaching. Because their success is too important to leave to chance. They wouldn't dream of going it alone. Yet most small business owners are actually proud of going it alone! As if that said something about them. It does not. It says that they are not fully committed to success. Make sure, though, that those giving advice, whether online or at seminars, are successful. More often than not, those who are espousing the principles of success and how to succeed are the ones who have run their businesses into the ground. There is nothing wrong with learning from past failures, but make sure they're doing really well now before you take their advice lock, stock, and barrel.

In addition, there are some on the photo lecture circuit who have been out of the business for several years and are earning a living teaching what worked and was acceptable five or ten years ago (or more). Depending upon the content, their advice may be timeless, such as talking about the importance of the proper care and feeding of a client or a creative way to light a subject, but other information about contracts or the state of the industry as seen from the front lines may no longer be applicable. If you're not sure about the timeliness of their advice, respectfully ask how many assignments they've completed in the last year for clients. This is one of several ways you can discern which insights they are sharing that are fresh and tested, and which may not be.

Know What You Don't Know (Revisited)

Another point about this. If all you read was your community newspaper, you might not know about the war (regardless of when you read this, there's always a war somewhere) and how it's going. You might not know about the politician or big businessman who's the subject of a federal probe, or just how the economy is doing right now. These things become points of idle conversation during meetings while a projector is being set up or you're awaiting a meeting participant. Although it's not smart to take a side about politics or religion, you can, by reading, engage the client and come across as knowledgeable. And always know what book you're reading, even if you've had it on your nightstand for the last three years.

If you're doing a lot of work with biotech companies, subscribe to their magazines. Try to learn about what's in their news and what photos they are used to seeing from a style standpoint. Use this to engage CEOs, engineers, and others during photo shoots or meetings. This holds true for any industry: Know what they know, which in the beginning is what you don't know...but you *will* know, and you will benefit from knowing in the long term by growing your bonds with the client and conveying to them that you care enough about their field to learn and be conversant about it.

If you find yourself being asked your opinion about, say, the drop in grain production in the Midwest and how it will affect food prices, and you know nothing about the subject, do not try to fake it. Ask an intelligent question (and anyone who tells you there are no stupid questions is just being nice), such as, "I'm not familiar with that situation. What was the basis for the report, and what do the analysts think about this long term?" Something like this will make it sound like you are interested in what the client is saying, and you're asking a question that puts the client in the position of power, where they can show off their understanding of the subject. You've allowed for the conversation to be opened up and continue, rather than just saying, "Oh, I've not heard about that."

Seminars, Seminars, Seminars: Go, Learn, and Be Smarter

One of the best opportunities to learn is from seminars. They are given at photo trade shows by professional organizations annually or semi-annually. They are given monthly by some, such as APA, ASMP, and others. They are given as traveling road shows by software, film, and camera manufacturers, and they are given online as distance learning or podcasts. Almost always, they are well worth the nominal per-seminar fees that are charged. Although I feel fairly proficient in Photoshop, for example, I welcome the opportunity to watch someone else demonstrate how he or she uses it. Learning masking tricks, channel sharpening, and noise reduction, as well as how to optimize images through high-dynamic-range (HDR) capabilities are among the more recent takeaways from seminars I have gone to. Seminars become especially useful when new versions of various software applications come out, and you can watch as these new features are demonstrated. It's much more engrossing to be shown than to read the manuals!

Understand going in that a program by a film manufacturer will probably include pitches for the product, and there are a number of other seminars at which speakers hock items they are paid to endorse or demonstrate. Although you will take away a lot of knowledge about those products or services, it should be abundantly clear what the presenter's relationship is with the sponsor. Sometimes a sponsor is covering the expense of the meeting; other times, there is more involved.

I learn best by observing. Others learn best by reading or listening and taking notes. If you are the type who best learns by observing an actual shoot, then attending a seminar that does not include this will reduce what you take away from the experience. Many seminars on computer programs will be in a lab format, where you actually sit at your own machine and practice. For me, that is more helpful than watching someone do the same thing without the interaction with the keyboard and mouse.

One last thing about seminars: The death knell for me is when the seminar is titled "Ansel Adams on Getting the Most out of the Zone System," and I arrive only to find him talking about all his photos and the challenges he surmounted in accomplishing them. Were it titled "An Evening with Ansel Adams," then I'd expect to hear his stories. If it's supposed to be an educational seminar and I end up hearing mostly "war stories," I'm going to be miffed. There are numerous photographers whose work I admire, whom I would greatly enjoy hearing speak about their experiences—their war stories—but I will choose those; I don't expect to hear about them during a seminar designed for me to learn about a style or technique.

Subscriptions and Research: How to Grow from the Couch

I subscribe to more than a dozen photo-related magazines. I usually learn something from each issue when I can find the time to read through them. When I find something that's important, I will tear out the article from the magazine and save it for later referral or a deeper read. There are a number of times when I find myself with idle brain cycles. Among them are when I'm

temporarily indisposed when nature calls, during takeoff and landing while traveling, and when I arrive early for an assignment and have time to pass. These magazines and the torn-out articles have allowed me to maximize what would otherwise be unproductive time.

Another thing that I find myself doing is Web research. When on a conference call or awaiting an instant message from a colleague or client or an e-mail that will allow me to move forward with contract or estimate preparation, with one ear to the call or one eye on my message notification icon, I will peruse blogs, review sites, and explore other resources online. It's simply amazing what information is out there, and other readers validate much of it. When a blogger posts something on a site about product capabilities, for example, other readers can (and will) comment on the fact or fallacy that's been presented. Of course, being sensitive to this, with a little effort you can separate the wheat from the chaff.

One absolutely untapped period of free time that photographers don't maximize is drive time. The time commuting, the time traveling to and from assignments, and that otherwise unproductive time in the car is frequently frittered away. You can rent audio books—almost all the recommended reading in this book is available as audio books—from the library, and within two weeks, you will have completed an entire book on self help, business growth, or the like. Although you might think that there is never enough time to read a book (and I hope you work to change that!), begin by listening to books in your car or on your iPod. It's an amazing untapped resource.

The Dumbest Person in Any Given Room Thinks He or She Is the Smartest

There is an ancient axiom: The only thing that a truly wise man knows is that he knows nothing. I have found myself in rooms full of rocket scientists (literally), where there were geniuses in residence, some parading around their intelligence like peacocks and others being more responsible stewards of their knowledge. Yet, take the rocket scientist out of his element, and that peacock's tail feathers wither. He might be an expert in his field, but he knows little about the endless specialties outside of his. As such, the peacock's attitude often causes him to miss opportunities to learn about other things.

One of the really wonderful things about the work I have done and the people I have worked with in the past is that I have had the privilege of being in rooms full of amazingly smart people. Their knowledge humbles me each time, and I take the opportunity to garner just a few insights into their field.

Chapter 25 Striking a Balance between Photography and Family: How What You Love to Do Can Coexist with Your Spouse, Children, Parents, and Siblings if You Just Think a Little about It

There is a verse in the Bible, Matthew 16:26, that translates to, "For what is a man profited, if he shall gain the whole world, and lose his own soul?" or "What shall a man give in exchange for his soul?" Now, if you're not a Bible reader, I am certain that there is a similar sentiment in the religious writings that you ascribe to, and if you are not a religious person, understand that this sentiment can, in the end-game analysis, translate to "You can't take it with you."

There is an often-quoted yet misleading statistic that 50% of marriages end in divorce. This statistic is based, at least in part, on the statement that "approximately 2,362,000 couples married in 1994, and 1,191,000 couples divorced in 1994," put forth by the National Center for Health Statistics' Annual Summary of Births, Marriages, Divorces, and Deaths. Each year, with some fluctuation, this summary reflects that the number of divorces is half the number of marriages. This would be accurate were the length of marriage one year; however, the National Center reports, in fact, that the median duration of marriage for divorcing couples is 7.2 years, and that most divorces occur within the first 10 years of marriage. These rates obviously fluctuate from year to year, but not by much.

Men with children should understand this additional statistic *clearly*: 72% of the time, where custody of children was awarded, it went the wife. Joint custody occurred only 16% of the time, and husbands were awarded custody only 9% of the time.

Regardless of what the exact numbers are, photographers have a higher divorce rate than people in almost any other profession. A study by the Missouri School of Journalism, which surveyed 2,100 news professionals in 2000, found the following highlights (or lowlights):

CHAPTER 25

NOTE

The Missouri School of Journalism report was a survey of television and radio reporters, but it makes salient points that, in my opinion and experience, are valid for photographers as well.

- Two of every five persons surveyed said their jobs had caused marital problems.
- At least a third of the problems stemmed from too little quality time with spouses. Survey respondents said odd working hours caused problems in their marriages. One respondent called schedules "tough," reporting, "My wife works 9 to 5, and I work 3 to 11. It doesn't leave a lot of time together." Another respondent said, "Long hours and being called in on my day off is hard for my husband to understand." A male photographer even reported having his honeymoon interrupted by a news emergency.

Some respondents reported missing "quality" time with their families. One respondent reported, "I wish I could be home for family, supper and bedtime stories."

▶ Job stress is reported as problematic too. Carrying the job and its stress home can also stress a marriage. One respondent stated, "I bring home lots of stress and anxiety. It's difficult to talk about job problems at home because it upsets my husband."

▶ Job devotion is a factor too. One respondent wrote, "I'm now separated from my second wife, who felt I was more devoted to news than to her. She didn't like the police scanners on in the car, living room, kitchen, and bedroom."

I hope this has made my point. This information above, if not heeded, is likely a harbinger of things to come if you don't focus on family and strike a balance.

When What You Love to Do Must Not Overwhelm Those You Love

It's easy to get caught up in the excitement of an assignment. For those in the news business, it's chasing news, meeting tight deadlines, and accomplishing editor demands. For commercial work, it's easy to lose yourself in the moment, which becomes hours, and when you look up at the clock, you've passed mealtime and your child's bedtime without so much as a "good night."

Photographer Rick Rickman, in an article for the SportsShooter.com Web site, makes several excellent points:

One of the most interesting things about this business is the fact that so many photographers I know are more interested in doing well in some contest than doing well with nurturing their family or relationships. This business is brutal on relationships! The amount of hours spent at work is relentless. The amount of time spent away from home is endless, and the numbers of times photographers choose work over family needlessly is mindboggling.... If we examine our photography carefully, in most cases we will find that if we work for 30 years at this craft, we may have a couple of chances in our lives that our pictures will actually have some effect or benefit to society or the world. If we're very fortunate, we may have an opportunity to do something good with our images.... Capturing a great moment is a wonderful thing, but does it hold a candle to having an opportunity to direct and shape the future of another human being? Truly having the chance to bring real good into the world is an enviable position to be in.... I'm concerned that this industry has lost sight of what is truly important in the world. Photographers seem to think that winning a contest validates their existence.... I think that a prerequisite for a photographer to enter any contest should be a letter of recommendation from their spouse or significant other saying that they have done well with their lives and duties at home and they should be allowed to enter said competition. No letter, no entry!

Consider that divorce is an option for the ignored spouse and, as the statistics noted earlier, the likelihood is extremely high that you will not only lose your spouse, but almost all access to your children if you are a man. Do not exchange a meaningless award (in the grand scheme of things) for the sorrow you will feel each morning you wake up alone without your spouse, and, if you're a man, for the sorrow you will feel due to the great likelihood that you will also lose your children, save for a few visitation days a month.

Solutions for a Happier Spouse/Partner and Children

Unless you are on a critical deadline, you should make the time when your two-year-old says, "Wanna play with me?" Or when your six-year-old says, "Can you come and play outside?" Or when your teenager says, "Can you come help me with...?" And even if you *are* on a deadline, finish the deadline work, and then seek out the now-departed child to re-engage him or her. When your spouse says, "Sweetheart, please come to bed/to dinner/home," be responsive.

One solution is to make certain you not only make time for dates, but you also are the instigator of planning those dates. Agreeing to go out, and then showing up at the appointed time is not the same as telling someone not to make plans for Friday or Saturday night, and then making reservations somewhere and arranging for tickets to a show or movie. Pack a picnic basket and head out for a nice lunch, or even plan a trip to a museum. Demonstrating that you are thinking about the other person and how he or she is important to you can ensure that your spouse or partner is happy.

For children, recognize that your schedule can and should make time for attendance at school functions, sporting activities, and such. Do not take the "out of sight, out of mind" mentality. Be a participant in their homework and field trips. Of course, your erratic schedule will likely preclude you from being a coach or going to all the games or recitals, but those absences won't be missed as much if you're there most of the rest of the time.

Dealing with the Jealousy of a Spouse or Partner

At points earlier in my wife's career (she's abundantly happy now!), there have been times when she has said to me, "You love your job, and I hate mine. That's not fair." That, dear reader, is when you help your spouse to find a new job and encourage him or her to take the time necessary to find one he or she loves. We are blessed by whatever higher power each of us believes in, because we have a gift or talent that can sustain us and that gives us pleasure day in and day out. Rather than get defensive, do everything within your power to see things from your spouse or partner's perspective.

Sometimes you have to protect your spouse from worrying about you. I know that might sound counterintuitive, but it's important to consider. If you're a freelance photojournalist traveling to a war zone or disaster site, a white lie may be in order (but avoid a straight lie). Don't say you're going to Arizona if you're really going to the Middle East. However, saying you're going to cover humanitarian efforts instead of that you are embedded in a combat unit will allow your spouse to worry less and focus on carrying on with life, your family's needs, and such. Of course you check in when you can, but don't talk about missing being ambushed by 50 yards or about a firefight that broke out after your helicopter took off. Vincent Laforet, Pulitzer prize-winning photographer, presented at the annual NPPA Northern Short Course in 2006. During a seminar entitled "Be Prepared," he said, "Sometimes the best thing I can do for my wife is be vague about exactly where I am so she won't worry, because when she's upset, I get upset, and I need to be focused on not only making pictures, but also my own safety, and worrying about her can't enter into the equation."

In my case, I am always out and about, usually in town, but frequently (less so now than when I was younger) I am traveling on assignment. For me, I love nothing more than coming home after being out all day and having a nice evening at home. My wife, who's been in an office environment all day, wants to go out, get dinner, or such. I make a conscious effort to go out because it's important to my wife and, as such, it's important to me. Traveling for me is definitely work, and I so look forward to a home-cooked meal. However, weekend destinations are trips we make together when I'd rather be home. Sure, I enjoy them, and I especially enjoy that my wife and children are having a fun time, but I relish more being at home working in the garage or out in the yard with the family. Striking that balance is so important in situations such as this.

Listening to Cues: What Those You Love Are Saying When They're Not Saying Anything

One of the refrains made by spouses of photographers is, "You love your camera more than you love me." The immediate response is always, "Of course not, sweetheart," or something to that effect. When you say that, you're not hearing what your spouse is actually saying, which is, "I want to spend time with you, and all you want to do is take photos."

It is extremely hard for a spouse to understand that, although it's not true that all we want to do is take photos, making photographs is as enjoyable to we photographers as whatever hobby our spouse or partner enjoys doing. We are blessed to be able to earn a living doing what we love. Robert Fulghum's book, It Was on Fire When I Lay Down on It, posits this question:

Is my occupation what I get paid money for, or is it something larger and wider and richer-more a matter of what I am or how I think about mvself?

It goes on to say:

Making a living and having a life are not the same thing. Making a living and making a life that's worthwhile are not the same thing. Living the good life and having a good life are not the same thing. A title doesn't even come close to answering the question "what do you do?"

I would submit that while what we do is work, it's not a job. However, we become so focused that we begin to ignore what's going on around us.

Often a spouse will begin to withdraw, and the dialogue about the day's activities may become perfunctory. Maybe your spouse decides to paint a room without talking to you about what color it should be. Or you may get the silent treatment if you don't notice weight loss, hairstyle changes, or such. I know I have fallen into that scenario, and getting out of the proverbial doghouse is an uphill battle.

Dale Carnegie, in his best-selling book, How to Win Friends & Influence People, makes these points:

- When a study was made a few years ago on runaway wives, what do you think was discovered to be the main reason wives ran away? It was "lack of appreciation." And I'd bet that a similar study made of runaway husbands would come out the same way. We often take our spouses so much for granted that we never let them know we appreciate them.
- Abraham Lincoln once began a letter saying, "Everybody likes a compliment." William James said, "The deepest principle in human nature is the craving to be appreciated." He didn't speak, mind you, of the "wish," "desire," or "longing" to be appreciated. He said the "craving."
- ▶ The difference between appreciation and flattery? That is simple. One is sincere, and the other insincere.
- "Here is one of the best bits of advice ever given about the fine art of human relationships," said Henry Ford. "It lies in the ability to get the other person's point of view and see things from that person's angle as well as your own."

Carnegie's citation of others studies and sentiments on the subject is to this point: Listen to what is being said, pay compliments, and convey genuine appreciation for your spouse or partner.

Vacations: Really Not the Time to Shoot Stock

Do not, I repeat, do not bring your camera on a family trip or vacation, unless, without prompting, your spouse asks you to take pictures of the two of you, your children, or other family members. This time is not only a time for you to recharge your mental energy, but it's CHAPTER 25

also a time to be away from your desk, workflows, and such. If you just can't stomach not having a camera, go out and buy the most expensive point-and-shoot-looking camera with a chip that is bigger than the most professional camera from just two years ago, and use that. Make sure it does not look like your work camera, and invite your spouse to take photos of you for a change! And do not hang back to make more images or schedule your walk along the beach for the golden hour. Enjoy the down time; there will be plenty of assignments waiting for you when you return.

Chapter 26 Charity, Community, and Your Colleagues: Giving Back Is Good Karma

Dale Carnegie, author of *How to Win Friends & Influence People*, has posted the following over his bathroom mirror as a daily affirmation and perspective to act from:

I shall pass this way but once; any good, therefore, that I can do or any kindness that I can show to any human being, let me do it now. Let me not defer nor neglect it, for I shall not pass this way again.

Robert Fulghum, author of *All I Really Need to Know I Learned in Kindergarten*, outlines these seemingly simple rules that really apply to all of society (or should):

- 1. Share everything.
- 2. Play fair.
- 3. Don't hit people.
- 4. Put things back where you found them.
- 5. Clean up your own mess.
- 6. Don't take things that aren't yours.
- 7. Say you're sorry when you hurt somebody.
- 8. Wash your hands before you eat.
- 9. Flush.
- 10. Warm cookies and cold milk are good for you.
- 11. Live a balanced life—learn some and think some and draw and paint and dance and play and work every day some.
- 12. Take a nap every afternoon.
- 13. When you go out into the world, watch out for traffic, hold hands, and stick together.

To me, that's a mantra for life. Take a minute to reread that. It really rings true.

Charity: A Good Society Depends on It

When a natural disaster strikes—from a tsunami, to a hurricane, to an earthquake or a terrorist act—it is human nature to join together and help those in need. It's obvious that it's necessary, and that it's a good thing. Following the terrorist strikes of 9/11, the American Red Cross and several other charitable organizations reported record donations, so much so that there was a concern among other charities for ailments and other worthy causes that the ability to collect donations to support their ongoing efforts would be impacted. In the short term, that was in fact the effect. Without your charitable contributions of time, money, or in-kind donations, those affected will not recover from a natural disaster or the life-threatening ailment that lacks a cure.

On a day-to-day basis, there are almost an infinite number of commendable charities that are worthy of your donations, and I encourage you to be generous. However, also be reasonable. One way to see just how charitable your donation might be is to ask whether the printer and designer are doing the work for free. If they are, then perhaps it's of value to do so as well.

Pro Bono Work: You Decide What to Do, Not in Response to a Phone Call Soliciting Cheap (or Free) Work

When the phone rings and it's the latest charity, that is not the time to decide to do pro bono work. I encourage every photographer I know, and with whom I discuss this, to choose charities or causes that are of interest to them and make outreach. By doing this, any guilt you might be feeling when the multiple calls each month come in from worthy causes seeking free or almost free work can be mitigated by your sense of the giving back for which you have already made arrangements.

Engaging the Photo Community: Participating in Professional Associations and Community Dialogue on Matters of Importance to Photographers

Most people are not loners by nature, although there are loners among us. The good thing about the Internet is that those loners can remain alone, but lurk on community blogs, forums, discussion groups, and e-mail listservs; in doing so, they benefit without having to participate. For those who are not loners, participation not only benefits them, but also contributes to the easily accessible body of knowledge from which others can learn.

In addition, being active with photo trade organizations, such as the ASMP, APA, NPPA, and PP of A, as well as the numerous specialty groups that will serve your particular niche, will benefit you greatly. Whether they are continuing education or lobbying on your behalf, these organizations all make a difference in your everyday life. Other examples include organizations that work with a

state to clarify sales tax issues as they apply to photographs; organizations that work with the federal government to protect your intellectual property from theft or the erosion of its value; and organizations that address important issues by, for example, engaging the Transportation Security Administration in a dialogue about the importance of allowing photographers an extra camera bag carry-on, just as they allow musicians with valuable instruments. You might not know that these organizations are doing things like this for you, but it's things like this that they work on every day. Supporting these organizations with your membership dollars will ensure this will continue, but moreover, the organizations will keep you informed of what they are doing and what they have done to warrant your continued membership.

Your Colleagues: They May Be Your Competition, but They're Not the Enemy

Many reasons why we are where we are today—in other words, the state of the business of photography—are because we treated our colleagues like the enemy and our price lists and contracts like nuclear launch codes. For years, retail stores posted their prices proudly. Why is it that there are only a handful of photographers who have their prices on their Web sites and make them easily available to those calling for more information? I encourage photographers to outline, in general terms, their pricing. It can be done with a caveat that all assignments are priced based upon their own unique factors, but nonetheless, the guidelines, when published, present an air of confidence that clients respect.

Even though you might feel as though those with whom you compete for assignments are your competition, consider this: There are truly few photographers who are in direct competition with one another for work. Niche services, unique styles, and other differentiators mean that it is very difficult to compare two photographers and suggest that they both bring identical skills and vision to the table.

On the rare occasion when you encounter someone for whom a negative karmic bank account is a way of life and who sees nothing wrong with backstabbing you, instead of engaging this person, getting enraged, or flying off the handle, take the high road. Early in my career, when I was approached by my photo agency, Black Star, to be represented by them, I was overwhelmed with excitement. A confluence of circumstances, including their regular photographer being on a long-term assignment out of town and their losing local assignments because of this, coupled with the quality of my work and my ability to begin working for them more so than "one here, one there" assignments, immediately meant I was the obvious choice for them. When I shared this exciting news with two of my closest friends and (I thought) confidants, one of them actually called my agency behind my back to try to bump me and take that position. The photographer's representative called me and said, "Hey, we really want to work with you, but why would [the photographer] call us and tell us they heard we were looking for another photographer and offer to be that photographer?" My next opportunity to address this with my "friend" was when they came over to my photo department's photo lab, where I was processing all their film for free (with my supervisor's permission). After loading the E-6 processor and turning on the lights in the darkroom, I asked about it. And the response I got was, "Hey, we're all going to be competition someday, so it's fair game." It took all of my will power not to flip

the top of the processor open and ruin the film I was processing for free, but I did not. Although I did alter what I disclosed to this person from that day forward, I do continue to answer questions about how to price an assignment for this person from time to time. Yet, I've never forgotten that backstabbing experience. But, I did everything I could to take the high road, and I do not regret doing so.

Do I consider that photographer my enemy? No, I do not. Dictionary.com defines an enemy as "a person who feels hatred for, fosters harmful designs against, or engages in antagonistic activities against another; an adversary or opponent." Frankly, I don't know any people toward whom expending that much energy is worthwhile. Having hateful feelings toward a person is an enormous waste of energy that can become all-consuming, and that energy can be better expended by doing something good. Sometimes, just ignoring a person who you think you might want to hate is the best solution. I am not suggesting you don't experience anger about things, but anger subsides naturally. Hate usually festers if left unresolved. And sometimes simply leading your life along a path of success is the best, most unintended form of revenge.

William Somerset Maugham was an English playwright who had one of the broadest audiences in the west. He was also, in the early part of the twentieth century, reported to be the highestpaid playwright. He once said, "The common idea that success spoils people by making them vain, egotistic, and self-complacent is erroneous; on the contrary, it makes them, for the most part, humble, tolerant and kind. Failure makes people bitter and cruel."

To that end, live up to Maugham's sentiment. I can tell you from experience that this holds true when dealing with celebrities. When working with the big, long-term, successful stars, I have found them to be agreeable and generally pleasant to work with. On the other hand, the latest flash-in-the-pan artists and actors, replete with handlers, managers, and such, are often the most difficult and egotistical, in my experience.

Reaching Out: Speaking, Interns and Apprentices, and Giving Back

There are several ways in which you can give back to the photographic community. For those considering the field, taking on interns or apprentices who are training or going to school to learn photography is a way to give back, as is simply creating an open dialogue among colleagues.

Whether to a high school, community college, or university class, taking the time to share with others your experiences can give prospective photographers an idea of what life is like as a photographer. They might have watched a Hollywood movie or a documentary about the life of a photographer, but hearing from a photographer—you—firsthand and being able to engage youwith questions is invaluable. Young photographer Douglas Kirkland attended a lecture in 1964 given by *Life* magazine photographer and legend Gordon Parks. This lecture moved Kirkland to recognize the enormous influence that photography can have and resulted in Parks becoming Kirkland's mentor and friend. In an April 2006 article by Kirkland on the Web site DigitalJournalist.com, Kirkland honored Parks by saying, "Gordon made me a different individual than I would have been had I never known him. He showed me that I had much greater possibilities than I realized."

One of the well-traveled paths of today's photographers has included internships or apprenticeships. I have maintained an intern program for more than seven years, with dozens of students and recent graduates spending time observing and asking questions—many for academic credit, and others for the experience and insights. Most have ended up as photographers or working in the photographic field. Interns that you bring into your sphere of influence should not be expected just to sweep or file receipts. They should be exposed to as many facets of the realities of being a photographer as they possibly can during their time with you. Encourage them to ask questions, and set limits to these when the client is present. I advise my interns that they can ask any question they want, but that they need to be sensitive to asking questions when the client is present. Instead, I ask them to save the questions for my standard debriefing after the shoot. At that time, I encourage questions and prompt for them if there are none to begin the dialogue. The worst thing you can do is to consider an intern as cheap labor to do only the grunt work around the office or studio. Instead, look at interns as people hungry to learn and to whom you owe an education in exchange for their assistance. Well-known photographer Gregory Heisler apprenticed under Arnold Newman in the 1970s, and the legendary Yousuf Karsh served as an apprentice first to his uncle in a photo studio in Canada. Karsh's uncle saw his promise and sent him to apprentice under photographer John Garo of Boston.

An open and respectful dialogue among colleagues can lead to inspirational experiences that can make a difference in the local community, as well as the world. Ansel Adams was first financed by a small insurance agency owner in San Francisco when Adams was 24. At 28, legendary photographer Paul Strand, on self-assignment in New Mexico, took the time to share with Adams his own negatives, which in turn convinced Adams of the potential value of photography as a form of fine art. Sharing positive and negative experiences among photographers can bring a group of photographers together, and each can grow through the encouragement and insight of the others.

Pay It Forward

I didn't write this book because I planned to become a writer. I didn't write it because I expected to be able to live off residuals. I wrote it as a vehicle to continue to be able to pay forward the knowledge that I learned, was given, or that otherwise came to me through osmosis. I did so because I made a karmic commitment to help whomever I could, and this book is one embodiment of that commitment...and certainly not the last.

In Malcolm Gladwell's book, *The Tipping Point: How Little Things Can Make a Big Difference*, he writes about how small, sometimes, imperceptible things can make a big difference. He cites the tipping point for the shoe brand Hush Puppies as occurring sometime between the end of 1994 and the first few months of 1995. Their sales had dropped to 30,000 pairs of shoes worldwide, mostly to small towns and outlets across the country.

At a fashion shoot, two Hush Puppies executives...ran into a stylist from New York who had told them that the classic Hush Puppies had suddenly become hip in the clubs and bars of downtown Manhattan.... [T]hen...in 1995, the company sold 430,000 pairs of the classic Hush Puppies, and the next year it sold four times that...how did that happen? Those first few kids...were wearing them precisely because no one else would wear them.... No one was trying to make Hush Puppies a trend. Yet, somehow, that's exactly what happened. The shoes passed a certain point in popularity, and they tipped.

Gladwell goes on later to say:

When we say that a handful of East Village kids started the Hush Puppies epidemic...what we are saying is that in a given process or system, some people matter more than others. This is not, on the face of it, a particularly radical notion. Economists often talk about the 80/20 Principle, which is the idea that in any situation roughly 80 percent of the "work" will be done by 20 percent of the participants.

Taking your success, you can turn around and help others who are climbing the ladder behind/below you and make a difference. You can be a part of that 20 percent and facilitate the tipping point. Running your business by adhering to standard business practices might seem to you a small, seemingly insignificant thing to the photo community at large, but your actions upholding reasonable standard business practices that apply across the board to every other business can make a difference. Through this, take the time to help others by both example and lesson. So, I ask of you: Take the insights you've gained from this book, and don't try to keep them a secret. Pay it forward.

Index

A

accountants, 91-92 **CPAs** (Certified Public Accountants), 92-93 Accountemps, 40 accounting, 81-93 bank accounts, 86 departments, contacting, 233-236 receipts, retaining, 82-85 reimbursing yourself, 85-86 software for, 81 Adams, Ansel, 317 **ADCMW** (Art Directors Club of Metropolitan Washington), 38 adhesion contracts, 99-100, 192 administrative fees, 238 Adobe. See also Photoshop Bridge, 277 Lightroom, 278 advertisers corporate/commercial contracts for, 144 fees and. 51-52 **Advertising Photographers of** America. See APA (Advertising Photographers of America) advertorial, use of term, 52 aerial photographers, 27 aging receivables, 237 air-to-air photography, 189 airlines cameras as carry-ons, 273-274

magazine contract, 117-119 upgrades for clients, 296-297 All I Really Need to Know I Learned in Kindergarten (Fulghum), 313 all rights, 48, 103-104 in corporate/commercial contracts, 144-145 fees for, 292 altruistic projects, 4 amendments of editorial contracts, 102-104 **American Society of Media** Photographers. See ASMP (American Society of Media Photographers) **American Society of Picture** Professionals (ASPP), 38 analog to digital conversions, 280-281 Angell, David, 246 anniversary party photography, 173 anticipatory breach of contract, 229 **APA** (Advertising Photographers of America), 38, 314 APA Payroll, 40 attorneys, referrals to, 225 contract boilerplate, 168 on personal archives online, 285 seminars from, 304 transferring rights clause, 182 Web site, 302

Aperture, Apple, 278 apo-chromatic (APO), 14 Apple Computers, 15. See also Mac computers Aperture, 278 apprentices, taking on, 316-317 arbitration, 191 for breach of contract, 231 archives. See also backing up analog to digital conversions, 280-281 for copyright registration, 218 personal archives online. 285-288 art directors, 105, 296-297 The Art of Digital Wedding **Photography:** Professional Techniques with Style (Cantrell & Cohen), 180 The Art of Client Service (Solomon), 252, 295, 296, 300 ASMP (American Society of Media Photographers), 38, 60, 314 attorneys, referrals to, 225 carry-on luggage, 273 contract boilerplate, 168 on personal archives online, 285 seminars from, 304 ASPP (American Society of Picture Professionals), 38 assets, 84 assistant photo editors, 105 assistants, 25-27 compensation of, 39

attachments to e-mail, 247 attorneys, 255-262 advice of, 257-258 in breach of contract action. 232 case establishment fees. 260 contingency cases, 261-262 contract review by, 256-257 copy/fax charges, 260 economics of lawsuits, 261 fees, 258-260 for infringement actions, 224-225, 257 law firm portrait contracts, 147-159 negotiations and, 256-257 phone calls, fees for, 260 relationship with client, 258 retainers for, 257, 258-260 taking advice of, 262 writing and, 244 audio books, 305 audits, 84 Augustine, Norman R., 190 **Aurora**, 288 automobile insurance, 74

B

backing up, 268-271 desktop, 268 dual backups, 271-272 laptops, 269-270 software validators, 274 12 steps of, 270-271 work in progress, 270-271 bank accounts, 86. See also checks bar/bat mitzvah photography, 173 BCCs, use of, 251-252 Beckford, Sam, 300 Beckwith, Harry, 8-9, 300 benefits for freelancers, 71-72 bid process, 141 birth photography, 173 Black Star, 277, 315 Blackwell, James A. "Mickey," 243 blimps, 17, 19 renting, 19 bonuses. 68-69 bookkeepers, 93 breach of contract, 229-232 small claims/civil court actions, 230-231 textiles company case study, 231-232 Bridge, Adobe, 277 bris photography, 173 budgets in corporate/commercial contracts, 143 in editorial contracts, 106 Buff, Paul C., 12 Burnett, David, 262 Business E-Mail: How to Make It Professional and *Effective* (Smith), 248, 253 business insurance, 76-80 business plans, 6-9 for existing businesses, 8-9 reviewing, 6-7 buyout rights, 48 in corporate/commercial contracts, 143 use of term. 52

2

cable modem routers, 266-267 camera sound blimp. See blimps cameras, 14 as airplane carry-ons, 273-274 dual cameras, use of, 272 insurance, 76-77 Camp, Jim, 62 canceled checks, retaining, 83 **Canon EOS Rebel**, 11 Cantrell, Bambi, 180 Carnegie, Dale, 311, 313 carry-on luggage, cameras in, 273-274 cases for lights, 13 catering billing for, 297-298 estimates, 142 CCs, use of, 251-252 cell phones, 6 certificates of insurance (COIs), 78-80 Chandler, Steve, 291, 293-296, 300, 302-303 charity, 314. See also pro bono work cheapest fees, charging, 50-51 Checketts, Darby, 300 checks canceled checks. retaining, 83 reimbursement by, 85-86 children. See family Chizen, Bruce, 205 christening photography, 173 civil courts, 230-231 clients. See also corporate/commercial contracts; editorial contracts; nonprofit clients airline upgrades for, 296-297 catering and, 297-298 copyrights and, 292 delivery to, 298-299 dinners with, 298 e-mail to, 299-300 estimates, sending, 299-300 honoring convenience of, 292-293 problems with, 295

repeat clients, ensuring, 293-296 scope of work, outlining, 23 - 24taking care of, 291-300 value-added services for, 296-297 **Code of Federal Regulations** (CFR), 238 Cohen, Herb, 62, 183-184, 190, 201 Cohen, Skip, 180 collateral defined, 56-57 **PLUS** (Picture Licensing Universal System) on, 54-56 use of term. 52 colleagues, 315-316 collections services. 239-241 color temperature shift, 12 common law and copyrights, 204 communications security, 265-266 community, interacting with, 314 compensation. See fees; salaries competition colleagues and, 315-316 surveying, 48-50 computers, 15-17. See also Apple Computers; Internet; laptop computers; Mac computers; software backing up, 268-271 desktop, backing up, 269 firewalls, 266 monitors, 17 viruses, 15, 266 concept images, 285 Constitution and copyrights, 204 consumer equipment, 11

consumer magazine contract, 127-138 contingency cases, 261-262 contingency plans, 24-25 contracts. See also breach of contract: editorial contracts: negotiating adhesion contracts, 99-100, 192 attorneys reviewing, 256-257 deal breakers, 191-192. 292 infringement settlement agreements. 225-228 photo agency contracts, 283-284 rites-of-passage photography contracts, 175-177 science competition contract, 194-200 take it or leave it contracts, 192 updating contracts, 168-172 wedding photography contracts, 175-177 Controlled Vocabulary, 279-280, 281 **CONUS** (Continental United States) fees. 189-190 Copy Fights: The Future of Intellectual Property in the Information Age (Thierer & Crews), 219 Copyright Act of 1976, 102-103 Copyright in Historical Perspective (Patterson), 219 **Copyright Registration** Certificate, 222

copyrights, 203-219. See also infringement actions: workmade-for-hire advanced registration, 210 all rights demands and, 103-104 archiving registration, 218 clients demanding, 292 Constitution and, 204 date of first publication of work, 216-217 defined. 205-206 fees for. 189-190 for foreign citizens, 209 independent contractors and, 40 Life magazine litigation, 60 multiple-image infringement, 214 nation of first publication of work, 216-217 nature of work, defining, 215-216 pre-registration, 206 published work defined, 218-219 sample registration, 206-213 selling, 57 signature on form, 218 titles of work, 213-215 unpublished work defined, 218-219 vear of creation of work, 216 Copyrights and Copywrongs: The Rise of Intellectual **Property and How It Threatens Creativity** (Vaidhyanathan), 219 Corbis, 55 corporate/commercial contracts, 3 all rights licensing in, 144-145

INDEX

bid process, 141 comparison of, 139-141 favorites, dealing with, 144 infringement settlement agreements with, 228 law firm portrait case study, 147-159 multi-party licensing agreements, 145-146 national corporate client case study, 160-164 negotiating, 142-145 regional corporate client case study, 165-167 requirements for, 141-142 signing off authority in, 141 stakeholders in events, 143-144 updating contracts, 168-172 correspondence. See letterwriting cost of doing business (CODB) calculators, 42-43 and salaries, 71 single line item, fees as, 44-45 cost-of-living-adjustments (COLAs), 43-44 raising rates and, 47 costs. See also fees of analog to digital conversions, 280-281 gift expenses, 84 interest expenses, 87-91 for transportation, 84 courts. See also small claims court civil courts, 230-231 **CPAs** (Certified Public Accountants), 92-93

crashed computers recovery, 274-275 creative directors, 105 creative/usage fees, 43-47 in corporate/commercial contracts, 142-143 creativity in negotiating, 187-190 credit cards accounting issues, 87-91 interest deductions. 87-91 interest markups, 66 and overhead, 63 Payment Breakdown form. 89-91 Statement Breakdown form, 87-89 credit rating, 4 Crews, Wayne, 219 CRT monitors, 17 **CTO gel**, 12 **Customer** Astonishment Handbook (Checketts), 300 CYA summary letters, 250

D

DAM system, 277-278 The DAM Book: Digital Asset Management for Photographers (Krogh), 277-278 Data Rescue II, 274 dates on copyright registration form, 217 of first publication of work, 216-217 Davidson, Cameron, 27 day rates, 101-102 deadlines, 298-299 families and. 308-309 deal breakers, 191-192, 292 death photography, 173 decision-making, 5-6

deliveries, 6-7 overhead, services as, 64 overnight delivery, 6 desktop, backing up, 269 **Digital Copyright: Protecting** Intellectual Property on the Internet (Litman), 219 Digital Railroad, 285-286 DigitalJournalist.com, 316 dinners with clients, 298 director of photography, 105 disability insurance, 75-76 disaster recovery software, 274-275 discounts, offering, 238 Disk Warrior, 274 divorce statistics, 307-309 DNG images, 275 drive time education, 305 DriveSavers, 274 dual backups, 271-272 Duboff, Leonard D., 219 **Dun & Bradstreet's Receivable Management Services** collections. 239-241 Dyna-Lites, 12

E

e-mail, 246-248 attachments, 247 CCs and BCCs, use of, 251-252 to clients, 299-300 contents of e-mail, 244 to non-paying clients, 233-234, 236 port forwarding and, 267 professionalism in, 248 responses to, 6 signatures, 248-250 subject line for, 247 summary letters, 250-251 eBay, 16

editorial contracts, 97-138 addendum to. 112 adhesion contracts, 99-100 amendments to, 102-104 consumer magazine case study, 127-138 day rates, 101-102 financial newspaper case study, 120-126 in-flight airline magazine case study, 117-119 negotiating, 97-100, 105-109 objectionable terms in, 98-99 personal/commercial use of created photographs, 108-109 sending contracts, 97-100 signatures on, 100 terms and conditions (T&Cs) in, 108 university magazine case study, 110-116 usage clauses, 100-101 word processing software for, 104-105 editorial fees, 7 Editorial Photographers (EP), 168 education, 301-305 research and, 304-305 **EIN (Employer Identification** Number), 87 The Elements of E-Mail Style: Communicate Effectively via Electronic Mail (Angell & Heslop), 246 The Elements of Style (Strunk & White), 246, 253 Email Marketing: Using **Email to Reach Your Target** Audience and Build **Customer Relationships** (Sterne & Priore), 253

employees, 31-40. See also assistants compensation of, 35-36, 39-41 definition of, 32-38 temporary employees, 40-41 engagement party photography, 173 entertainment expenses, 84 enthusiasm for assignments, 107 equipment, 11. See also cameras; lighting renting, 18-19 specialized equipment, 17-19 estimates to clients, 299-300 ethical policies, 190 **EULA (End User Licensing** Agreement), 44 event-type photos, 142 exceptions to policies, 190-191 exclusive licenses, 61 expenses. See costs

F

family, 307-312 jealousy, dealing with, 310 listening to, 310-311 portraits, 173 solutions for, 309 vacations. 311-312 fashion photography, 179 faxing, 245 attorneys' fees for, 260 slow-paying clients, 233 fees, 41-62, 43-44. See also creative/usage fees; negotiating; slow and nonpaying clients administrative fees, 238 for all rights, 292 attorneys' fees, 258-260 in breach of contract action, 232

competition, surveying, 48-50 for copyrights, 189-190 for delivery, 6 editorial fees, 7 exceptions to policies, 191 late fees. 237-239 lost assignments and, 193-194 lowest fees, charging, 50-51 in multi-party licensing agreements, 146 of photo agencies, 283-284 photo agency fees, 7 pro bono work, 52-53 raising, 47-48 for reprints, 107-108 separate line items for. 45-47 services covered by, 51 as single line item, 44-45 for wedding photography contracts, 178 FileMaker. 104 updating contracts with, 168 film expenses, 64-65 financial advisors, 67 financial newspaper contract, 120-126 firewalls, 266 firing employees, 37 Fisher, Roger, 62 fisheve lenses, 17 flash duration, 12-13 flexibility, 24-25 Fong, Gary, 174 food. See also catering photography, 12 Ford, Henry, 311 foreign citizens, copyrights for, 209 fotoBiz, 81, 205 fotoQuote, 106-107 theft of. 205

401K plans, 67

Free Culture: How Big Media Uses Technology and the Law to Lock Down Culture and Control Creativity (Lessig), 219 freelancers business model for, 7 salaries for, 71-72 FTC (Federal Trade Commission), 49 FTP servers, 265-266 port forwarding and, 268 Fulghum, Robert, 311, 313 fundamental breach of contract, 229

G

Garo, John, 317 Gartner Group, 268 gate-checking cameras, 273-274 generators, 18-19 **Getting Down to Business:** Successful Writing at Work (Kirschman), 253 Getting Past No: Negotiating Your Way from Confrontation to Cooperation (Ury), 62 Getting to Yes: Negotiating Agreement Without Giving In (Fisher, Ury & Patton), 62 Getty, 55, 284 GIF graphics in signatures, 249-250 gift expenses, 84 Gladwell, Malcolm, 317-318 grammar, 243-244 Griffin, Jack, 253 gross receipts, 83 gyros, 17, 19

Η

half-day rates, 102 hand delivery, 6 Hasselblad, 14 health insurance, 73-74 Heisler, Gregory, 317 helicopter shots, 27 Hensel lights, 12 Heslop, Brent, 246 high-dynamic-range (HDR), 304 high-resolution images, 299 high-tech companies, 191 Hindsight software, 81 hiring employees, 37-38 hobbyist photographers, 48 homeowner's insurance, 76-77 honeymoon photography, 173 How to Grow as a Photographer: Reinventing Your Career (Luna), 301-302 How to Say It at Work: **Putting Yourself Across** with Power Words. Phrases, Body Language, and Communication Secrets (Griffin), 253 How to Win Friends & Influence People (Carnegie), 311, 313

I

images.com, 288 in-flight airline magazine contract, 117-119 independent contractors, 40 infringement actions, 205 attorneys in, 224-225, 257 low press run infringers, 223 and outright theft, 224 potential client infringers, 223-224 settlement agreements, 225-228 timeline for. 222 types of infringers, 222-224

instructions to employees, 33 insurance, 73-80. See also liability insurance business insurance, 76-80 certificates of insurance (COIs), 78-80 disability insurance, 75-76 health insurance, 73-74 life insurance, 74 and taxes, 80 interest expenses, 87-91 International Harvester World. 140 Internet, 4. See also Web sites corporate/commercial contracts and, 144-145 personal archives online, 285-288 port forwarding, 266-268 publication on, 219 research on, 305 security issues, 266 spam, 266 interns, taking on, 316-317 intranet addresses, 267 Intuit QuickBooks, 81 IP addresses, 267 **IPNStock**, 287-288 **IRS** (Internal Revenue Service), 3-4 EIN (Employer Identification Number) from, 87 employees, definition of, 32-38 W-9 forms, 235 **ISP** (Internet Service Provider), 267 It Was on Fire When I Lay Down on It (Fulghum), 311 iView, 81, 277-278

Jacobsen blimps, 17, 19 James, William, 311 jargon in writing, 245 jealousy of spouse. See family job stress, 308 JPEG format, 14 signatures, graphics in, 249-250

K

Karsh, Yousuf, 317 Kenyon Gyro, 18-19 keywords in DAM system, 277-278 Kirkland, Douglas, 302, 316 Kirschman, DeaAnne, 253 Kraft services, 297 Krages, Bert P., 219 Kramon, James M., 253 Krogh, Peter, 277-278 Kuhns, Brad, 287

L

Laforet, Vincent, 310 laptop computers, 16 backing up, 269-270 late fees, 237-239 late-paying clients. See slowand non-paying clients latitude of chip, 14 law firm portrait contracts, 147-159 The Law, In Plain English, for Photographers (Duboff), 219 Law.com, 48-49 laws, intent of, 57 lawyers. See attorneys LCD monitors, 17 Legal Handbook for **Photographers:** The Rights and Liabilities of Making Images (Krages), 219 legal issues. See also attorneys; breach of contract; copyrights; infringement

actions policies and, 190 work-made-for-hire, 57-61 legal obligation, defined, 262 Leicas, 14 Leipzig, Mimi, 60-61 lenses pro-line lenses, 14 types of, 17 Lessig, Lawrence, 219 letter-writing, 243-253. See also e-mail CCs and BCCs, use of. 251-252 consistency in, 245-246 summary letters, 250-251 thank-vou notes, 252-253 liability insurance, 77-80 for wedding photography, 178-179 licensing, 53-57 exclusive licenses. 61 fotoQuote for estimating, 106-107 language of, 54-57 multi-party licensing agreements, 145-146 pricing and, 50 transferring rights clause, 182 life insurance, 74 Life magazine, 140 rights issues, 60 lighting excess equipment, 272-273 kit rentals. 18-19 professional lighting, 12-13 specialists, 25-27 Lightroom, Adobe, 278 Lincoln, Abraham, 311 liquidated damages, 256-257

listening to family, 310-311 and negotiating, 186 Litman, Jessica, 219 LLCs (limited liability corporations), 3 location managers, 26 lost assignments, 193-194 low press run infringers, 223 Lowe, Jacques, 275 Luna, Tony, 301-302 lunch, providing, 297-298

M

Mac computers, 15 port forwarding, 268 prices of, 16 .Mac service, 268-269 magazines. See also advertisers; clients consumer magazine contract, 127-138 day rates, 101-102 subscriptions to, 304 makeup specialists, 26 marking images, 288 markup rates, 66 marriage. See family MasterCard, 4 material breach of contract, 230 Maugham, William Somerset, 316 McDougall, Angus, 140 media buys, 46 Medicare/Medicaid, 75-76 metadata. 277-278 Microsoft iView, 81, 277-278 Monev, 81 Windows, 15 Milwaukee Journal, 140 minimum wage, 31 minor breach of contract, 229

INDEX

Missouri School of Journalism report, 307-308 monitors, 17 moral policies, 190 mortgage insurance, 74 multi-party licensing agreements, 145-146 multi-photography events, 179-180

N

Nagel, Patrick, 102-103 naming systems, 279 work. 213-215 Nardelli, Bob, 302 nation of first publication of work, 216-217 national corporate client contract, 160-164 **National Press Photographers** Association. See NPPA (National Press Photographers Association) natural disasters, 275 nature of work, defining, 215-216 NCAA Photos, 286 negotiating, 181-201 adhesion contracts, 192 attorneys and, 256-257 corporate/commercial contracts. 142-145 creative solutions in, 187-190 deal breakers, 191-192 defining policies, 190-191 editorial contracts, 97-100, 105-109 lost assignments, 193-194 "no" and, 192 positions of strength in, 182-186

reading recommendations, 62 science competition contract, 194-200 take it or leave it contracts, 192 techniques, 53 thinking through and, 184-185 twelve essential rules of. 185-186 wedding photography contracts, 177-178 Negotiating Stock Photo Prices (Pickerell), 62 Neri, Grazia, 286 **Network Attached Storage** (NAS), 271 Newman, Arnold, 60-61, 317 Newsweek magazine, 101 9 Lies That Are Holding Your **Business Back...and the** Truth That Will Set It Free (Chandler & Beckford), 291, 294, 300, 302 Nisselson, Evan, 286 "no" in negotiating, 192 non-disclosure agreements, 97 non-exclusive granting, 181 non-paying clients. See slowand non-paying clients nonprofit clients, 53 discounts to, 238-239 NPPA (National Press Photographers Association), 314 attorneys, referrals to, 225 CODB calculator, 42-43 contract boilerplate, 168

0

observation, learning by, 304 office insurance, 77 office managers, 93 Olive, Tim, 302 on/off site archives, 271-272 Ontrack, 274 outlining scope of work, 23-24 over the transom clients, 184 overhead. 63-66 examples of, 63 identifying, 63-64 markup rates, 66 retirement plans in, 67 overnight delivery, 6 ownership. See also copyrights Playboy Enters., Inc. v. Dumas, 102-103 work-made-for-hire and, 59

Ρ

Parks, Gordon, 316 part-time employees, 32 partnerships, 3 Patterson, Lyman Ray, 219 Patton, Bruce, 62 paying employees, 39-41 paying it forward, 317-318 Payment Breakdown form, 89-91 PC computers, 15 PDF files, 233-234 and backing up, 270-271 personal/commercial use of created photographs, 108-109 photo agencies, 283-285 fees, 7 photo archive services, 285-288 Photo District News, 70, 225 photo editors, 105, 296-297 photo fees. See fees The Photographer's Guide to Negotiating (Weisgrau), 62, 192, 201 photojournalism, 140

PhotoShelter, 286-287 Photoshop in cost of doing business (CODB), 44 theft of, 205 pi, calculation of, 187 Pickerell, Jim, 62 Picture Agency Council of America (PACA), 55 pilots, 27 pirated software, 44 planning, 21-27, 277. See also business plans conveying your plan. 23 - 24readiness and, 23 for unexpected circumstances, 22 Playboy Enters., Inc. v. Dumas, 102-103 **PLUS** (Picture Licensing Universal System), 54-57 policies, defining, 190-191 port forwarding, 266-268 portfolio reviews, 23 portrait photography, 7 law firm portrait contract, 147-159 school portrait photography, 173 post-production as overhead, 64 potential client infringers, 223-224 **PPA** (Professional Photographers of America), 314 attorneys, referrals to, 225 contract boilerplate, 168 and rites-of-passage photography, 174 pre-billed late fees, 238 pre-production for wedding photography, 174-175

preexisting clients, infringement by, 222-223 price-fixing, 48-50 price-shopping, 50 prices. See fees Priore, Anthony, 253 pro bono work, 52-53, 314 exceptions to policies, 191 producers, 26 product photography, 12 productivity, computers and, 16 professional associations, 314-315. See also specific associations **Professional Photographers of** America. See PPA (Professional Photographers of America) profits and losses of employees, 36-37 Profoto 7Bs. 13 prosumer equipment, 11 Publication 583 (IRS), 84 published work defined, 218-219 punctuation, 243-244 purchases, receipts for, 83

Q

Quad 2.5-GHz G5 computers, 16 QuickBooks, 81 quotes for editorial contracts, 106-107

R

raising rates, 47-48 Randstad, 40 RAW images, 275 reading recommendations for client relations, 300 for copyright registrations, 219 for letter-writing, 253

for negotiating, 201 for wedding photography, 180 receipts. 82-85 **IRS** (Internal Revenue Service) requirements, 83-85 recommended readings. See reading recommendations recovery software, 274-275 redundancy, 265 **Redux**, 286 Reese, Kay, 60-61 Reggie, Dennis, 174 regional corporate client contract. 165-167 registering copyrights. See copyrights Reiks, David, 279 reimbursing yourself, 85-86 renting equipment, 18-19 repeat clients, ensuring, 293-296 reports by employees, 35 reprint fees, 107-108 research, 303-305 for assignments, 9 retainers for attorneys, 257, 258-260 retirement plans, 67 reunion photography, 173 Revenue Ruling 87-41, 32-38 Rickman, Rick, 262, 308-309 rites-of-passage photography, 173-180. See also wedding photography contracts, 175-177 friends/relatives and. 173-175 packages for, 178 Robertstock, 288 royalty payments, 284 rushing images, 298-299

S

Saba, Marcel, 286 safety issues, 27 salaries, 68-71 for employees, 35-36, 39-41 experience level and, 70-71 fair salaries, establishing, 68-70 for freelancers, 71-72 minimum wage, 31 Salary.com, 67-68 sales. See also licensing of copyrights, 57 Sanschagrin, Grover, 287 scanning analog images, 280 school photography, 173 science competition contract, 194-200 scientific photography, 12 scope of work, outlining, 23-24 The Scribes Journal of Legal Writing, 244 seamless, 22 Sebastian, John, 222 Secrets of Closing the Sale (Ziglar), 201 security of communications networks, 265-266 redundancy, 265 Sedlik, Jeff, 60, 213 seminars, 302-304 Seneca, 21 senior portraits, 173 senior prom photography, 173 services of employees, 33-34 settlement agreements in breach of contract action, 232 in infringement actions, 225-228

shall, use of term, 243 shipping. See deliveries short-duration flash, 13 "Should Lawyers Punctuate" (Wydick), 244 signatures on copyright registration form, 217 e-mail signatures, 248-250 on editorial contracts, 100 for multi-party licensing agreements, 146 silence and negotiating, 186 Sint, Steve, 180 slave triggers, 176 slow- and non-paying clients, 233-241 aging receivables, 237 collecting unpaid invoices. 236-237 collections services, 239-241 e-mailing, 233-234, 236 late fees, 237-239 talking to, 233-236 **Small Business** Administration (SBA), 8 on data loss, 265 small claims court for breach of contract actions, 230-231 for slow- or non-paying clients, 241 Smith, Lisa A., 248, 253 software accounting software, 81 disaster recovery software, 274 275 for editorial contracts, 104-105 Macs vs. PCs, 15 pirated software, 44 theft, 205 validators, 274

Solomon, Robert, 252, 295, 296, 300 spam, 266 specialists, 25-27 specialized equipment, 17-19 sports league photography, 173 Sportshooter.com, 287 **spouses.** See family Spring, Tom, 266 staff photographers business model for, 7 copyrights and, 57-58 Starbucks, 297-298 Start with NO...The Negotiating Tools that the Pros Don't Want You to Know (Camp), 62 Statement Breakdown form, 87-89 statutes of limitations on audits. 84 Steinberg, Leigh, 185-186, 201 Sterne, Jim, 253 Stieglitz, Alfred, 183 Stillwell & Stillwell, 40 Stock Artists Alliance (SAA), 285 stock images, 285-288 StockView, 81 Strand, Paul, 317 strategic decision-making, 5-6 Strunk, William, Jr., 246, 253 studios, 7 stylists, 26 subscriptions, 304 Success Teams, 302 summary letters, 250-251 Sunbelt Rentals, 19 sweet sixteen photography, 173 Symantec, 274

tactical decision-making, 5-6 take it or leave it contracts. 192 taxes, 3-4. See also IRS (Internal Revenue Service) insurance and, 80 preparation services, 92 receipts, retaining, 83-85 W-9 forms, 235 Tech Tools Pro, 274 telephones attorneys, phone calls to, 260 cell phones, 6 Voice Over IP (VOIP), 266 templates, e-mail, 248 temporary employees, 40-41 10,000 Eyes: The American Society of Magazine **Photographers'** Celebration of the 150th Anniversary of Photography (Newman), 60-61 termination of employees, 37 terms and conditions (T&Cs). 108 terrorist incidents, 275 thank-you notes, 252-253 theft. See also infringement actions software theft, 205 Thierer, Adam D., 219 third-party infringements, 223 Timbuktu, 266 Time magazine, 101 timing shots, 24-25 Tinervin, Tom, 286 The Tipping Point: How Little Things Can Make a Big Difference (Gladwell), 317-318 titles of work, 213-215 trade association meetings, 38

T

trade shows, 304 training employees, 33 transferability of rights, 182 transportation, 27 expenses, 84 Transportation Security Administration, 315 traveling expenses of employees, 36 triptychs, 101 trust fund photographers, 183 2/10 net 30 invoices, 238

U

university magazine contract, 110-116 UNIX operating system, 15 unpublished work defined, 218-219 updating contracts, 168-172 Ury, William L., 62 US News & World Report, 101 US Treasury discount calculator, 238 usage. See also creative/usage fees editorial contract usage clauses, 100-101

V

vacations, 311-312 Vaidhyanathan, Siva, 219 Vallam, Nadia, 295 value-added services, 296-297 verbal contracts, 100 video with Mac computers, 16 VII, 286 viruses, 15, 266 Visa, 4 VNU, 287 Voice Over IP (VOIP), 266

W

W-9 forms, 235 Walker, David, 70 Web sites APA National Web Site, 302 Controlled Vocabulary, 279-280, 281 CPA directory.com, 93 Digital Railroad, 285-286 DigitalJournalist.com, 316 Dun & Bradstreet's Receivable Management Services, 241 IPNStock, 287-288 IRS.gov, 84 Jacobsen Sound Blimp, 17 Kenvon Gvro, 18 PhotoShelter, 286-287 PLUS (Picture Licensing Universal System), 54 Small Business Administration (SBA), 8 US Treasury discount calculator, 238 zsCompare, 274 wedding photography, 7, 173-180 canceled weddings, 176 contracts, 175-177 liability protection, 178-179 liquidated damages and, 256-257 multi-photography events, 179-180 negotiating contracts, 177-178 pre-production for, 174-175 Wedding Photography: Art, Business & Style (Sint), 180 Weisgrau, Richard, 62, 192, 201

What Clients Love: A Field Guide to Growing Your Business (Beckwith), 8-9, 300 White, E. B., 253 White Lightnings, 12 wide-angle lenses, 17 will, use of term, 244 Wing-Lynch rotary tube processors, 301 Winning with Integrity: **Getting What You Want** Without Selling Your Soul-A Guide to Negotiating (Steinberg), 185, 201 Woods, Tiger, 302 word processing software, 104-105

WordPerfect, 104 work hours of employees, 34 work-made-for-hire, 48, 57-61, 72 categories of, 58-59 as deal breaking policy, 191 declining, 107 Playboy Enters., Inc. v. Dumas, 102-103 stealth contracts. 61 workflow solutions, 278-280 workman's compensation, 38 writing. See e-mail; letterwriting Wydick, Richard, 244

year of creation of work, 216 You Can Negotiate Anything (Cohen), 62, 183, 190, 201 You Don't Need a Lawyer (Kramon), 253

Z

Y

Zeiss glass, 14 Ziglar, Zig, 201 zoom lenses, 17 zsCompare software, 274 Zucker, Monte, 174